100
MASTERPIECES
OF PAINTING

INDIANAPOLIS
MUSEUM OF ART

100
MASTERPIECES
OF PAINTING

INDIANAPOLIS
MUSEUM OF ART

Anthony F. Janson
with A. Ian Fraser

© 1980
Anthony F. Janson
Indianapolis Museum of Art
1200 West 38th Street
Indianapolis, Indiana 46208

Credits:

Design: *Anthony F. Janson*
 Meyer Miller
 Nancy Singleton
 Marcia Hadley
 Jennifer Janson

Photography: *Robert Wallace*

Composition: *Weimer Typesetting Co., Inc.*

Printing: *Crippin Printing Corporation*

ISNB 0-936260-01-7

INDIANAPOLIS MUSEUM OF ART
STAFF LIST—JANUARY 1980

Administration:
Robert Yassin . Director
Isabel Martin Executive Secretary
Pamillia Cavosie General Office Assistant

Curatorial:
Anthony Janson Senior Curator, Curator of
 Painting and Sculpture
Ellen Lee Associate Curator, Painting and
 Sculpture
Janet Feemster Curatorial Secretary
Peggy Gilfoy Curator, Textiles and
 Ethnographic Art
Yutaka Mino Curator of Oriental Art
James Robinson Assistant in Oriental Art
Catherine Lippert Associate Curator of
 Decorative Arts
Ian Fraser Research Curator, Clowes Fund
 Collection
Martin Krause, Jr. Assistant Curator, Prints
 and Drawings
Daphne Miller Print Room Technician
Martin Radecki Conservator
David Miller . . . Associate Conservator, Paintings
Harold Mailand . . Assistant Conservator, Textiles
Richard Sherin . . . Assistant Conservator, Objects
Catherine Collins Conservation Intern
Alan Conant Conservation Intern
Claire Hoevel Conservation Intern
Marilyn Sullivan Administrative Assistant
Martha Blocker Librarian
Ronald Barnard Research Assistant, Library
Elizabeth Fowler Research Assistant, Library
Mary Kay Horn Research Assistant, Library
Julie Su Cataloguer, Library
Hilary Bassett Registrar
Vanessa Wicker Burkhart Associate Registrar
Sarah Cloar Assistant Registrar
Theresa Harley S.T.E.P. Coordinator
Larry Head Assistant Registrar, Foreman,
 Technical Services
Daniel Smith Assistant Registrar,
 Technical Services
Barbara Wolfe Clerk/Typist, Registration
Robert Wallace Photographer
Sherman O'Hara Preparator

Sam Smith Foreman, Preparation Crew
Denny Paff . Carpenter
Theodore Allen Assistant to the Preparator
Richard McClain Assistant to the Preparator
Randall Smith Assistant to the Preparator

Education:
Donna Ari Director of Education
Laurinda Dixon . Assistant Director of Education
 for Adult Services
Phyllis Baker Secretary
Peggy Ammerman Administrator
Carole Darst . Assistant Director of Education for
 School and Youth Services
Patricia Grady Docent Scheduler
Barbara Shoup School Program Coordinator
Mary Hickam Lilly Pavilion Coordinator
David Mickenberg Lecturer
Gloria Butsch Program Coordinator
James Burkett Director of Media Production
 and Services
Barry Moss Supervisor of Media Services
Robert Dooley Assistant, Media Services
Carolyn Metz Director of Visual Resources
 and Services
Cynthia Shipley Assistant, Visual Resources
 and Services
Ginger Hoyt Director of Special Services
Monica Meyers Information Coordinator
Teresa Jones Assistant, Special Services

Development and Membership:
Wendy Boyle . . Director of the Annual Campaign
Jo Ellen Kenner Administrative Secretary
Mary Arceneaux . . . Director, Residence Division,
 Operating Fund
Susan Pfeifer Assistant, Residence Division,
 Operating Fund
Sharline Kodroff Membership Coordinator
Linda Armstead Records Center Manager
Ann Bancroft Word Processor Operator
Nancy Carnes . . . Membership Records Assistant
Virginia King Records Clerk
Gail Liebert Records Clerk
Barbara Gabriel Assistant in Development,
 Historical and Grant Research

CONTENTS

FOREWORD

100 Masterpieces of Painting in the Indianapolis Museum of Art celebrates the Museum's 10th anniversary at its new facilities. With the move to the former J. K. Lilly, Jr., estate in 1970, the Indianapolis Museum of Art joined the ranks of the major museums in America. At that time it already possessed a strong core collection. Since then, the IMA's holdings have expanded dramatically in every area. Fully one-fifth of the works in this book were acquired through gift or purchase in the last decade, including seven within the past two years alone. Clearly the Indianapolis Museum of Art has come a long way since it was founded in 1883.

100 Masterpieces of Painting in the Indianapolis Museum of Art chronicles nearly 100 years of continuous progress. The IMA's Centennial in 1983 will be marked by the publication of other major catalogues documenting the Museum's important collections, a program launched with the recent publication of *British Drawings and Watercolors 1775-1925* by Martin F. Krause. More generally, *100 Masterpieces of Painting in the Indianapolis Museum of Art* is the culmination of two years' intensive work by the Painting and Sculpture Department. It represents only one part of a larger program of assessment of the collections and their future direction, a program that also includes the complete reinstallation of the Museum's permanent collections and even closer structuring of the collecting and exhibition programs in cooperation with the Museum's education department.

The production of a book of the scope of *100 Masterpieces of Painting in the Indianapolis Museum of Art* is an undertaking of no small magnitude. Our thanks go to Dr. Anthony F. Janson, the Museum's Senior Curator, for seeing this publication through to such a splendid conclusion. Dr. Janson has brought both his enormous breadth of scholarship and his skill in writing to this formidable task, and mere thanks are really not enough to express the depth of our gratitude to him for his efforts. Thanks, too, are extended to Mr. A. Ian Fraser, Research Curator of the Clowes Fund Collection, for his many contributions of research and scholarship to this volume.

As it approaches its 100th birthday, the Indianapolis Museum of Art is already looking forward to a second century of even better service to art and to the public.

Robert A. Yassin
Director

INTRODUCTION

It is an unfortunate fact that, except for a handful of the most famous works, the collection of European and American paintings at the Indianapolis Museum of Art has remained poorly known, both to our public and to scholars, despite the publication in 1970 of Dwight Miller's fine *Catalogue of European Paintings* and the illustrated checklist of American paintings, as well as of A. Ian Fraser's *Catalogue of the Clowes Collection* in 1973. *100 Masterpieces of Painting in the Indianapolis Museum of Art* identifies the finest pictures in our holdings and presents what we know about them. In addition to a review of the existing literature, a considerable amount of new research was undertaken, especially on the recent accessions. This book represents the present state of our thinking, but scholarship is, by its very nature, an ongoing process, and it should be emphasized that, try as we might, the results must inherently elude the definitiveness which remains the impossible dream of every author.

In the main, the best paintings, like all good art, have proved themselves out, including several about which we initially harbored severe reservations. At the same time, it must be admitted that there have also been some disappointments, several of them major ones. Like all museums, the Indianapolis Museum of Art has a number of "important" paintings which, upon closer scrutiny, emerge as unauthentic, misattributed or substandard. Fortunately, they constitute only a small minority amid what emerges as a fine collection on the whole.

The primary purpose in writing *100 Masterpieces of Painting in the Indianapolis Museum of Art* is to make this knowledge readily accessible to the Museum's general public. For this reason, the present catalogue is aimed as much as possible at that audience. Only the thornier problems have been addressed to specialists. Otherwise, the main emphasis is on the broad historical interpretation of each work. For the sake of consistency, all the writing has been done by me, using an approach designed to complement H. W. Janson's *History of Art* when appropriate.

The material on the Clowes Collection relies largely on the research of A. Ian Fraser, whose role in the entire project has been essential. More generally, the catalogue is the fruit of work done by many people. In addition to the scholars who have written independently on these paintings and provided the benefit of their expertise to us, there has been a long line of talented researchers at the Indianapolis Museum of Art, among them its distinguished long-time director Wilbur D. Peat, Dr. Stephen Ostrow and David Carter. I am also indebted to my present colleagues for their contribution: Director Robert A. Yassin, himself a former Senior Curator of the museum, Associate Curator Ellen W. Lee and Assistant Curator Martin F. Krause, Jr.

I owe a special note of thanks to Martha Blocker, our librarian, who has ordered books, arranged interlibrary loans and solved research problems on countless occasions with unfailing helpfulness and cheerfulness. With the expertise and assistance of Chief Conservator Martin Radecki and Paintings Conservator David Miller, many questions were resolved in the laboratory that would otherwise have remained unanswered.

Publication of *100 Masterpieces of Painting in the Indianapolis Museum of Art* would have been impossible without the support of the Director and Trustees. Nor could it have appeared without the efforts of Nancy Singleton, Head of Publications, Robert Wallace, Staff Photographer, and Janet Feemster, Curatorial Secretary. My thanks also go to Dr. Diane C. Johnson for editing the text with so much care and tact. Professor Joanne Kuebler, Herron School of Art, Indiana University-Purdue University at Indianapolis, wrote the majority of the biographies. Finally, I should like to express my gratitude to my wife for bearing her art historical widowhood with such good grace over the past year.

ABBREVIATIONS OF FREQUENTLY CITED WORKS

Miller: Dwight Miller, *Catalogue of European Paintings*, Indianapolis Museum of Art, 1970.

Bulletin: *Bulletin of the John Herron Museum of Art.*

Fraser: A. Ian Fraser, *A Catalogue of the Clowes Collection*, Indianapolis, 1972.

Clowes 1959: *Paintings from the Collection of George Henry Alexander Clowes, a memorial exhibition,* John Herron Art Museum, Indianapolis, 1959.

Clowes 1962: *Italian and Spanish Paintings from the Clowes Fund Collection,* Indiana University Museum of Art, Bloomington, 1962.

Clowes 1963: *Northern European Painting—The Clowes Fund Collection,* Indiana University Museum of Art, Bloomington, 1963.

Each painting is accompanied by a selected bibliography and exhibition list.
References are restricted to material of scholarly interest.

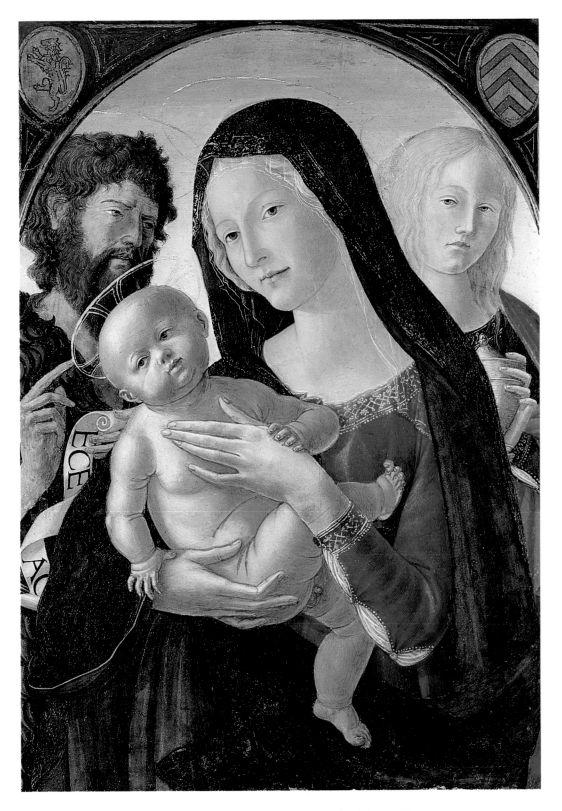

Neroccio di Bartolommeo (Neroccio dei Landi).
Madonna and Child with Saints John the Baptist and Mary Magdalene. ca. 1495
tempera on panel, 28 x 20⅛ (71.2 x 51.1)
The Clowes Fund Collection

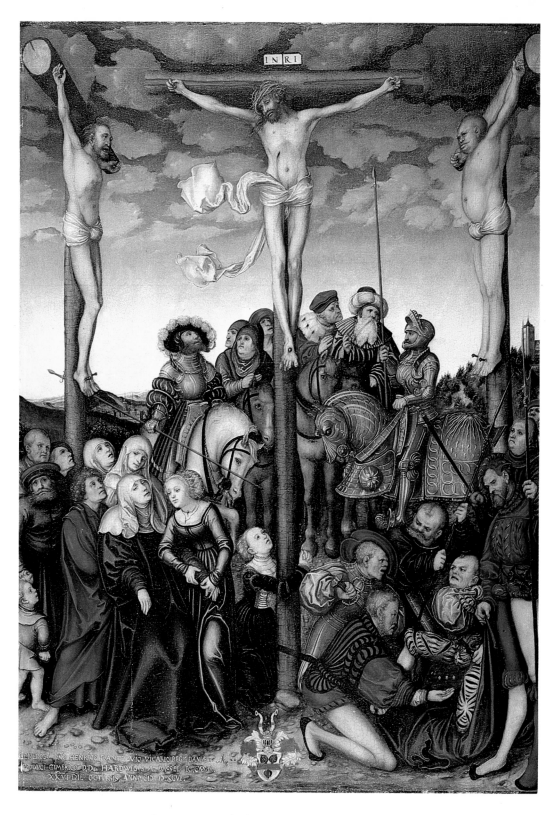

Lucas Cranach the Elder. *Crucifixion.* 1532
oil on panel, 30 x 21½ (76.2 x 54.6)
The Clowes Fund Collection

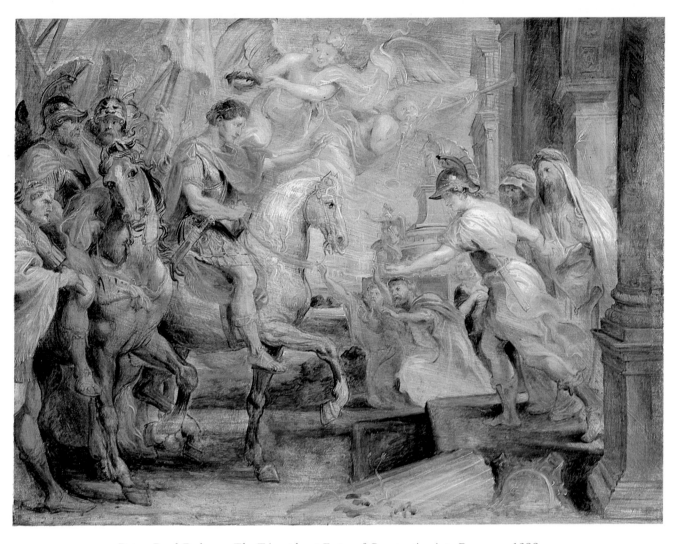

Peter Paul Rubens. *The Triumphant Entry of Constantine into Rome. ca.* 1622
oil on panel, 19 x 25½ (48.4 x 64.1)
The Clowes Fund Collection

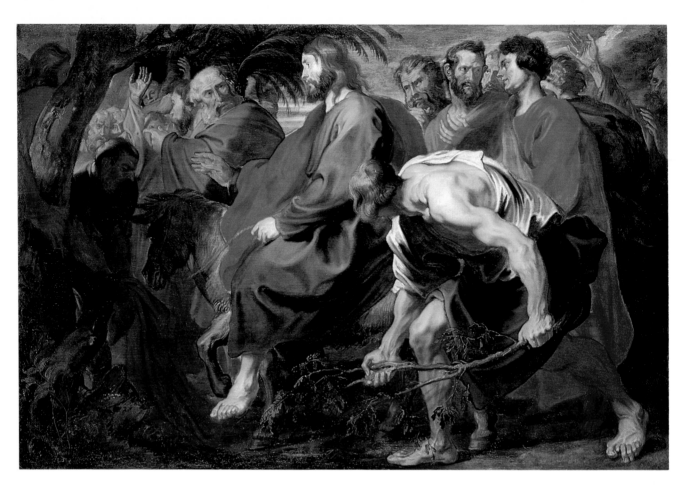

Anthony Van Dyck. *The Entry of Christ into Jerusalem. ca.* 1617-1618
oil on canvas, 59½ x 90¼ (151.1 x 229.2)
Gift of Mr. and Mrs. Herman C. Krannert. 58.3

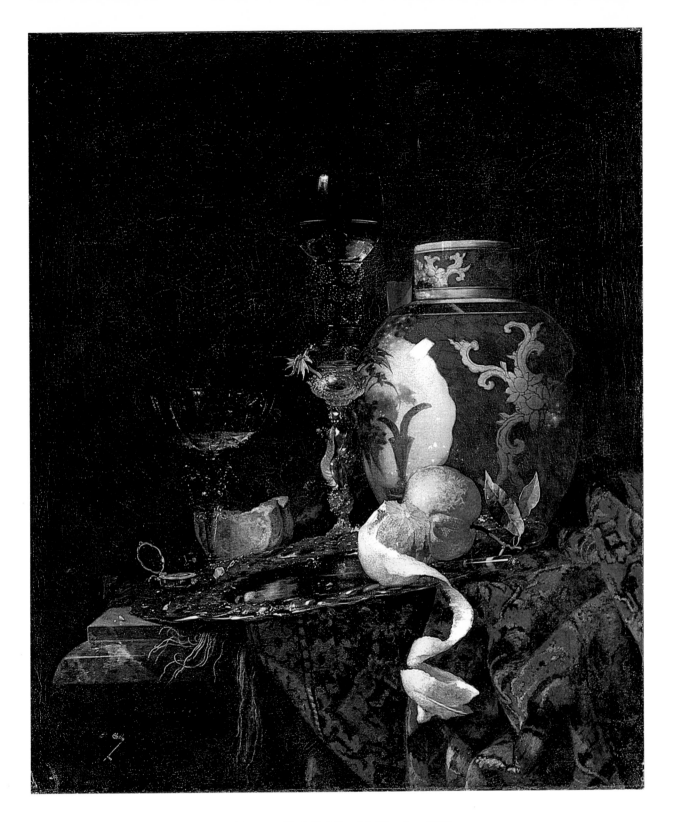

Willem Kalf. *Still Life with Blue Jar.* 1669
oil on canvas, 30¾ x 26 (78.1 x 66)
Gift of Mrs. James W. Fesler in memory of Daniel W. and Elizabeth C. Marmon. 45.9

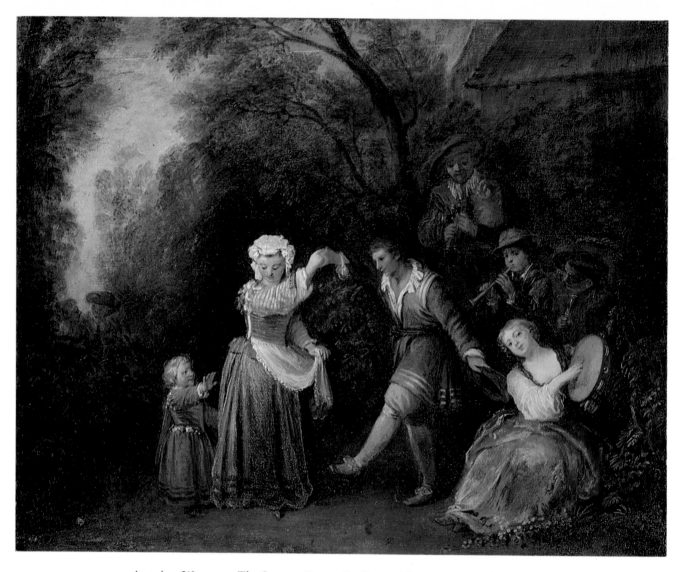

Antoine Watteau. *The Country Dance (La Danse Champêtre). ca.* 1706–1710
oil on canvas, 19½ x 23⅝ (59.6 x 60)
Gift of Mrs. Herman C. Krannert. 74.98

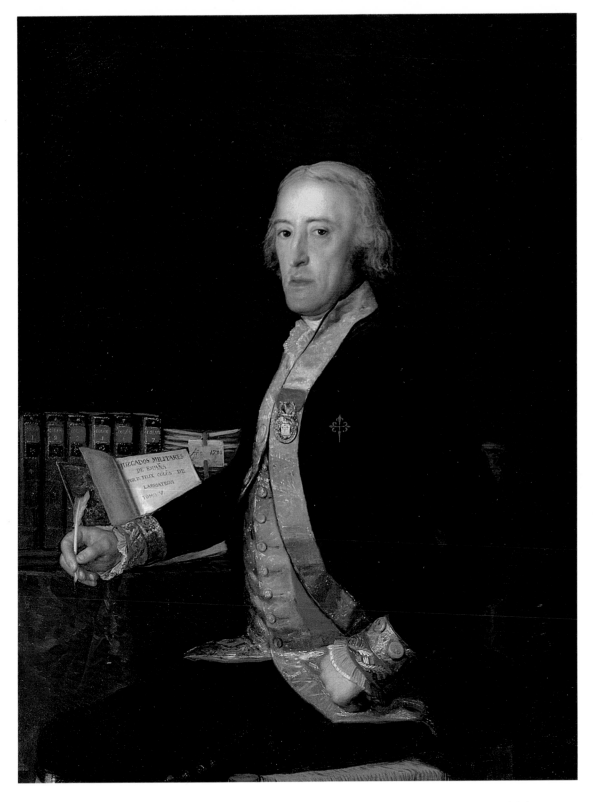

Francisco Jose de Goya y Lucientes. *Portrait of Don Felix Colon de Larreategui.* 1794
oil on canvas, 43⅝ x 33⅛ (110.8 x 79.1)
Gift of the Krannert Charitable Trust. 75.454

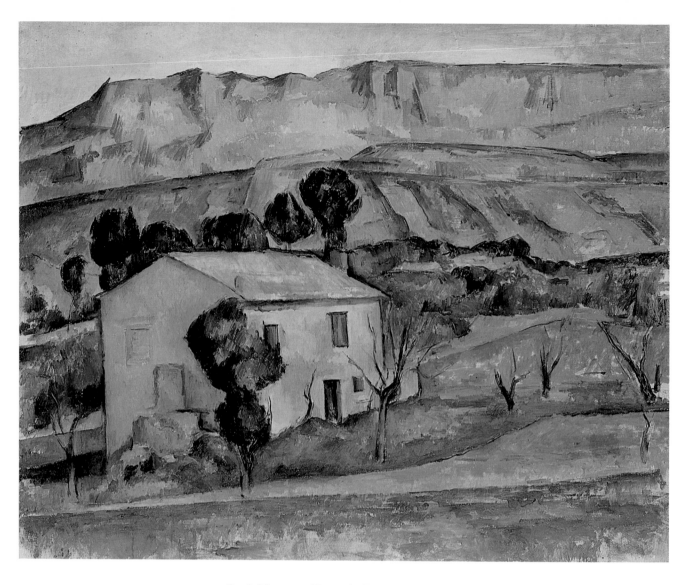

Paul Cézanne. *House in Provence. ca.* 1885
oil on canvas, 25½ x 32 (64.8 x 81.3)
Gift of Mrs. James W. Fesler in memory of Daniel W. and Elizabeth C. Marmon. 45.194

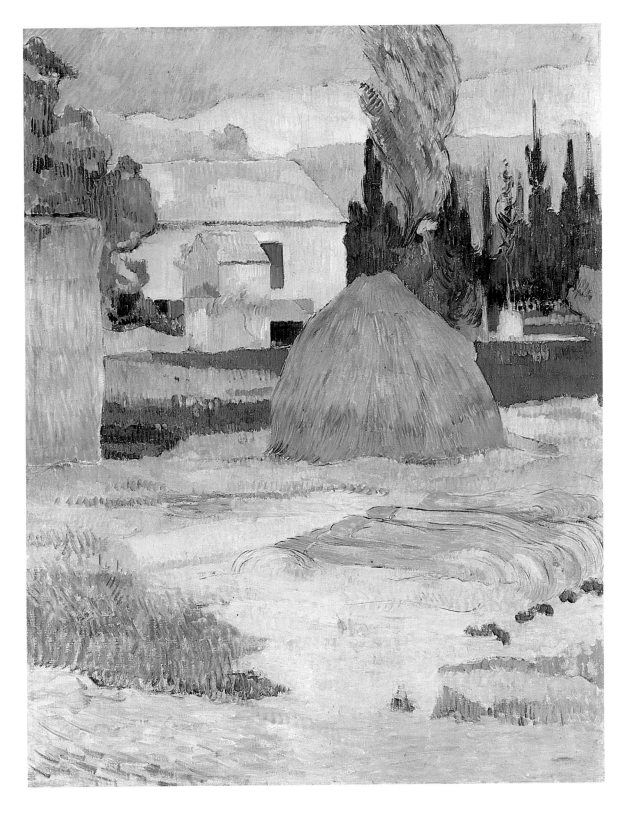

Paul Gauguin. *Landscape near Arles.* 1888
oil on canvas, 36 x 28½ (91.4 x 72.4)
Gift in memory of William Ray Adams. 44.10

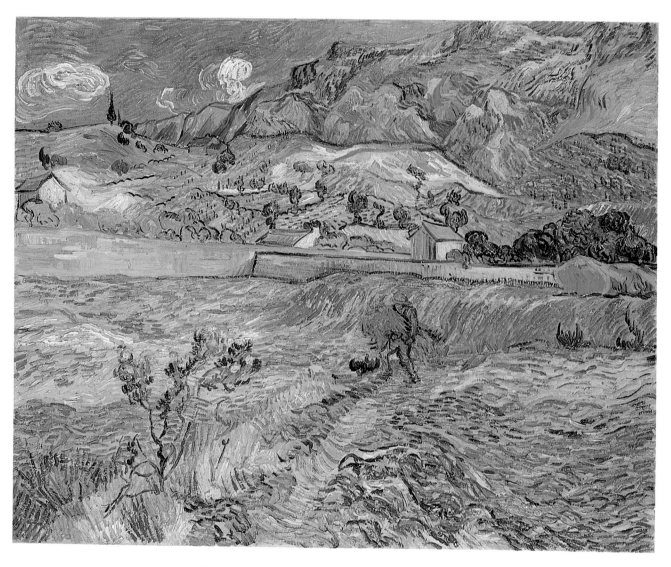

Vincent Van Gogh. *Landscape at Saint-Rémy (The Ploughed Field).* 1889
oil on canvas, 29 x 36¼ (73.7 x 92.1)
Gift in memory of Daniel W. and Elizabeth C. Marmon. 44.74

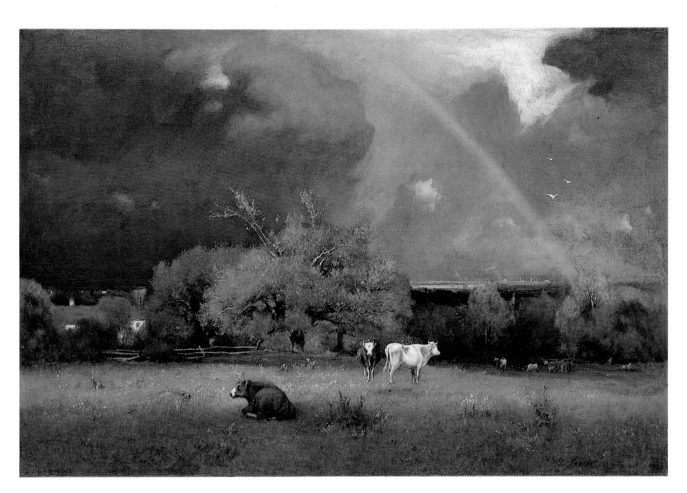

George Inness. *The Rainbow. ca.* 1868
oil on canvas, 30¼ x 45¼ (76.8 x 114.9)
Gift of George E. Hume. 44.137

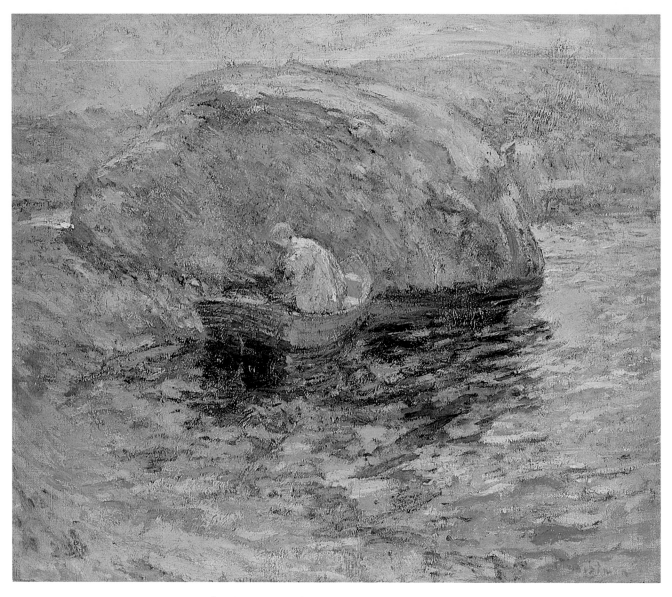

John Henry Twachtman. *A Summer Day. ca.* 1900
oil on canvas, 25 x 30⅛ (63.5 x 76.5)
John Herron Fund. 07.3

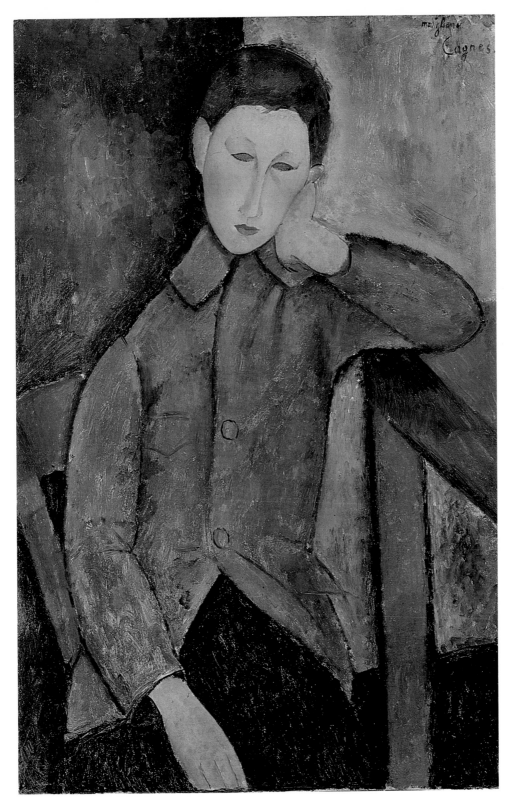

Amedéo Modigliani. *The Boy.* 1919
oil on canvas, 36¼ x 23¾ (92.1 x 60.3)
Gift of Mrs. Julian Bobbs in memory of William Ray Adams. 46.22

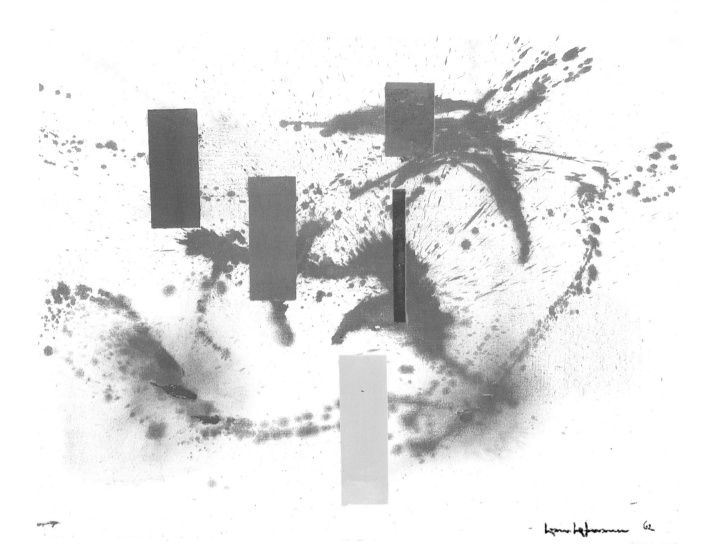

Hans Hofmann. *Poem d'Amour*. 1962
oil on canvas, 36¼ x 48 (92.1 x 121.9)
Gift of the Contemporary Art Society. 64.15

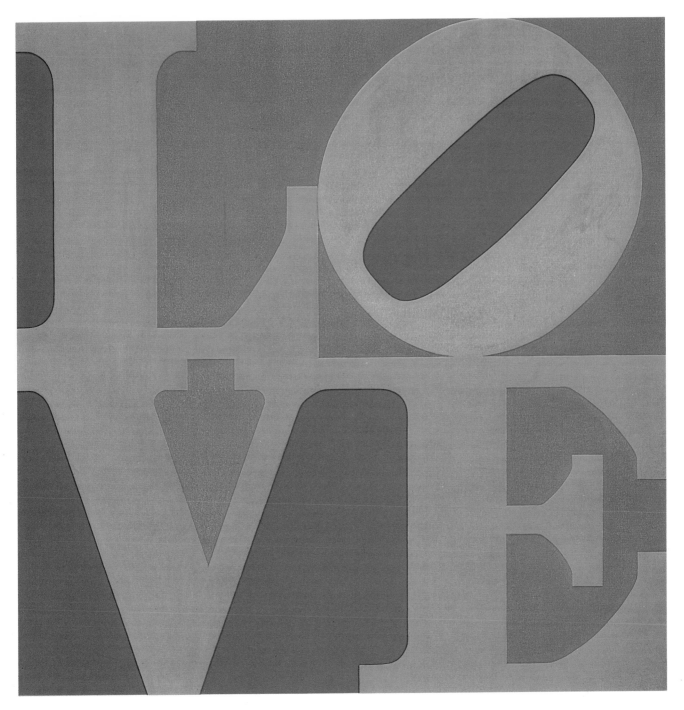

Robert Indiana. *Love.* 1966
acrylic on canvas, 71⅞ x 71⅞ (180.7 x 180.7)
James E. Roberts Fund. 67.08

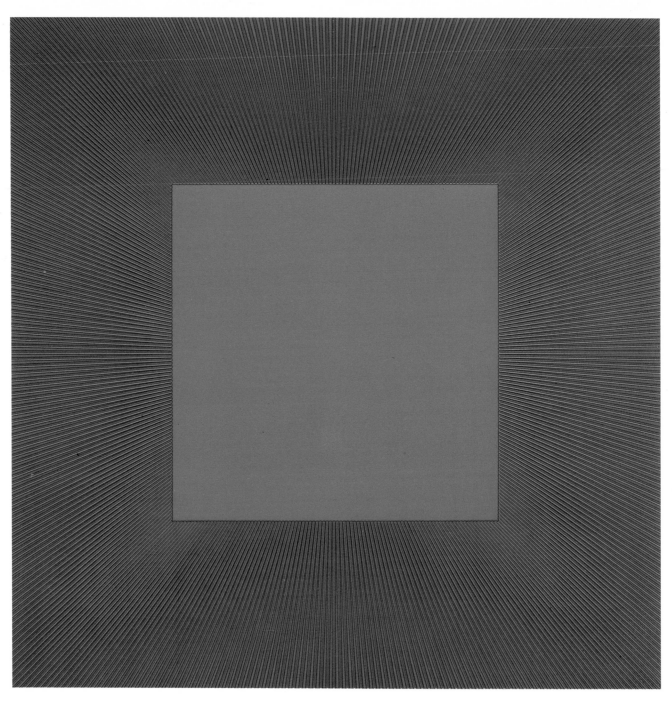

Richard Anuszkiewicz. *Red Edged Emerald Green.* 1980
acrylic on canvas, 48 x 48 (121.9 x 121.9)
Henry K. and Katherine DeBoest Fund. 80.195

SPANISH SCHOOL

Christ's Entry into Jerusalem.
The Marriage at Cana. ca. 1125
frescoes transferred to canvas, 70¾ x 121 (179.6 x
 307.4)
Gift of G. H. A. Clowes and Elijah B. Martindale
57.151 and 58.23

These two frescoes are from the early twelfth-century Mozarabic church of San Baudelio near Berlanga, Spain. With most of the rest of the intact fresco decorations, they were taken down, transferred to canvas and dispersed to American collections in the 1920s. The pagan Mozarabic scenes from the lower register were subsequently returned to the Spanish government and are now on indefinite loan to the Prado Museum, but the cycle dealing with the miracles and Passion of Christ remain in the IMA, Metropolitan Museum of Art, Boston Museum of Fine Arts and Cincinnati Art Museum. The scenes were arranged in a coherent sequence. Flanking the western entrance to the church were the *Marriage at Cana* (IMA) and *Temptation of Christ* (New York). On the north wall of the nave were the *Entry into Jerusalem* (IMA) and *Last Supper* (Boston). The paintings on the east wall have not survived but they included *The Garden of Gethsemane,* while the eastern apse held *Noli Me Tangere* (Boston), as well as other post-Resurrection subjects which were lost. What makes the program unusual is the juxtaposition on the south wall of the *Three Maries at the Sepulchre* (Boston) with the *Healing of the Blind Man* and *Raising of Lazarus* (New York). Together these illustrate the continuing promise of miracles and eternal life to the faithful.

The frescoes are important for being among the few early Romanesque cycles to come down to us relatively complete. Like other provincial Spanish churches of the period that still stand, San Baudelio de Berlanga owed its survival to its remote location, which left it relatively inaccessible to the turmoil that has often marked the country's history. The precise date and art historical position of the paintings have been debated, but Frinta is certainly correct in assigning them to three artists active late in the first quarter of the twelfth century. Our two frescoes were evidently done by two different hands, although only

one artist must have been responsible for the designs. The most accomplished and progressive painter was the author of the *Marriage at Cana.* His assistant executed the *Entry into Jerusalem* and was apparently also responsible for the slightly later decorations in the hermitage church of the Holy Cross at Maderuelo. The frescoes have further affinities with decorations in the churches of San Clemente and Santa Maria in Tahull, which are roughly comtemporaneous.

Although the team was most likely a trio of Catalonians who travelled from church to church on commission, the scenes from the life of Christ were painted entirely in the early Romanesque manner prevalent throughout a large part of France in the early twelfth century, when stylistic currents passed back and forth to northern Spain with considerable ease and rapidity. This style is characterized by impressive figures within monumental compositions. The abstract shapes of our frescoes are created by the play of contrasting angular and swelling black lines over flat areas of color, supplemented by broad green and cream strokes to model the forms. Despite the schematic rendering, the San Baudelio frescoes are effective in the expressive use of line and in the lively play of gestures between the figures, whose emotions are portrayed with sympathetic understanding. We find a comparable style in the famous frescoes of St. Savin-sur-Gartempe, as well as those in St. Aignau, Brinay, where the *Marriage at Cana* is remarkably similar in composition and treatment to ours. (Compare also the frescoes in the Chapel of the Priory of St. Gilles, Montoire, and St. Martin-de-Vic, Nohant-Vicq.)

The Marriage at Cana and *Entry into Jerusalem* incorporate a combination of Anglo-Saxon and Byzantine elements similar to the mixture first established in early Carolingian manuscripts of around 800 A.D. at Aix-la-Chapelle by the Ada School (compare the Gos-

pel Lectionary of Godescalc, Bibliothèque Nationale, Paris) and the Palace School (compare the Gospel Book of Charlemagne, Kunsthistorisches Museum, Vienna). Ottonian illuminators continued this Carolingian style but added new components and subjects from the life of Christ that can only have come from Byzantine manuscripts (compare the Codex Egberti, Stadtbibliothek, Trier). Fresco painting, which was less common, was something of a separate specialty and shows a certain degree of independence from manuscript painting, although the two are often closely related. Thus, the style of our two scenes also developed out of ninth-century frescoes done in northern Italy (S. Salvatore, Brescia, and S. Benedetto, Malles Venosta) and in southern France (St. Germain, Auxerre).

It is, however, the influence of monumental Byzantine painting that marks the *Entry into Jerusalem* and *Marriage at Cana* as specifically Romanesque. Beginning with the lost mosaics executed by Greek artists for Desiderius at the abbey of Montecassino around 1080, an up-to-date Byzantine style began to play an increasingly important role in fresco painting, first in the decorations at S. Angelo in Formis near Capua (which were also done for Desiderius) and then gradually elsewhere, until its impact was felt on both sides of the English Channel. As it became diffused over Europe, this Byzantine style mixed with the ongoing Carolingian-Ottonian tradition and was consequently given the distinctly un-Byzantine expression found in the frescoes for San Baudelio de Berlanga and the Priory at Berzé-la-Ville.

PROVENANCE: Gabriel Dereppe.
LITERATURE: C. H. Hawes, "Two Twelfth Century Frescoes from the Hermitage Church of San Baudelio de Berlanga, Spain," *Bulletin of the Museum of Fine Arts,* Boston, XXVI, 153, Feb. 1928, pp. 6-11. W. S. Cook, "Romanesque Spanish Mural Painting (II), San Baudelio de Berlanga," *Art Bulletin,* XII, 1, Mar. 1930, pp. 21-42. C. R. Post, *A History of Spanish Painting,* Cambridge, 1930, I, pp. 197-201, 208-209. D. Carter, "Two Romanesque Frescoes from San Baudelio de Berlanga," *Bulletin,* XLVI, 1, Mar. 1959, pp. 2-19. M. S. Frinta, "The Frescoes from San Baudelio de Berlanga," *Gesta,* 1-2, 1964. Miller, pp. 2-4.

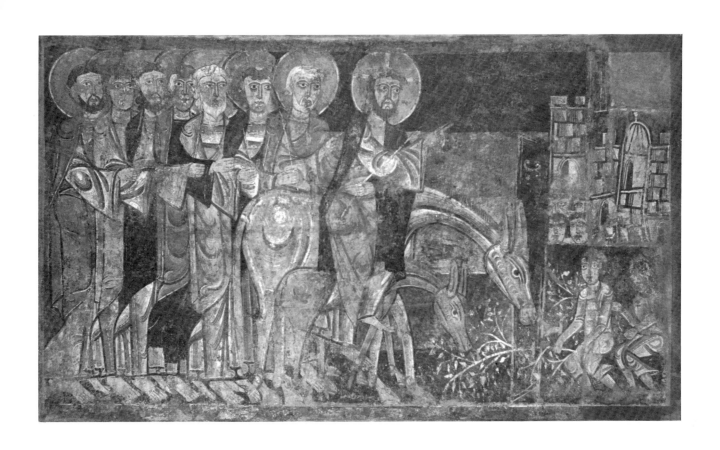

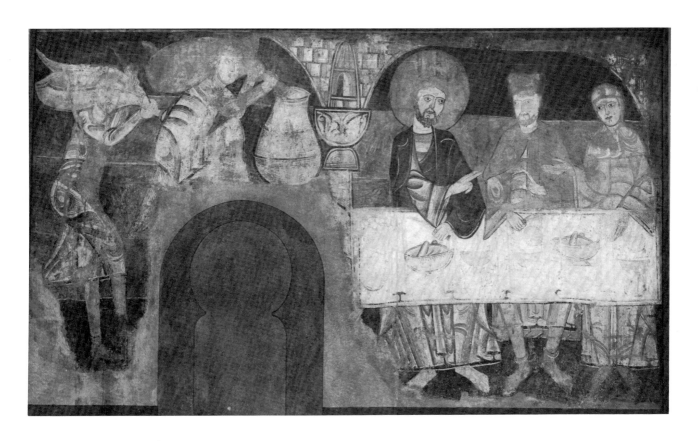

BARNABA DA MODENA
Italian, active ca. 1364-1383

Crucifixion. ca. 1374

tempera on panel, 41 x 26½ (104.7 x 67.3)
Presented to the John Herron Art Association by
 James E. Roberts
24.5

As his name attests, Barnaba was born in the Tuscan town of Modena, at an unknown date. He was active in Genoa, perhaps as early as 1364 and certainly by 1367 at the latest, then in Liguria and Piemonte until 1380, when he was called to Pisa to complete Andrea da Firenze's fresco cycle in the Camposanto. He is last heard of as being again in Genoa in 1383.

Our *Crucifixion* is one of several by Barnaba. It is most closely related in composition and presumably in date to one of 1374 in the National Gallery, London (others are in the Parochial Church, Lavagnola, and a Private Collection, Milan). In addition to the high quality of its execution, the panel is notable for its unusual iconography: The soul of the good thief, being borne aloft on a sheet of honor by two angels on the left, is depicted wearing undergarments as a sign of virtue to further distinguish him from the tormented soul of the bad thief being carried away by the devil on the right.

This particular kind of crowded Crucifixion scene had its main development in Siena, beginning with Duccio and his famous Maestà altar (Cathedral Museum, Siena) and continuing through Ambrogio Lorenzetti (altar in Fogg Museum, Cambridge) and Barna da Siena (fresco in the Collegiata, S. Gimignola). Barnaba was a master synthesizer, and his work combined features derived from earlier Florentine and Sienese painting. Of particular importance was his revival of prototypes from the second quarter of the fourteenth century. To the Florentine style of Giotto he added the grace of Duccio, the decorative appeal of Simone Martini and the naturalism of the Lorenzetti, all of Siena. After mid-century these qualities had been repudiated by many Tuscan artists in favor of a harsher doctrinal content and more intense expressiveness which followed in the wake of the economic, political and social upheavals of the 1340s, culminating with the bubonic plague epidemic of 1348 that killed half the populations of Florence and Siena.

The Indianapolis *Crucifixion* reasserts the lyricism and spontaneity traditional in Sienese painting—note the play of expressions in the group of gambling soldiers to the lower right, for example—and shows a renewed interest in naturalism as well, but at the expense of Florentine monumentality. It can be said that Barnaba's painting, though less charged than Barna da Siena's Crucifixion fresco, reflects the return of stability to Italy after about 1370. That Barnaba played a leading role in this revival is indicated by his apparent influence on the predella of an altar of about the same date in the Louvre by Agnolo Gaddi, his younger contemporary in Florence who was later to become the most influential artist in Tuscany. Barnaba's painting also stands as a splendid early example of the International Style, that tendency toward stylistic homogeneity which flourished on both sides of the Alps between roughly 1375 and 1425. The figures on the crosses, for example, have acquired the expressive elongation characteristic of Gothic art in the North, which in turn proved increasingly receptive to Sienese Crucifixion scenes of the sort represented by our panel.

LITERATURE: L. Venturi, *Italian Painting in America*, New York, 1933, I, pl. 119. B. Berenson, *Italian Pictures of the Renaissance*, Oxford, 1932, p. 42. R. Tschaegle, "Italian Paintings of the Permanent Collection," *Bulletin*, XXVII, 1, Mar. 1940, p. 2 f. A. Gonzalez-Palacios, "Una Crocefissione di Barnaba de Modena," *Paragone*, no. 181, Mar. 1965, pp. 30-31, pl. 31. Miller, pp. 7-9.

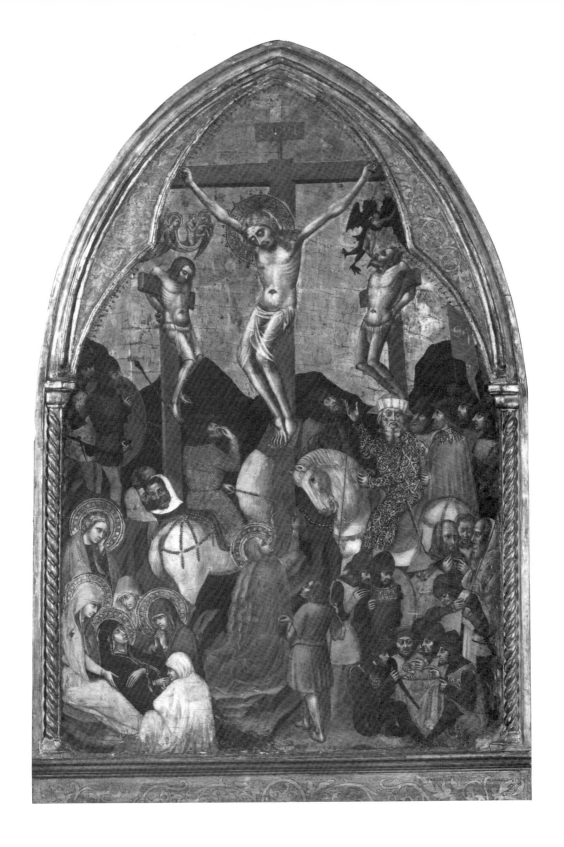

NEROCCIO DI BARTOLOMMEO (NEROCCIO DEI LANDI)

Italian, 1447-1500

Madonna and Child with Saints John the Baptist and Mary Magdalene. ca. 1495

tempera on panel, 28 x 20⅛ (71.2 x 51.1)
The Clowes Fund Collection

Neroccio di Bartolommeo, also known as Neroccio dei Landi, was born of a noble family in Siena. He trained under one of Siena's leading artists, Vecchietta, also known as Lorenzo di Pietro, from 1461 or 1462 to 1467. Neroccio then entered into a partnership with Francesco di Giorgio around 1468. After this arrangement was dissolved in a dispute, Neroccio established an independent shop. He wed twice, once between 1477 and 1483, and again in 1493. He died in Siena in 1500.

Throughout his career, Neroccio and his shop painted a considerable number of panels of the Madonna and Child, often in the company of saints. Such images, popular throughout Italy from the thirteenth century on, were in especially heavy demand in Siena. The Virgin was Siena's patron saint, and the city was rededicated to her in 1483. The Clowes panel is a distinguished example of Neroccio's art. It is of a type established by him in the mid-1470s (compare the *Madonna and Child with Saints* in the Pinacoteca, Siena) as an elaboration of a picture painted near the beginning of his activity as an independent artist (ca. 1467, Visconti Venosta Collection, Rome). The early versions were influenced by Neroccio's former partner Francesco di Giorgio, as well as by Matteo di Giovanni. The treatment in later examples indicates that he also responded to the styles of Fra Filippo Lippi, Domenico Ghirlandaio, Andrea del Castagno and, above all, Luca Signorelli, whose work greatly affected him from 1493 on. Because of his sources in these Florentine artists, Neroccio parallelled the better-known Sandro Botticelli in many respects. In fact, some of Neroccio's depictions of the Madonna and Child suggest Botticelli's direct influence.

Although it is a fully independent work painted when the artist was at the height of his powers, *The Madonna and Child with Sts. John the Baptist and Mary Magdalene* shares Botticelli's grace and serenity. The idealized forms created by expressive line and the lyr-ical mood evoked by the warm, sunlit colors lend the painting a charm which, with the careful finish and relatively good condition, help rank it among the masterpieces of Neroccio's career. The Clowes panel is closely related to a painting in the Kress Collection (ca. 1495, National Gallery, Washington) and to Neroccio's major altarpiece of 1496 in Santissima Annunziata, Montisi (as well as to slightly earlier examples in the Centraal Museum, Utrecht, and the Stoclet Collection, Brussels).

PROVENANCE: Conti Chigi-Saraceni, Siena; Count Ladislaus Karolyi, Budapest.
EXHIBITIONS: Clowes 1959, no. 42. Clowes 1962, no. 8.
LITERATURE: B. Berenson, *The Central Italian Painters of the Renaissance*, New York and London, 1897, p. 157, 2nd ed., 1909, p. 207. E. Jacobsen, *Das Quattrocento in Siena*, Studien in der Gemäldegalerie der Akademie, Strassburg, 1908, p. 83. P. Rossi, "Neroccio di Bartolomeo Landi e la Sua Piu Grande Tavola," *Rassegna d'Arte*, XIII, 5, May 1913, pp. 73-74. L. Dami, "Neroccio di Bartolomeo Landi," *Rassegna d'Arte*, XIII, 10, Oct. 1913, p. 164. J. A. Crowe and G. B. Cavalcaselle, *A History of Painting in Italy*, ed. L. Douglas and T. Boyenius, London, 1914, V, p. 159, no. 6. P. Schubring in Thieme-Becker, *Künstler-Lexicon*, Leipzig, 1928, XXII, p. 295. B. Berenson, *Italian Pictures of the Renaissance*, Oxford, 1932, p. 389, (Italian ed., 1936, p. 335). R. van Marle, *The Development of the Italian Schools of Painting*, The Hague, 1937, XVI, p. 312. C. Brandi, *Quattrocentisti Senesi*, Milan, 1949, p. 272. G. Coor, *Neroccio de'Landi, 1447-1500*, Princeton, 1961, pp. 98, 102, 103 f., 105, 169 f., 173, 181, no. 23, figure 87. Fraser, p. 20.

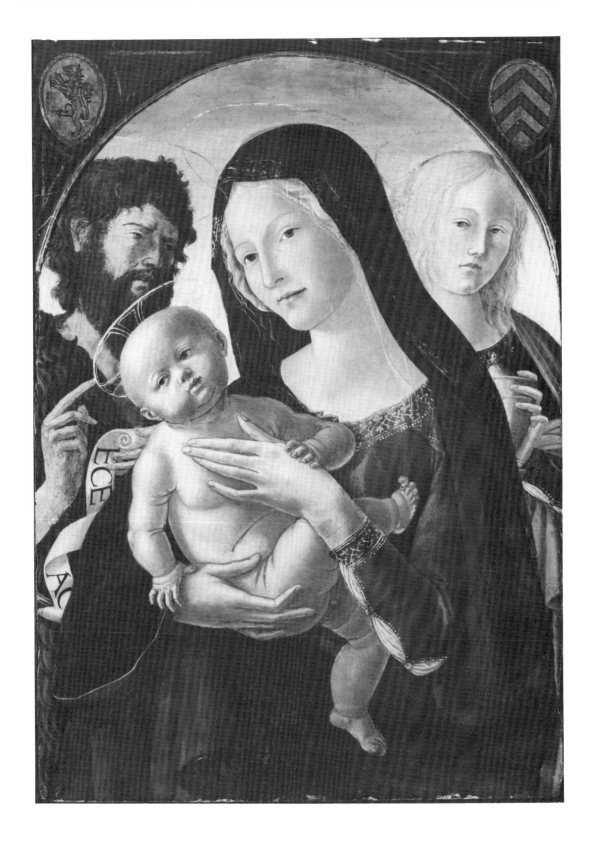

39

TITIAN (TIZIANO VECELLI)
Italian, ca. 1488-1576

Portrait of a Man. ca. 1512

oil on canvas, 23½ x 18½ (59.7 x 47)
Gift in Memory of Booth Tarkington
47.1

Titian was born around 1488-1490 in Pieve di Cadone. He was sent to Venice at the age of nine to work in the studio of Sebastiano Zuccato. Later he became a student of the aged Gentile Bellini, Giovanni Bellini and Giorgione, with whom he collaborated on a fresco in the Fandaco dei Tedeschi. Upon Giorgione's death in 1510 Titian became an independent master and went to Padua to decorate the Scuola di S. Antonio. He declined an invitation in 1513 to become court painter to Pope Leo X in Rome. In 1516 he went to Ferrara where the duke became his longtime patron. Titian's work was in great demand during the 1520s; he was active in Brescia in 1521, Mantua in 1523, and Ferrara in 1524. He married in 1525, but his wife died five years later. He went to Bologna in 1529 and again in 1533 to paint portraits of Emperor Charles V, who named him court painter and gave him letters of nobility. He was also active for the Duke of Urbino and the Farnese family, who called him to Rome in 1545-1546. Charles V called Titian to Augsburg in 1548 and 1550; thereafter he worked mainly for Philip II. A fresco commission in 1565 took him to Pieve di Cadone. He died in the plague of 1576 in Venice.

Like his portrait of Jacopo Samazzaro (Hampton Court), which is similar in treatment, this must be a relatively early work by Titian, datable around 1512 or a little earlier. The traditional identification of the sitter as the famous writer Ariosto (accepted by many authorities in the past but rejected by such recent scholars as Harold Wethey) can therefore no longer be maintained. Ariosto would have been considerably older than the man in this portrait at the time it was painted. Furthermore, the few reliable portraits of the author, including a frontispiece after Titian, were mostly done a good deal later, when his features had been altered too much by age to permit direct comparison with our painting. There are superficial similarities of attire, coiffure and style, but the only real resemblance lies in the aquiline nose, which is shared, however, by so many Italians that it is hardly a sufficient basis for calling our sitter Ariosto.

Despite extensive damage, the IMA portrait remains impressive. Stylistically it proceeds from the portraits of a boy (Staatliche Museen, Berlin) and of a man (National Gallery, Washington) by the artist's teacher, Giorgione. Titian has followed Giorgione's then-revolutionary practice of painting directly on the surface without the benefit of preliminary drawings or studies. He has further adhered to Giorgione's example by reducing the man's features to simpler geometric shapes. Arising out of the classicism and ornamental linearism of such earlier Venetian artists as Andrea Mantegna, this tendency toward abstraction is used to construct idealized forms which lend the portrait added beauty and nobility. Similar effects are found in late heads of Christ by Giovanni Bellini, with whom Titian also studied.

Titian must have known the sitter well, for while it is hardly intimate, the portrait projects a forceful personality that epitomizes the spirit of the High Renaissance. The extraordinary presence demonstrates why Titian was in such demand as a portraitist throughout his long career. Few artists could rival him in the ability to reveal character with such conviction. Even in its present condition, the IMA portrait has a technical facility in the modelling of the face and the treatment of the shirt and fur that anticipates his achievements of only a few years later, notably the *Young Man with a Glove* (Louvre, Paris) and the *Young Man with a Red Hat* (Frick Collection, New York).

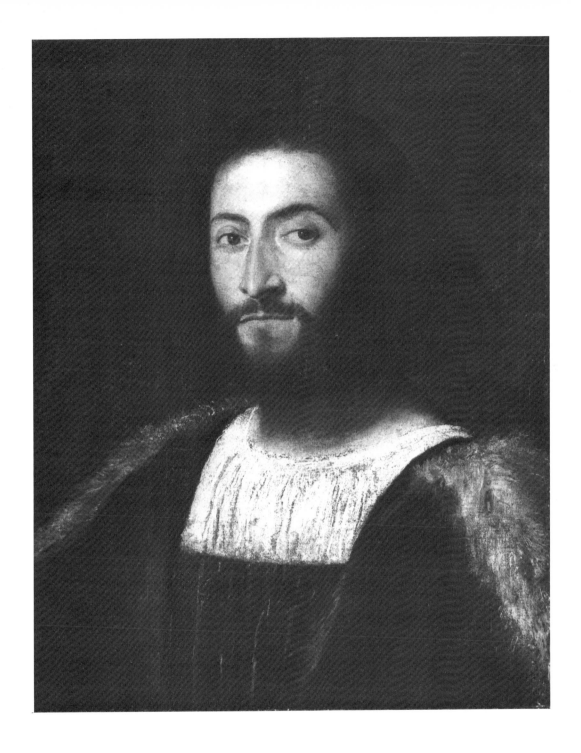

PROVENANCE: Prince Orloff, Palais Catchina; Duc de Mouchy; Jean Schmidt, Paris; Sotheby's, London; E. and A. Silberman Galleries, New York; Booth Tarkington, Indianapolis.

EXHIBITIONS: *Venetian Painting from the Fifteenth Century Through the Eighteenth Century,* The California Palace of the Legion of Honor, San Francisco, 1938, no. 70. *Four Centuries of Venetian Painting,* Toledo Museum of Art, 1940, no. 65. *2500 Years of Italian Art and Civilization,* Seattle Art Museum, 1957, no. 118.

LITERATURE: C. Ridolfi, *Le Maraviglie dell'Arte...,* Venice, 1648, and Berlin, 1914, I, p. 65. G. Agnelli, "I Ritratti del'Ariosto," *Rassegna d'Arte,* IX, 1922, pp. 82-98. W. D. Peat, "Portrait of a Man," *Bulletin,* XXXIV, 1, April 1947, pp. 3-5, reprinted *The Art Quarterly,* X, Winter 1947, pp. 64-67. H. Tietze, *Titian,* London, 1950, p. 24, pl. 23. J. D. Morse, *Old Masters in America,* 1955, p. 165. F. Valcanover, *L'opera completa di Tiziano,* Milan, 1969, no. 72. R. Pallucchini, *Tiziano,* Florence, 1969, I, p. 250, fig. 119. H. Wethey, *The Paintings of Titian,* London, 1971, II, p. 77, no. 7, pl. 217.

PELLEGRINO TIBALDI
Italian, 1527-1596

Holy Family with Saint John the Baptist.
 ca. 1553-1558

oil on panel, 15 x 9½ (38.1 x 24.2)
Martha Delzell Memorial Fund
66.233

Born in Puria in Valsolda in 1527, Pellegrino Tibaldi was the son of the painter Tebaldo Tibaldi, from whom he presumably received his initial training. The early years of his career were spent in Bologna. Around 1549-1550 he went to Rome, where he worked mainly for Cardinal Poggi. After working in the Marches, Loreto and Ancona, Tibaldi returned around 1553 to Bologna, where he was employed primarily by Cardinal Carlo Borromeo. It was during this time that he went to Ancona for a long stay as a festival architect and decorative painter. Borromeo took him to Milan in 1564. Tibaldi paid brief visits to Bologna in 1565 and 1569. Philip II called him to Spain in 1585, but he did not go until 1587. He remained in Spain until 1594 or 1595, then returned to Milan, where he died in 1596.

Mannerism remains difficult for many people to accept, for it lacks the ingratiating beauty and serenity found in Neroccio's *Madonna and Child with Sts. John the Baptist and Mary Magdalene* and Giuliano Bugiardini's *Madonna and Child with St. John*, done under the influence of Raphael (compare, for example, *The Alba Madonna*, National Gallery, Washington, D.C.) and Fra Bartolommeo (compare *The Madonna with Four Saints*, Academy, Florence). The High Renaissance had posed a normative ideal based on the twin standards of nature and the Antique, but like all classic styles, its perfection was necessarily short-lived and, in fact, contained the seeds of its destruction. Michelangelo cited divine inspiration and his creative genius as the sole authorities for his art. Thus, his early *Doni Madonna* (ca. 1503, Uffizi Gallery, Florence) is hardly natural in its forms or particularly classical in its spirit. While it was equally unclassical, Mannerism was by no means anti-classical, at least initially, for it drew inspiration from the very artists who had created the High Renaissance: Michelangelo, Leonardo and Raphael. Emphasizing personal vision, the Mannerists extended both the expressive range and the aesthetic possibilities of the High Renaissance without the rational restraints of classicism. For that reason, Pontormo's *Holy Family* (National Gallery, Washington,

D.C.) has a subjective latitude surpassing the *Doni Madonna's.*

This *Holy Family* evinces a direct experience of those paintings. It was first ascribed to Giovanni Bezzi, called Nosadella, by former IMA curator Stephen Ostrow while acknowledging the possibility that the artist might actually be Nosadella's teacher, Pellegrino Tibaldi. The attribution was subsequently affirmed by Dwight Miller. More recently, Jürgen Winkelmann has argued that the painting should be considered a work by Tibaldi. The attribution to Nosadella rests on its relationship to several paintings of the Holy Family assigned to him by Hermann Voss ("Giovanni Francesco Bezzi Gennant Nosadella," *Mitteilungen des Kunsthistorischen Institut in Florenz*, III, 1932, p. 448 f.), who attempted a partial reconstruction of the artist's corpus on the basis of comments made by the writer Malvasia and Nosadella's only two secure works (both in the Oratoria di santa Maria della Vita, Bologna): a *Madonna and Child with Saints* and a *Circumcision of Christ*, the latter having been finished after Nosadella's death by Prospero Fontana. While Voss' hypothesis is perfectly reasonable in the main, it is largely conjectural, and Nosadella's *oeuvre* remains poorly defined. Of the several Holy Families illustrated by Voss, the one listed in the collection of King Charles

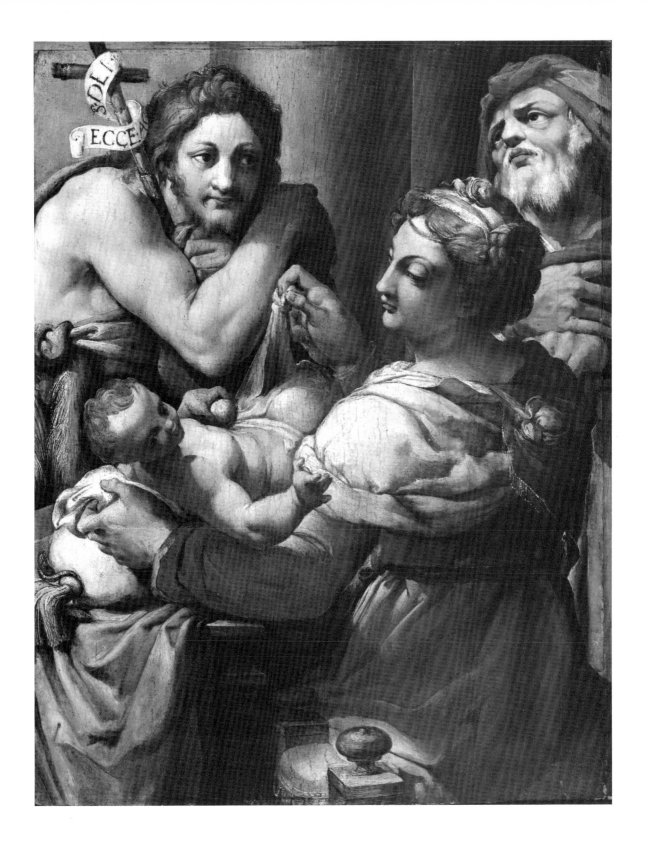

I of Roumania, for example, can be accepted as a product by Nosadella. However, the Holy Family then in a Berlin private collection, which is stylistically similar to our painting, should be properly reassigned to Tibaldi, since it has little to do with Nosadella's artistic personality as defined by Voss.

To this writer, the IMA *Holy Family*, like that formerly in Berlin, has more in common with Tibaldi's painting of the same subject in the Museo di Capodimonte, Naples, than it does with works that are arguably by Nosadella. With Tibaldi's picture it shares an asymmetrical composition, cramped space, nervous line and expressive distortion. Moreover, it reveals a distinct similarity with paintings by Salviati (compare the *Charity* in the Uffizi Gallery, Florence) and Daniele da Volterra (compare the *Madonna with the Young St. John and St. Barbara*, ca. 1552, and *The Prophet Elisha*, both in the D'Elci Collection, Siena), the two main influences on Tibaldi and the leading second-generation Mannerists in Rome around mid-century. Points in common can also be found between our *Holy Family* and works by such other important Mannerists as Jacopino del Conte, Lelio Orsi and Giorgio Vasari.

Although Malvasia wrote that the artist's work was all fury and bizarreness, Nosadella emerges in his known pictures as more Raphaelesque, with overtones of Parmigianino, than does Tibaldi, whose style was indebted through Salviati and Da Volterra to Michelangelo while retaining features deriving from Pontormo (compare *The Deposition*, S. Felicità, Florence).

The difference is, to be sure, only one of degree between the vigorous, abstract art of Tibaldi and the graceful, elegant one of Nosadella. These hitherto divergent approaches were no longer mutually exclusive by around 1550 when Mannerism, having lost much of its original inventiveness, often evinced a tendency toward synthesis which tempered previous excesses to suit the new piety of the Counter-Reformation. In much the same way, Nosadella "corrected" Tibaldi's "irregularities" by smoothing them over.

Since it still shows the marked influence of Salviati and Da Volterra, the IMA *Holy Family* should be seen as a mature work done by Tibaldi not long after he returned in 1553 to Bologna, where he became Nosadella's teacher. It was certainly painted before Tibaldi went to Milan in the '60s, when he turned largely to architecture. Although the issue of primacy in inventing this type of Holy Family has been raised by Winkelmann, there is no compelling reason to believe that the composition is other than Tibaldi's own, rather than a prototype originated by his pupil Nosadella, whose work appears largely imitative.

PROVENANCE: H. Shickman Gallery, New York.
LITERATURE: S. Ostrow, "Curator's Report," *Bulletin*, III, 3, Sep. 1966, pp. 60-62. Miller, p. 33. J. Winkelmann, "Sul Problema Nosadella-Tibaldi," *Paragone*, XXVII, no. 317-319, Jul.-Sep. 1976, p. 107, pl. 78.

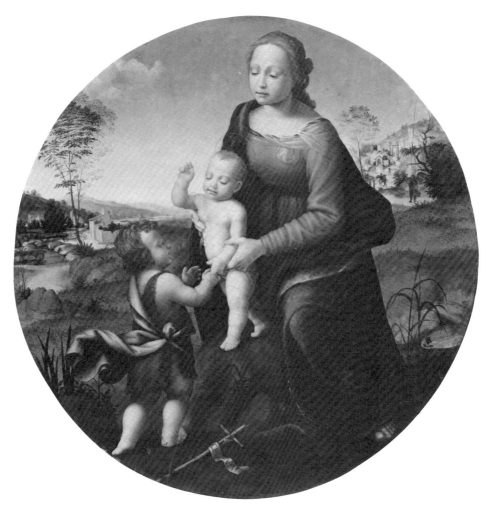

Giuliano Bugiardini. *Madonna and Child with St. John.* ca. 1508-1510. oil on panel, diam. 34¼ (87).
Gift of Mr. and Mrs. William H. Ball. 79.1133.

FRANCESCO BASSANO
Italian, 1549-1592

Portrait of a Priest. ca. 1590

oil on canvas, 22¾ x 17⅜ (57.8 x 44.2)
Martha Delzell Memorial Fund
54.51

Francesco Bassano was born in 1549 in Bassano, the eldest son of Jacopo Bassano (da Ponte) under whom he received his training. He married Giustina Como in 1578 and a year later left his father's shop for Venice. He had a successful career there, until he died of a fall from his window in 1592.

In its unusually forceful personality, the *Portrait of a Priest* is a worthy successor to Titian's *Portrait of a*

Leandro Bassano. *Man with a Glove.* 1580s. oil on canvas, 29½ x 23 (75 x 58.4). The Clowes Fund Collection.

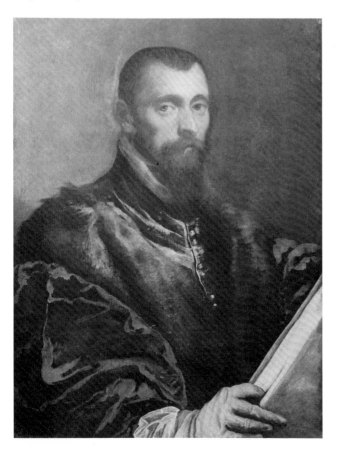

Man. It must have been painted during the early 1590s by either Leandro or Francesco Bassano the Younger in Venice, where they had settled the previous decade after leaving the shop of their famous father, Jacopo. Leandro executed a considerable number of portraits over the course of his long career, while Francesco did only a few during his brief activity. Yet the majority of recent opinions in the museum's files favor an attribution to the latter artist. Francesco was undoubtedly the stronger painter of the two, and it appears that Leandro's portrait style underwent a distinct change in the early 1590s away from the painterly freedom of his earlier *Portrait of a Man* (1580s, Clowes Collection) to one very close to his brother's more linear manner. Indeed, the *Portrait of a Man* in the Dresden Gallerie given to Leandro is virtually identical in style to Francesco's *Self-Portrait* of ca. 1590-1592 in the Uffizi Gallery. With few firm points of reference to go on, however, it is difficult to resolve the authorship of the IMA painting. While associated particularly with Francesco's work, the color and brushwork are equally characteristic of Leandro's during that brief period of the early 1590s.

Perhaps the strongest argument in favor of Francesco's authorship is the sharp-eyed realism which enhances the strength of the characterization. Such naturalism, which often emerges as rather timid or dry in Leandro's lesser pictures, was especially cultivated by Francesco in his mature works. Stemming most immediately from the verism that counterbalances earlier Mannerist elements in Jacopo Bassano's style from around mid-century on, this precise realism

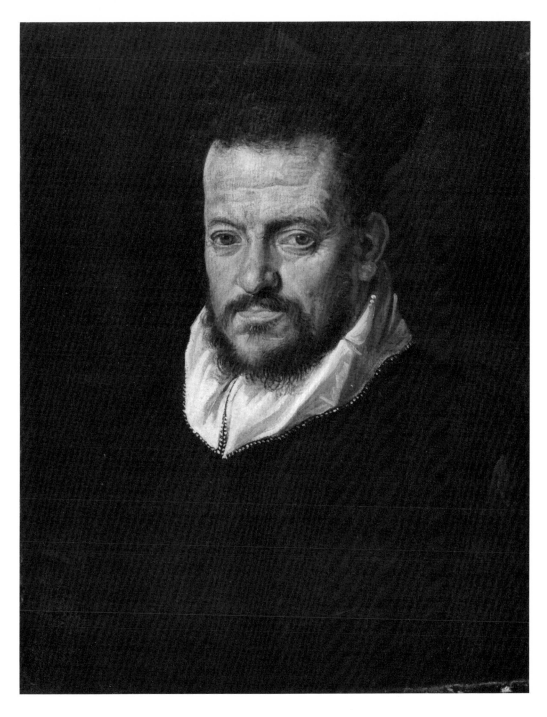

can also be seen as part of a larger tendency toward naturalism in the 1590s, a trend that contributed to the early Baroque art of Caravaggio. Ultimately this realism derived from Flemish painting, which was highly esteemed in Northern Italy, where it consequently exercised considerable influence. In fact, the *Portrait of a Priest* bears a noticeable, if coincidental, resemblance to Jan van Eyck's putative *Self-Portrait* (1433, National Gallery, London).

PROVENANCE: Private Collection, Paris; Jacques Seligmann and Co., New York.
EXHIBITIONS: *Les Bassano*, Galerie Sambon, Paris, 1929, no. 12, pl. 2. *Pontormo to Greco*, The John Herron Art Museum, Indianapolis, 1954, no. 54.
LITERATURE: R. Parks, "Bassano Revisited," *Bulletin*, LXI, 2, Oct. 1954, pp. 24-26. Miller, p. 42.

GERMAN SCHOOL

Passion of Jesus Christ. ca. 1400-1420
tempera on panels, each ca. 14 x 7 (35.6 x 17.8)
The Clowes Fund Collection

These twelve panels depicting the Passion formed part of an altar that had initially belonged to a convent near Bregenz along the Bodensee before entering an Austrian private collection. Because of their similarity to a later Dutch altar of ca. 1460 (illustrated in Max Friedlaender, *Early Netherlandish Painting*, Leiden, 1968, III, pl. 57), it can be surmised that they were complemented by six more on top showing the Annunciation, Nativity, Circumcision, Adoration of the Magi, Presentation in the Temple, and Entry into Jerusalem. The two altars presumably are linked to a lost work, perhaps through one of the pattern books which circulated freely from workshop to workshop through Europe.

Artistically, this German altar represents a later stage of development in Gothic art than the *Crucifixion* by Barnaba da Modena. However, it is typical of the relative uniformity of the International Style that the origin and date are difficult to determine with precision. The provenance would suggest an artist active in the vicinity of Bregenz, but the style argues against both the nearby Swabian and Austrian schools. To be sure, the Clowes altar is close to two paintings in the Ferdinandeum, Innsbruck, showing *The Birth of Christ* and *The Adoration of the Magi,* but they are exceptional in Austrian art around 1400 and suggest a painter trained—and perhaps working—in a major center elsewhere. Like the Innsbruck panels, the Clowes altar has affinities instead with the Westphalian School around Cologne, particularly the work of Master Bertram who was active primarily in Hamburg and Lübeck but who came from the town of Minden, and of Konrad von Soest (compare the Niederwildungen Altar of ca. 1403 in Nuremberg). But the closest comparison is with the Bohemian School centered in Prague, which under Charles IV flourished as a major art center, drawing eclectically on the achievements of Germany, France and Italy. The approach to volume and narrative, as well as the physiognomy of the fig-ures, follows the manner established there around the middle of the fourteenth century by Master Theodoric, whose work influenced Master Bertram's in both character and style. The compositions and elongated proportions also bear similarities to later altars produced by followers of the Master of the Wittingau Altar (active around 1380), although the Clowes panels lack the elegant, poetic qualities of his style. While a dating of ca. 1380 is conceivable, details in the handling of costumes, landscape and architectural settings indicate that our artist was active around 1400-1420, when the authority of the Prague school had declined considerably. Indeed it is possible that the altar was executed in Bavaria, which for a while was strongly influenced by Bohemian art (as can be seen in the Pähler Altar, Bayerisches Nationalmuseum, Munich). Nor can an origin in Austria be ruled out entirely.

The Clowes altar is a fine example of late Gothic painting in Germany. The artist retains the admirable directness and liveliness of earlier Bohemian art and invests it with a particular charm. The altar is of special interest for its internal unity. Each panel has been composed with the entire ensemble in mind. In the lower register, for example, the strong verticals in the center panels are balanced harmoniously by forceful diagonals in the scenes on either side. Because many of the motifs can be traced back to earlier Westphalian altars, it is tempting to believe that the compositional scheme also originated in the area around Cologne. However, no direct prototype has yet been found, and this satisfying arrangement may well be the invention of our anonymous painter.

PROVENANCE: Convent near Bregenz; Austrian Private Collection.
EXHIBITION: Clowes 1959, no. 2.
LITERATURE: Fraser, p. 172.

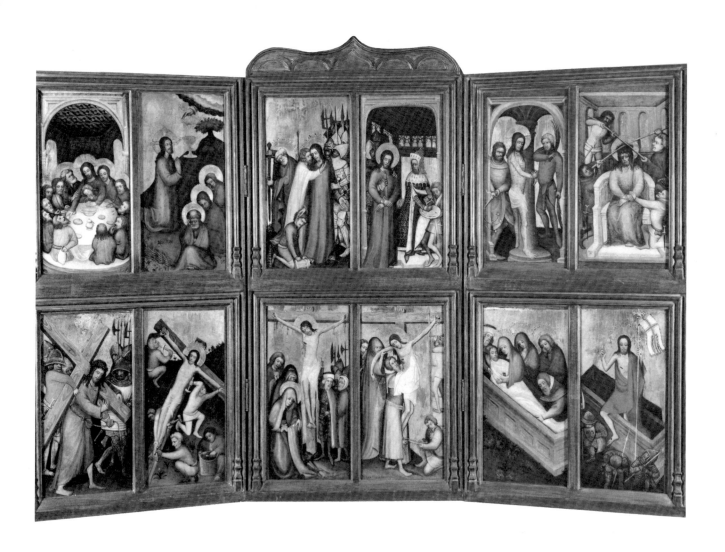

LUCAS CRANACH THE ELDER
German, 1472-1553

Crucifixion. 1532

oil on panel, 30 x 21½ (76.2 x 54.6)
signed and dated l.l.: dragon insignia 1532
The Clowes Fund Collection

Lucas Cranach was born in 1472 in Kronach, where he was trained by his father, Hans. He moved to Vienna around 1500 (no later than 1503), and probably visited Albrecht Dürer on his way there. In 1504 he became court painter to Frederick the Wise in Wittenberg, and moved there a year later to establish a large workshop. He visited Antwerp and the Netherlands in 1508 on what was probably a diplomatic mission, and was elevated to nobility that year. After the 1544 siege of Wittenberg by Charles V, he followed his patron, John Frederick the Magnanimous, into exile in Augsburg. When John Frederick was made a prince of the Empire by Charles V, Cranach accompanied him to Weimar, where he died in 1553.

Among Cranach's many Crucifixions, the Clowes painting is of a type that he repeated only seldom, notably in a panel from a year later in the Worcester Collection of the Chicago Art Institute. (A later copy was sold in 1957 at auction by Matthías Lempertz, Cologne.) The panel is authentically monogrammed and dated (the lengthy inscription to the lower left is considerably later). The execution is of the highest quality throughout this well-preserved painting. The details are especially beautiful in their crispness. This Crucifixion is among the finest of the artist's late religious paintings, a side of his output that remains understudied. As Jakob Rosenberg noted in a letter to the author, its quality indicates that most of the work may well be by his own hand, in contrast to the majority of his pictures, which are actually products of his large, highly successful workshop. The draughtsmanship accords well with drawings generally accepted as by him. Only the female figures, with their soft, appealing roundness, suggest the presence of another hand, probably the artist's eldest son, Hans. The rest of the figures, especially the most important ones, evince Lucas' direct involvement in what must have been an important commission.

Cranach's reputation today rests largely on the mythological scenes he painted for wealthy patrons, such as *The Judgment of Paris* (1530, Staatliche Kunsthalle Karlsruhe) in which coquettish females cavort before a richly clad knight. The same courtly taste, which delighted in such playful eroticism and romance and which contributed to the rise of Mannerism in Italy and France after 1520, is reflected in the Clowes *Crucifixion*. The scene takes place before an aristocratic crowd of the greatest refinement in dress and sentiment. Missing is the fervor that enlivens every passage in Cranach's youthful *Crucifixion* of 1503 (Alte Pinakothek, Munich), done before his conversion to Protestantism, although the beauty of the composition and surface in the Clowes painting testifies to the artist's unabated talent.

The courtly elegance brings to mind the International Style, and indeed the Renaissance in the North had a very different flavor than it did in Italy. Humanism, with its love of antiquity and learning, played a relatively modest and brief role in art north of the Alps, despite the fact that it was of considerable importance to the intellectual life of Germany. In Germany the Renaissance was cut short by the Reformation, which was antithetical to it in spirit. To the extent that it can be said to have existed at all, German Renaissance art was largely the work of Albrecht Dürer and only secondarily of Cranach.

On his way to Vienna around 1500, Lucas probably visited Dürer in Nuremberg. In any event, he fell under Dürer's lasting stylistic influence. In fact, many of the figures in the Clowes *Crucifixion* paraphrase

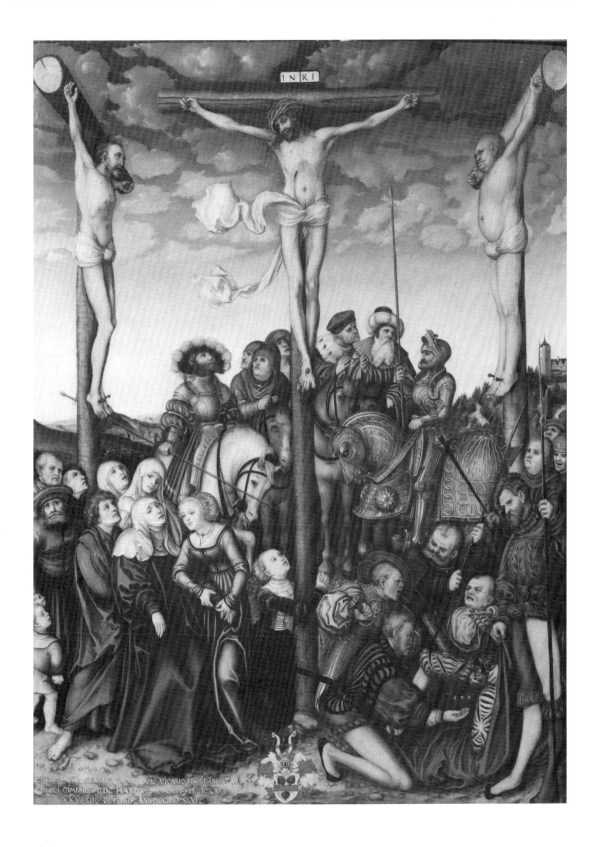

Dürer's prints; for example, the mounted soldier to the right of Christ is derived in all likelihood from Dürer's famous engraving *Knight, Death and Devil* of 1513. The figure of Christ is also very similar to the one found in Dürer's *Crucifixion* in the Dresden Galerie. In other respects, the resemblance can be explained by both artists' reliance on comparable Netherlandish and German sources. These influences Cranach invested with a highly individual expression, however.

Four years after Cranach became court painter to Frederick the Wise, Elector of Saxony, in Wittenberg, Martin Luther was appointed professor of theology there. The two developed a close friendship; Luther even became godfather to one of Cranach's children. While the Reformation often took an iconoclastic turn, so that the artist continued to work for Catholic patrons, Luther himself seems to have been largely indifferent to religious painting, neither fully condemning nor condoning it. He did, however, fully appreciate Cranach's paintings for their propaganda value, and the majority of Lucas' altars have a specifically Protestant meaning which is nevertheless infused with the gentle humanistic spirit found in his mythological scenes.

In a brilliant article to be published in the IMA's *Bulletin*, Laurinda Dixon has convincingly elucidated the Protestant iconography of the Clowes *Crucifixion*. Briefly summarized, her thesis is that the right half is populated by heretics and sinners who have been seduced by materialism and worldliness, as was the bad thief himself, seen averting his gaze. Among them are recognizable portraits of Pope Julius II in the red cap, signifying the Catholic church; the turbaned Muley Hassan, Bey of Tunis and leader of the Turks who were then threatening Europe; and Charles V, the Holy Roman Emperor shown in full armor, who was to take Elector John Frederick prisoner in the struggle for German independence. Together they represent the dominant forces at work in the world during the 1530s. Around the good thief in the left half of the picture are gathered the swooning Madonna, being supported by St. John the Evangelist, and other holy women, including Mary Magdalene. St. Longinus, who was converted upon casting his lance into Christ's side, is a portrait of John the Steadfast, brother of Frederick the Wise and staunch defender of Luther against the Pope and Emperor. The monk next to him shows Luther himself. Nearby are ordinary people who are in the process of experiencing their personal revelations leading to conversion, as well as a child symbolizing the simplicity and accessibility of the new faith. Although it is based on German and Flemish paintings of the fifteenth century, Cranach has stripped his Crucifixion of all signs of the supernatural, sainthood, resurrection, relics or haloes, which had been traditional in Catholic representations, although they were gradually abandoned after 1450. All this is consistent with Luther's *95 Theses* which he nailed to the Wittenberg castle door in 1527, his treatise *To the Christian Nobility of the German Nation* which was published in 1520, and his *Little Catechism* which was printed in 1529.

PROVENANCE: Doctor Hardwig, Dassel; Henrich Rantzau, Plon; Count Wilezek, Schloss Kreutzenstein; E. and A. Silberman Galleries, New York.
EXHIBITIONS: *Holbein and His Contemporaries*, John Herron Museum of Art, Indianapolis, 1950, no. 19. Clowes 1959, no. 20. Clowes 1963, no. 42.
LITERATURE: D. C. Rich, *Catalogue of the Charles H. and Mary E. S. Worcester Collection of Paintings, Sculpture and Drawings*, Chicago, 1938, p. 39. Fraser, p. 176. M. J. Friedlaender and J. Rosenberg, *The Paintings of Lucas Cranach*, rev. ed., Ithaca, 1978, no. 218.

Albrecht Dürer. *Crucifixion,* from "The Small Passion." 1511. woodcut,
5 x 3¹³/₁₆ (12.7 x 9.7). John Herron Fund. 13.480.

HANS LEONHARD SCHAUFFELEIN
German, ca. 1480-ca. 1538

Portrait of a Man. 1504
oil on panel, 17½ x 12 (44.5 x 30.5)
dated l.r.: 1504, ALT. 23
The Clowes Fund Collection

Hans Leonhard Schauffelein is the first known student of Albrecht Dürer. Born around 1480 in Nuremberg, he probably became Dürer's apprentice there not long after the latter returned from Italy in 1495, then remained in Dürer's studio as a valued assistant, for he acted as the lieutenant of Dürer's Nuremberg studio during the artist's second visit to Italy in 1505. Schauffelein left Dürer's studio by 1509, when he spent a year wandering the Tyrol. Six years later he settled in his father's home town of Nordlingen, where he remained until his death sometime between 1538 and 1540.

During a visit to the Clowes Collection, Dr. Kurt Locher correctly reattributed this portrait from Albrecht Dürer to Hans Schauffelein. Indeed, the painting conforms in its general characteristics to such later portraits as *Sixtus Oelhafen* (Kunstgeschichtliches Museum, Würzburg), which likewise was formerly given to Dürer and is now accepted as a work by Schauffelein. With the reattribution, Wilhelm Suida's tentative identification of the sitter as Dr. Christoph Scheurl, Jr. appears unlikely.

The Clowes *Portrait of a Man* is contemporary with Schauffelein's earliest known works. However, the conception and style are indebted to Dürer's portraits of the mid-1490s, such as his *Self-Portrait* of 1493 (Louvre, Paris), painted while he was in Basel and sent to his future father-in-law in Nuremberg as part of the match-making process that resulted in his marriage a year later. This traditional portrait type was used as well by Dürer's teacher, Michael Wolgemut, in another painting of a young man (1486, Detroit Institute of Arts). As in Dürer's and Wolgemut's paintings, the man holds an Eryngium, the symbol of luck in love and of impending marriage. The Eryngium is known in antique literature, and its appearance in these portraits testifies to the cultivation of learning in Nuremberg's humanist circles, which included Dürer and no doubt Schauffelein himself. (Dr. Locher has also suggested that the monogram woven into the shirt, which was misread as Dürer's own, refers to the sitter's betrothed.)

Schauffelein must also have known Dürer's *Portrait of Frederick the Wise of Saxony* (ca. 1496, Staatliche Museen, Berlin), but he simplified the image in a somewhat old-fashioned way by introducing a greater linearism and expressive distortion. The results are reminiscent of portraits by Hans Baldung Grien, such as the one of Graf von Loewenstein (1513, Deutsches Museum, Berlin). Grien, too, was a member of Dürer's studio in 1503-1504, and his portrait style parallelled Schauffelein's long after both artists had gone their separate ways. Schauffelein's linear approach and direct, yet expressive, characterization are the same virtues that distinguish his graphics, which were prized even by Dürer, the greatest printmaker in the history of art.

PROVENANCE: Private Collection, Hungary.
EXHIBITIONS: *Holbein and His Contemporaries*, John Herron Art Museum, Indianapolis, 1950, no. 24. Clowes 1959, no. 22. Clowes 1963, no. 41.

LITERATURE: H. Tietze, *Meisterwerke Europäischer Malerei in Amerika*, Vienna, 1936, pp. 338-339, no. 202. G. Glück, "Ein Neu Gefundenes Werk Albrecht Dürers," *Belvedere*, 7-8, 1934-1936, p. 117 f. H. Tietze and E. Tietze-Conrat, *Kritisches Verzeichnis der Werke Albrecht Dürers*, Basel and Leipzig, 1937-1938, II, pt. 2, pp. 77-78, 217. E. Panofsky, *Albrecht Dürer*, Princeton, 1945, p. 19, no. 92. Fraser, p. 174. D. Koepplin and T. Falk, *Lukas Cranach*, Basel, 1976, II, pp. 673, 675, ill. 326d.

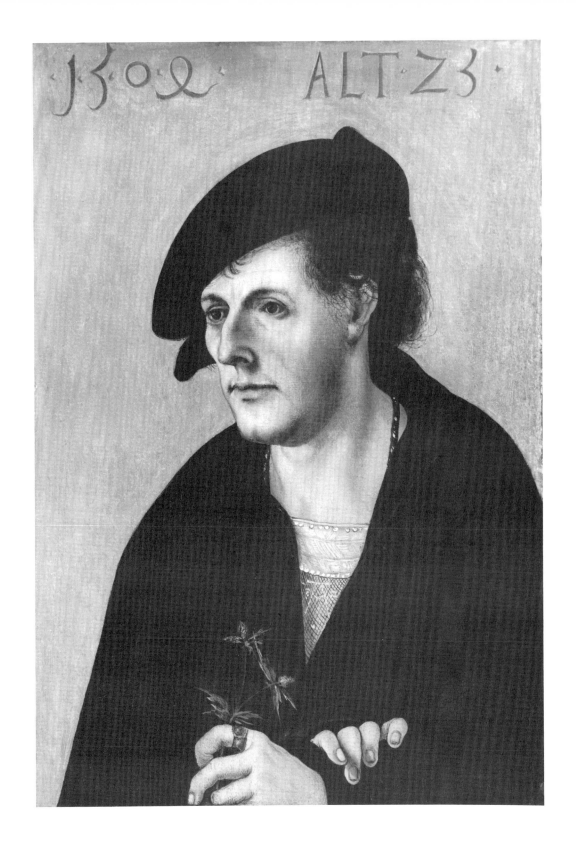

FRANÇOIS CLOUET
French, 1510?-1572

Portrait of the Marquis François de Scepeaux,
 Maréchal de Vieilleville. 1566

oil on panel, 12½ x 9¼ (31.8 x 23.5)
dated u.r.: 1566
The Clowes Fund Collection

François Clouet was born perhaps as early as 1510, possibly at Tours. The son of the famous artist Jean Clouet the Younger, who was of Flemish birth, François was probably trained in his father's workshop. After Jean's death in 1540, Clouet succeeded his father as Painter and Valet of the King's Bedchamber to Francis I, and continued to hold the court appointment under Henry II, Francis II, and Charles IX. Clouet died in 1572.

In his reconstruction of the artist's *oeuvre,* Etienne Moreau-Nélaton (*Les Clouets et leurs emules,* 3 vols., Paris, 1924) attributed a similar painting of Scepeaux (Musée de Versailles) and the drawing on which it is based (British Museum, London) to François Clouet on the basis of signed portraits of Pierre Quth (Louvre, Paris) and Charles IX (Musée de Vienne; related drawing in the Hermitage, Leningrad). Moreau-Nélaton evidently did not know the present picture, which remained in the Scepeaux family until entering the Clowes Collection. It is discernibly by the same hand and of the same high quality as the Louvre and Versailles portraits, so that it, too, can be accepted with confidence as a work by François.

François continued the style of his illustrious father, Jean Clouet, who was, with Hans Holbein (whom he influenced), the most acute portraitist of his age in the North. The Clowes painting shares many of the same characteristics as the famous portrait of Francis I in the Louvre which is presumed to be by Jean. The eyes and lips, for example, are treated as abbreviated arabesques which accentuate the sitter's haughty mien and serve, with the costume, to indicate his rank and status. Such elements were derived by Jean, along with other aspects of his style, from the Italian Mannerists patronized by Francis I. François also reveals himself to have been a dedicated Mannerist in his paintings of nudes, notably *The Bath* (Sir Frederick Cook, Richmond), in which the same stylizations are to be found as in the portrait of Scepeaux. They are as individual as François' trenchant characterizations, which reflect the same powerful personality that emerges in contemporary accounts of the artist.

PROVENANCE: François de Scepeaux, Paris, and his descendants.
EXHIBITIONS: Clowes 1959, no. 14. Clowes 1963, no. 6.
LITERATURE: Fraser, p. 142.

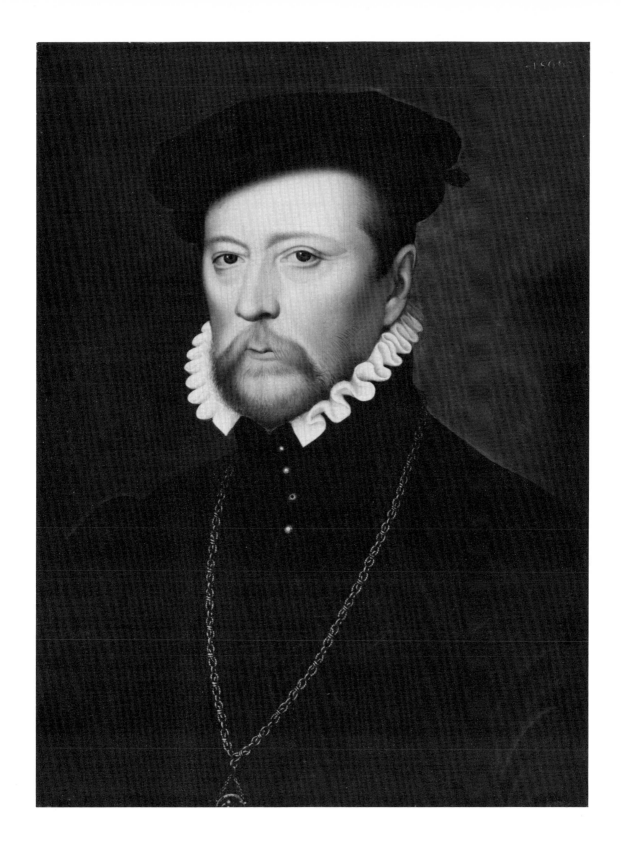

GEORGE GOWER
English, 1540-1596

Lady Philippa Coningsby. 1578

oil on panel, 37 x 27⅝ (94 x 70.3)
inscribed: Ano:dom. 1578/14 Aetatis Suae . . ./
DAME PHI: CONINGESBY ESSENDO
DONSELLA/FITZ WILLIAM BY FATHER AND
SIDNEY BY MOTHER; legend 1.1.: Les Plaisirs
sont mortels,/mais les honneurs on pardurables
James E. Roberts Fund
56.107

George Gower was born in England in 1540. His earliest portraits date from 1573, but little is known about his career, except that he was appointed "Serjeant Painter for life" to Queen Elizabeth I in 1581, and that he died in 1596.

The attribution to Gower of portraits of Lady Coningsby, her husband (Viscont Hereford, Hampton Court) and her mother (Earl of Fitzwilliam, Milton Park) was first proposed by Roy C. Strong of the National Portrait Gallery, London, and is confirmed by comparison with Gower's paintings of Sir Thomas and Lady Kytson (Tate Gallery, London). *Lady Coningsby* has the stiffness of formal English portraits of this period in general and of Gower's in particular. Equally characteristic is the emphasis on ornamentation rendered with considerable attention to detail. The elaborate costume creates an imposing grandeur worthy of the sitter's station. At the same time, the monumental effect is partly offset by the less plastic treatment of the face, which becomes somewhat lost in a sea of decoration. While not as flat as other works by the English school around the same time, the painting is executed largely as a series of lines and patterns lying on the surface. Of particular interest is the inscription admonishing the viewer that virtues are eternal but pleasures are short lived. The moral injunction is reinforced by the cherries, which are a disguised symbol of transience.

Lady Coningsby remains an impressive example of the English achievement in portraiture under Queen Elizabeth, to whom Gower became "Serjeant Painter for life" in 1581. While Nicholas Hilliard reigned supreme in the field of miniatures, Gower was the leading monumental portraitist in England during the last quarter of the century. He thus occupies a niche of considerable importance as one of the few native artists of any significant talent in the early history of English portraiture, which was otherwise dominated by foreigners until the middle of the eighteenth century. Gower's own style, however, is based on portraits done in the 1520s by Hans Holbein for Henry VIII and his court, as well as on the contemporaneous paintings of Jean Clouet in Paris. To these he added elements of a more up-to-date Flemish style. It was introduced to England first by Antonis Mor, painter to King Philip II of Spain who worked at the English court in the mid-1550s and probably paid a final visit in 1568, and then by Cornelius Ketel, who was active in London between 1573 and 1581.

PROVENANCE: Coningsby Family, Hampton Court, Herefordshire; Knight, Frank and Rutley, London, Hampton Court Sale, 1925; Francis Howard, London; Christie's, London; F. Kleinburger and Co., New York.
LITERATURE: R. Strong, "A Portrait by Queen Elizabeth I's Serjeant Painter," *Bulletin*, L, 3, Dec. 1963, pp. 52-53. R. Strong, *The English Icon*, London, 1969, p. 174. Miller, pp. 40-41.

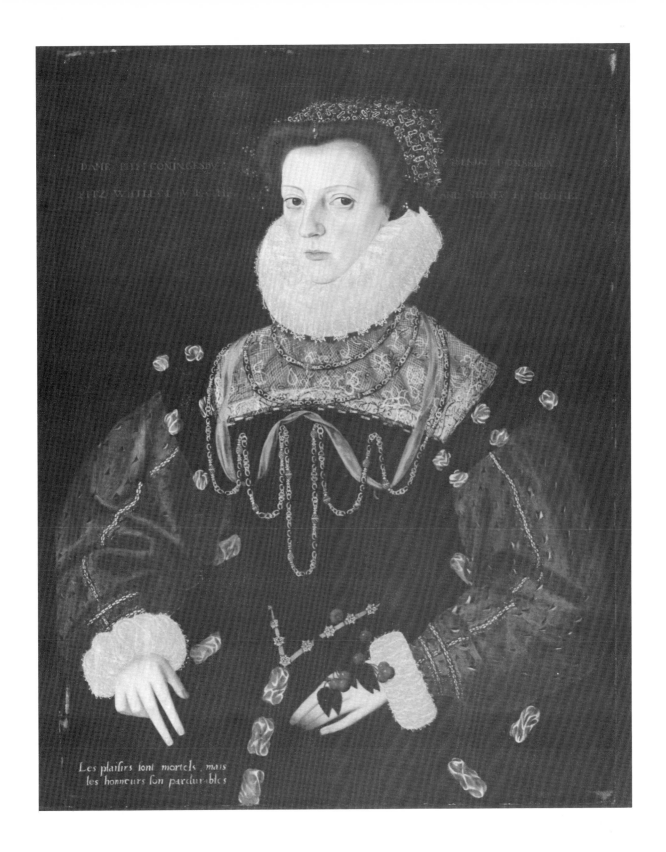

EL GRECO (DOMENIKOS THEOTOKOPOULOS)
Spanish, ca. 1541-1614

Saint Matthew. ca. 1610-1614

oil on canvas, 28⅜ x 21⅞ (72.1 x 55.6)
signed m.r. with El Greco's initials in Greek
The Clowes Fund Collection

El Greco (Domenikos Theotokopoulos) was born around 1541 near Candia, Crete. His earliest training was in Crete but soon after 1560 he went to Venice where he studied with Jacopo Bassano. He continued his training there under Tintoretto in 1565-1566, and then under Titian in 1568. In 1569 El Greco went to Rome where he was influenced decisively by Mannerism. He left for Madrid in 1572, then moved in 1577 to Toledo, where he died in 1614 after a long illness.

After 1600 El Greco painted several series of the Apostles with the Saviour, in addition to a consider-able number of individual saints. The earliest set, in the Cathedral of Toledo, was begun around 1605 or

Studio of El Greco. *St. Simon.* ca. 1610-1614. oil on canvas, 28⅜ x 21⅞ (72 x 55.6). The Clowes Fund Collection.

Studio of El Greco. *St. Luke?* ca. 1610-1614. oil on canvas, 28⅜ x 21⅞ (72 x 55.6). The Clowes Fund Collection.

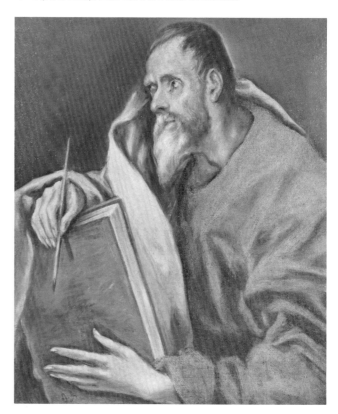

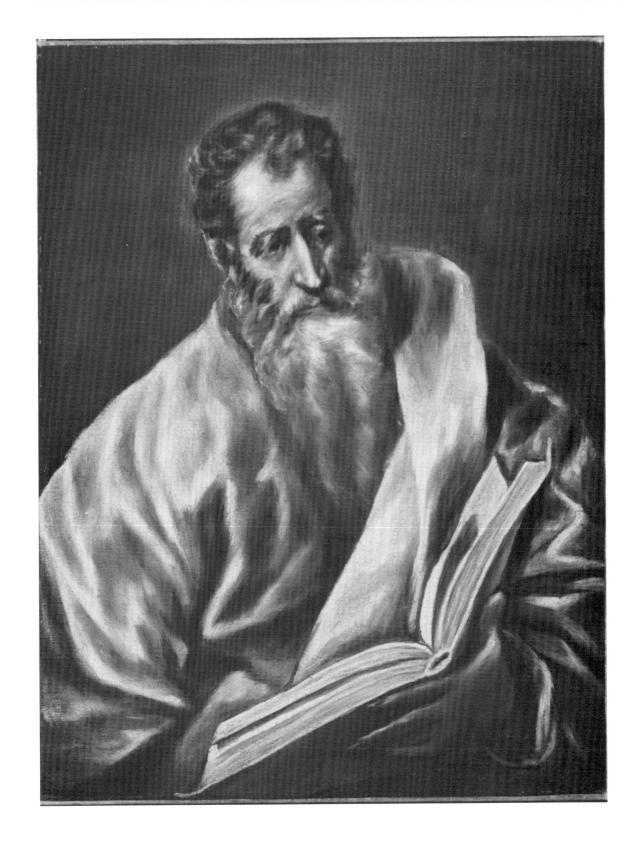

three later ones done around 1610-1614; the Museo a little earlier and established the iconography for El Greco (Toledo) series, the Henke series (various collections), a smaller partial set (dispersed) and the Almadrones series. The Almadrones set included the Clowes *St. Matthew, St. Simon* and *St. Luke,* as well as six other canvases now in the Kimball Art Foundation, Fort Worth, The Los Angeles County Museum and the Prado, Madrid (which at one time also owned the American paintings). El Greco suffered from a protracted illness during his later years and left much of the work to studio assistants. He relied heavily on his workshop to execute the Almadrones series from his designs. The *St. Matthew* is, however, very similar in treatment to its counterpart in the Cathedral set and can therefore be considered authentic. Like the others in this series, *St. Matthew* has been cropped at the waist and shoulders, so that the right hand holding his pen in the Toledo painting has been omitted.

This *St. Matthew* exemplifies El Greco's late style. Using the Tintorettesque color and expressive brushwork he had learned in Venice, the artist has created a spiritual counterpart to his imagination, in contrast to traditional images of saints which were given a convincing physical presence. Every passage is alive with El Greco's peculiar religiosity, which is felt as a nervous exaltation occuring as the dream-like vision is conjured up. This kind of mysticism is very similar to the spiritual exercises of St. Ignatius of Loyola, the Spanish founder of the Jesuits whose work provided much of the basis for the Counter-Reformation. St. Ignatius sought to make visions so real that they would seem to appear before the very eyes of the faithful. Such mysticism could be achieved only through strenuous devotion. That effort is mirrored in the intensity of El Greco's work, which fully retains a feeling of spiritual struggle. While a comparable subjectivity was inherent in the aesthetic of Il Rosso and Pontormo, Mannerism was by and large antithetical in spirit to the Counter-Reformation, which demanded a far greater visionary power than is found in Tibaldi's *Holy Family,* for example. El Greco revitalized a moribund Mannerism by effectively adapting it to suit the prevailing mysticism of Catholic Spain. The magnitude of his contribution is further indicated by the IMA's *St. Francis in Prayer,* executed by Francisco de Zurbarán's school if not by the master himself, which is based on prototypes developed by El Greco around the same time that he painted the Clowes *St. Matthew.* There is nevertheless an essential difference between the two paintings. Although it, too, follows Loyola's spiritual exercises, *St. Francis in Prayer* has a typically Baroque theatricality and Caravaggesque realism that are clearly distinguished from the Counter-Reformation ethereality of *St. Matthew.*

School of Francisco de Zurbarán. *Saint Francis in Prayer.* oil on canvas, 61½ x 38¼ (156.2 x 97.2). Gift of Mr. and Mrs. Herman C. Krannert. 62.13.

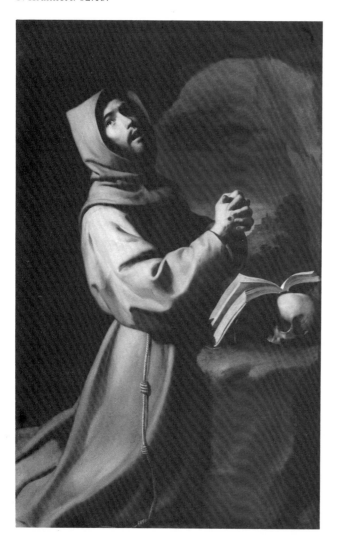

PROVENANCE: Church of Almadrones, Spain; Prado Museum, Madrid.
EXHIBITIONS: *Pontormo to Greco,* John Herron Art Museum, Indianapolis, 1954, no. 65. Clowes 1959, no. 32. Clowes 1962, no. 27. *El Greco to Goya,* John Herron Art Museum, Indianapolis, 1963, no. 22.
LITERATURE: E. Lafuente Ferrari, "El Greco: Some Recent Discoveries," *Burlington Magazine,* 86-87, 1945, pp. 296, 299. J. Camon Aznar, *Dominico Greco,* Madrid, 1950, II, pp. 981, 1053, 1372, no. 291. *Catalogo de los Cuadros,* Museo del Prado, Madrid, 1952, pp. 293-294 and *Catalogo de las Pinturas,* 1963, p. 306 f. G. Martin-Mery, *Le Greco,* Bordeaux, 1953, no. 22. H. E. Wethey, *El Greco and His School,* Princeton, 1952, I, fig. 233, II, p. 107 f, no. 191. Fraser, p. 50.

CARAVAGGIO (MICHELANGELO MERISI DA CARAVAGGIO)

Italian, 1571 or 1572-1610

Sleeping Cupid. ca 1608

oil on canvas, 25¾ x 41 (65.4 x 104.2)
The Clowes Fund Collection

Michelangelo Merisi da Caravaggio (named after his birthplace near Milan) was born in 1571 or 1572. He was apprenticed to Simon Peterzano from 1584 to 1588. In late 1592 or early 1593 he went to Rome, where he worked for a while with the Cavaliere d'Arpino. A libel suit was brought against him in 1603 by the artist Giovanni Baglione. More trouble followed, and he fled Rome after murdering a man in a dispute over a ball game. He subsequently led a peripatetic existence, moving to Naples in 1607, Malta in 1608, and back again to Naples in 1609. He died of malaria in 1610 at Porte Encole near Civitavecchia while en route to Rome for a rumored pardon.

When he published both the Clowes *Sleeping Cupid* and a nearly identical canvas in the Pitti Palace, Florence, as both authentic works by Caravaggio, Walter Friedlaender wrote: "The painting in Indianapolis is not a copy after the Pitti painting. Although there are no definite examples of Caravaggio's repeating himself literally, it is not impossible that this *Cupid*, his first mythological figure since the *Amor Victorious* in Berlin, was painted on the commission of one of the knights of Malta and that because of the appealing theme, a duplicate was ordered from Caravaggio to be sent to the Grand Duke of Tuscany." The other version in the Pitti, which is inscribed on the back "Opera di Michelangelo Marese Da Caravaggio i(n) Malta 1608," must, according to Friedlaender, "have come to Florence at an early date, since its composition was used by Giovanni da San Giovanni in a fresco of *Cupid with a Swan* of about 1620 on the facade of the Palazzo dell'Antella, Piazza Santa Croce, Florence, as Baldinucci relates (now destroyed)." (The fresco is known only in an old photograph.)

Although the inscription, documentation and provenance are not necessarily reliable, the Pitti *Cupid* has been accepted with little question, while the Clowes painting, which is superior in quality, has been rejected as a copy by most experts for the past two decades. It has been attributed variously to Giovanni Battista Caracciolo or his circle (compare Caracciolo's variants in the Benedictine Monastery, Monreale, and Museo Nazionale, Palermo), Angelo Caroselli and Orazio Gentileschi, despite the fact that the style does not accord with their secure works. The Clowes canvas does make an unusual impression, which would lead one to think of a skilled copyist or imitator in the mold of Louis Finson, for example, who executed a faithful copy (Museé des Beaux-Arts, Marseilles) after Caravaggio's *Fainting Magdalene* (G. Klain Collection, Naples) and who is documented to have made replicas of other paintings by Caravaggio as well. It must be emphasized, however, that the painting, which was later overpainted as the figure of a Christ-Child sleeping on a cross with his head resting on a crown of thorns, has suffered considerably, particularly from abrasion. Stripped of such alterations, what remains is nevertheless a characteristic painting in Caravaggio's style of about 1606-1608. It shows some similarities with the *Martyrdom of St. Lucy* (Church of St. Lucy, Syracuse), painted by Caravaggio in late 1608 shortly after he arrived in Syracuse from Malta, and especially to *The Seven Acts of Mercy* (Chiesa del Monte della Misericordia, Naples), executed by the artist in Naples in 1607 before he left for Malta, as well as to the *Fainting Magdalene* copied by Finson. Indeed, the handling of such features as the ears is entirely consistent with Caravaggio's work of that period.

The arguments against the Clowes *Cupid* ignore a

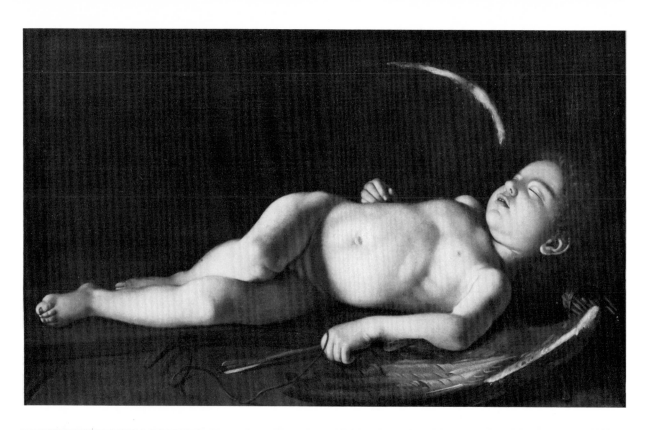

Radiograph of *Sleeping Cupid* by Caravaggio.

crucial piece of evidence noted duly by Friedlaender: the radiograph (x-ray photograph) reveals numerous *pentimenti* and the remnants of a foreshortened face in the upper left-hand corner which is, in Friedlaender's words, "similar to the head of St. Lucy in the *Martyrdom of St. Lucy* painted at about the same time in Syracuse." The radiograph is hard to read because the head was covered by a layer of lead white applied with a knife. However, the face almost surely belongs to the same Cupid seen from another angle, for the eyes, nose and mouth (which is certainly closed, despite initial appearances to the contrary) are the same in shape and size to his features as we now see them. The Clowes painting therefore cannot possibly be a copy and must be an original work, since the artist began with one conception and then changed his mind. Published radiographs of paintings by Caravaggio are scarce, but the Clowes radiograph is essentially consistent with those of the much earlier *Calling of St. Matthew* and *Martyrdom of St. Matthew* (ca. 1598, S. Luigi dei Francesi, Rome). Typical of Caravaggio, many of the *pentimenti* are hard to read, but they suggest that originally the figure was intended to recline in the manner of St. Francis in *The Ecstasy of St. Francis* (ca. 1596, Wadsworth Atheneum, Hartford). It is probable that after rejecting that solution, the artist cut the top of the canvas and added the strips on the bottom and right edge which are visible in the radiograph. Infra-red reflectography uncovers remnants of underdrawing, including adjustments in the angle of the head, the contour of the arm and the position of the bow. In light of this evidence, it is difficult to escape the conclusion that the Clowes *Cupid* is an original work by Caravaggio. Friedlaender's original opinion remains as authoritative today as when it was written a quarter of a century ago.

PROVENANCE: Private Collection, Ireland.
EXHIBITIONS: Clowes 1959, no. 13. Clowes, 1962, no. 22. *Art in Italy, 1600-1700*, Detroit Institute of Arts, 1965, no. 4. *Gods and Heroes—Baroque Images of Antiquity*, Wildenstein and Co., New York, 1968, no. 3.
LITERATURE: W. Friedlaender, *Caravaggio Studies*, Princeton, 1955, p. 212, no. 38B. B. Joffroy, *Le Dossier Caravage*, Paris, 1959, pp. 340-342. H. Hibbard and M. Lewine, "Seicento at Detroit," *Burlington Magazine*, 107, 1965, p. 370 f. A. Moir, *The Italian Followers of Caravaggio*, Cambridge, Mass., 1967, I, p. 212. M. Kitson, *The Complete Paintings of Caravaggio*, Milan, 1967 and New York, 1969, pp. 105, 107. Fraser, p. 42. A. Moir, *Caravaggio and His Copyists*, New York, 1976, pp. 8, 102.

Detail from radiograph of *Sleeping Cupid* by Caravaggio.

Detail from *Sleeping Cupid* by Caravaggio.

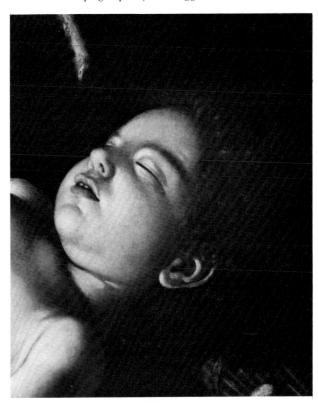

VALENTIN DE BOULLOGNE
French, 1591-1632

The Concert (Soldiers and Bohemians). ca. 1625
oil on canvas, 47 x 62¾ (119.4 x 159.4)
William A. Zumpfe Memorial Fund
56.162

Valentin de Boullogne was born in 1591 in Coulommiers, France. He settled about 1612 in Rome where he became associated with painters working in the Caravaggesque idiom. By 1620 he was well known in Rome and received important commissions, including one for an altarpiece for St. Peter's. His bohemian existence led to his demise, for it is said that he died of a fever after a plunge in the Fontana del Barberino in 1632.

Valentin came to Rome two years after Caravaggio had died, and some six years after he had fled to Naples. Consequently, Valentin learned the master's style from Caravaggio's followers, notably Bartolommeo Manfredi. Except for the subject, Valentin's *Concert* is similar to his slightly earlier *Denial of St. Peter* (Prado, Madrid), which closely emulates Manfredi's treatment of the same theme (Herzog Anton Ulrich-Museum, Brunswick). In fact, our painting itself can be regarded as a variant of Manfredi's *A Drinking and Musical Party* (Private Collection, Paris). *The Concert* exemplifies Valentin's mature style of the mid-1620s when he was, with Simon Vouet, the most important French Caravaggesque painter in Italy.

In the 1620s, genre had triumphed over religious painting in the Caravaggesque school, which was by then on the decline. In *The Calling of St. Matthew* (ca. 1597-1598, Contarelli Chapel, S. Luigi dei Francesi, Rome) Caravaggio had fused North Italian genre elements with Roman classicism to produce a monumental religious style intended to appeal to the common man by making Biblical events so realistic that they seemed to be taking place in contemporary Italy. While appreciated by connoisseurs and patrons, the startling results scandalized a public which preferred glorification through idealization. The function of Caravaggio's naturalism was not always understood even by his own followers, who were most attracted to the genre elements of his style and often relegated it to low-life scenes while adopting the manner of the Carracci school in their religious paintings. At the same time, Caravaggio's classicism was increasingly diluted by a more dynamic Baroque mode which is responsible for enhancing the colorful appeal of Valentin's lively scene. Consequently, after about 1630 Caravaggesque painting was largely abandoned, its achievements having been assimilated into the styles of other schools. Furthermore, most of its chief first-generation proponents had died around 1620, while those of the second generation, including Valentin himself, were gone barely a decade later.

PROVENANCE: Galerie Heim, Paris.
EXHIBITIONS: *Figures at a Table*, Ringling Museum of Art, Sarasota, 1960, no. 8. *Caravaggio and His Followers*, Cleveland Museum of Art, 1971, no. 71.
LITERATURE: R. Longhi, "Appropos Valentin," *Revue des Arts*, no. 2, November 1958, pp. 59, 61. B. Nicolson, "Figures at a Table at Sarasota," *Burlington Magazine*, CII, 686, May 1960, p. 226. C. Coley, "Soldiers and Bohemians," *Bulletin*, XLVII, 4, December 1960, p. 60 f. A. Elsen, *Purposes of Art*, New York, 2nd ed., 1967, pp. 197-198, pl. 24, 3rd ed., 1977, p. 185, fig. 243. Miller, pp. 66-67. J.-P. Cuzin, "Pour Valentin," *Revue de l'Art*, 28, 1975, p. 59.

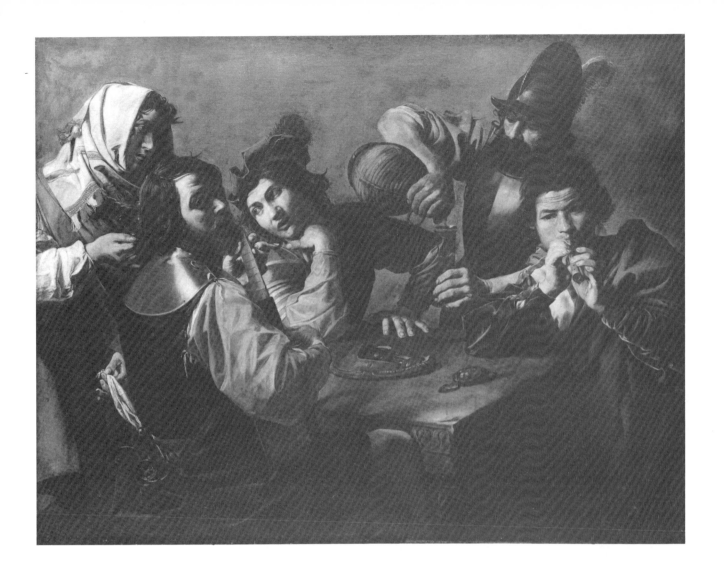

VALENTIN DE BOULLOGNE
French, 1591-1632

Rafaello Menicucci. ca. 1630-1632
oil on canvas, 31½ x 25⅝ (80 x 65.1)
Delavan Smith Fund
56.72

Erich Schleier successfully identified the sitter as Rafaello Menicucci on the basis of two prints by Ottavio Leoni (dated 1625) and Claude Mellan (active in Rome 1624-1636). The figure holds a sheet of paper showing a tower and bearing his name, as well as the inscription "Rocca del Conte," so that he has been confused with a later architect of the same name. However, our sitter was, as Pierre-Jean Mariette informs us, a buffoon with an insatiable desire for fame who was attached to the court of Pope Urban VIII. Schleier

may well be correct in surmising that Menicucci did not outlive Urban VIII, who died in 1644; thus it is likely that Menicucci was born in Monte San Sabino well before 1590.

When it appeared on the market in 1955, the painting was labelled as Roman School ca. 1620, and was subsequently attributed to a variety of artists. Schleier, for example, considered the canvas to be the work of Giovanni Lanfranco. Recently Cuzin has given it to Valentin on the basis of style and the inventory of

Ottavio Leoni. *Rafaello Menicucci.* 1625. etching, 5⅝ x 4⅜ (14.2 x 11). Mr. and Mrs. Julius F. Pratt Fund. 79.137.

Claude Mellan. *Rafaello Menicucci.* etching, 9⅝ x 7⅜ (24.4 x 18.9). Gift of James Bergquist. 79.725.

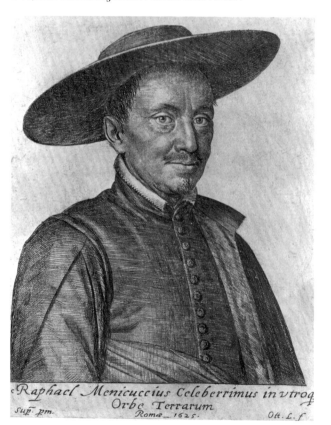

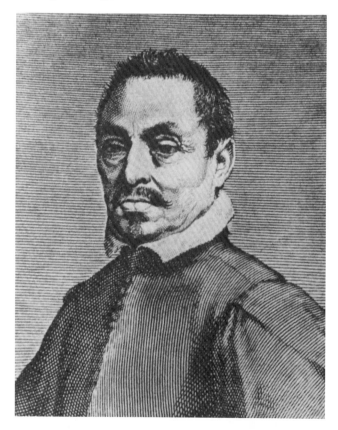

68

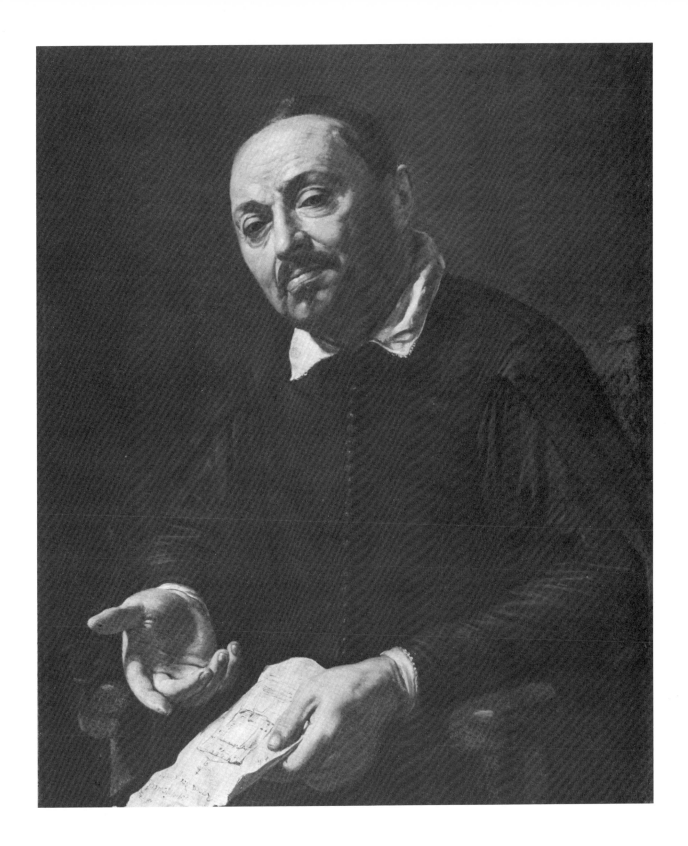

Cardinal Mazarin, which records as no. 1270 a portrait of Menicucci by Valentin that describes our painting perfectly. As a direct comparison of the portrait with the IMA *Concert* demonstrates, the attribution is persuasive, and Schleier himself reportedly now accepts it. Rafaello Menicucci is important as the only portrait by Valentin to come to light so far, although he is documented to have executed others.

Like Schleier, Cuzin dated the picture around 1625 but posed the possibility that it could have been done slightly later. In fact, it should be dated to the early 1630s. By the time he sat for Mellan, Menicucci had aged noticeably and was well into his forties, at least five years older than when Leoni engraved his image in 1625. Our portrait must have been painted at almost the same time that Mellan did his print. Moreover, the characterization accords well with Valentin's late works.

Valentin must have been familiar with Orazio Borgianni's *Self-Portrait* (ca. 1617, Academy of St. Luke, Rome), which is the prototype of the illusionism and plastic treatment found in Menicucci's portrait. At the same time, Valentin was certainly influenced by the youthful work of Simon Vouet, who strongly affected Mellan's style as well and who was the leading French Caravaggesque painter in Rome until his departure in 1627. Drawing on these sources, our artist has created a portrait which epitomizes the Baroque ideal of the man of the world who achieves success through the force of his personality. The painting well conveys Menicucci's megalomania in the dramatic gesture and vigorous characterization. At the same time, the expression is curiously veiled, while the features have a hardness that suggests a certain bitterness or disillusionment acquired through experience. For all their activity, the figures in Valentin's late Biblical scenes are, like the portrait of Menicucci, often withdrawn into a private world, especially as seen in *Crown of Thorns* (Staatsgemäldesammlungen, Munich) and *Christ and the Samarian Woman* (Prince Augusto Barberini). Despite the fact that this painting has a dry touch and realism found in the earlier *Concert*, we are dealing here with one of the artist's last works.

PROVENANCE: Galerie Sanct Lucas, Vienna; Benedict Nicolson, London; The Arcade Gallery, London.
EXHIBITION: *Italienische Barockmalerei*, Galerie Sanct Lucas, 1937, no. 114.
LITERATURE: C. Gilbert, "A Florentine Baroque Painting," *Bulletin*, XLVII, 4, December 1960, pp. 55-59. E. Schleier, "The Menicucci Portrait Restudied," *Bulletin*, LII, 4, December 1965, pp. 78-86. Miller, pp. 51-53. J.-P. Cuzin, "Pour Valentin," *Revue de l'Art*, 28, 1975, pp. 53-54, figure 1.

JUSEPE DE RIBERA
Spanish, 1591-1652

Archimedes. 1637

oil on canvas, 49 x 39 (124.5 x 99.1)
signed l.l.: Jusepe de Ribera, español F. 1637
The Clowes Fund Collection

Jusepe de Ribera was born in 1591 in Jativa near Valencia. According to Palomino, he was a student of Ribalta. By 1615 he was in Rome and became a member of the Academy of Saint Luke in 1616. Later that year he married and settled in Naples where, with the exception of a few brief trips, he spent the rest of his career. Ribera's chief patrons were the Spanish Viceroys who administered that city. The Pope admitted him to the Military Order of Christ in 1648. He died in 1652 after twelve years of poor health.

The Clowes painting was one in a series of six portraits of ancient philosophers formerly in the collection of the Count of Liechtenstein, Vaduz. Signed and dated 1637, they were probably painted for a major patron, perhaps the Count of Alcala or, more likely, the Count of Monterrey who was then nearing the end of his tenure as viceroy of Naples. The entire series was previously accepted by all authorities, but recently it has been doubted, first by Felton and then by Spinosa. Both of them know the Clowes picture only from photographs and reproductions, but interestingly enough, Spinosa reportedly changed his mind later about a canvas from the same series now in the Wadsworth Atheneum, Hartford, when he visited this country, while Felton now accepts both that painting and the Clowes philosopher.

It must nevertheless be admitted that the Liechtenstein cycle poses some major problems. Ribera's large production in 1637-1638 raises questions about his studio practices, for it is difficult to believe that he could have executed so many major canvases without considerable help from assistants thoroughly versed in his style. Moreover, his style, which proved highly influential in Naples well into the eighteenth century, was easily imitated. It is sometimes difficult to tell Ribera's own works from paintings by such skilled followers as Francesco Fracazano, the young Luca Giordano and Giuseppe Ricca, a Spaniard active in Naples. Many of their canvases are separated from his by only minor differences. The problem of Ribera's

saints and philosophers from the 1630s is especially acute. Because of their popularity, they were widely copied and imitated. Felton is certainly correct in identifying the large majority of them as school pieces. The best ones, however, show such close similarities with Ribera's secure paintings that they must be accepted. In other cases, the issue is in doubt. Among the latter are the Liechtenstein canvases.

Although he did not invent them, Ribera's beggar philosophers perfected a picturesque type common among early seventeenth-century Caravaggesque paintings, which often paired Democritus, the laughing philosopher, with Heraclitus, the weeping one. The asceticism for which certain ancient philosophers, like the prophets and saints, were known appealed strongly to the otherworldliness of Spanish Catholicism. At the same time, the learned humanism of these figures reflected the interests of the Spanish nobility who ruled Naples and who were Ribera's most important patrons. They no doubt took considerable pleasure in trying to determine the identity of each philosopher from his attributes, an often impossible task today. Ribera's saints and philosophers generally evince a high degree of consistency in the choice of physical types, poses and gestures. Almost always seen in a frontal or three-quarter pose from the waist up, his middle-aged and elderly figures typically establish eye contact with the viewer when they are not looking down toward the opposite corner of the picture or turning dramatically to the heavens in prayer. These

are not hard and fast criteria, however. More important is the peculiar combination of theatricality and inner intensity, created by subtle nuances in the handling of form and light. Thus, it is the conceptual and expressive power which most clearly distinguishes Ribera's figures from those of even his most skilled imitators.

When compared to the artist's philosophers of the early 1630s, the Liechtenstein paintings at first seem uncharacteristic of Ribera. Their proximity to the prophets Ribera painted for the Monastery of San Martino a year later, which constitute his major achievement and which were inspired in part by Michelangelo's figures on the Sistine ceiling, presents the best argument in their favor, for they share a comparable variety and heroic stature. The Liechtenstein philosophers may therefore been seen as participating in the height of Ribera's creativity during 1636-1638, when he experimented with new artistic problems and different stylistic solutions.

Of the entire Liechtenstein cycle, the Clowes painting is the most atypical and, hence, the most problematic. Only rarely are Ribera's figures shown both posed in profile and lost in thought, which here acquires an unaccustomed melancholy. The Clowes philosopher is not entirely without precedent in his work however. It is basically derived from his early *Sense of Touch* (ca. 1616, Norton Simon Museum, Los Angeles), while a similar inner contemplation can be found in some of the philosophers from the early 1630's, for example, *Plato* (Musée Picardie, Amiens.) The picture is furthermore indistinguishable in style from *The Drinker* (1637, Private Collection, Geneva) and *Elijah* (1638, National Museum of San Martino, Naples), although Felton had considered the Liechtenstein paintings as a whole to be inferior to Ribera's secure works and Spinosa has suggested Fracazano as their possible author. Above all, the Clowes painting has the incisiveness missing from similar figures by Ribera's followers, for example an *Allegory of Winter* attributed correctly to Fracazano (sold recently at Sotheby's, London) or an *Elijah* given variously to Fracazano and Ricca (Victor Spark, New York). The strength and dignity of the characterization are convincingly Ribera's, as is the appearance, which exemplifies his Caravaggesque realism at its finest. How, then, can the unusual conception be explained? The answer must be sought in the identity of the philosopher and the sources of the figure.

It is difficult to determine the name of each of the Liechtenstein figures. The oldest inventories list them as Diogenes, Anaxagoras, Aristotle, Plato, Crates and Protagoras, but these were later changed without explanation to Diogenes, Anaxagoras, Archimedes and three unidentified philosophers. Diogenes and Anaxagoras (both in private collections) are readily identified, but the rest (Wadsworth Atheneum, Hartford; Los Angeles County Museum; Private Collection) have so far eluded a fully satisfactory answer. The Clowes philosopher is no doubt the one listed as Archimedes or Aristotle. But which one is correct? The traditional identification as Archimedes is based on the overlapping circles, which play a role in his geometry and philosophy. Ribera's earlier *Archimedes* (1630, Prado, Madrid) also includes a sheet of geometric drawings, but shows him holding a compass. (The other five "Archimedes" listed by Felton as school pieces generally have too little in common with each other to aid in their identification.) Despite the reference to geometry, Dr. D. Fitz Darby argued in favor of Aristotle on the basis of the torn sleeve, in which she saw a "cunning suggestion of the *brachium exsertum,*" or exposed arm, found on ancient statues of that philosopher. If correct, this would be the only painting of Aristotle by Ribera or his school. Neither attribute, however, is sufficient in itself to provide a fully convincing identification.

Further evidence can be found in the appearance of the figure itself. The resemblance in pose and mood between the Clowes philosopher and Rembrandt's *Aristotle Contemplating the Bust of Homer* (1653, Metropolitan Museum, New York) is tantalizing—but coincidental. Both painters relied in part on Renaissance portraits of learned men and philosophers, and these prototypes served merely to help establish their figures as philosophers in general, not Aristotle in particular. More significant is the curious but obvious similarity, both in features and costume, to Velazquez's *Water Carrier* (ca. 1619, Wellington Museum, London). According to the artist's biographer Antonio Palomino, *The Water Carrier* was famous in Velazquez's own day and was kept in the Palace of the Buen Retiro. Despite the fact that he never returned to Spain, Ribera could have known the picture indirectly. For example, while no prints were made after *The Water Carrier,* very old copies exist, and perhaps one made its way to Naples. Alternatively, Ricca or another Spaniard working in Italy might have transmitted the image to Ribera. It is equally possible that Velazquez may have discussed the picture with Ribera during his visit to Italy in 1630, which evidently led Ribera to adopt, on occasion, his countryman's silver tonality. It

is ironic that Velazquez—whose early *bodegones,* including *The Water Carrier,* were probably inspired by paintings like *The Sense of Touch* mentioned above and *The Sense of Taste* (Wadsworth Atheneum, Hartford) from the same series, perhaps through early copies—should in turn influence Ribera, but the resemblance between *The Water Carrier* and the Clowes philosopher is too singular to permit any other conclusion. At the same time, it is equally apparent that the artist did not merely copy or imitate Velazquez's example but reinterpreted it within a strikingly original work. The Clowes painting is consistent in character with Ribera's own paintings, including *The Sense of Touch* which can be regarded as the ancestor of both canvases.

If this reasoning is accepted, then the incorporation of *The Water Carrier's* imagery in the Clowes painting may well be a veiled reference to Archimedes. Archimedes was famous for his work in hydraulics and practical science, but he regarded these experiments as less important than his contribution to pure science and philosophy. The contrast between the books of learning (philosophy) and the tools of geometry (science) on the one hand and, on the other hand, the allusion to water and practical labor in the paraphrase of *The Water Carrier* is fully appropriate to the iconography of Archimedes. While impossible to prove conclusively, this hypothesis affords a most satisfying, not to mention intriguing, explanation of the Clowes philosopher's identity and significance. The ingenious conception further lends support to Ribera's authorship, for it accords well with the complexity of thought underlying his other portraits of philosophers.

PROVENANCE: Fürstlich Liechtensteinsche Gemäldegalerie, Vaduz.
EXHIBITIONS: *Exhibition of Paintings and Graphics by Jusepe Ribera,* Oberlin College, 1957, no. 4. Clowes 1959, no. 49. Clowes 1962, no. 31. *El Greco to Goya,* John Herron Art Museum, Indianapolis, 1963, no. 70.
LITERATURE: *Descrizione completa di tutto cio che titrovarsi nella Galleria di pittura e scultura di sua altezza Giuseppe Wenceslas del S. R. I. principe regnante della casa di Liechtenstein,* Vienna, 1767, p. 105. *Description des tableaux et des pieces de sculpture que renferme La Gallerie de Son Altesse François Joseph chef et Prince Regnant de la Maison de Liechtenstein . . . ,* Vienna, 1780, pp. 160, 169. A. Kronfeld, *Fuhrer durch die fürstlich Liechtensteinsche Gemäldegalerie in Wien,* Vienna, 1931, p. 23, cat. no. A57. B. de Pantorba, *Jose de Ribera,* Barcelona, 1946, p. 25. "Bibliografia," *Archivo Español de Arte,* XXX, 120, 1957, p. 349, pl. 3. E. H. Turner, "Ribera's Philosophers," *Wadsworth Atheneum Bulletin,* Spring, 1958, pp. 5-14, note 5, fig. 2. D. Fitz Darby, "Ribera and the Wise Men," *Art Bulletin,* 45, 1962, p. 298 f., fig. 9. Fraser, p. 60. C. Felton, *Jusepe de Ribera: A Catalogue Raisonné,* University of Pittsburgh, 1971, p. 420, no. x-18. N. Spinosa, *L'opera completa del Ribera,* Milan, 1978, no. 403.

CLAUDE LORRAIN (GELÉE)
French, 1600-1682

The Flight into Egypt. ca. 1635

oil on canvas, 28 x 38 (71.1 x 96.5)
inscribed on stone l.c.: CLAV IN . . .
The Clowes Fund Collection

Born in 1600 in Chamagne (Vosges), Claude arrived in Italy as early as 1612. He became a student of Goffredo Wals in Naples around 1618 and then of Agostino Tassi in Rome. Except for a brief return in 1625 to Lorraine, where he was an assistant to Claude Douet, he spent his career in Rome, and died there in 1682.

The Flight into Egypt has been accepted by every authority as an authentic work by Claude, although it is not recorded in the artist's account book called the *Liber Veritatis* (British Museum), which was begun in 1636 and omits many of his early paintings. As Röthlisberger notes, the picture must have been executed in the mid-1630s, for it is consistent with other canvases by Claude from those years: *Landscape with the Judgment of Paris* (1633, Duke of Buccleuch), *Landscape with Cephalus and Procris Reunited by Diana* (destroyed) and two pastoral scenes (F. Madan, Esq., London, and the Earl of Fitzwilliam). Claude also did a slightly later *Flight into Egypt* (The Lord St. Oswald) which is similar in mood but which is quite different in composition, except for the bridge in the middle distance.

In part, Claude's landscapes parallel *vedute* (views) done by other Northerners, especially Dutch painters, in Rome during the first few decades of the seventeenth century. But his owe their somewhat different character to the ideal landscapes synthesized by Annibale Carracci from Venetian sixteenth-century prototypes. In contrast to Nicholas Poussin's heroic landscapes, Claude's are historical not by virtue of the figures, which were almost always added afterwards by other artists specializing in *staffage*, but because of the Arcadian spirit, which evokes a nostalgia for a bygone era.

The binding medium for Claude's achievement was his naturalism, which must, however, be understood in a very particular sense. His numerous drawings of the Roman Campagna, which forms the background of *The Flight into Egypt*, are primarily atmospheric observations rather than topographical studies. In them he rarely recorded a scene in any detail, but preferred to capture the main effect of light in summary fashion. Thus, truth to nature was for him above all a matter of mood conveyed by light and atmosphere. While convincing as an actual landscape, details were added later from memory to *The Flight into Egypt,* and the composition was manipulated with considerable freedom in order to create the poetic sentiment which unifies the painting. This attitude toward landscape, which ultimately stemmed from Venetian art, inherently permitted a wide expressive range. By 1640 Claude began to invest his scenes with greater fantasy, until in the 1660s they drew closer to the epic spirit of Poussin, who was himself influenced in turn by Claude's gentle poetry.

PROVENANCE: Durjeu Gallery, Paris; Viscount Palmerston, Broadlands, and his descendants; Sir E. Guinness (Earl of Iveagh); Christie's, London; M. Knoedler and Co., London; Thomas Agnew and Sons, London.
EXHIBITIONS: Clowes 1963, no. 9. C. Whitfield, special exhibition of the painting at Indiana University Museum of Art, Bloomington, 1968. *From El Greco to Pollock: Early and Late Works by European and American Artists*, Baltimore Museum of Art, 1968, no. 3. *Romance and Reality*, Wildenstein and Co., New York, 1978.
LITERATURE: M. Röthlisberger, *Claude Lorrain—The Paintings*, New Haven, 1961, I, p. 466, (p 204), II, fig. 35. Fraser, p. 154.

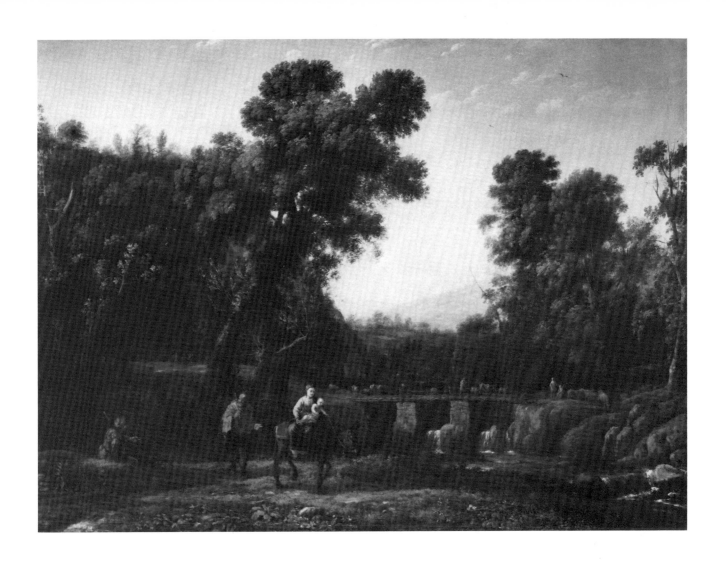

GIOVANNI FRANCESCO ROMANELLI
Italian, ca. 1610-1662

The Finding of Moses. ca. 1656-1657

oil on canvas, 34 x 45 (86.4 x 114.3)
Gift of the Alliance of
 the Indianapolis Museum of Art
72.18

Born around 1610, Romanelli studied briefly with Domenichino, then with Pietro da Cortona. His principal patron was Cardinal Francesco Barberini, whom he joined in exile in Paris during 1646-1647. Romanelli returned in 1655-1657 to Paris where he was showered with commissions. He died in Viterbo in 1662.

According to Professor Italo Faldi, who is compiling a catalogue of the artist's works, *The Finding of Moses* was done in 1656-1657 during Romanelli's second stay in Paris, when he painted the Palais Mazarin frescoes. In addition to the stylistic similarities with the Mazarin decorations and other paintings of the same period, our canvas can be related specifically to seven Old Testament scenes Romanelli is known to have executed in 1657, including a *Finding of Moses* in the Palais de Compeigne.

Despite his long association with Pietro da Cortona, Romanelli never fully assimilated his master's high Baroque style, which was better understood, for instance, by Luca Giordano, whose treatment of *The Finding of Moses* (ca. 1685, North Carolina Museum of Art, Raleigh) is considerably more dramatic and painterly than our canvas. Instead, this painting, like many of Romanelli's later works, shows the influence of Domenichino from the 1620s when Romanelli was briefly his student. A favorite pupil of Annibale Carracci, Domenichino was the leading classical painter of the early Baroque in Italy. While variable in its success, Romanelli's fusion of elements drawn from Cortona and Domenichino was not unnatural, for Cortona himself often displays a strong classical streak suggesting an appreciation of Domenichino's work. The easel paintings of the two artists usually differ only in degree, not in kind, and are differentiated chiefly by Cortona's more painterly, Venetian style. (Compare Cortona's *St. Jerome in the Desert*, ca. 1637, Detroit Institute of Arts, with Domenichino's *St. Jerome*

with Angels, ca. 1608-1610, Denis Mahon, London.) Only in their frescoes is there an unbridgeable gulf between Cortona's North Italian illusionism and Domenichino's classicism, which was based on Carracci and Raphael.

With his training under Domenichino and Cortona, Romanelli adopted a manner which was in keeping with Italian classicism around mid-century. The virtues of this style are readily apparent in *The Finding of Moses*. The classically conceived figures react with the utmost delicacy and grace within the charming Arcadian setting, which enhances the lyrical mood. The color is at once decorative and classical in its brilliance and clarity. During his initial visit to France, Romanelli's decorative classicism influenced the official court style under Louis XIII and Cardinal Richelieu. The French style had been established by Simon Vouet and was decisively reinforced by the more severe art of Nicolas Poussin during his two years in Paris in 1640-1642. Poussin's work, however, was more heroic than the Parisian school's or Romanelli's. *The Finding of Moses* shares the gentle spirit of mature paintings by Eustache Le Sueur, Vouet's favorite pupil. At the same time, a comparison with François Tortebat's engraving of Vouet's tapestry design for *The Finding of Moses* of ca. 1630 suggests that Vouet and his followers in turn affected Romanelli and indicates that the exchange was mutually beneficial.

PROVENANCE: Colonel H. Clowes, England; Christie's, London; Arcade Gallery, London; Sir Godfrey Llewellyn, England; Christie's, London; Loewi-Robertson, Inc., Los Angeles.

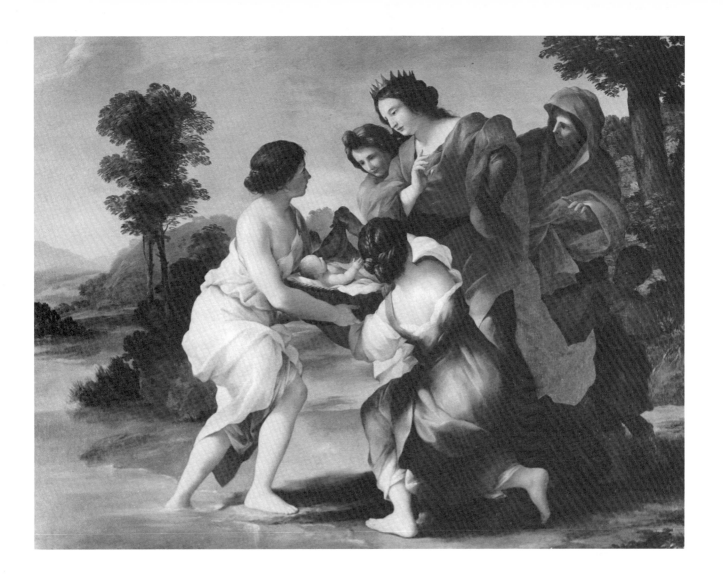

LUCA GIORDANO
Italian, 1634-1705

The Dream of Saint Joseph. ca. 1700

oil on canvas, 46⅝ x 54¼ (118.4 x 137.8)
Martha Delzell Memorial Fund
77.52

Luca Giordano was born in 1634 in Naples, where he was trained under Jusepe de Ribera. He worked there for much of his career but took numerous trips to North Italy, especially Florence which he visited in 1652-1653, 1665, 1682, and 1685. He worked in Spain from 1692 to 1702, then returned to Naples where he died in 1705.

Probably painted around 1700 toward the end of his ten-year stay in Spain, *The Dream of St. Joseph* is also known in several workshop copies: They are in the Valenciano Collection, Barcelona; the Infantado Collection, Madrid; and the Cathedral, Toledo. It has sometimes been assumed that our painting was done as a tapestry design for the Fabrica de los Tapices in Madrid because the Toledo copy was moved from the factory's cathedral. However, there is no evidence to support that hypothesis. In addition, the Infantado copy had a pendant, *The Education of the Virgin*, which must also have existed in an original version, now lost, but it is unclear whether it was intended as a companion to our picture.

The germ of this unusual composition can be found already in an *Annunciation* (formerly French and Company, New York), probably painted in the late 1650s or early '60s. Like *The Adoration of the Shepherds* (Detroit Institute of Arts) of ca. 1665-1670, it reveals the strong influence of *The Annunciation* (San Francesco, Cortona) by Pietro da Cortona. Giordano came to admire Cortona's work during his three visits to Northern Italy and especially to Florence, where the extensive decorations executed by Cortona for Grand Duke Ferdinand II between 1637 and 1647 established the official court style for the rest of the century. Giordano absorbed Cortona's turbulent, light-filled style, as seen in *The Dream of St. Joseph*. With Bernini's protégé Giovanni Battista Gaulli (called Baciccio), he became Cortona's successor to the high Baroque tradition of decorative painting.

The Dream of St. Joseph is nevertheless a highly original work. Cortona himself painted nothing like it. The tool shelf ingeniously divides the scene into two halves which are given equal weight and which are united by the clouds spilling down from heaven and surrounding the angel. The subject is taken from Matthew I: 18-21, particularly verse 20:

> But while he thought on these things, behold, the angel of the Lord appeared unto him in a dream, saying, Joseph, thou son of David, fear not to take unto thee Mary thy wife: for that which is conceived in her is of the Holy Ghost.

The miraculous event is depicted as if it were taking place in virtually the same time and space as the dream. The novelty of this solution is emphasized by the very different approaches adopted by Giordano in two other versions of the same subject. A painting of ca. 1684 in the Landesmuseum Joanneum, Graz, is comparable with a drawing by Gaulli (ca. 1675, Robert and Bertina Manning, New York) in showing the angel pointing to the Madonna in the far background. In its striking foreshortening and unusually low vantage point, the second picture, of about 1696 (Prado, Madrid), strongly suggests the example of Correggio's fresco *The Assumption of the Virgin* in the dome of Parma Cathedral. The IMA's *Dream of St. Joseph*, in contrast, elides the distinction between the earthly and the divine, making the vision all the more vivid and, hence, believable.

PROVENANCE: Walter P. Chrysler, New York; Thomas Agnew and Sons, London.
EXHIBITIONS: *1550-1650, A Century of Masters from the Collection of Walter P. Chrysler, Jr.*, Fort Worth, 1962, no. 28.
LITERATURE: M. Milkovich, *Luca Giordano in America*, Brooks Memorial Gallery, Memphis, 1964, p. 38. O. Ferrari & G. Scavizzi, *Luca Giordano*, 1966, I, pp. 132, 246, II, pl. 432.

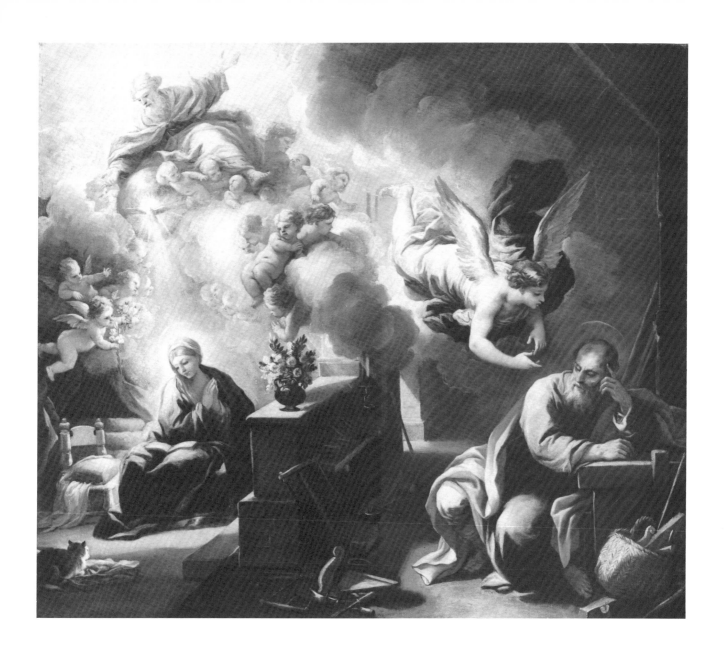

JAN BRUEGHEL THE ELDER
Flemish, 1568-1625

Canal Scene. 1612

oil on panel, 15 x 24 (31.1 x 61)
signed and dated 1.1: Brueghel 1612
The Clowes Fund Collection

Jan was born in Brussels in 1568, the son of the famous artist Pieter Brueghel the Elder. His teachers are disputed. Brueghel spent 1590-1595 in Italy. He settled in Antwerp, where he became a master in the guild in 1597 and its dean in 1601. He was married twice, in 1599 and in 1605. Except for visits to Prague in 1604 and Nuremberg in 1606, Brueghel remained in Antwerp, where he died in 1625.

This *Canal Scene* of 1612 is virtually identical to a painting by Jan in the Kooninglijke Museum voor Schoone Kunste, Antwerp, which is signed and dated 1603. The basis of the landscape can be found in the work of Jan's father, Pieter Brueghel the Elder, for example *Landscape with Christ on the Sea of Galilee* (1553, Private Collection). Famous for his flower still lifes, Jan was equally important as perhaps the last great representative of Northern Mannerist landscape painting. Begun by the printmaker Hieronymous Cock and his brother Matthew, that tradition was defined by Pieter Brueghel and was continued after his death in 1569 by his contemporaries Hans Bol, Lucas Van Valckenborch, Gillis Mostaert and the slightly older Jakob Grimmer. Jan was thoroughly ingrained with this heritage, and the source of many of his motifs can be found in the work of those artists.

From its inception, the Mannerist landscape was characterized by imaginative compositions made credible by the faithful rendering of details. Unlike his contemporary Gillis van Coninxloo, who emphasized the element of fantasy, Jan tended toward naturalism. Indeed, *Canal Scene* is painted with much the same directness found in the work of an anonymous member of Cock's circle known today as The Master of the Small Landscapes. The high vantage point is still old-fashioned, but the triangular surface geometry is precociously Baroque. The simple structure controls spatial depth and helps unify the composition. The scene is further integrated by the idyllic, lazy summer afternoon atmosphere created by Brueghel's melting color.

PROVENANCE: Jakob de Wit, Antwerp; Königlichen Gemäldegalerie, Dresden; Duke of Saxe-Meiningen.
EXHIBITIONS: Clowes 1959, no. 10. Clowes 1963, no. 25. *Le Siècle de Rubens*, Musées Royaux des Beaux-Arts, Brussels, 1965, no. 21.
LITERATURE: Fraser, p. 118.

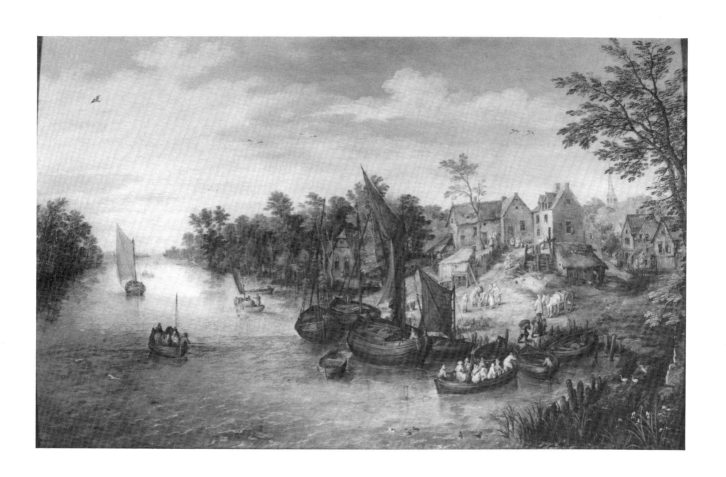

PETER PAUL RUBENS
Flemish, 1577-1640

*The Triumphant Entry of Constantine
 into Rome. ca. 1622*

oil on panel, 19 x 25½ (48.3 x 64.1)
The Clowes Fund Collection

Peter Paul Rubens was born in Cologne in 1577. Around 1588 he moved to Antwerp where he studied under Tobias van Haecht in 1591, Adam van Noort sometime before 1594, and Otto van Veen in 1596. He entered the guild in 1598 and went to Italy two years later. In Italy Rubens worked primarily for the Duke of Mantua, although he spent the years of 1606 to 1608 in Rome. His mother's illness brought him back to Flanders in 1608. The following year he wed Isabella Brandt, who died in 1626. Throughout much of his career, Rubens served as confidential advisor at court, and was involved as a diplomat with numerous sensitive negotiations in Paris, Madrid and London, a role he carried out until 1633. In 1630 he married the sixteen-year-old Helena Fourment. They later lived at Castle Steen, which Rubens purchased in 1635. He died in Antwerp in 1640.

The Triumphant Entry of Constantine into Rome is one of the oil sketches Rubens painted for a set of twelve tapestries now in the Philadelphia Museum of Art. The circumstances surrounding the commission remain obscure because there are only a few documents relating to it. The most likely explanation is that the commission was placed with Rubens by the Saint-Marcel tapestry workshop under the general patronage of Louis XIII of France, for whom the life of the first Holy Roman Emperor must have had a special significance. A contract was presumably drawn up during Rubens' first visit to Paris in January and February, 1622. The first four sketches were received November 24 that year, the rest presumably in January of 1623, although the artist never received full payment for his work. In September, 1625, seven finished tapestries were presented by the king to Cardinal Francesco Barberini, who at first accepted them reluctantly but then had six more tapestries done in Rome during the 1630s from designs by Pietro da Cortona, not Rubens.

The Clowes panel depicts the fourth scene in the Constantine cycle. It shows the Emperor's return to Rome after the battle of the Milvian Bridge, which is the subject of the third tapestry (sketch in the Wallace Collection, London). The event is described by Cardinal Baronius, who drew his information from Eusebius. Rubens has embellished his story by adding allegorical figures. *Rome*, dressed in a warrior's helmet, greets Constantine with a statuette of victory. They stand at the entrance to what is perhaps a temple, where Constantine is being crowned with a wreath by *Victory* while *Fame* blows a pair of trumpets.

The composition has been consciously patterned after Roman reliefs, notably those on the Arch of Constantine and the Arch of Titus, as well as after the equestrian statue of Marcus Aurelius. Rubens also followed antique sources closely in *The Marriage of Constantine* (M. W. Leatham, Finchampstead), *The Death of Constantine* (Private Collection, Paris) and *The Apparition of the Monogram of Christ* (John G. Johnson Collection, Philadelphia Museum of Art). In the sketches for *The Baptism of Constantine* (Vicomtesse de Noailles, Paris) and *The Campaign Against Licinius* (Nelson Gallery-Atkins Museum, Kansas City), he turned for inspiration to Raphael as well, along with other High Renaissance artists, primarily because no direct precedents in ancient art could be found.

The insistent classicism of the Constantine sketches was the result of the numerous studies Rubens executed after ancient and Renaissance art during his six years in Italy and following his return to Flanders.

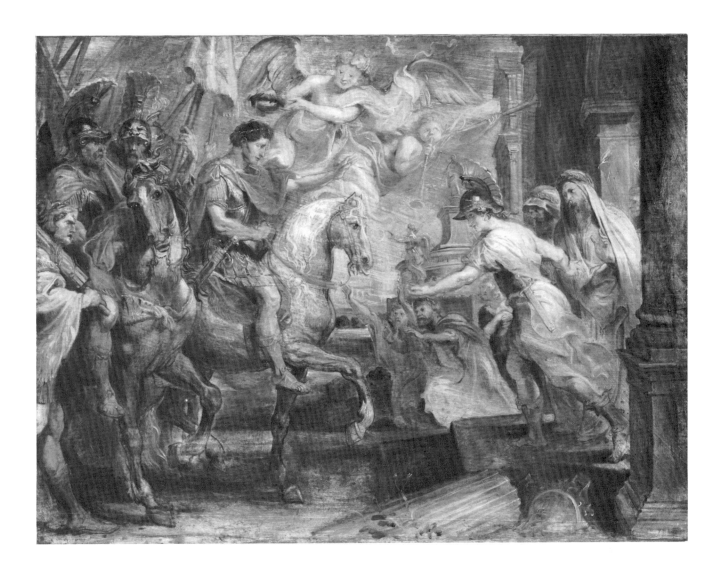

These motifs he incorporated into the rest of his work, usually by transforming them to a substantial degree. The deliberate quotation of Roman art may be attributed to the strong tradition of classicism in late sixteenth-century French art and partly to the imperial ambitions of the French court, which already showed a decided preference for Roman motifs because of their iconographical and historical associations. We can be sure, however, that the stylistic decision must have been made solely by Rubens himself as most appropriate to the life of Constantine.

The Clowes sketch is hardly as exceptional for Rubens at this time as it seems at first. In fact, *The Triumphant Entry of Constantine into Rome* is remarkably similar in style and conception to the upper half of his sketch for *Marie de'Medici, Queen of France, Landing in Marseilles* (ca. 1622, Alte Pinakothek, Munich), done at nearly the same time. Even the figure of Rome is repeated almost verbatim. Thus, classicism remains central to one of the artist's most fully Baroque works. In both pictures, Rubens elevates an historical event to the realm of allegory in which heaven and earth unite in joyous celebration. While the tritons and nereids lend a greater sweep and turbulence to the Marie de'Medici painting, what animates the two scenes is not so much the dynamism of the compositions or the activity of the figures as the liveliness of the brushwork.

Like other sketches by the artist, the Clowes picture reveals Rubens' own energy and imagination much more directly than the finished product, which was executed by others. The tapestry alters the format of the composition, cramping as well as, of course, reversing it. The results, although handsome enough, lack the vitality of the sketch, that sense of vibrant life which is the very essence of Rubens' art. In excellent condition, the beautiful Clowes sketch suggests the supreme imagination, intellect and zest of the man himself.

PROVENANCE: Probably Louis XIII; Saint-Marcel tapestry workshop, Paris; Marc de Comans, Paris; François de la Planche, Paris; probably Henri de Valois, Paris; Philippe, Duc d'Orleans, Palais Royal, Paris; Earl of Liverpool, London; John Smith, London; Hon. G. J. Vernon, England.

EXHIBITIONS: Clowes 1959, no. 50. Clowes 1963, no. 32. *Constantine The Great, The Tapestries—The Designs, Philadelphia Museum of Art*, 1964, no. 4a.

LITERATURE: J. Smith, *Catalogue Raisonné of the Works of the Most Eminent Dutch, Flemish and French Painters*, London, 1830, II, p. 204 f., no. 739. A. von Hasselet, *Histoire de P. P. Rubens*, Brussels, 1840, p. 284, no. 583. G. F. Waagen, *Treasures of Art in Great Britain*, London, 1854, II, p. 502, no. 14. A. Michiels, *Catalogue des Tableaux et Dessins de Rubens*, Paris, 1854, p. 21, no. 510. C. Bland, *Le Trésor de la Curiosité*, Paris, 1858, II, p. 151. M. Rooses, *L'Oeuvre de P. P. Rubens*, Antwerp, 1890, III, p. 213, no. 723. E. Michel, *Rubens, His Life, Work and His Time*, New York, 1899, pp. 26, 31. L. van Puyvelde, *The Sketches of Rubens*, London, 1940, p. 28, no. 6. D. Du Bon, *Tapestries from the S.H. Kress Collection at the Philadelphia Museum of Art*, London, 1964, no. 4, fig. 60. Fraser, p. 124. J. Held, *The Oil Sketches of Peter Paul Rubens*, Princeton, 1980, pp. 75-76, no. 43.

ANTHONY VAN DYCK

Flemish, 1599-1641

The Entry of Christ into Jerusalem.
 ca. 1617-1618

oil on canvas, 59½ x 90¼ (151.1 x 229.2)
Gift of Mr. and Mrs. Herman C. Krannert
58.3

Van Dyck was born in 1599 in Antwerp, where he became a student of Hendrick van Balen in 1610. He was made a master in the Antwerp painters guild in 1618. During this time he was living with Rubens, whom he served as a valued assistant, although he never was his pupil as such. After a visit to England in 1620, Van Dyck spent the years 1621-1626 in Italy, primarily Genoa. Upon returning to Antwerp in 1627, he soon established himself as a successful artist and was named court painter to the Archduchess Isabella in 1630. Two years later he moved to England, where he became painter to the London court. Except for a visit to Antwerp and Brussels in 1634, he remained there until 1640, when he tried unsuccessfully to negotiate new positions in Antwerp and Paris. Soon after his return to London in 1641 Van Dyck became seriously ill and died later that year.

The Entry into Jerusalem was painted during Van Dyck's first Antwerp period, when he was a valued assistant to Rubens. He adopted Rubens' vibrant color, brilliant brushwork and monumental figures but combined them in a highly individual manner to produce this surprisingly mature masterpiece. For all of its energy, *The Entry into Jerusalem* has a restraint that reveals the essentially lyrical personality of Van Dyck, whose character was less heroic than Rubens'.

The painting has a classical quality achieved before Van Dyck's visit to Italy a few years later. As Horst Vey has pointed out in discussing a copy (present whereabouts unknown) of the lost preparatory drawing, *The Entry into Jerusalem* was derived in part from two prints after the sixteenth-century Flemish artist Martin de Vos. But the treatment of this subject, which was rare in the North, must also have been inspired at least as much by the abundant Italian prototypes beginning with Duccio, for our painting has a monumentality rare in previous Flemish art. In attempting such a synthesis, Van Dyck followed the example set by Rubens, who had fused traditional Flemish painting with lessons learned in Italy to create his epic Baroque style.

The monumental power of *The Entry into Jerusalem* is far removed from the delicate refinement of the miniature *Vertumnus and Pomona* painted around 1608 by Van Dyck's teacher, Hendrik van Balen, which demonstrates by way of contrast just how crucial Rubens actually was in the formation of Van Dyck's art. Though unsigned, *Vertumnus and Pomona* can be securely attributed and dated on the basis of Van Balen's *Judgement of Paris* (1608, Brukenthal Museum, Sibiu, Roumania); the under-drawing as revealed by infrared reflectography is furthermore consistent with such sheets as *Diana and Acteon* of 1605 in the Antwerp Print Room. In style *Vertumnus and Pomona* brilliantly exemplifies the final phase of Flemish Mannerism, at about the time Rubens returned from Italy and not long before Van Dyck entered Van Balen's atelier. Set against a landscape in the manner of Jan Brueghel the Elder, with whom Van Balen often collaborated, the figure of Pomona harks back to Marten de Vos' allegorical drawing of Africa (1594, Antwerp Print Room) and ultimately to prints after Primaticcio and the School of Fontainebleau. With Hendrik van Clerck and Frans Francken II, Van Balen was a leading member of the older generation of Antwerp painters, who made concessions to Rubens' new style but never fully acceded to it. In *The Entry into Jerusalem*, on the other hand, Van Dyck adopts Ruben's grandiose Baroque mode wholeheartedly—but without forget-

ting the lessons he had learned in Van Balen's shop, for the construction of the landscape and the figure of Christ clearly hark back to *Vertumnus and Pomona*.

Hendrik van Balen. *Vertumnus and Pomona*. ca. 1608. oil on copper, 10¼ x 8¾ (26 x 22.2). Gift of Allen Whitehill Clowes. 80.200

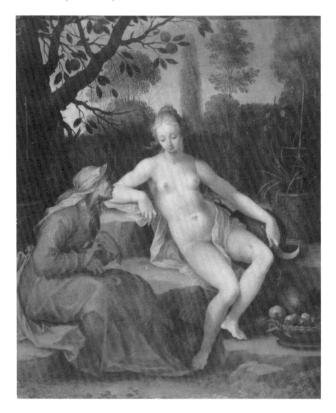

The *Entry into Jerusalem* exemplifies the spirituality of seventeenth-century Flanders. In contrast to the other worldly mysticism emphasized during the Counter-Reformation, the Baroque presented Biblical events as if they were taking place in the present. To make this dramatic impression all the more persuasive, Van Dyck's nearly life-size figures fill the frame, so that they act out their roles in a space which is continuous with ours. The drama is further heightened by the animation of the crowd and the expressiveness of the color. The relief-like procession parallel to the picture plane places us among the crowd lining the road, and at the same time serves to emphasize the gravity of the event and the calm dignity of Christ. Van Dyck's ability to render each participant as a fully realized individual anticipates the sensitivity to different personalities that was to make him the foremost portrait painter of his day.

PROVENANCE: Dr. Paul Mersch, Paris; Keller and Reiner, Berlin; Rudolf Kohtz, Berlin; Paal Kaasen, Oslo; P and D. Colnaghi Ltd., London.
EXHIBITION: *Van Dyck as Religious Artist*, Princeton, 1979, no. 18.
LITERATURE: W. von Bode, *Die Meister der Holländischer and Vlämischer Malerschulen*, Leipzig, 1917, p. 370. H. Rosenbaum, *Der junge Van Dyck*, Munich, 1928, p. 56. G. Glück, *Van Dyck*, Klassiker der Kunst, Stuttgart, 1931, p. 524, pl. 55. D. Carter, "Christ's Triumphal Entry into Jerusalem," *Bulletin*, XLV, 2, June 1958, pp. 15-24; L. van Puyvelde, *Van Dyck*, Brussels, 1959, pl. 9. H. Vey, *Die Zeichnungen Anton van Dycks*, Brussels, 1962, I, p. 110. Miller, pp. 70-72.

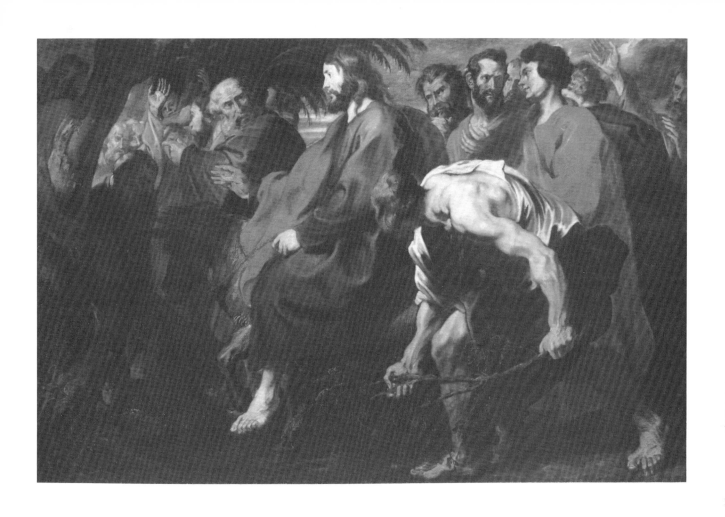

DAVID TENIERS THE YOUNGER
Flemish, 1610-1690

The Archers. ca. 1648

oil on canvas, 22⅛ x 33⅛ (56.2 x 84.1)
signed l.r. on split log: D. Teniers Fec.
Gift of Mr. and Mrs. A. W. S. Herrington
64.248

Teniers was born in 1610 in Antwerp, where he became a master in the guild in 1633 after receiving his training under his father, David Teniers the Elder. In 1637 he married Jan Brueghel the Elder's daughter Anna. Teniers became dean of the guild in 1644, and was named court painter to Archduke Leopold three years later. He moved to Brussels in 1651 to become curator of the Archduke's picture gallery. He accompanied Leopold to Vienna, where he became court painter to Don John of Austria in 1656 and was rewed to Isabella de Fren. There are dated works by him until 1680. He died in Antwerp in 1690.

The Archers was bought directly from Teniers by Archduke Leopold in 1651, when the artist was appointed curator of the Archduke's collection in Brussels. On the basis of such dated works as *Soldiers Plundering a Village* (1648, Kunsthistorisches Museum, Vienna), *The Archers* can be placed in the immediately preceding years, when Teniers was still living in his native Antwerp. The painting has little to do with the artist's subsequent style possessing a greater refinement intended to prove he was worthy of his aristocratic appointment (he even applied to the court for a title of nobility).

The Archers continues the kind of rural scene begun in the latter half of the 1560s by Pieter Brueghel the Elder (for example, *The Peasant Dance*, 1567-1568, Kunsthistorisches Museum, Vienna) and further popularized by his son Jan Brueghel the Elder (*Village Street*, 1610, Alte Pinakothek, Munich). Indeed, the setting of *The Archers* incorporates many of the same devices used by Jan Brueghel the Elder in the Clowes *Canal Scene*. Perhaps because he was a genre painter, Teniers largely escaped the impact of Peter Paul Rubens, whose towering genius had overwhelmed many Flemish artists, and was affected instead by currents imported from neighboring Holland. Teniers' early work was influenced by the raucous low-life scenes of Adriaen Brouwer in the manner of Frans Hals, while his mature paintings are closer in subject and treatment to later Dutch artists. The structure and subdued palette of *The Archers* indicate that Teniers knew the monochrome landscapes painted in the 1640s by Jan van Goyen and Salomon van Ruysdael, which had likewise evolved ultimately out of the Mannerist tradition. This cross-fertilization, which proved vital to the golden age of painting in Flanders and the Netherlands, resulted from the relative ease with which artists crossed the border between the two countries after the truce of 1609.

PROVENANCE: Archduke Leopold William, Brussels; Belvedere Palace, Vienna; Kunsthistorisches Museum, Vienna; A. W. S. Herrington, Indianapolis.
LITERATURE: C. von Mechel, *Catalogue des Tableaux de la Galerie Impériale et Royale de Vienna*, Basel, 1784, p. 125, no. 17. J. Smith, *A Catalogue Raisonné of the Works of the Most Eminent Dutch, Flemish and French Painters of the Seventeenth Century*, London, 1831, III, p. 261, no. 9. G. Waagen, *The Most Distinguished Monuments of Art in Vienna*, 1886, p. 146, no. 35. E. Engerth, *Kunsthistorisches Sammlungen des Allerhöchsten Kaiserhauses . . .*, Vienna, 1884, II, p. 483, no. 1298. A. von Wurzbach, *Niederländisches Künstlerlexikon*, Vienna and Leipzig, 1910, II, p. 697. Miller, pp. 84-85.

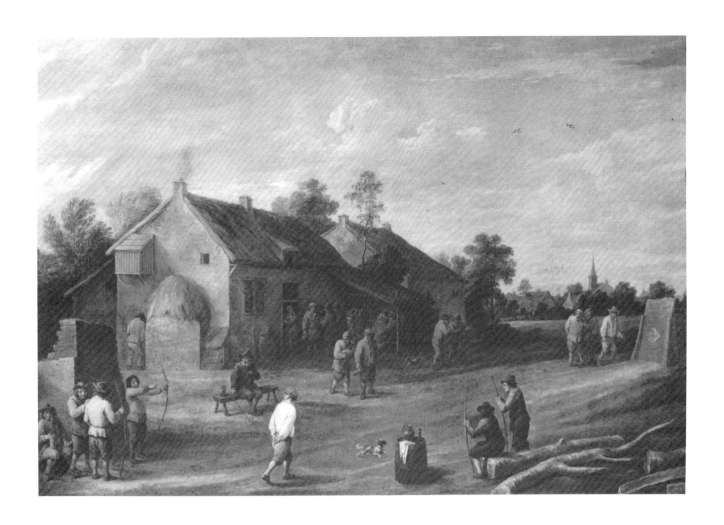

REMBRANDT HARMENSZ VAN RIJN
Dutch, 1606-1669

Self-Portrait. ca. 1629

oil on panel, 17 x 13 (43.2 x 53)
signed l.r. with Leiden monogram: (RHL)
The Clowes Fund Collection

Rembrandt was born in Leiden, where he attended Latin School and studied under Isaacsz van Swanenburgh between 1621 and 1623. Later he studied for several months with Pieter Lastman in Amsterdam. He shared a studio in Leiden with Jan Lievens between 1626 and 1631. Rembrandt settled permanently in Amsterdam in 1632. He wed Saskia van Uylenburg in 1634; she died eight years later. A financial crisis in 1656 required Rembrandt to liquidate all of his possessions, including his considerable art collection and his house. He suffered further tragedies with the death of his mistress, Henrickje Stoffels, in 1663 and of his son, Titus, in 1668. Rembrandt died in Amsterdam in 1669.

Since Horst Gerson published his revised edition of Bredius' catalogue of Rembrandt paintings in 1968, pictures that were considered authentic a generation ago are now being questioned as part of a much-needed re-evaluation of the artist's *oeuvre*. In many cases the doubts are warranted. For example, the IMA's *Portrait of a Woman (Saskia?)* is no longer accepted as a Rembrandt by the museum and has been reassigned tentatively to his student Govaert Flinck. At the same time, works which at first do not appear promising often prove to be bona fide Rembrandts. A case in point is the *Self-Portrait* in the Clowes Collection.

During his Leiden years, Rembrandt often used his own face to investigate a wide range of expressions. Besides a variety of etchings and drawings, there are some eight painted self-portraits of unassailable authenticity. In addition, nine other pictures have been widely disputed or rejected in recent years. Among the casualties is the Clowes painting, which has been supported as a Rembrandt only by A. Ian Fraser and Kurt Bauch during the past fifteen years. Horst Gerson, for example, wrote, "The original is unknown to me, but existing copies suggest a prototype by Lievens rather than Rembrandt." In a letter to the author, Dr. J. Bruyn states that the Rembrandt Study Group considers a panel in a Swedish private collection to be the original of the Clowes painting, a matter which will be

examined later in this essay. (An inferior copy in New York need not be considered here.)

In his famous comparison of the two artists, who shared a studio together in Leiden, Constantijn Huygens stated that Rembrandt was superior in judgement and in the representation of lively emotional expressions, while Lievens had a grandeur of invention and boldness which Rembrandt did not achieve. Their early works are often remarkably similar, suggesting that they influenced each other considerably. There are, however, consistent, if subtle, differences in their styles, which are revealed by comparing Lievens' *Portrait of a Young Man* (National Gallery of Scotland, Edinburgh) to Rembrandt's *Self-Portrait* of 1631 in the Petit Palais, Paris, or Lievens' *Portrait of "Rembrandt"* (Daan Cevat Collection, Guernsey) to Rembrandt's *Self-Portrait* of ca. 1629 in the Mauritshuis, The Hague. While the lighting, vigorous brushwork and "lively emotional expression" are characteristic hallmarks of Rembrandt's style which argue strongly in favor of the Clowes *Self-Portrait*, the possibility that the painting may be by Lievens must nevertheless be taken into serious consideration, as must the suggestion that it could be an eighteenth-century copy, although there is no evidence to support such a conjecture.

The Clowes painting, which is in nearly mint condition, has the drama of the authentic Rembrandt self-

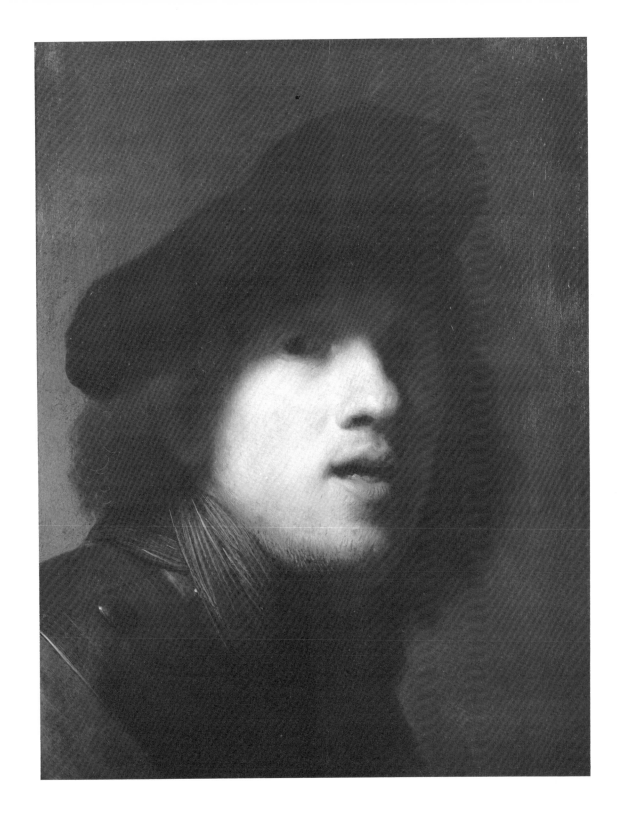

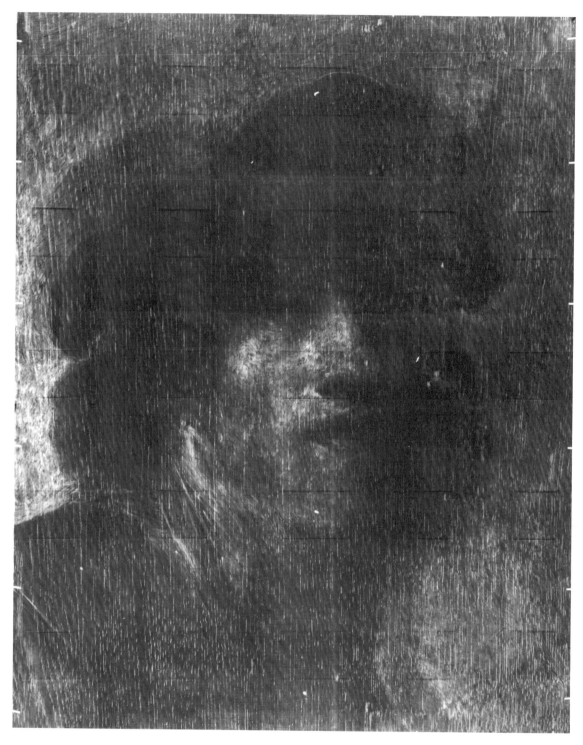

Radiograph of *Self-Portrait* by Rembrandt.

portraits of 1629 in the Alte Pinakothek, Munich, and in the Rijksmuseum, Amsterdam, which exists in a duplicate version (Gemäldegalerie, Cassel) attributed to Lievens by Bauch but upheld as a Rembrandt by Slive and Rosenberg. At the same time, it bears a marked similarity to the slightly later pictures in the Walker Art Gallery, Liverpool, and the Isabella Stewart Gardner Museum, Boston, which have some of the refinement of the Mauritshuis self-portrait. The fact that the Clowes panel shares characteristics with all those paintings rather than fitting neatly into a single category challenges our understanding of Rembrandt's early development. Is the painting a mere pastiche or copy; or is it a link among these other self-portraits?

The author was able to thoroughly examine the self-portrait in the Gardner Museum through the courtesy of Deborah Gribbon, curator of the collection. Because of the different conceptions, the two panels initially create very different impressions. For example, the Clowes painting is distinguished by its smoother surface and stronger chiaroscuro in the face. Upon closer scrutiny, however, the Gardner and Clowes self-portraits are much alike. Not only are the heads almost exactly the same size, but the treatment of the facial features is virtually identical in every detail—notwithstanding the abrasion along the nose and around the right eye in the Boston painting. Both are equally vigorous in their execution. The differences in texture are only superficial and are probably due to differences in the amount of varnish mixed in the paints. And although it is placed differently, the scoring of the surface with the butt end of the brush in the hair, beard and lower lip of the Clowes self-portrait is clearly by the same hand that inscribed the area above the hat in the Gardner picture and the same markings in the hair of the Amsterdam and Munich paintings referred to above. The scarfs are also very similar in execution, despite the different materials, while the collarplate is indistinguishable in treatment from the one found in in the Mauritshuis panel. The corre-

Jan Lievens. *Copy of Rembrandt's Self-Portrait.* oil on panel. Private Collection, Sweden.

Radiograph of *Copy of Rembrandt's Self-Portrait* by Jan Lievens.

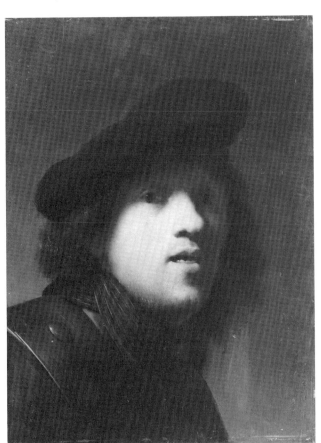

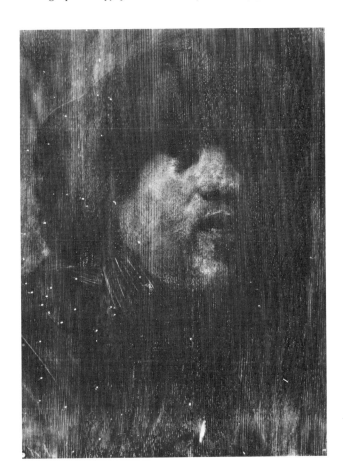

spondence extends to the radiographs of the Clowes and Gardner self-portraits, which were compared side by side. Although the Gardner negative is difficult to read at first, careful inspection reveals that the brushwork in both faces is exactly the same. The placement of each stroke is entirely characteristic of Rembrandt in a way that no other artist, not even the most skilled copyist, could duplicate.

The comparison is nearly as close with the Walker self-portrait, which is of unassailable authenticity, having been purchased in 1629 by Lord Ancram directly from Rembrandt. The radiographs again emphasize the similarities in brushwork and features between the Clowes and Walker paintings, and reveal that the artist experimented with different treatments of the hats in both pictures. Interestingly enough, the radiograph of Lievens' *Portrait of "Rembrandt"* in the Cevat Collection is markedly different from either.

The inescapable conclusion is that the Clowes painting is neither a copy nor a work by Lievens, but an authentic self-portrait by Rembrandt himself. It is certainly not by his closest Leiden students Gerard Dou or Isaak de Jouderville, whose *Portrait of a Young Man* (1630s, National Gallery of Ireland, Dublin) successfully imitates Rembrandt's *Self-Portrait* in the Walker Art Gallery.

What about the version in the Swedish private collection? The two pictures are so similar as to pose a genuine dilemma comparable with the quandary over the Rijksmuseum and Cassel self-portraits. To this writer, however, there are good reasons for attributing the Swedish painting to Lievens. Despite its resemblance to Rembrandt's self-portrait in the Mauritshuis, the treatment accords in every respect with Lievens' *Portrait of "Rembrandt"* (Daan Cevat Collection, Guernsey), *Portrait of a Young Man* (National Gallery of Scotland, Edinburgh) and *Eli Instructing Samuel* (J. Paul Getty Museum, Malibu). The hair has the same silkiness and detail, the eyes the identical precision and liquidity, the shoulder plate a comparably meticulous finish and the hat a like flatness. Even such details as the eyebrows, lips, scoring and background show Lievens' soft touch, which was characteristically smoother and less vigorous compared to Rembrandt's. Finally, the radiograph of the Swedish painting is clearly different in appearance from those of the Gardner and Walker Rembrandt self-portraits, and has none of the bold sureness shared by them and the Clowes picture. On the contrary, there is much stronger affinity with the radiograph of Lievens' *Portrait of "Rembrandt"* in the Cevat Collection.

To this writer, then, the Clowes painting is an original self-portrait by Rembrandt, the other one a brilliant copy by Lievens. That this should be the case is not so surprising as it may seem at first. The recent exhibition devoted to Lievens indicates that he was initially the more accomplished painter but that the two artists soon became equals who learned a great deal from each other, until by 1629 Lievens began to come under the sway of Rembrandt's more dominant personality. (In at least one case noted by Slive, they even collaborated on a painting.) Lievens' copy of the Clowes self-portrait further demonstrates Rembrandt's growing impact on Lievens. Indeed, the Swedish panel helps us to better understand the appearance of strongly Rembrandtesque qualities in Lievens' *Portrait of "Rembrandt"* mentioned above, which must have been painted only a short time later. It is evident that Lievens adapted elements of Rembrandt's composition, technique and expressiveness which he had absorbed in the process of copying the Clowes Picture.

PROVENANCE: Pieter Locquet, Amsterdam; Prince Georges Lubomirski, Lemburg, Poland.

EXHIBITIONS: *Exhibition of Paintings by Rembrandt on the Occasion of the Inauguration of Queen Wilhelmina*, Stedelijk Museum, Amsterdam, 1898, no. 9. *Fêtes de Rembrandt*, Leiden, 1906, no. 53c. *Dutch Paintings, The Golden Age*, Metropolitan Museum, New York, 1954, p. 60. *Rembrandt and His Pupils*, North Carolina Museum of Art, Raleigh, 1956, no. 3. *The Young Rembrandt and His Times*, John Herron Art Museum, Indianapolis, 1958, no. 2. Clowes 1959, no. 47. Clowes 1963, no. 37.

LITERATURE: C. Hofstede de Groot, *L'Exposition Rembrandt à Amsterdam*, Amsterdam, 1899, no. 9. A. Bredius, "Kritische Bemerkungen zur Amsterdamer Rembrandt-Ausstellung," *Zeitschrift für Bildende Kunst*, NF 10, 1898-1899, p. 167. M. Nicolle, "L'Exposition Rembrandt à Amsterdam," *Revue de l'Art*, 2, 1898, p. 424 f. M. Bell, *Rembrandt van Rijn*, London, 1901, p. 118. E. Moes, *Iconographia Batava*, Amsterdam, 1905, II, no. 6693.11. W. von Bode and C. Hofstede de Groot, *The Complete Works of Rembrandt*, Paris, VIII, 1906, p. 54, no. 546. F. Schmidt-Degener, "Le Troisième Centenaire de Rembrandt en Hollande," *Gazette des Beaux-Arts*, 36, 1906, p. 276. J. Veth, "Rembrandtiana, V, L'Exposition en honneur de Rembrandt à la Halle du drap de Leyde," *L'Art Flamand*, 6, 1906, p. 88, and *Onze Kunst*, 5, 1906, p. 84. W. R. Valentiner, *Rembrandt, des Meisters Gemälde*, 3rd ed., Stuttgart, 1909, pp. 29, 550, 567. A. von Würzbach, *Niederländisches Kunstler-Lexicon*, Vienna and Leipzig, 1910, II, p. 401. C. Hofstede de Groot, *A Catalogue Raisonné of the Works of the Most Eminent Dutch Painters of the Seventeenth Century*, London, 1916, VI, p. 272, no. 549. D. S. Meldrum, *Rembrandt's Paintings with an Essay on his Life Work*, London, 1923, p. 29, no. 19. K. Bauch, *Die Kunst des Jungen Rembrandt*, Heidelberg, 1933, p. 209, pl. 207. A. Bredius, *The Paintings of Rembrandt*, Vienna, 1936, no. 3. P. L. Grigaut, "Rembrandt and his Pupils in North Carolina," *Art Quarterly*, 19, 1956, p. 106. K. Bauch, *Rembrandt Gemälde*, Berlin, 1966, no. 289. H. Gerson, rev. ed. of A. Bredius, *The Paintings of Rembrandt*, London, 1968, no. 3. Fraser, p. 82.

ABRAHAM BLOEMAERT
Dutch, 1564-1651

Coronation Scene. 1629

oil on panel, 35⅜ x 49¾ (89.9 x 126.4)
signed and dated on cover of book l.r.:
 A. Bloemaert fe 1629
James E. Roberts Fund
58.2

Bloemaert was born in Gorinchem in 1564. He studied under his father, Cornelis, and under Joos de Beer in Utrecht, as well as with Jean Basset and Hieronymous Francken in Paris, where he resided in 1580-1583. Except for the years 1591-1592, when he worked in Amsterdam, Bloemaert spent the rest of his career in Utrecht and became the teacher of all its leading painters. He died there in 1651.

Bloemaert began his career working in the Mannerist style of Cornelis van Haarlem and Joachim Witewael, but gradually adopted the greater naturalism which in part marks the rise of Baroque painting, although he can no longer be regarded as a pioneer of that vein. During the 1620s he came under the influence of his former student Gerrit van Honthorst and other Utrecht Caravaggisti, including his own son, Hendrick Bloemaert. Toward the end of that decade he also absorbed elements from the Romanists (a term preferable to Pre-Rembrandtists) Pieter Lastman and Jan Pynas, who returned from Italy in 1607-1608 and established the main line of Dutch history painting culminating in Rembrandt, Lastman's prize pupil. The heroic style of the Romanists often set the narrative in a landscape, a convention originated by the Northerners Adam Elsehimer and Paulus Brill working in Rome, where it was adopted for a while by such diverse artists as Carlo Saraceni and David Teniers the Elder. Over the years Bloemaert's paintings show an increasing similarity to works by those artists. The change is especially evident in Bloemaert's *Preaching of St. John the Baptist* (ca. 1630, Musée des Beaux-Arts, Nancy), which more closely resembles Pynas' treatment of the subject (Pitti Palace, Florence) than his own picture of ca. 1600 in the Rijksmuseum, Amsterdam.

The IMA painting is a fine example of Bloemaert's late style. Unfortunately, the left third of our panel containing onlooking soldiers was cut off some 40 years ago (it is now in the collection of Mrs. C. Ten Horn, Kasteel Loon, Opzand, Holland). While not critical to the narrative, the missing portion is essential to the composition, which was originally similar to the Nancy *Preaching of St. John the Baptist* in its spaciousness and balance. The lost figures were of further interest in resembling similar ones by Jacques Callot while retaining elements of Bloemaert's Mannerism. (The standing figure seen from the back is found as number 58 in Bloemaert's influential seven-part drawing manual.) What remains, however, evinces the impact of the Romanists in the composition and figures, the influence of Honthorst in the blond tonality, and contact with the Leiden school of still-life painting in the detailed handling of the booty.

The subject has proved problematic. *The Daughters of Alexander, The Continence of Scipio* and *David and Abigail* have been suggested. Yet the scene is clearly a general receiving the crown of a vanquished king, ruling out these proposals. The composition, architecture and costumes are of little help in identifying the event, since they are ubiquitous in Dutch pictures of ancient and Biblical themes. However, coronations of victorious generals are remarkably rare among the numerous accounts of conquests which fill the Old Testament and the histories of Greece and Rome. The only one told in the Bible accords generally well with Bloemaert's painting. It is David's victory at Rabbah,

as given in II Samuel 12: 30-31 (as well as I Chronicles 20: 2-3):

> And he took their king's crown from his head, the weight whereof was a talent of gold with the precious stones; and it was set on David's head. And be brought forth the spoil of the city in great abundance. And he brought forth the people that were therein . . .

Stechow rejected *The Triumph of David* as the subject of our painting, which does not conform entirely to the Biblical accounts, and suggested that the source might lie in an obscure text from ancient history or Italian literature. Maybe so, but Bloemaert might also have turned to the story of David as retold in Dutch writing or drama. The story of David, the slayer of Goliath who conquered his enemies and became ruler of a mighty empire, must have held particular meaning for the Dutch in their struggle for independence against the Spanish, although paintings of David in seventeenth-century Holland were generally restricted to variations of him with the head of Goliath (based on Caravaggio's astonishing picture in the Borghese Gallery, Rome) by Utrecht Caravaggisti who had been Bloemaert's pupils. Be that as it may, the riddle posed by our mysterious painting resists a definitive answer, pending new research.

PROVENANCE: Sir Francis Sharp Powell, Bradford, York; Sotheby's, London; Andersen Galleries, New York; John C. Myers Collection, Ashland, Ohio; P. de Boer, Amsterdam.
EXHIBITIONS: *Loan Exhibition of Paintings Selected from the John C. Myers Collection,* Allen Memorial Art Museum, Oberlin, 1941, no. 7. *The Young Rembrandt and His Times,* John Herron Art Museum, Indianapolis, 1958, no. 75.
LITERATURE: Miller, pp. 46-47.

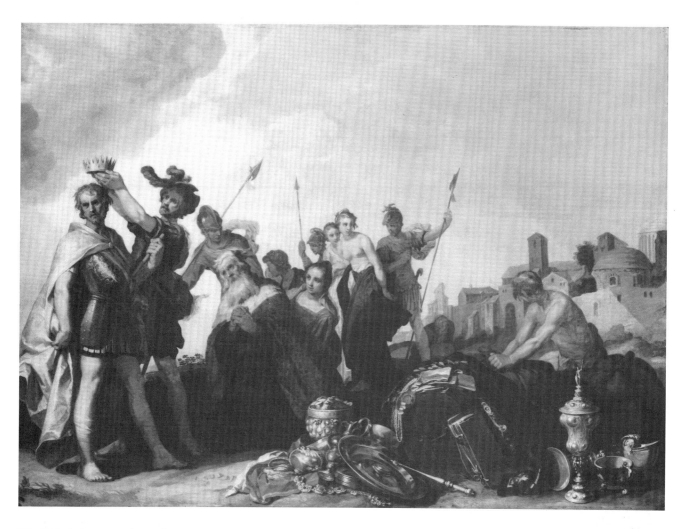

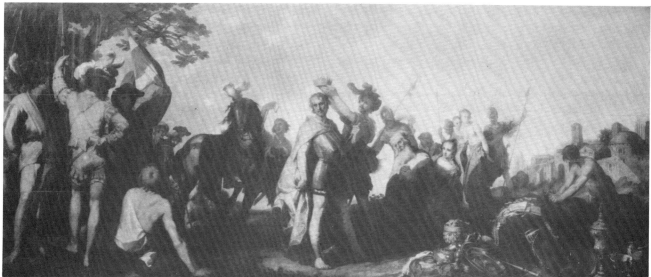

Entire *Coronation Scene* by Bloemaert.

JAN VICTORS
Dutch, ca. 1620-after 1676

Jacob Seeking Forgiveness of Esau. 1652

oil on canvas, 70¼ x 81½ (178.4 x 207)
signed and dated on paper, 1.1.: J. Victors/1652
Martha Delzell Memorial Fund
79.330

Victors was born in Amsterdam around 1620 and probably became Rembrandt's pupil there in the mid- to late 1630s. He was married in 1642 in Amsterdam and is documented in that city until 1676, when he set out for the Dutch East Indies and was never heard from again.

Jacob Seeking Forgiveness of Esau is one of Victors' greatest masterpieces. Short of Rembrandt's own work, there are few more brilliant history paintings in all of Dutch Baroque art. The handling of the forms and color is of the highest quality throughout the canvas. Taken from Genesis 33:1-3, the picture is unique in showing the moment before the reconciliation of the two brothers, rather than their actual embrace, which was preferred by every other artist who treated this subject. Following the Biblical text, Victors puts the two handmaids and their children foremost, but for the sake of dramatic effectiveness, he has condensed the scene by omitting Leah and Rachel and their children. It is likely that some of the main figures in the foreground represent portraits of the artist's family, since they recur in other paintings by him of the same period. The painting otherwise remains faithful to the spirit of the text by depicting the scene quite literally and with convincing naturalism.

Most extraordinary is the novel conception, without precedent in Dutch painting, of excluding Esau from the picture. Instead, it is clear from Jacob's pose and the handmaiden's sharp-eyed glance that the viewer himself is Esau. This ingenious omission is the epitome of Baroque theatricality. The effect is further heightened by the nearness of the figures and the monumental scale of the canvas which, by establishing a direct emotional contact and visual continuity with the viewer, includes him in the scene. The dramatic pitch of the confrontation is increased by the activity of the other "actors" around Jacob as he looks off in remorse and fear. Like Rembrandt, Victors was con-cerned primarily with penetrating the human content of the subject. Rather than merely conjuring up the event in an historical sense, he interpreted it with telling effect by isolating the protagonist and creating a contrasting play of emotions across the canvas. The portrayal has the same liveliness and grandeur found in Rembrandt's work of the later 1630s, when Victors studied with him.

Victors fully understood his teacher's humanism. Like Rembrandt and other members of his school, the artist often turned to the life of Jacob, one of the most human of all stories in the Bible. The potent drama and emotional content provided an irresistible challenge to history painters. Moreover, like David, Jacob must have held a special meaning for the Dutch. In their successful war of independence with Spain, they often compared their struggle with the liberation of the Jews from Egypt, and Amsterdam became a new Jerusalem where Jews lived in an atmosphere of religious tolerance. The sternly religious but wealthy Dutch, especially the Calvinists, readily identified with Jacob, who met with God's special favor and prospered because of his steadfast devotion. In fact, Jacob was one of the most popular names in seventeenth-century Holland. Curiously enough, however, the *Reconciliation of Jacob and Esau* was seldom depicted by Dutch artists. Perhaps nationalist sentiment negated the appeal of the theme, which might have been seen as a parallel to Holland and Flanders. Much preferred were *Isaac Blessing Jacob* and *Jacob Blessing Joseph's Sons*, subjects which Victors himself also painted.

Jacob Seeking Forgiveness of Esau is one of a series of

100

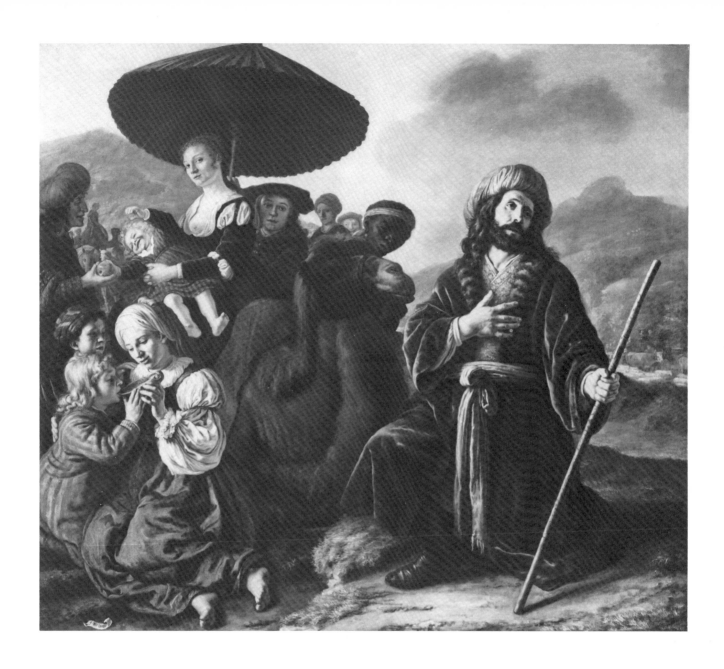

"caravan" subjects by Victors—including *Moses Taking Leave of Jethro* (Museum of Fine Arts, Budapest) and *Isaac and Rebecca* (Private Collection, Budapest)—which incorporate elements found in his genre scenes of the same time. Our painting is firmly rooted in the conventions of Dutch Baroque history painting; indeed, it is derived from the work of Rembrandt's teacher Pieter Lastman, specifically *Abraham on the Road to Canaan* (1614, Hermitage, Leningrad), as well as *The Sacrifice of Manoah* (1627, Daan Cevat, Guernsey) and *Tobias and His Son Kneeling before the Angel* (State Museum of Art, Copenhagen), especially in the pose and expression of Jacob. Victors also assimilated ideas from Jan and Jacob Pynas, who had likewise affected the early Rembrandt. The influence of Rembrandt's exemplars on one of his students is perhaps surprising, but Dutch history painting had far greater continuity than is sometimes supposed, so that despite his importance as the supreme master of the vein, Rembrandt was hardly an isolated phenomenon.

Victors' work of the 1640s, in fact, shows a combination of influences from the Romanists and the Rembrandt school. The example of Ferdinand Bol, who had been Rembrandt's pupil ca. 1633-1635, is seen in *The Dying David Admonishes Solomon* (1642, State Mu-

seum of Art, Copenhagen), that of Jan Pynas in *The Dismissal of Hagar* (Museum of Fine Arts, Budapest; compare Pynas' version in the Daan Cevat Collection, Guernsey). By the middle years of the decade Victors had developed a mature style which is characterized by large, highly finished figures acting out their roles in the foregrounds of crowded narrative scenes with exaggerated but wooden poses and gestures that are dramatically unconvincing. (Compare *Ruth and Boaz* and *Laban Burying the False Gods,* both in the State Museum of Art, Copenhagen.) In the late 1640s the impact of two other former Rembrandt pupils is felt: Gerbrand van den Eeckhout, who had studied with Rembrandt around the same time as Bol, and Govaert Flinck, who may have been Victor's fellow apprentice in Rembrandt's studio. Eeckhout's influence is found in *Isaac Blessing Jacob* (Louvre, Paris; compare Eeckhout's painting of 1642 in the Metropolitan Museum of Art, New York), Flinck's in *The Angel Leaving Tobit and His Family* (1649, J. Paul Getty Museum, Malibu; compare Flinck's *Return of the Prodigal Son,* North Carolina Museum of Art, Raleigh) and *Jacob Blessing Joseph's Sons* (Museum of Fine Arts, Budapest; compare Flinck's version of 1638 in the Rijksmuseum, Amsterdam). That Victors looked at the work of later Rem-

brandt pupils as well is indicated by the motif of the child playing happily with an apple in his mother's arms in both *Moses Taking Leave of Jethro* and *Jacob Seeking Forgiveness of Esau*. This image is closely related to *The Happy Child* (Toledo Museum of Art) attributed to Nicolaes Maes.

Inspired by Rembrandt's etching of 1637, Victors painted a second *Dismissal of Hagar* in 1650 (Israel Museum, Jerusalem), which shows a new mastery. Compared to his earlier version in Budapest, it is at once technically more refined and dramatically more effective. Each figure reacts to the central event in emotionally credible terms, and it is evident that Victors suddenly developed a more profound insight into human character. *Jacob Seeking Forgiveness of Esau* was painted at the height of his powers. Like *Isaac Blessing Jacob* and *The Dismissal of Hagar,* it carries a conviction otherwise found only in paintings by Rembrandt and a handful of his best pupils. Within a few years, however, Victors apparently decided to give up history painting in favor of the outdoor genre scenes he had begun to execute in 1650 (*A Cow on a Ferry Boat*, State Museum of Art, Copenhagen). Although he lived for another twenty years, history paintings by him are rare after ca. 1655. *Jacob Seeking Forgiveness of Esau* thus represents the culmination of Victors' career.

PROVENANCE: The Danby Family; George Affleck; Samuel Cunliffe-Lister; Richard L. Feigen and Co., New York; P. and D. Colnaghi and Co., London.
LITERATURE: E. Zafran, "Jan Victors and the Bible," *The Israel Museum News,*12, 1977, p. 116, fig. 31 (as *The Family of Abraham* or *The Migration of Jacob*).

JAN BOTH
Dutch, ca. 1615-1652

Scene in the Roman Campagna. ca. 1647-1648

oil on canvas, 27⅛ x 33⅝ (68.9 x 85.4)
signed l.r.: Both
James E. Roberts Fund
55.225

Both was born around 1615 in Utrecht and received his training there under his father, as well as Abraham Bloemaert in all probability. He visited France on his way to Italy, perhaps as early as 1635, and is recorded in Rome from 1638 till 1641. He then returned to his native town, where he died in 1652.

In spite of its Italian subject, this scene was painted after Both's return to Holland and can be dated around 1647-1648. There is an earlier version in the Toledo Museum of Art; both paintings are related in type to a drawing with a similar composition in reverse (British Museum, London). Like most Dutch Italianates, Both produced scenes of the Campagna almost exclusively following his return to the North. Such vistas were highly popular with the Dutch, who were enthused by faraway places after 1640. In this painting, however, the setting has been adapted to Dutch taste by making the fantasy look more Northern. As the golden, late afternoon light suggests, Both may have been influenced by Claude Lorrain, for the affinities between their work cannot be explained entirely on the basis of their mutual sources in earlier landscapes by Northerners living in Rome. Both's style was nevertheless highly individual. Moreover, his real development came after he returned to Holland. He must have learned from the forest scenes of Her-man Saftleven and Simon de Vlieger (compare *Entrance to a Forest,* Museum Boymans-van Beuningen, Rotterdam). Together with those two artists, Both influenced the work of Jacob van Ruisdael. Our canvas represents the fresh infusion in Dutch landscape painting which helped reinforce new tendencies that arose after 1640. Both's pictures were extremely influential, above all on the mature landscapes of Aelbert Cuyp.

PROVENANCE: Sir John Neeld, Grittleton House, and descendants; Charles O'Neil, London; Christie's, London.
EXHIBITIONS: *The Young Rembrandt and His Times,* John Herron Art Museum, Indianapolis, 1958, no. 79. *Italy Through Dutch Eyes,* University of Michigan Museum of Art, Ann Arbor, 1964, no. 16. *Nederlandse 17e Eeuwse Italianiserende Landschapschilders,* Centraal Museum, Utrecht, 1965, no. 54, pl. 55.
LITERATURE: G. Waagen, *Art Treasures in Great Britain,* London, 1854, II, p. 248. C. Hofstede de Groot, *A Catalogue Raisonné of the Most Eminent Dutch Painters of the Seventeenth Century,* London, 1912, IX, no. 155. D. Carter, "An Italianate Landscape by Jan Both," *Bulletin,* XLII, 1, Apr. 1956, pp. 3-5. Miller, pp. 89-90.

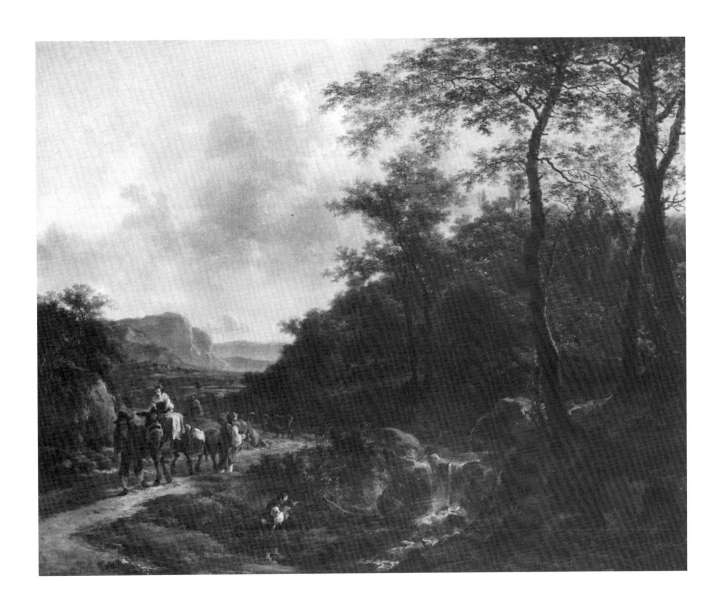

AELBERT CUYP
Dutch, 1620-1691

The Valkhof at Nijmegen. ca. 1665
oil on panel, 19¼ x 29 (48.9 x 73.7)
signed l.r.: A. Cuyp
Gift in commemoration of the 60th anniversary of
 the Art Association of Indianapolis in memory of
 Daniel W. and Elizabeth C. Marmon
43.107

Aelbert Cuyp was born in 1620 in Dordrecht, where he studied under his father, Jacob, and his uncle, Benjamin. However, the most important influences on his style came from Jan van Goyen and Jan Both. He died in Dordrecht in 1691.

In fine condition, *View of Nijmegen* shows Cuyp at his most radiant. The panel is a smaller version of a canvas in the collection of the Duke of Bedford, which differs only in the staffage figures along the foreground. Since there are so few firm reference points in dating Cuyp's works, the position of our painting in the artist's chronology is problematic. Reis believes that Cuyp lost interest in painting soon after his marriage in 1658 and therefore dates the IMA panel to the mid-1650s. To this writer, on the other hand, the internal evidence of Cuyp's pictures and a comparison with their sources in Dutch Italianate landscapes suggests a slower development lasting roughly another decade before tapering off rapidly. On the basis of its style and composition, *View of Nijmegen* can be placed with equal plausibility in the mid-1660s.

Cuyp began as a follower of Jan van Goyen, but by the late 1640s he began to be influenced by Dutch Italianate painters—notably Jan Both, as well as Jan Asselijn and, later, Adam Pynacker. As a result, he gradually abandoned the tonalism and broken brushwork found in his earlier work, and began to favor the golden sunlight of late afternoon, which allowed him to express more poetic moods through subtle atmospheric effects. The sense of repose in *View of Nijmegen* is enhanced by the balanced structure of the composition and the cubic handling of the architecture, which together with the light mold the pictorial space. This nearly classical manner, so opposed to high Baroque dynamism, is related to the landscape tradition arising from Giorgione and Bellini and culminating in Poussin and Claude Lorrain. The style of Cuyp's painting, then, marks a late stage in the development of Dutch landscape painting, just before the invigorating effect of Italianate influences was replaced by the imitation of newer tendencies imported from abroad, signalling the demise of the golden age of art in Holland.

PROVENANCE: King George V of Hannover; Ernest August, Duke of Cumberland, Gmuden; Ernest August, Duke of Brunswick; Gotha Museum; Cassirer Gallery, Amsterdam; Heinemann, New York; Arnold Seligmann, Rey and Co., New York.
EXHIBITION: *Seven Centuries of Painting*, Palace of the Legion of Honor, San Francisco, 1940, no. 54.
LITERATURE: C. Hofstede de Groot, *A Catalogue Raisonné of the Most Eminent Dutch Painters of the Seventeenth Century*, London, 1909, II, no. 196. B. Stillson, "The Valkhof at Nijmegen," *Bulletin*, XXXI, 1, Apr. 1944, pp. 6-9. *The Marmon Memorial Collection of Paintings*, John Herron Art Museum, Indianapolis, 1948, pp. 10-13. W. Stechow, "Cuyp's Valkhof at Nijmegen," *Bulletin*, XLVII, 1, Mar. 1960, pp. 4-11. W. Stechow, *Dutch Landscape Painting of the Seventeenth Century*, London, 1966, pp. 61-62, fig. 102. Miller, pp. 92-94. S. Reiss, *Aelbert Cuyp*, Boston, 1975, p. 173, no. 130.

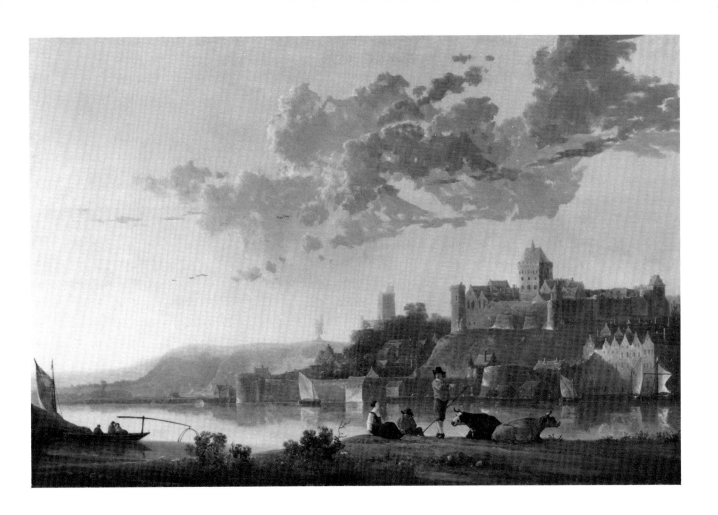

MEINDERT HOBBEMA
Dutch, 1638-1709

The Water Mill (The Trevor Landscape). 1667
oil on canvas, 40 ¼ x 53 (102.2 x 134.6)
signed and dated l.l.: M. Hobbema f. 1667
Gift in commemoration of the 60th anniversary of
 the Art Association of Indianapolis in memory of
 Daniel W. and Elizabeth C. Marmon
43.108

Meindert Hobbema was born in 1638 in Amsterdam. He worked there as an assistant to Jacob van Ruisdael in the late 1650s. In 1668 he was married and was appointed wine-gauger in the Amsterdam customs office, and after that time his production decreased significantly. He continued to work in the customs office until his death in 1709.

Painted in 1667, this justly famous landscape shows Hobbema at the height of his powers, before his output fell off considerably in quantity and, to some extent, in quality a year later. Hobbema's early scenes with watermills of ca. 1662 (examples in the Cincinnati Art Museum and the Toledo Museum of Art) are based on a prototype developed the previous year by his mentor, Jacob van Ruisdael (Rijksmuseum, Amsterdam), who normally preferred to depict lonely forest interiors. By about 1664-1665 Hobbema's compositions became less active and more integrated (compare the landscapes in the Art Institute of Chicago and Frick Collection, New York), and it was at this time that the artist formulated his classic style which culminates in the IMA painting. The viewer is placed at the edge of the grove and is led visually through it in a serpentine fashion which allows the eye to linger over the wealth of detail. At the juncture of the stream and cottages, he may either look to the left across a field or enter a sunlit clearing, where the pair of large trees both enlivens and anchors the view. The harmony of subtle blues, greens, yellows and greys differs decidedly from the glaring color contrasts sometimes found in the artist's earlier work.

Most of Holland is, of course, unforested, and the popularity of wooded scenes such as *The Water Mill* represents the desire for an escape from urban life into nature. During the 1660s Dutch culture was heavily affected by more luxurious tastes imported from abroad, especially from France. Rural landscapes seem to evoke a nostalgia for the simpler way of life that was rapidly disappearing. The highly civilized life style of the wealthy Dutch burghers extended from the town to the country, where they maintained aristocratic homes modelled on French examples, complete with landscaped gardens. This shift in culture was largely responsible for sapping native Dutch art of its vitality and leaving it open to the foreign influences which soon overwhelmed it.

PROVENANCE: Fourth Lord Trevor, Bedfordshire; Viscountess Hampden, London; Christie's, London; Mr. Woodin; John Walter, Bearwood; Thomas Lawrie, London; Sir Edgar Vincent, London; J. Pierpont Morgan, London; M. Knoedler and Co., New York; Caroline Marmon Fesler, Indianapolis.

LITERATURE: J. Smith, *Catalogue Raisonné of the Works of the Most Eminent Dutch, Flemish and French Painters*, London, 1833, VI, pp. 146-147, no. 92; G. Waagen, *Galleries and Cabinets of Art in Great Britain*, London, 1857, IV, p. 296; F. Cardell, *Landscape and Portrait Painters of Holland*, London, 1891, p. 156; T. Ward and W. Roberts, *Pictures in the Collection of J. Pierpont Morgan, Prince's Gate and Dover House*, London, 1907, II, pl. 8; C. Caffin, *The Story of Dutch Painting*, New York, 1909, pp. 184, 191-192. C. Hofstede de Groot, *Catalogue Raisonné of the Most Eminent Dutch Painters of the Seventeenth Century*, London, 1912, IV, p. 383, no. 87. G. Broulhiet, *Meindert Hobbema*, Paris, 1938, pp. 72, 152, no. 101. C. Wheeler, "The Water Mill; 'The Trevor Landscape' by Meindert Hobbema," *Bulletin*, XXXI, 1, Apr. 1944, pp. 3-4. *The Marmon Memorial Collection of Paintings*, John Herron Art Museum, Indianapolis, 1948, pp. 18-21. F. Kimball and L. Venturi, *Great Paintings in America*, New York, 1958, pp. 126-127; Miller, pp. 107-109.

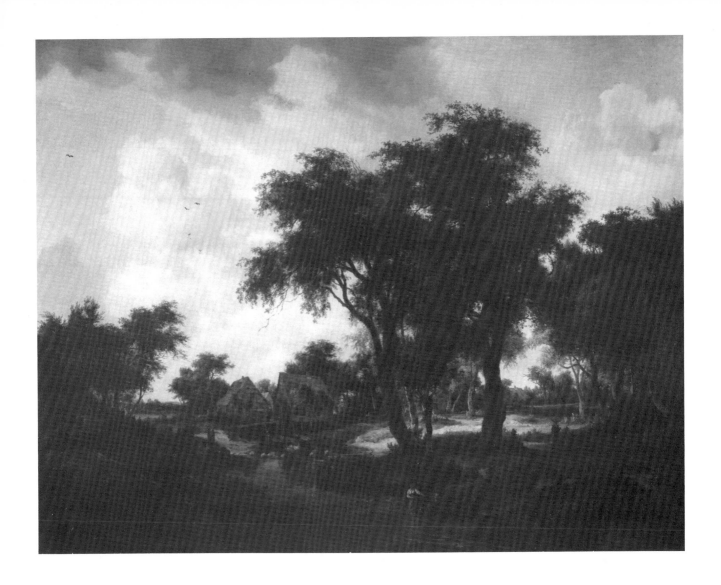

JACOB VAN RUISDAEL
Dutch, 1628 or 1629-1682

Landscape with Cascade. ca. 1670-1675

oil on canvas, 30 x 37 (76.2 x 94)
signed l.r.: J v Ruisdael
Gift in memory of Daniel W. and Elizabeth C.
 Marmon
44.54

Jacob van Ruisdael was born around 1628-1629 in Haarlem. He studied there under his father, Isaac, although he was influenced mainly by his uncle, Salomon van Ruysdael. He was enrolled in the guild in Haarlem in 1648. Ruisdael worked for a time abroad, in the region of Germany bordering Holland, before settling in Amsterdam in 1656. He returned to Haarlem in 1681, where he died the following year.

The background of *Landscape with Cascade* suggests a locale along the Dutch-German border, an area Ruisdael knew well. Otherwise the scene conforms to the Scandanavian views he painted from around 1660 on. Unlike Allaert van Everdingen, whose lead he followed, Ruisdael never visited Scandanavia, and his scenes are entirely imaginary. *Landscape with Cascade* is similar in character to the *Waterfall* in the Toledo Museum of Art, which must be a painting of the late 1670s. Like the Cincinnati Art Museum's *Scene in Westphalia,* however, our canvas can be dated to the first half of the same decade, and is a fine example of his work from that period.

The vogue for such scenes, like the popularity of Dutch-Italianate landscapes, reflects the taste in Holland around mid-century for faraway places. In contrast with Jan Both's sunny *Scene in the Roman Campagna,* Ruisdael's *Landscape with Cascade* is marked by a brooding atmosphere which anticipates the appearance and the mood of nineteenth-century Romanticism without sharing its elevated pantheism. In Ruisdael's painting, nature remains apart from, yet totally comprehensible to man, who enjoys nature for its appearances, not its philosophical implications. In fact, the treatment of *Landscape with Cascade* is quite straightforward. The human scale, supplied by the figure on the bridge, is further emphasized by the lack of the strong vertical accents found in the artist's earlier pictures, such as *Waterfall with Castle* (Fogg Art Museum, Cambridge).

PROVENANCE: Lord Gwydyr, London; Harman, London; Christie's, London; R. R. Reinagle, London; John Dean Thompson; Duke of Mecklenburg; Mr. Pereire, Paris; Léon Gaucherel Gallery, Paris; Prince Demidoff, San Donato; Christie's, London; American Art Galleries, New York; M. C. D. Borden, New York; Dr. A. Canfield, New York; Arnold Seligman, Rey and Co., New York; James W. Fesler, Indianapolis.

LITERATURE: J. Smith, *A Catalogue Raisonné of the Works of the Most Eminent Dutch, Flemish and French Painters,* London, 1829, VI, pp. 71-72, no. 224. C. Hofstede de Groot, *A Catalogue Raisonné of the Most Eminent Dutch Painters of the Seventeenth Century,* London, 1912, IV, p. 87, no. 265. W. Valentiner and A. Jaccaci, *Old Masters in the Collection of M. C. D. Borden,* New York, 1911, I, no. 8. J. Rosenberg, *Jacob van Ruisdael,* Berlin, 1928, p. 85, no. 217. D. M. Mattison, "The Cascade by Jacob van Ruisdael," *Bulletin,* XXXI, 2, Oct. 1944, pp. 25-27. *The Marmon Memorial Collection of Paintings,* John Herron Art Museum, Indianapolis, 1948, pp. 14-17. Miller, pp. 98-99.

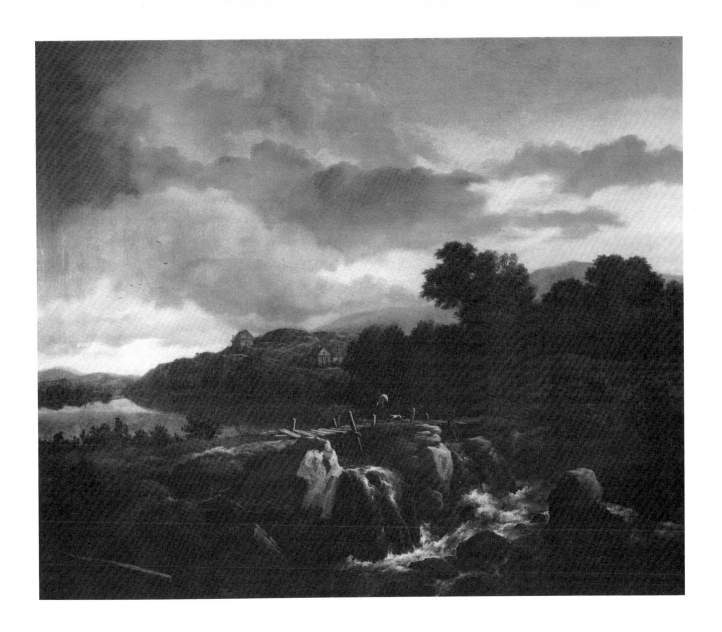

JACOB DUCK
Dutch, ca. 1600-1667

Woman with Theorbo (Vanitas). ca. 1660-1663
oil on panel, 12⅛ x 10⅛ (30.8 x 25.7)
Gift of Mr. and Mrs. Arthur W. S. Herrington
60.189

Jacob Duck was born around 1600 in Utrecht and received his artistic training in that city; records indicate that he was a student in the Guild of St. Luke in 1621 and a master in the guild by 1630. He is known to have been in The Hague during 1656-1660. He died in Utrecht in 1667.

Throughout most of his career, Duck painted tavern scenes with soldiers in the style of Pieter Codde and merry company scenes in the manner of Dirk Hals, both of Haarlem. Perhaps as a result of his stay in The Hague, however, his subject matter and style underwent an almost complete transformation, reflecting recent tendencies initiated by Frans van Mieris of Leiden and Gerard TerBorch of Deventer. Duck's later genre scenes, while hardly innovative, are successfully eclectic, incorporating an almost bewildering array of elements drawn from diverse sources. *Woman with Theorbo* was done probably in the early 1660s, although a date as early as 1658 cannot be ruled out. The faces are indebted to the Utrecht Caravaggesque painter Dirk van Baburen, the tonalism of the background to Codde and the Haarlem school, the still life to Gerard Dou and the Leiden Vanitas school, the treatment of the dress and the colorism of the foreground to TerBorch, and the composition to Van Mieris. Iconographically and visually, then, the picture makes concessions both to an older tradition and to the latest developments which culminated in Jan Vermeer's *The Letter* (ca. 1665, Rijksmuseum, Amsterdam) and *Woman with Scales* (1666, National Gallery, Washington).

Like many Dutch genre paintings, this apparently simple scene is filled with hidden meaning which would have been readily understood by Duck's contemporaries. The artist has made his intention abundantly clear through the old woman pointing emphatically to the hourglass behind the skull on the table laden with jewelry: Everything worldly is transient; hence, all earthly delights are vanity. By implication the painting carries the moral injunction to contemplate more serious things and follow higher pursuits. Indeed, in a painting of the same period in the Centraal Museum, Utrecht, Duck pointedly contrasts virtue with folly in the figures of a woman ironing clothes and a child playing with a paper windmill.

The image of a woman looking into her mirror is a traditional symbol of Vanitas in emblem books, such as Jacob Cats' *Spiegel* where it bears the motto "Know Thyself." In Medieval and Renaissance magic, the mirror revealed not only the truth but also the future and hidden aspects of the past. In a painting of 1594 by Stradanus (Teyler Museum, Haarlem), a similar confrontation takes place in an even more sumptuous setting between a young woman and a hag whose aged features stand for the impermanence of beauty and the inevitability of death. The theorbo, a kind of lute, is yet another symbol of Vanitas occuring in many paintings and representing the brevity of sensuous pleasure. At the same time, the musical instrument and its shape connote sexuality (compare the amorous *Music Party* by Pieter de Hooch in the IMA). The woman in Duck's panel props her foot on a foot warmer, which is associated with love in Roemer Visscher's emblem book *Sinnepoppen* of 1614. Even *amor* is fleeting in this pictorial sermon preaching traditional virtues by demonstrating human folly.

PROVENANCE: Sir Edgar Speyer, London; J. Robert Hewitt, Philadelphia; Parke-Bernet Galleries, New York; Jack Partridge, North Edgecomb, Me.
EXHIBITION: *The Collection of Mr. and Mrs. A. W. S. Herrington of Indianapolis, Indiana*, Krannert Art Museum, University of Illinois, Champaign, 1964, no. 21.
LITERATURE: C. Coley "Three Dutch Allegorical Paintings," *Bulletin*, XLIX, 2, June 1962, pp. 10-13. Miller, pp. 105-107.

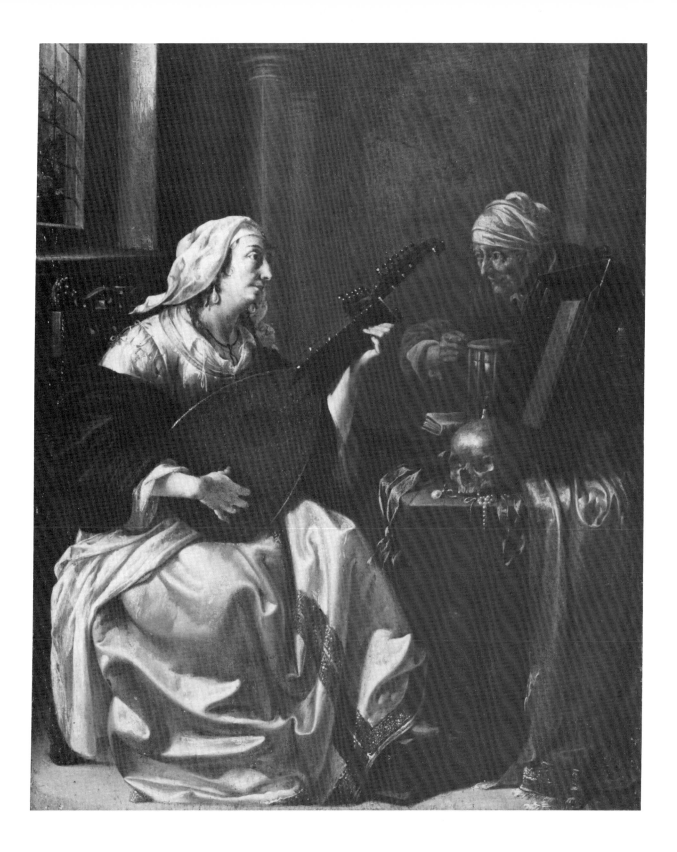

113

WILLEM KALF
Dutch, 1619-1693

Still Life with Blue Jar. 1669

oil on canvas, 30¾ x 26 (78.1 x 66)
signed and dated l.r.: W. Kalf (16)69
Gift of Mrs. James W. Fesler in memory of Daniel
 W. and Elizabeth C. Marmon
45.9

Willem Kalf was born in 1619 in Rotterdam. According to Houbraken, he studied in Haarlem under Hendrik Pot. It is possible that he studied also under François Rijckhals. He went to Paris in 1642, and returned to Rotterdam in late 1646. In 1651 he travelled to Hoorn, where he was married later that year. By 1665 Kalf had moved to Amsterdam, where he became a member of the St. Luke's guild. He was active as a dealer and authenticator, and probably stopped painting by 1688. He died in Amsterdam in 1693.

Dated 1669, *Still Life with Blue Jar* is significant as one of Kalf's last "pronk," or fancy, still lifes and his final masterpiece in this classic manner. Stylistically it reverts to prototypes Kalf had used a decade earlier (compare the similar pictures in the Musée de Picardie, Amiens, and the Dutch Embassy, Lima), when he was painting only sporadically, and shows otherwise little development from his work of 1663. It is not at all surprising that the Indianapolis painting adheres to such an eminently successful approach which began in 1653, when Kalf settled in Amsterdam, and which hardly varied for more than a decade and a half, when he executed one masterpiece after another.

The inventory of objects in our still life is thoroughly characteristic of Kalf's mature works: a Ming vase, oriental rug, silver platter, Venetian and Dutch glassware, an orange and a partially peeled lemon. Such rich displays lend pronk still lifes an inherent Vanitas connotation, which is discreetly alluded to by the open watch signifying temperance. More important, this subject matter provided the artist an opportunity to show his full talent for capturing the subtlest distinctions in colors and textures. Despite its visual complexity, the painting achieves a classical calm. The composition represents a simplification of the pronk still lifes painted in the 1640s by such artists as Willem Claesz Heda. And unlike his predecessors, Kalf was a true colorist. (Compare Pieter Claesz' *Still Life with Flagon* in the IMA.) His predilection for dark, cool colors is offset by sparkling highlights and warm hues. His palette derives partly—and rather belatedly—from his teacher Hendrik Pot (compare the IMA's *Coin Collector*), who had been a pupil of Rembrandt. While the air of mystery is his own, Kalf's concern for

Pieter Claesz. *Still Life with Flagon.* 1640. oil on canvas, 17½ x 23½ (44.5 x 59.7). William Ray Adams Memorial Collection. 47.2.

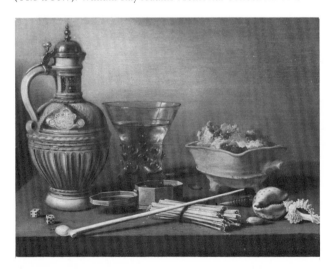

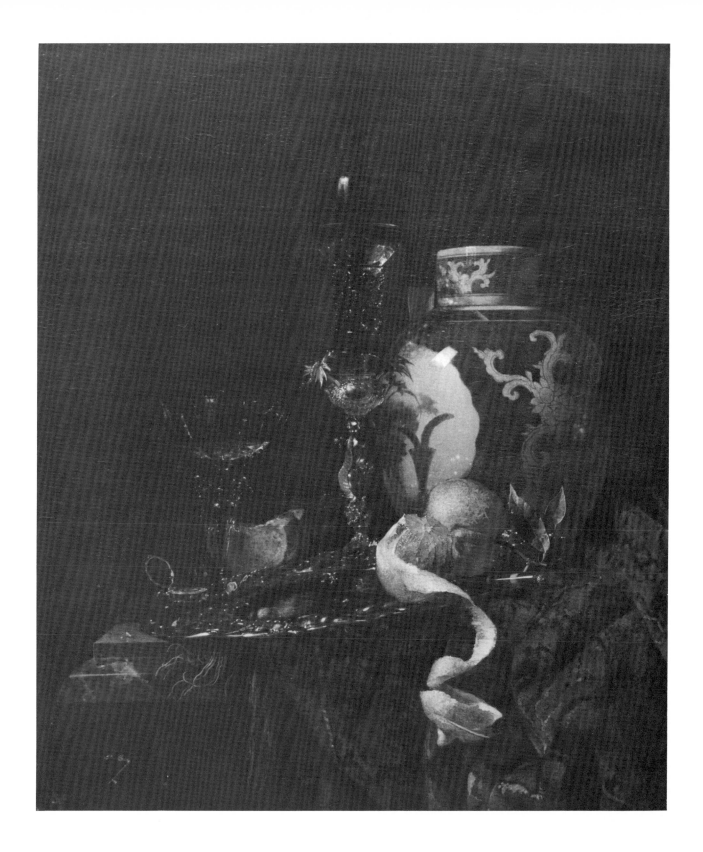

Hendrik Gerritsz Pot. *The Coin Collector.* oil on panel, 18 x 15⅞
(45.7 x 40.4). Gift of Mrs. Albert J. Beveridge. 38.10.

the poetic and visual effects of light has much in common with paintings by his great contemporary in Delft, Jan Vermeer, who was influenced decisively by Carel Fabritius, another former Rembrandt pupil. Although it is tempting to believe that Kalf may have affected Vermeer, the similarities suggest that at the very least the two artists evolved parallel attitudes stemming ultimately from the same source, the work of Rembrandt.

PROVENANCE: E. Reiffenberg, Cologne; A. S. Drey, Munich and New York; Herman Berg, Haarlem; M. Knoedler and Co., New York.
EXHIBITION: *Tentoonstelling van Oude Kunst*, Rijksmuseum, Amsterdam, 1936, no. 85.
LITERATURE: W. D. Peat, "Still Life with Blue Jar by Willem Kalf," *Bulletin*, XXXII, 2, Oct. 1945, pp. 28-29. *The Marmon Memorial Collection of Paintings*, John Herron Art Museum, Indianapolis, 1948, pp. 22-25. A. Spriggs, "Traditional Porcelain Ginger Jars," *Oriental Art*, XI, 2, 1965, p. 3, fig. 10. Miller, pp. 90-92. L. Grisebach, *Willem Kalf*, Berlin, 1974, pp. 128, 144 f., 150, 158 f., 276, cat. 135, pl. 145.

MATTHIAS WITHOOS
Dutch, 1627-1703

Allegory of the Apocalypse. ca. 1670
oil on canvas, 32¾ x 37¾ (83 x 96)
signed l.r.: M. Withoos
Gift in memory of Estelle Burpee Chambers by her
 family and friends
80.18

Matthias Withoos was born in 1627 in Amersfoort and studied there with Jacob van Campen. In 1648 he accompanied Otto Marseus van Schrieck to Italy, where he was nicknamed "Calzetta" (Little Stockings) by the Bentvueghels (Birds of a Feather), the group of Dutch artists living in Rome. Withoos returned to Amersfoort in 1653, then settled in 1672 in Hoorn, where he died in 1703.

This masterpiece by Withoos must have been done around the same time as *Brambles with Hedgehog* of 1669 (Eric Palmer Collection, London), which incorporates many of the same elements. Withoos was the most original follower of Van Schrieck, whom he accompanied to Italy. Aptly nicknamed "De Snuffelaer" (The Ferret) by the Bentvueghels because he collected every unusual variety of flora and fauna, Van Schrieck was fascinated by the little dramas acted out in the hidden world of nature, which he observed in minute detail and invested with nightmarish mystery. The phantasmagoric natural histories of Van Schrieck and Withoos are far removed from the dispassionate scientific naturalism found in the Clowes Collection's *Flowers in a Glass Vase* of the 1620s by Ambrosius Bosschaert the Younger. It is related instead to the dramatic phase of Dutch still-life painting initiated by Jan de Heem which subordinated pictorial elements into decorative designs of typically Baroque sweep, rather than depicting each object with equal clarity.

Whereas Van Schrieck's teeming paintings were born of his strange imagination, Withoos' often evince a philosophical cast of mind which makes explicit what is implied in his mentor's work: that everything is Vanity. In fact, our canvas is an extended allegory of the Apocalypse. The thorns, thistles and shaft of wheat are taken from Genesis 3:17-18, in which the angry God says to Adam and Eve after they have committed the Original Sin, represented here by the lizard:

Cursed is the ground for thy sake; in sorrow shalt thou eat of it all the days of thy life. Thorns also and thistles shall it bring forth to thee; and thou shalt eat the herb of the field.

They are also symbols of the Passion: the Scourging of Christ, the Man of Sorrows and the Eucharist. The globe thistle (*Echinops sphaerocephalus*), seen amid the *Cirsium arvense* and *Onopordon acanthium* thistles, may be a veiled reference to the *orbis terrarum* held by Christ as Saviour of the World (*Salvator Mundi*). The hedge of thorns is a symbol of sloth. So is the mouse nibbling on the wheat, a motif popular in Dutch still lifes which is derived from an old proverb about untended fields. The bramble (*Rubus fruiticosa*) is a lowly bush associated with thorns and thistles as symbols of the Judgement Day, but it was used on occasion as a metaphor of the Virgin's purity. Prickly as a thorn, the hedgehog about to eat the mouse stands for the inevitability of death, signified by the white poppy to the right. The hedgehog also serves as a symbol of the Apocalypse, and in a most unusual way. Depictions of the Immaculate Conception from Revelation 12:1, such as Albrecht Dürer's print of *The Virgin on the Crescent Moon* in which she is "clothed with the sun," often show the Madonna with spikey rays radiating from her like the quills of a porcupine, which is found as a symbol of light in Baroque emblems.

Although they are traditional symbols of Vanitas

because of their brief blooming season (compare J. Falk's *Vanitas Still Life* in the IMA), flowers are attributes of Flora, the personification of springtime, when life is renewed (note the nest of blue robin's eggs). The Madonna or Easter Lily (*lilium candidum*) is an old Christian symbol of purity. In the Incarnation it stood for the Immaculate Conception and Virgin Birth, and later became a symbol of the Resurrection as well. Originally an attribute of Venus, the rose—in this case, the Cabbage or Provence rose (*Rosa centifolia*) —was first used by Saint Bernard as a symbol of Mary, whose beauty was subsequently compared to a flower's in French *chansons*. Like the lily, the red rose became a symbol of the Passion, signifying Christ's blood. Both flowers were intensively cultivated by the Dutch. These "civilized" plants are pointedly contrasted to the unruly growth of wild nature, which is frightening in its savageness. They can be taken as standing for the *hortus conclusus*, the enclosed garden which is a symbol of both the Madonna and Paradise (perhaps represented here by the distant landscape). This imagery comes ultimately from the Song of Songs (also known as the Song of Solomon and the Canticles):

> I am the rose of Sharon, and the lily of the valleys. (2:1)
> As the lily among thorns, so is my love among the daughters. (2:2)
> For, lo, the winter is past, the rain is over and gone. (2:11)
> The flowers appear on the earth; the time of the singing of birds is come. (2:12)
> A garden inclosed is my sister (4:12)

The Song of Songs was considered a parable of God's love for Israel, the Church and the faithful, who may be symbolized by the dog rose (*Rosa canina;* the dog is a standard emblem signifying faithfulness). Within Withoos' bleak setting, the lily and the rose offer the promise of salvation and eternal life on the Judgement Day to Christians, whose sins are redeemed by the Passion. In light of Withoos' iconography, the most appropriate title for the Indianapolis painting is *Allegory of the Apocalypse,* because it subsumes the Immaculate Conception and the Song of Songs, with which it had fused in later sixteenth-century theology.

Allegory of the Apocalypse is firmly rooted in a Catholic

Ambrosius Bosschaert the Younger. *Flowers in a Glass Vase.* ca. 1625. oil on panel, 12½ x 9¼ (31.8 x 23.5). The Clowes Fund Collection.

J. Falk. *Vanitas Still Life.* 1629. oil on panel, 18⅛ x 15 (46 x 38.1). Gift of Alfred Brod, London. 59.27.

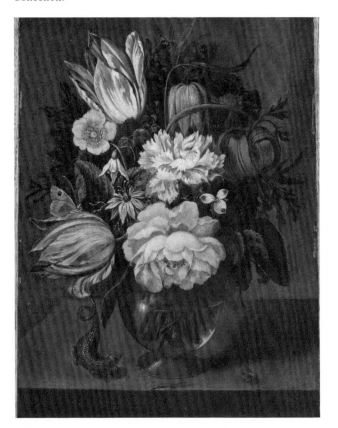

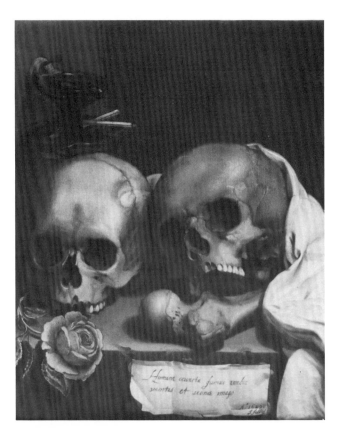

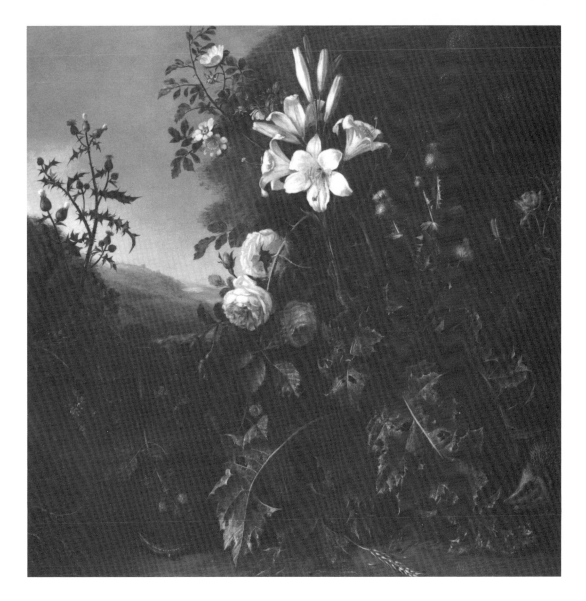

tradition going back to the Middle Ages which, although embellished by the contribution of emblematic literature, had changed but little in its basic symbolism since the Master of Flémalle painted the Merode Altar (Metropolitan Museum of Art, New York) around 1425. The extraordinary conception of our painting, however, cannot be explained solely by the sources of its iconography and imagery. Underlying it are a tragic outlook and romantic imagination which found inspiration in the paintings of Salvator Rosa. As a letter written by Withoos from Rome in 1651 attests, Rosa's *Democritus Deep in Thought* (1650, State Museum of Art, Copenhagen) created a sensation when it was exhibited that year. Several of Withoos' outdoor Vanitas paintings, notably *Mors Omnia Vincit* (Death Conquers All, 166?, Musée Jean-

d'Aoville, La Fère), reveal the impact of Rosa's picture, which in 1662 was issued as an engraving bearing the motto "Democritus omnium derisor/in omnium difigitur" (Democritus, who derides all things, is nevertheless struck with terror at the thought of their passing). While treated in very different visual terms deriving from Van Schrieck, the Indianapolis painting shares the same sense of foreboding but finds hope in faith. The complex symbolism helps us to understand *Allegory of the Apocalypse*, but what makes the picture compelling is not the meaning as such but the intensity of the artist's vision, which welds the multitude of separate ideas into a unified image of powerful expressiveness.

PROVENANCE: Cornelius du Bois Wagstaff; National Society of Colonial Dames, New York; S. Nystad Oude Kunst, The Hague.

EDWARD COLLIER (EDWAERT COLYER)
Dutch, ca. 1640-ca. 1707

Trompe l'Oeil Still Life. ca. 1696

oil on canvas, 19⅛ x 24¼ (48.6 x 61.6)
signed on a letter at far left: For Mr. E. Collier/
 Painter att./London
James E. Roberts Fund
62.163

Edward Collier was born in Breda ca. 1640 and began his career in Haarlem by 1662. In 1673 he moved to Leiden, but returned to Haarlem in 1686. He paid a visit to London from 1696 to 1698. Collier was later active in Leiden and London, where he painted his last-known picture in 1707.

Collier painted this card rack in 1696, at the beginning of his three-year stay in London. The rack holds two politically important papers: a folded copy of William III's speech to Parliament on October 20, 1696, following an assassination plot involving the French and followers of the exiled King James II, and a copy of *The Flying Post* with the dateline "Turin, May 1," alluding to the accommodation made that year by Savoy with Louis XIV during France's struggle with Spain. Our picture is similar in subject and treatment to other card racks by Collier of ca. 1701 (Victoria and Albert Museum, London) and ca. 1703 (Lackenhal Museum, Utrecht). A close variant was sold recently at Sotheby Parke Bernet, New York.

Collier was the last major representative of the Leiden school of Vanitas painting, as well as an important painter of *trompe l'oeil* still lifes in the manner of Cornelis Gysbrechts. In fact, the two types are often linked in Collier's work. His elaborate Vanitas paintings generally include references to tragic historical events, especially the deaths of major figures. Thus, the moral of our picture might well be, "How the mighty have fallen."

Trompe l'oeil, which means "to fool the eye," had been practiced in ancient Roman frescoes and, on a lesser scale, in Italian Renaissance decorations. The image of the card rack, however, was one of the creations of the late Baroque. Such continuing pictorial inventiveness helps to explain why still-life painting escaped the stagnation that other genres suffered in Holland after 1670. *Trompe l'oeil* painting enjoyed immediate popularity, which continued unabated until the end of the nineteenth century on both sides of the Atlantic (compare Jacob Atkinson's *Souvenir of the Columbian Exhibition, 1893* in the IMA).

PROVENANCE: Paul Drey Gallery, New York.
LITERATURE: H. Hilberry, "Painting Illusions by Edwaert Colyer," *Bulletin*, XLIX, 5, Feb. 1963, pp. 12-17. Miller, pp. 97-98.

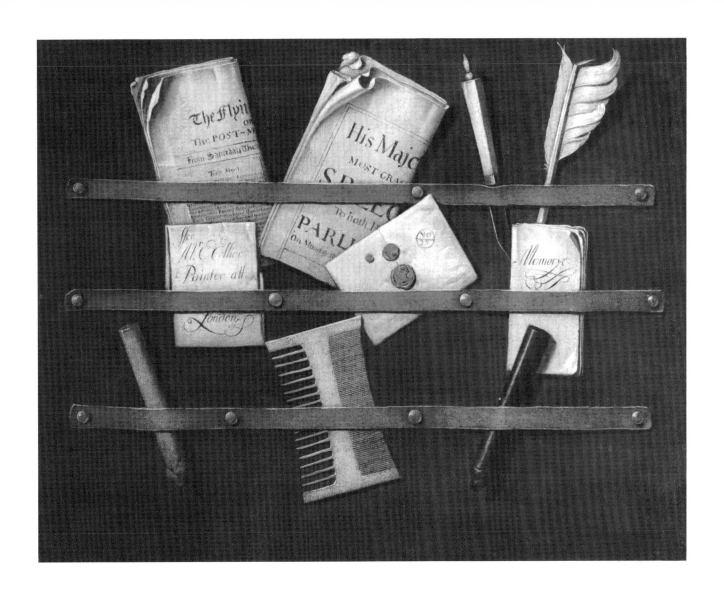

HYACINTHE RIGAUD
French, 1659-1743.

Portrait of a Gentleman. ca. 1705
oil on canvas, 32 x 25¾ inches (81.3 x 65.4)
James E. Roberts Fund
56.56

Hyacinthe Rigaud was born in 1659 at Perpignan. His early artistic training began at Montpellier under Paul Pézet. Later he went to Lyon to study with Antoine Ranc. Although he won the Prix de Rome in 1682, he did not go to Italy. He became a court painter to Louis XIV, and retained the position under Louis XV. Rigaud died in Paris in 1743.

The former attribution of this portrait to Largil-lière is as implausible as the old identification, based purely on tradition, of the sitter as Monsieur Beaujon, presumably the financier Nicolas Beaujon, who was not even born until 1718. The softer handling of the brushwork marks the painting as unquestionably a work of Rigaud's maturity. The style and costume, including the wig, indicate that the portrait could have been painted any time between roughly 1690 and 1725. However, it seems to have the most in common with Rigaud's portraits of the early 1700s, including his famous full-length painting of Louis XIV (1704, Louvre, Paris), and should be dated to those years.

Our portrait exemplifies the age of Louis XIV. Even without the commanding pose and haughty facial expression, it has many of the same qualities found in the Louvre portrait of the Sun King. Here the artist has softened them to provide a more straightforward likeness of the sitter, despite the full regalia of his "official" image. The IMA painting adheres to the stately prototypes of Louis and his court formulated in sculpture by Antoine Coysevox and in painting by Charles LeBrun. Under these two artists the Baroque dynamism of Van Dyck and Bernini (who actually worked for a while at the French court) was tempered by Roman classicism, a style which was chosen partly for its imperial associations. Seventeenth-century painters, especially in France, increasingly relied on the trappings of rank to indicate social status and the power inherited by the nobility and achieved sometimes by the rising bourgeoisie. Changes in the wig act as an index to evolution of the court's self-conception. In the IMA portrait it both hides the character of the sitter and endows him with an illusion of grandeur that imposes its presence on the viewer, as does the massive drapery. Nevertheless, Rigaud could not resist allowing us a glimpse of the personality behind this facade, for the treatment of the face itself is surprisingly sympathetic and individual.

PROVENANCE: Compte de Ganay; Graf Linzerdorf; John McFadden, Jr., New York; Parke-Bernet Galleries, New York.
EXHIBITION: *French Masters: Rococo to Romanticism*, University of California at Los Angeles Gallery, 1961, p. 13.
LITERATURE: Miller, pp. 110-111.

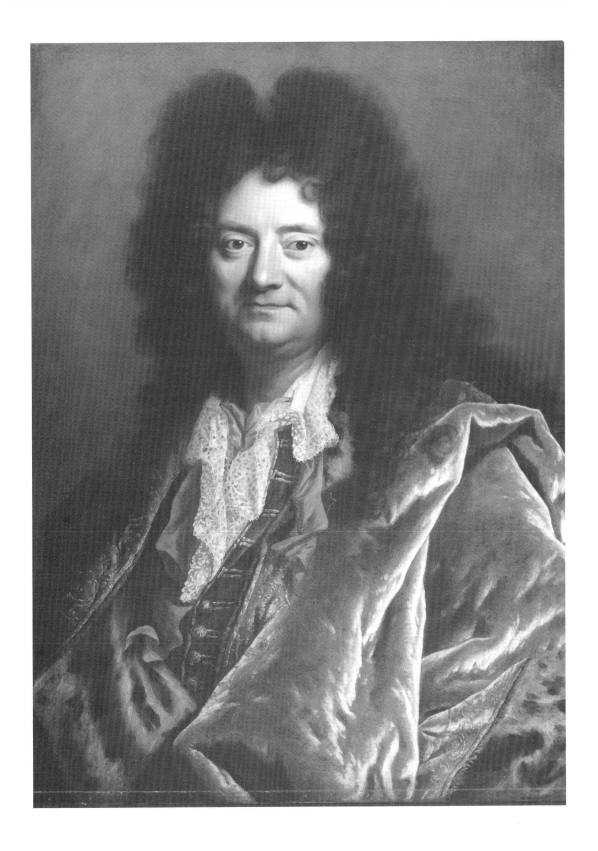

ANTOINE WATTEAU
French, 1684-1721

The Country Dance (La Danse Champêtre).
 ca. 1706-1710

oil on canvas, 19½ x 23⅝ (59.6 x 60.0)
Gift of Mrs. Herman C. Krannert
74.98

Antoine Watteau was born in Valenciennes in 1684; he was apprenticed there to Jacob-Albert Gérin in 1699. In the early 1700s he went to Paris where he studied with Claude Gillot from 1703 to 1707 or 1708 and then with Claude Audran, Curator of the Palais du Luxembourg. He became agréé of the Academy in 1712 and a full member in 1717. Following a brief visit to England in 1720, he died at Nogent-sur-Marne near Paris in 1721.

There can be little doubt that this is the original painting for the engraving by Pierre Dupin of *The Country Dance*, which was first published in Jullien's *L'Oeuvre d'Antoine Watteau* of 1726. Radiography and infra-red photography reveal changes inconceivable in a mere copy: a group of figures behind the musicians was omitted; the head of the dancing maiden was shown in three-quarter view looking back to the

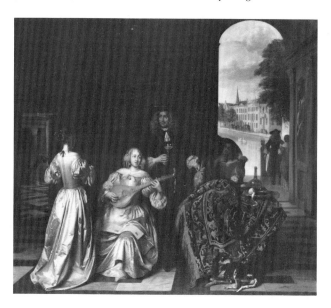

Pieter de Hooch. *A Music Party. ca.* 1675. oil on canvas, 36½ x 43¼ (92.8 x 109.9). Gift of Mr. and Mrs. Miklos Sperling. 67.21.

little girl at a sharper angle; and the hand of the tambourine player was bent more. Like many canvases by this artist, ours has suffered considerably from abrasion. Fortunately, the restorer responsible for the overpainting did little to change the basic character of the picture, although the effects of the retouching are most noticeable in the faces.

Despite the fact that the canvas has never been published before, *The Country Dance* has generally been accepted *in absentia* as an early work by Watteau on the basis of Dupin's engraving, which is, however, so mediocre that several authorities suspended further judgement. The painting itself is something of a paradox. On the one hand, it has the hallmarks of an early work by Watteau, so that it has been dated usually around 1704-1705. The picture bears a thematic and compositional similarity to *The Peasant Dance* (Musée des Beaux-Arts, Valenciennes), perhaps his first-known painting, and likewise evinces a considerable debt to Dutch art, which influenced him heavily during his early years. The somewhat awkward poses and rather unconvincing spatial effect, particularly in the foreground, are further signs of artistic immaturity. On the other hand, the colorful palette, surprising bravura touches in the tambourine player's dress, and the pair of lovers in the background to the left are characteristic of Watteau's first mature fêtes.

Because of its contradictory nature, *The Country Dance* creates an odd impression which initially suggests a pastiche, but the same puzzling qualities can be

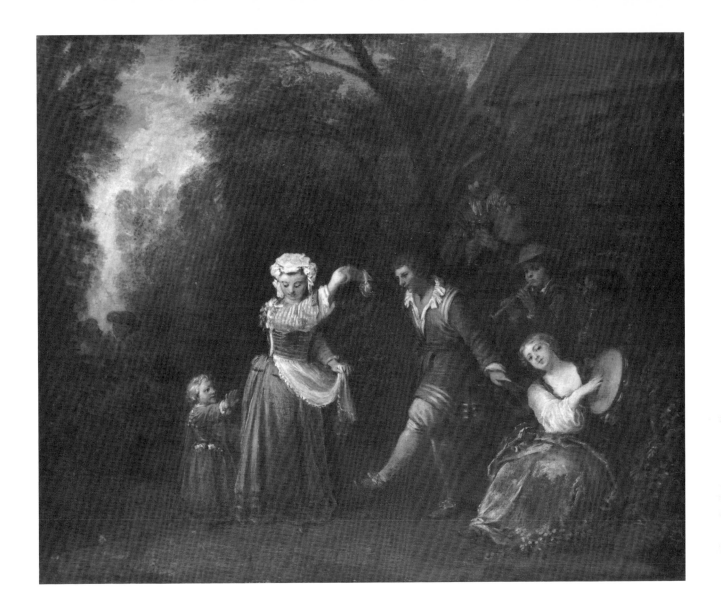

interpreted with equal reasonableness as indicating a transitional work which looks forward and backward at the same time. Here it must be said that Watteau presents extraordinary problems. Beyond some thirty indisputable paintings, there is little consensus about his corpus of authentic works. Of the few dated pictures, the earliest is 1712, so that it is impossible to reconstruct his youthful development with precision. Limitations of space preclude a detailed examination here of such a complex question, which is a matter for specialists, beyond making a few observations.

The Country Dance is not the kind of subject that was taken up by Watteau's imitators, and there is no pastiche like it. The basic quality of the painting and the numerous changes evince an earnest attempt at orig-

inality, without resorting to the formulaic devices that are the imitator's stock in trade. It is, in fact, difficult to impeach the canvas in any major respect. On the contrary, aspects of the poses and execution accord quite well with works generally dated about 1708. These include *Harlequin, Emperor of the Moon* (Musée des Beaux-Arts, Nantes), the two Commedia dell'Arte scenes engraved by Charles-Nicolas Cochin, the Singeries and Chinoiseries in the Besançon de Wagner Collection, Cannes, the decorations for the Hôtel de Nointel now known only in engravings, and *The Village Girl* engraved by Pierre-Alexandre Aveline. Because of the difficulties surrounding Watteau's early development, *The Country Dance* should be assigned to the general period of 1706-1710. Moreover, it is entirely

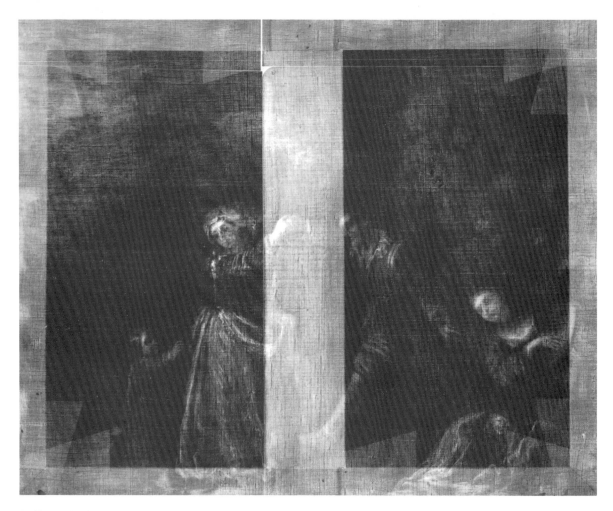

Radiograph of *The Country Dance* by Watteau.

possible that, contrary to his normal practice, Watteau continued working on the painting for several years. This would help to explain why *The Country Dance* seems to anticipate directly several works which, if authentic, are arguably from the years around 1710-1712: *Contented Pierrot* (engraved by Edme Jeaurat), *The Country Ball* (engraved by Jacques Couché) and *The Nest Hunters* (National Gallery of Scotland, Edinburgh). It has affinities with such late pictures as *The Gallant Harlequin* (Wallace Collection, London) and *The Game of Love* (National Gallery, London), while the radiograph is consistent with those of *The Perfect Accord* (Lord Iveagh, London) and *The Delights of the Ball* (Dulwich College, London).

The Country Dance is considerably different in conception from *The Peasant Dance*. In character it may be called a pastoral idyll rather than a low-life scene, for the rustic figures have acquired a new grace,

the landscape a greater poetry. As in Dutch genre painting, dancing is a prelude to love, but here the amorous intent is stated more subtly than in *The Peasant Dance*, which was derived from a print by Adriaen van Ostade and includes a crude embrace. The greater refinement can be attributed to Watteau's further study of such Dutch artists as Gerard TerBorch and Jan Steen, as well as of the Fleming David Teniers the Younger. The most significant influence seems to have come from Pieter de Hooch, however. The auxiliary group of musicians is a rustic counterpart to the merry makers in the IMA's *Concert* of ca. 1675 by De Hooch, while the dancers emulate the central figures in *The Social Glass* (formerly Fernand Houget, Verviers) and other canvases by him of around the same time. Even the child is a variant of the little girls who populate the Dutch artist's pictures, such as *The Cellar* (ca. 1658, Rijksmuseum, Amsterdam), *The Courtyard*

126

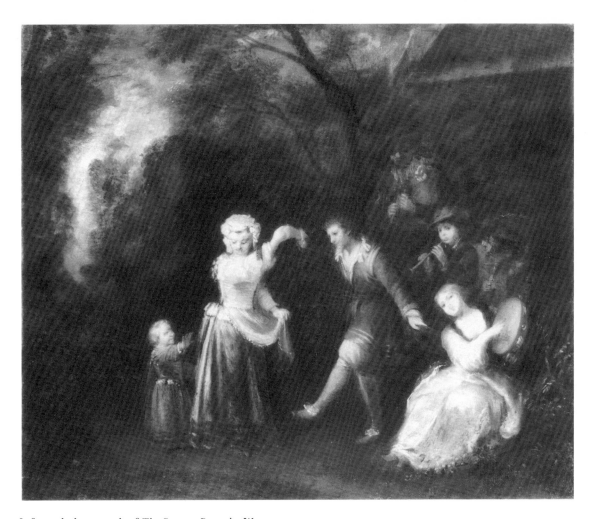

Infra-red photograph of *The Country Dance* by Watteau.

(1658, National Gallery, London) and *Woman Giving Money to a Servant* (ca. 1675, Los Angeles County Museum of Art). Watteau turned repeatedly to Dutch, as well as Flemish, art for inspiration throughout his career but especially in his early years. Unlike *The Peasant Dance*, the IMA *Country Dance* does not merely paraphrase its sources but reinterprets them in a new way. For example, to the best of the author's knowledge there is no iconographic precedent for the little girl interrupting the dancing lovers to join in the fun. With its innocent intruder in the adult world of love, *The Country Dance* is already Rococo in spirit and definably Watteau's in personality, unlike some of the other early works attributed to him. Our painting further anticipates later French paintings which are more piquant in their meaning and which sometimes convey a subtle moral admonition as well.

The popularity of Northern Baroque prototypes in paintings by Watteau and other French artists contributed directly to the rise of the Rococo at the expense of the classicism favored by Charles LeBrun and the Academy. The conflict of color *versus* line represented the struggle of the imagination against the intellect, of personal taste against official art, and of a modern spirit against tradition. The battle, initiated by such artists as Antoine Coypel and Claude Gillot, ended in success with the election of Watteau to the French Academy in 1717, although it was Watteau's heirs rather than he himself who were to be the main beneficiaries of this triumph.

PROVENANCE: Private Collection, Southern France; Wildenstein and Co., New York; Max Safron Galleries, New York; J. K. Lilly Collection, Indianapolis; Mr. and Mrs. Herman C. Krannert, Indianapolis.

JEAN BAPTISTE SIMÉON CHARDIN
French, 1699-1779

Vegetables for the Soup. ca. 1733
oil on canvas, 12¼ x 15⅜ (30.1 x 39.1)
signed c.r.: Chardin
Gift of James E. Roberts
36.22

Jean Baptiste Siméon Chardin was born in 1699 in Paris, where he studied under Pierre Jacques Cazes, Noël Nicolas Coypel and Jean Baptiste Van Loo. With Nicolas de Largillière's support, he was made an agréé and full member of the Academy in one day in 1728. He wed Marguerite Stainard in 1731. Beginning in 1755, Chardin was in charge of hanging the Salon. His fame declined after 1770. He died in Paris in 1779.

The composition of *Vegetables for the Soup* is repeated in three other versions (all in private collections). The IMA picture is similar as well to a painting in the Hermitage Museum, Leningrad. Closely related to a series of kitchen scenes done around 1733, these still lifes were inspired by minor Dutch and Flemish seventeenth-century artists, such as Floris van Schooten, whose names are largely forgotten today by all but specialists. It was only later in his career that Chardin was influenced appreciably by Willem Kalf and Pieter Claesz.

Unlike Baroque still-life painters, Chardin summarized his objects, subtly altering their appearance rather than describing them in minute detail, although he was a close observer of his subjects. The change is most apparent in their textures, which are integrated into the overall surface of the painting. This transformation reveals the inner nature of things as perceived by the artist's imagination. Chardin discovered in even the most mundane objects a poetry which he communicated by suspending them in time and space. In this way, he endowed the humble repast in *Vegetables for the Soup* with a timeless dignity devoid of sentimentality.

The artist's intention is made clear by his kitchen interiors, which translate Baroque prototypes into a distinctly Rococo outlook. Simple subjects acquire the status of moral exemplars affirming the rightness of the existing social order and its values to the rising middle-class professionals who most often patronized Chardin. By incorporating similar pictorial elements in a like style, *Vegetables for the Soup* subtly proclaims the same virtues of hard work, frugality, honesty and devotion to family.

PROVENANCE: Leroux, Paris; Charles Stern, Paris; Galerie Cailleux, Paris; L. Michel Lévy, Paris; Galerie Schaeffer, Paris.
EXHIBITIONS: *Retrospective Exhibition of French Art*, Amsterdam, 1926, no. 19. *Exposition Chardin*, Galerie Pigalle, Paris, 1929, no. 11. *Het Stilleven Tentoonstelling*, J. Goudstikker, Amsterdam, 1933, no. 41, pl. 48. *Chardin: His Paintings and His Engravings*, Columbus Art Gallery, 1965, no. 4. *Chardin*, Grand Palais, Paris, 1979, no. 42.
LITERATURE: J. Guiffrey, *Jean-Baptiste Siméon Chardin, Catalogue complet de l'oeuvre du maître*, Paris, 1908, p. 84, no. 176. E. Pilon, *Chardin*, Paris, 1909, p. 167. H. Furst, *Chardin*, London, 1911, p. 127. G. Wildenstein, *Chardin*, Paris, 1933, no. 1006. A. Tompkins, "A Still Life by Chardin," *Bulletin*, XXIII, 3, Sep. 1936, pp. 36-40. G. Wildenstein, *Chardin*, Paris, 1963, Oxford, 1969, no. 53, fig. 24. Miller, pp. 124-125.

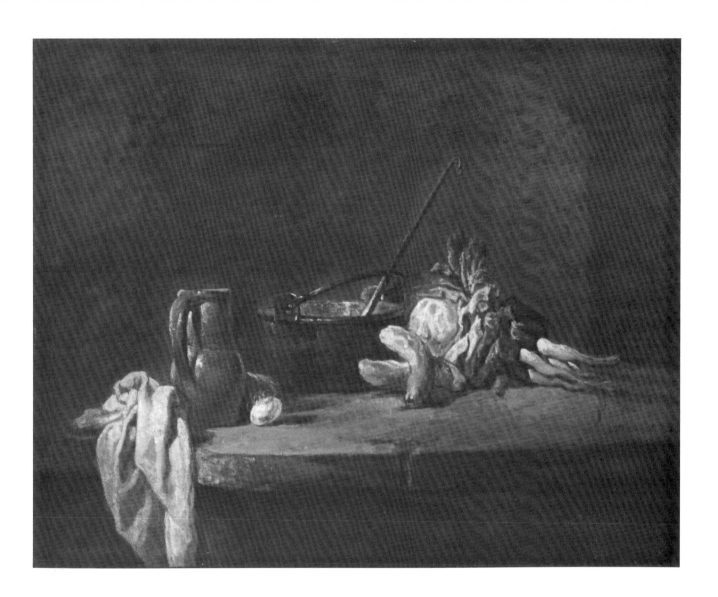

NICOLAS LANCRET
French, 1690-1743

The Swing (l'Escarpolette). ca. 1728-1730
oil on canvas, 37¾ x 35½ (95.9 x 90.2)
Gift of the Krannert Charitable Trust
75.456

Nicolas Lancret was born in Paris in 1690. He studied with Pierre Dullin, then entered the studio of Claude Gillot in 1712. He was admitted to the French Academy in 1719. Lancret died in Paris in 1743.

The Swing was part of a series of decorations done around 1730 by Lancret for the Hôtel de Boullongne, 23 Place Vendôme, Paris. A photograph of 1894 (Wildenstein fig. 182) shows it above a door to the right of a fireplace, over which was the oval *Sleeping Shepherdess*. Our painting had two pendants: *The Bird Cage* (Wildenstein fig. 189) and *The Gallant Bag Pipe Player* (Wildenstein fig. 190). Five panels with individual figures from the Commedia dell'Arte completed the set.

Wildenstein records a dozen paintings by Lancret with swings, half of them with a variety of pendants. The Indianapolis picture is closest to one in the Victoria and Albert Museum; other variants are to be found in the Cleveland Museum of Art, the National Museum, Stockholm, and the Sanssouci, Potsdam.

Our painting incorporates the main motif found in *La Balanceuse* from the Bacchic Festival cycle (known only in Scotin's engravings) by Watteau, who treated the theme on several occasions during his early years. In fact, all the pictures executed by Lancret for the Hôtel de Boullongne are heavily indebted in subject and style to Watteau's decorative works of about 1708-1710. Lancret was in direct contact with Watteau only briefly in 1712 while in Gillot's studio; it is said that the two soon quarrelled because Watteau saw in the younger artist a talented rival. Lancret nevertheless remained truer to Watteau than did any other follower, including Jean Baptiste Pater, Watteau's own pupil, whom he surpassed in ability and inventiveness. While they lack the expressive depth of Watteau's mature works, Lancret's paintings have more originality than is often granted. Even in so derivative a piece as *The Swing,* the figures have a gentle sweetness that is all their own, while remaining close to the lyrical spirit of Watteau. And although imitative, our canvas remains a charming decorative painting.

Lancret's roundels tell a tale of amorous pursuit in the country. The young man's love is awakened by *The Sleeping Shepherdess.* He then tries to win her heart as he tugs at *The Swing.* The swain succeeds in capturing his lady fair in *The Bird Cage.* Finally, the girl reacts with surprise and delight at the invitation to make love offered by *The Gallant Bag Pipe Player,* with its inherent sexual symbolism. Despite such innuendos, Lancret's paintings, like Watteau's, lack the overt eroticism often found in works by Boucher, who represents a younger generation that arose a full decade later and had a fundamentally different point of view. If Watteau raised tender love to the level of mythology, Boucher elevated playful eroticism to the realm of the divine. While Lancret's delicate art was perfectly suited in temperament to the early reign of Louis XV, Boucher came to epitomize the age of Madame de Pompadour, who became the king's mistress two years after Lancret's death. Just as Watteau's style was passed on to Lancret, Boucher's art was continued by his brilliant pupil Fragonard, whose *Swing* (Frick Collection, New York) is in such telling contrast to our painting.

PROVENANCE: Hôtel de Boullongne, Paris; Casimir Cheuvreux, Paris; George Blumenthal, Paris; Thelma Chrysler Foy; Mr. and Mrs. Herman C. Krannert, Indianapolis.
LITERATURE: E. T. Gersaint, *Catalogue Raisonné de diverse Curiosités de Cabinet du feu M. Quentin de Lorangere,* Paris, 1744, p. 193. E. Bocher, *Catalogue de l'Oeuvre de Lancret,* Paris, 1877, pp. 91-92. J. J. Guiffrey, *Eloge de Lancret par Ballot de Savot, accompagné de diverses notes sur Lancret . . . ,* Paris, n.d., p. 34, pls. 45-47. A. de Champeaux, "L'Art Decoratif dans le Vieux Paris," *Gazette des Beaux-Arts,* 1894, le semester, XI, 3me periode, pp. 342-343. G. Wildenstein, *Lancret,* Paris, 1924, no. 734, figs. 182, 188. S. Rubenstein-Bloch, *Catalogue of the Collection of George and Florence Blumenthal,* Paris, 1930, I, pl. 1.

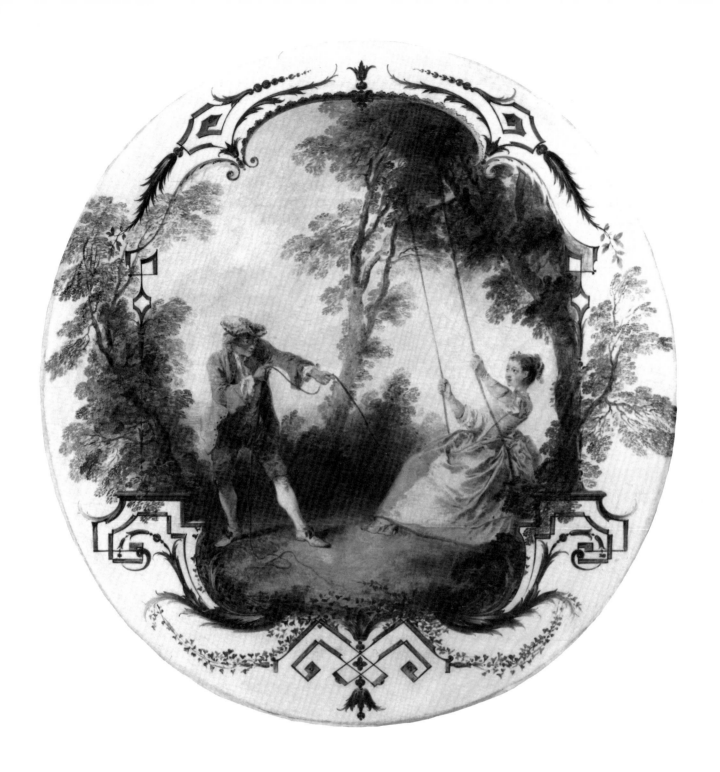

FRANÇOIS BOUCHER
French, 1703-1770

Idyllic Landscape with Woman Fishing. 1761
oil on canvas 19½ x 26 (49.5 x 66)
signed on rock beneath boy: F. Boucher, 1761
Gift of Mr. and Mrs. Herman C. Krannert
60.248

François Boucher was born in Paris in 1703, where he studied under his father and François Lemoyne. He worked for the engravers Laurent Cars and Julienne. In 1724 Boucher won the Prix de Rome. In 1727 he went to Italy with Carle Van Loo to study for four years. Upon his return to Paris in 1731 he was made an agréé of the French Academy, a full member of the Academy in 1734, an adjunct Rector in 1752, a Rector in 1761, and finally Director in 1765. Among other honors, he became a *surinspecteur* at the Gobelin tapestry factory upon the death of Jean Baptiste Oudry in 1755, and was appointed First Painter to King Louis XV when Van Loo Died in 1765. Boucher died in Paris in 1770.

Boucher was the foremost decorative artist, as well as the finest landscape painter in France during the age of Madame de Pompadour. His finest efforts in landscape were done from the early 1750s through the '60s, then he regularly produced several each year. *Idyllic Landscape with Woman Fishing* of 1761 must be accounted among the gems of his large output in this genre. It is of a size and type favored by the artist during these years. (Compare, for example, *The Footbridge,* 1760, Toledo Museum of Art, and *Landscape with the Pont de Pierre,* 1764, Cincinnati Art Museum.) Here, however, he omits the mill which recurs so often in his landscapes that it amounts to a visual cliché.

Like most of his landscapes, this one is based loosely on Flemish prototypes, as well as on observations made during strolls through the countryside with friends in search of picturesque scenery. Nature and the Baroque were, however, merely the points of departure for Boucher's imagination. The rustic view in *Idyllic Landscape with Woman Fishing* parallels the landscape architecture of the picturesque gardens which became popular in France after 1730 because of their carefully cultivated appearance of hospitable wildness and their artificial ancient ruins. The scene is, moreover, like a setting for the pastorales that were frequently staged in French theaters at that time. The artist uses decorative forms and colors to transport the viewer into a realm of fantasy having all the playfulness and eternal youthfulness of the nymphets he painted for Madame de Pompadour. Although it is fashionable to dismiss such art as superficial, the magic of this never-never land demonstrates an unsurpassed understanding of the world of daydreams that enrich man's life.

PROVENANCE: Mme. de Poles, Paris; Galerie Georges Petit, Paris; Rosenberg and Stiebel, New York.
LITERATURE: Miller, pp. 127-128. A. Ananoff with D. Wildenstein, *François Boucher*, Paris and Lausanne, 1976, II, p. 213.

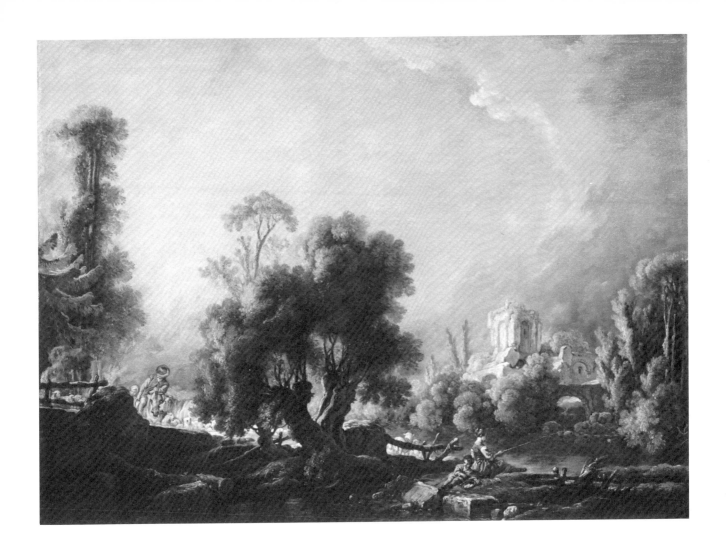

JEAN HONORÉ FRAGONARD
French, 1732-1806

The Joys of Motherhood (Les Délices Maternelles).
 ca. 1752

oil on canvas, 57 x 38½ (144.8 x 97.8)
Gift of Mrs. Herman C. Krannert
73.103.2

Jean Honoré Fragonard was born in Grasse in 1732. He studied with François Boucher and won the Prix de Rome in 1752, then spent the years 1755 to 1761 in Rome. He was made an agréé of the French Academy in 1765, but never became a full member. He returned to Italy for a brief stay in 1773-1774. Fragonard produced few works after 1776, for his paintings went out of style as the revolution approached. Jacques Louis David appointed him a curator of the Musée des Arts in 1793. He died in Paris in 1806.

The Joys of Motherhood was executed in the early 1750s toward the end of Fragonard's apprenticeship with Boucher. It is closely related to the slightly later *Shepherdess*, which has as its pendant a *Woman Gathering Grapes* (both in the Art Institute of Chicago), although no companion piece for the IMA painting is known. The subject and style follow the example of Boucher's scenes of pastoral life (compare *The Rewarded Shepherdess*, 1749, Wallace Collection, London), which Fragonard continued to paint for more than twenty-five years. The contentment radiated by the bright color, cheerful light, decorative landscape forms and serenely beautiful woman in this bucolic picture is a conceit that blithely ignores social reality. The simple pleasures of life in the country are idealized as virtuous, in contrast to the licentious decadence of the urban aristocracy catered to in the erotic paintings for which Fragonard is better known. While it conveniently supported the status quo, that idealized outlook contained the germ of Jean Jacques Rousseau's Emile, the uncorrupted repository of natural morality who was the very antithesis of the civi-lized man extolled by Voltaire. Indeed, Fragonard's later paintings often show the impact of the Enlightenment philosophy of Diderot in depicting peasant families as closely knit and stable because of the emotional satisfaction (as well as sexual pleasure) that binds a woman to her husband and child.

PROVENANCE: Comte de Malleray, Versailles; Jules Bache, New York; Baron de Rothschild, Paris; Wildenstein and Co., New York; J. K. Lilly, Indianapolis; Mr. and Mrs. Herman C. Krannert, Indianapolis.
EXHIBITIONS: *Five Centuries of European Painting*, Los Angeles Museum, 1933, no. 34. *Paintings by French Artists of the XVIIth, XVIIIth and XIXth Centuries*, The Union League Club, New York, 1935, no. 16. *A Survey of French Painting*, Carnegie Institute, Pittsburgh, 1936, no. 22. *Masterpieces of French Painting*, Delgadò Museum of Art, New Orleans, 1953, no. 41. *Fragonard*, Musée des Beaux-Arts, Bern, 1954, no. 13. *Trends in Painting: 1600-1800*, Albright Art Gallery, Buffalo, 1957, p. 51.
LITERATURE: R. Mauray, "Les Scènes Familiales de Fragonard," *Revue de L'Art*, Mar. 1925, pp. 159-164. D. Wildenstein, *Fragonard*, London, 1960, pp. 198-199, no. 30. C. Duncan, "Happy Mothers and Other New Ideas in French Art," *Art Bulletin*, LV, 4, Dec. 1973, p. 583, fig. 16.

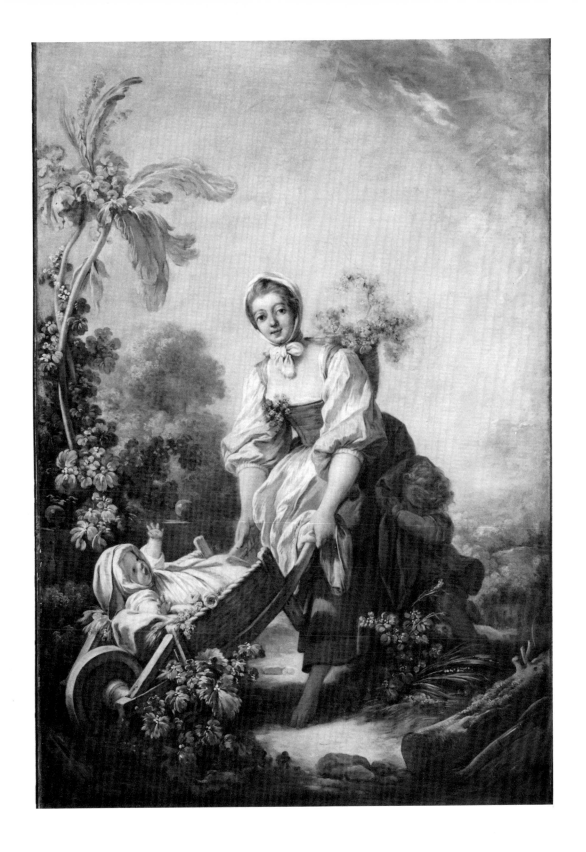

HUBERT ROBERT
French, 1733-1808

Architectural Scene with Women Washing
 Clothes at a Pool. 1799

oil on canvas, 70 x 43 (177.8 x 109.2)
Martha Delzell Memorial Fund
58.88

Hubert Robert was born in Paris in 1733. He was a pupil of the sculptor Michelangelo Slodtz. In 1754 he went to Italy with the French Ambassador, the Comte de Stainville. In 1761 Robert and Fragonard were together in the south of Italy and Sicily. Robert returned to Paris in 1765 and entered the Academy in the following year; he participated in his first Salon in 1767. Imprisoned during the French Revolution, he was later appointed a curator of the Musée des Arts with Fragonard. He died in Paris in 1808.

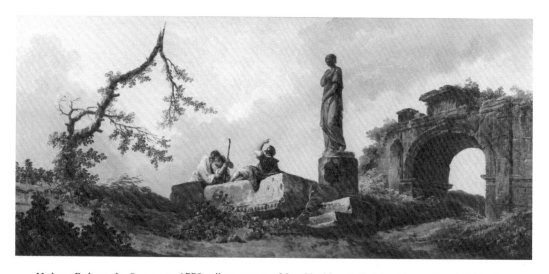

Hubert Robert. *La Statue*. ca. 1773. oil on canvas, 26 x 60 (66 x 154). The Clowes Fund Collection.

Upon returning to Paris after more than a decade in Rome, Robert quickly established himself as the preeminent painter of architectural fantasies in France. His early work, exemplified by *La Statue* of ca. 1773 in the Clowes Collection, participates fully in the French Rococo. *Architectural Scene with Women Washing Clothes at a Pool,* executed in 1799 toward the end of the artist's career, responds to newer tendencies without entirely renouncing his earlier allegiance. This work is from a series of nine canvases painted for the Hôtel de Massa, Paris (others are in the Stockholm collections of C. H. Langenskjöld, Dr. E. Perman, and the National Museum). In its picturesque grandeur, the scene reveals a continuing debt to both Panini and Piranesi, who affected Robert about equally while he was in Rome. The sunlit ambience and stage-like space remain decidedly Rococo in flavor as well. The cubic severity of the pristine setting, on the other hand, incorporates the Neo-Classicism which dominated French art and architecture in the final quarter of the eighteenth century. As the underdrawing still clearly visible beneath the paint reveals, the architecture was initially intended to be considerably more elaborate in the upper reaches, which were simplified for the sake

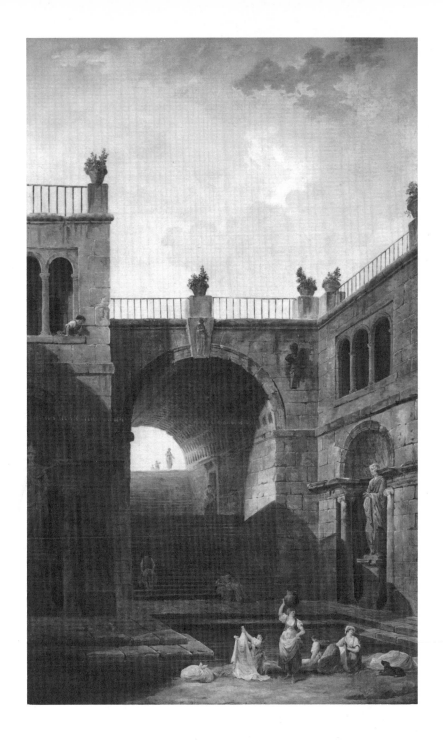

of compositional effectiveness. Rather than hindering Robert's vivid imagination, the Neo-Classical vocabulary has been adapted with results approximating the visionary designs of Claude Nicolas Ledoux. At the same time, the Arcadian figures of *La Statue* have been transformed into the colorful peasant types beloved for another century by French Romantic painters in Italy from Leopold Robert (no relation to Hubert) through Camille Corot and Adolphe Bouguereau.

PROVENANCE: Duc de Richelieu, Paris; B. Osterman, Stockholm; Matthiesen Gallery, London.
LITERATURE: J. Dickerson, "An Architectural Scene with Figures by Hubert Robert," *Bulletin*, XLVI, 4, Dec. 1959, pp. 63-66. Miller, pp. 140-141.

ALESSANDRO MAGNASCO
Italian, 1667-1749

Landscape with Gypsies and Washerwomen.
 ca. 1705-1710

oil on canvas, 33⅜ x 40¾ (84.8 x 103.5)
James E. Roberts Fund
50.63

Alessandro Magnasco was born in 1667 in Genoa. He studied first with his father, Stefano Magnasco, and then under Filippo Abbiati in Milan. He remained in Milan for the early part of his career, except for visits to Spain and a sojourn in Florence from 1703 to around 1710-1711. He returned to Genoa in 1735 and died there in 1749.

With so few dated and securely dateable works, Magnasco's chronology is far from clear. However, the relatively solid construction of the forms and apparent debt to Rosa and Dughet mark *Landscape with Gypsies and Washerwomen* as a relatively early painting. On stylistic grounds, the canvas should be assigned tentatively to the period of 1705-1710, when the artist was in Florence. There he collaborated with such artists as Crescenzio Onofri, who evidently influenced our painting. (Compare Onofri's *A Southern Italian Landscape* of ca. 1700 in the IMA, with figures by Antonio Giusti.) The picture is closest in treatment to a landscape with soldiers in a Venetian private collection (Geiger fig. 62). More generally it belongs to a large group of paintings spanning Magnasco's career which are populated by a variety of picturesque figures.

Although it has been suggested that the bucolic theme of washerwomen is related to comic Italian *favole boschereccie* and *favole lidereccie*, the IMA landscape is one of some twenty-four paintings by Magnasco contrasting industry and idleness, civilization and nature, permanence and transience. The construction rising like a Tower of Babel in the background seems a monument to man's folly, for it is dwarfed by the nature that surrounds it, as are the tiny figures who populate the scene. The wandering gypsies are a further mockery of organization and industriousness, symbolized by the washerwomen.

Magnasco's irony reflects the skepticism of the period. As Parks has noted: "Magnasco lived in the Age of Doubt. In Italy, as elsewhere, the air was full of religious and civil unrest. The tensions and torpors of the era are suggested in Magnasco's pictures." The scene, for all its bizarre qualities, has the tragic melancholy of Poussin's landscapes of around 1650, which share a comparable, if more subdued, pessimism.

In Italian literature and art, human passions found their reflection in natural phenomena, which in turn elicited preconditioned responses in the viewer. The sharp changes of light to dark in Magnasco's painting accord with the tenor of pathos in contemporary tragedies, which are marked by dramatic shifts in mood. The instability of form further evokes the mutability

Crescenzio Onofri. *A Southern Italian Landscape. ca.* 1700. oil on canvas, 38 x 53 (96.5 x 134.6). Emma Harter Sweetser Fund. 77.53.

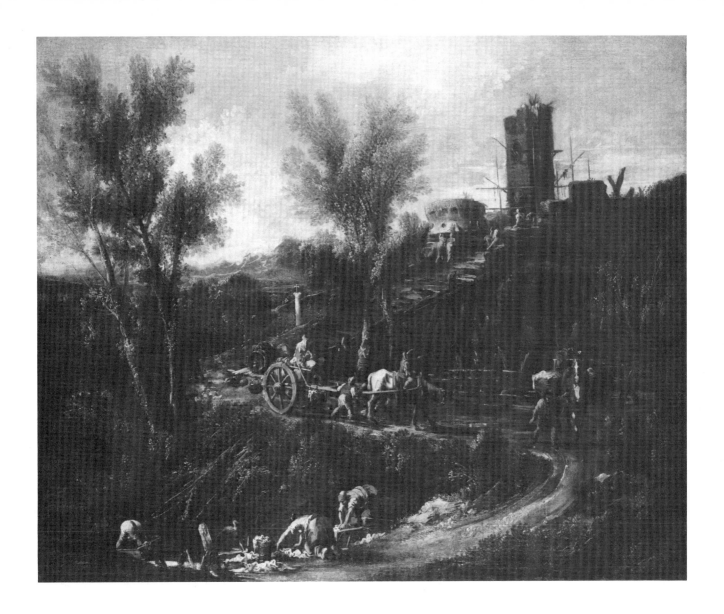

of man's fate, while the suppressed fury of the scene suggests the fragility of the human condition. The grandiose scale elevates the landscape to epic tragedy, reflecting the moral tenor of religion at the time. As part of this bleak outlook, there is a curious tension between anxiety and fatalism on the one hand and the hope born of pessimism on the other.

PROVENANCE: Private Collection, Bergamo; Galleria Augusto Lurati, Milan; Professor J. Bartoli, Milan; Parke-Bernet Galleries, New York; Professor Langdon Douglas, New York.

EXHIBITIONS: *Notable Paintings from Midwestern Collections*, Joslyn Art Museum, Omaha, 1956. *Masterpieces in the Midwest*, Flint Institute of Arts, 1961, no. 11.

LITERATURE: B. Geiger, *Magnasco*, Bergamo, 1949, p. 112, pl. 79. R. Parks, "A Bizzara Invenzione by Magnasco," *Bulletin*, XXXVIII, 1, Apr. 1951, pp. 7-10. Miller, pp. 112-113.

MARCO RICCI
Italian, 1676-1729

Ships in a Breeze off a Coast. ca. 1705-1708
oil on canvas, 36¼ x 49 (92.1 x 124.5)
Martha Delzell Memorial Fund
70.44

Marco Ricci was born in 1676 in Bellino but spent most of his life in Venice. He was a student of his uncle, Sebastiano Ricci, and is known to have collaborated with him on some paintings. Sebastiano and he visited Florence in 1705 and in 1706-1707, as well as England in 1716. (Marco had previously stayed in London in 1708 with Giovanni Pellegrini.) Marco Ricci died in 1729 in Venice.

There is little known about the first decade or so of Marco's career, but in addition to what he could have learned from the work of Antonio Francesco Peruzzini in Florence, he must have known a great deal of Northern and Central Italian landscape painting at first hand through travels in the 1690s. It is otherwise difficult to account for the wide variety of influences on his art, which range from Titian and Niccolo dell'Abate through Pieter Mulier the Younger (*Il Cavalier Tempesta*), among many others.

While it has affinities with scenes by the contemporary Venetian artist Bartolommeo Pedon, for example, the IMA landscape is essentially alien to the Venetian tradition and represents a type found more commonly in late Genoese Baroque painting. It belongs to a considerable group of similarly tempestuous marine subjects that can be dated around 1705-1708 on the basis of their stylistic similarities with two paintings in Newsam House, Leeds, which were done in 1706-1707. The dominant influence is unquestionably Magnasco, with whom Marco is known to have collaborated in 1705 and with whom he would have become reacquainted while working with his brother Sebastiano on decorations for the Palazzo Marucelli in Florence during 1706-1707. Comparable pictures abound in Magnasco's work, and although they are usually assigned to the period 1735-1749 when he retired to Genoa from Milan, the artist must have produced such canvases throughout his career, since a number of them seem decidedly earlier than others, for example *Rocky Inlet with Monks and Ships* (Alte Pinakothek, Munich).

In Magnasco, Marco discovered an expressive liberty surpassing that of Salvator Rosa, who had provided the main example during the first phase of his career. Beyond the evident stylistic influence, Magnasco's supreme originality seems to have stimulated our artist's imagination toward the freer creativity that marks his work during these years. With its agitation and impulsiveness welding all his sources into a unified style, the Indianapolis canvas is a brilliant example of Ricci's landscapes from this period.

The theme of dangerous and fatiguing voyages, fraught with perils from wind and wave, was a favorite among Baroque writers, for example Fulvio Testi. The turbulence of such scenes in both literature and art dramatically conveys a sense of the instability of the human condition. Thus, Marco's *Stormy Landscape* expresses the tragic vision of life widely held in Italy during the late Baroque and early Rococo.

PROVENANCE: H. Schickman Gallery, New York.

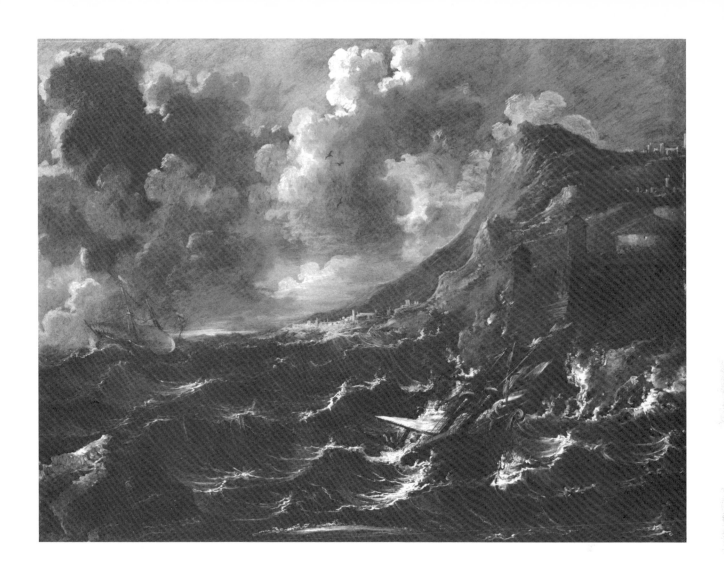

CANALETTO (GIOVANNI ANTONIO CANAL)

Italian, 1697-1768

View of the Piazzetta San Marco Looking South.
 ca. 1735

oil on canvas, 21⅛ x 28¼ (53.7 x 71.8)
Gift of Mr. and Mrs. Elijah B. Martindale
53.8

Giovanni Antonio Canal, called Canaletto, was born in 1697 in Venice where he was trained in scenography by members of his family. Most of his work was done in Venice with the exception of two fruitful visits to Rome in 1720 and 1741, and several lengthy sojourns to London between the years 1746 and 1756. He died in Venice in 1768.

View of the Piazzetta San Marco Looking South is a prime example of Canaletto's mature work. (Two closely related paintings are in the National Gallery, Washington.) The onion-like top on the campanile of San Giorgio dates the picture after 1728 but before it was purchased, evidently with a painting in the Toledo Museum of Art and another canvas, by Prince Josef Wenzel of Liechtenstein around 1740. Stylistically related to Canaletto's works of the early to mid-1730s, the painting is characteristic of his work in its use of precise draughtsmanship and masterful perspective to record the scene and its choice of relatively warm colors to capture the light and atmosphere of Venice. Likewise typical is the artist's omission of the right side of the square, which would have intruded on the scene. He has instead suggested its presence by a long shadow, which also enhances the picture by adding a tonal, atmospheric and spatial contrast.

Canaletto remains the most famous eighteenth-century *veduta* (view) painter. The *veduta* tradition had its beginning in the early years of the previous century, when many foreigners living in Rome specialized in depicting the surrounding countryside, usually with a considerable degree of license. Stimulated by later Roman vedutists, such as Vanvitalli, Canaletto and other Venetian artists of the 1700s turned their attention to painting views of their city. These scenes are often topographically exact (*vedute reale*). As we have seen, however, Canaletto—who was born into a family of scenographers—was not above tampering with visual accuracy. In extreme cases he combined different views, perhaps through the use of mechanical or optical aids, to produce his ideal views (*vedute ideale*). Both types of pictures were highly popular, not only with local patrons but also with foreigners, especially the English, who purchased them as souvenirs of the fashionable grand tours of Italy.

PROVENANCE: Prince Franz Joseph of Liechtenstein; Liechtenstein Collection; Newhouse Galleries, New York.
EXHIBITIONS: *Venice, 1700-1800*, Detroit Institute of Arts and John Herron Art Museum, Indianapolis, 1952, no. 10. *Canaletto and Bellotto*, The Berkshire Museum, Pittsfield, Mass., 1960, no. 13. *Canaletto*, Toronto Art Gallery, 1964, p. 58, no. 19. *The William A. Gumberts Collection of Canaletto Etchings*, Santa Barbara Museum of Art, 1979, p. 15, fig. 6, p. 42.
LITERATURE: G. Waagen, *The Most Notable Art Treasures in Vienna*, Vienna, p. 58. O. Brendel, "Three Paintings from Eighteenth Century Venice," *Bulletin*, XLI, 1, Apr. 1954, pp. 6-12. W. Constable, *Canaletto*, Oxford, 1962, I, no. 58, pl. 22. Miller, pp. 22-24.

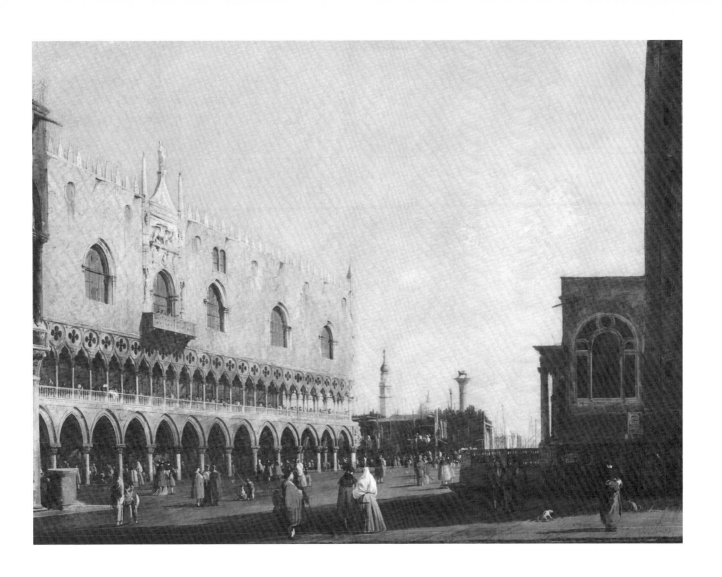

GIOVANNI PAOLO PANINI
Italian, 1691-1765

The Colosseum and Other Monuments. 1735
oil on canvas, 38¾ x 52½ (98.4 x 133.3)
signed and dated on the pedestal for the Borghese
 Warrior: I. P. Panini/Romae 1735
Gift of Lila Allison Lilly in memory of her husband,
 Josiah Kirby Lilly
50.5

The Pantheon and Other Monuments. 1735
oil on canvas, 39 x 53½ (99 x 135.9)
signed and dated on base for warrior group on left:
I. P. Panini/Romae 1735
Gift of Lila Allison Lilly in memory of her husband,
Josiah Kirby Lilly
50.6

Giovanni Paolo Panini was born in 1691 in Piacenza and studied in Rome with Benedetto Luini beginning in 1711. He entered the Rome Academy in 1719 and became its president in 1754-1755; he also was a member of the French Academy in Rome. He died in 1765 in Rome.

Painted in 1735, at just about the same time as Canaletto's *View of the Piazetta San Marco Looking South,* these two canvases are by the artist who was the most popular vedutist in Italy during his lifetime. They are related to similar pictures in the Lawrence Art Museum, Williams College; Staatliche Museen, Berlin-Dahlem; Walker Art Gallery, Liverpool; Houston Museum of Art; Mrs. P. de Koenigsberg Collection, Bueños Aires; and Marcello Guidi Collection, Florence. Studies for some of the figures are in the Print Room, Berlin-Dahlem.

Like two scenes of the Roman forum done in the same year (now in the Detroit Institute of Arts), the Indianapolis paintings are ideal views which freely combine a variety of favorite monuments in surprising juxtapositions. Miller has described the inventories of both pictures:

> In the former picture, the celebrated *Borghese Warrior* and the *Dying Gaul* are placed before the Colosseum; to the right is seen the Pyramid of Caius Cestus, the Arch of Constantine and the three columns of the Temple of Castor and Pollux in the Forum Romanum. The companion piece brings together from left to right the Temple of Mars Ultur (?), the Pantheon, the Obelisk of Tutmose III, the Temple of the Sibyl at Tivoli, the *Maison Carrée* at Nîmes (which Panini could only have known through a drawing or print), and the Theater of Marcellus. In the center of the scene stands the celebrated

equestrian portrait of the Emperor Marcus Aurelius, while to the left is a struggling warrior group, and to the right, a large porphyry sarcophagus of Constantine the Great and an unidentified male statue with upraised arms.

Every feature has been observed with the passion of an archeologist, yet each has been fully incorporated into a scene of unsurpassed sweep. These improbable fantasies are unified by the artist's sure sense of composition and color, as well as by his command of perspective and other spatial devices.

Such a play between reality and fantasy was entirely characteristic of the theatrical Rococo, even more than of the Baroque. Like Canaletto, Panini had training as a scenographer. Their *vedute* are closely related to the theatrical backdrops both artists are known to have frequently designed. Panini's work is distinguished by its lively imagination. In this sense, it was the direct antecedent of the more romanticized scenes by Piranesi, whose masterful etchings of *Prison Caprices* are virtually stage designs.

PROVENANCE: Duke of Norfolk, Yorkshire; Dr. Arturo Grassi, Rome and New York.
EXHIBITION: *Neo-Classicism: Style and Motif,* Cleveland Museum of Art, 1964, nos. 1 and 2.
LITERATURE: W. D. Peat, "Two Paintings of Roman Monuments by Panini," *Bulletin,* XXXVII, 2, Oct. 1950, pp. 22-25. R. Wunder, "The Colosseum Series: A Glimpse into Panini's Stylistic Development," *The Art Quarterly,* XXI, 2, Summer 1958, pp. 160-165. F. Rainey and R. Smith, *The Ruins of Rome,* Philadelphia, 1960, nos. 63, 68. F. Arisi, *Paolo Panini,* Piacenza, 1961, p. 149, nos. 101-102. Miller, pp. 118-120.

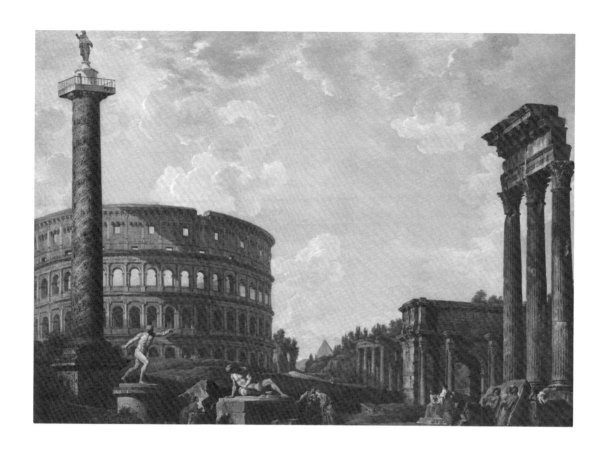

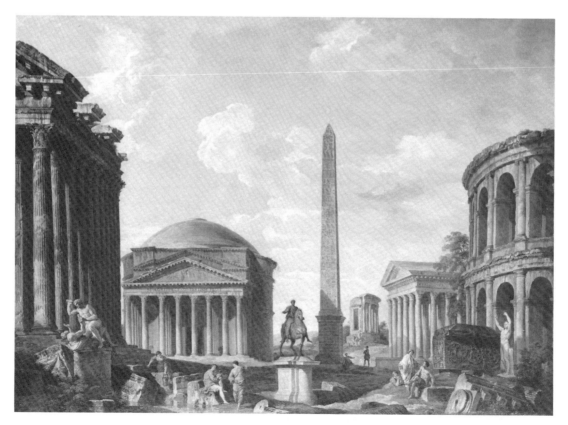

JOSHUA REYNOLDS
English, 1723-1792

Charles Brandling. 1760

oil on canvas, 48½ x 38½ (123.3 x 97.9)

Gift of Mrs. Thomas Chandler Werbe
 in memory of her husband

52.34

Reynolds was born in 1723 in Plympton, Devonshire. After serving an apprenticeship under the portraitist Thomas Hudson from 1740 to 1743, he alternated stays in London and Devonshire until 1749, when he was invited by Captain Augustus Keppel to join him on a trip to Algiers and Minorca. Reynolds then spent two crucial years in Italy and one in France before returning to England where he quickly established himself as London's leading portraitist. In 1768 he was elected first president of the Royal Academy, which he had helped to found, and was knighted in the same year. In 1769 he delivered his first *Discourse* at the Academy and continued to give them each year, despite suffering a paralytic stroke in 1782, until 1790, when the loss of sight in one eye caused him to cease all artistic activity. He died in 1792 in London.

The scion of an old and eminent family, Charles Brandling (1732-1802) was to become an important banker, High Sheriff, and Member of Parliament. According to Reynolds' account book, Brandling paid the artist 63 Pounds in late 1760 for both the IMA portrait and a similar one (formerly John Wanamaker Collection) which differs primarily in showing him in a gray rather than a blue coat.

Brandling's portrait is particularly significant, for it is one of the rare works in Reynolds *oeuvre* with a specific source in Van Dyck. Our painting is virtually the mirror image of Van Dyck's *Philip, Lord Wharton* (1632, National Gallery, Washington) in pose, expression and setting, except that Brandling is sitting and lacks Wharton's *houlette* (shepherd's scoop) and elaborate drapery. Despite these differences, there can be little question that *Lord Wharton*, a distinctive work unlike anything else in Van Dyck's oeuvre, was a primary model for Reynolds' painting. The reversal of the image would seem to suggest that Reynolds knew the Van Dyck through a print, but this was not the case since none was done after the painting. It is instead likely that when he painted Brandling, Reynolds also had in mind Van Dyck's portrait of *Philip, 5th Earl of Pembroke* (1635-1639, Wilton House, Salisbury), which likewise echoes Lord Wharton's pose in reverse and shares Brandling's languid expression. Whether

Sir Joshua Reynolds. *Portrait of Lady Ward.* 1760. oil on canvas, 26 x 21½ (66 x 52.1). Gift of Mr. and Mrs. John G. Rauch, Sr. 67.23.

Reynolds knew the Earl of Pembroke's portrait in the original or through Peter Lombard's engraving is uncertain, but there is good reason to believe that he had seen *Philip, Lord Wharton*, owned at the time by George Walpole, the nephew of the well-known writer, Horace Walpole. While not an intimate friend of the artist, Horace Walpole moved in the same circles as Reynolds, whom he regarded as the finest painter in England. Indeed, Reynolds executed portraits of Walpole in 1756 and 1757. It must have been at that time that Reynolds came to know the painting of Lord Wharton in George's collection. We find immediate echoes of it in two portraits done by Reynolds in the following year: *Charles, Third Duke of Richmond* (Duke of Richmond and Gordon, Goodwood) and *Captain Torryn* (Musée Jacquemart André, Paris). It seems probable that Reynolds had occasion to view *Lord Wharton* several times over the years. The IMA's portrait of Lady Ward, which is documented as having also been painted in 1760 by Reynolds, attests to such a likelihood, for the color and heavy folds of the drapery closely imitate Van Dyck's picture. The impact of

Lord Wharton is seen even more clearly a few years later in Reynolds' portrait of *Edward Lascelles, First Earl of Harewood* (ca. 1762-1764, Earl of Harewood, Harewood House), which is similar in conception to *Charles Brandling*.

Reynolds did not simply adopt Van Dyck's example wholesale but altered it to suit his own needs, thereby disguising the debt as well, however thinly. Brandling assumes a less formal pose than Lord Wharton or the Earl of Pembroke, and the canvas is executed with a deft, painterly touch in the blues and grays favored by the artist during his early period. For all its apparent casualness, however, the portrait has a suprising drama. The comparison indicates that Reynolds admired Van Dyck's achievement from a distinctly eighteenth-century perspective. Intensely competitive, he sought to equal the standard of technical excellence and to emulate the elegant sophistication of Van Dyck, thereby establishing his own preeminence in portraiture. At the same time, he also responded to a facet of Van Dyck's mentality that was uniquely in harmony with his own outlook.

Sir Joshua Reynolds. *Joseph Baretti.* ca. 1775. oil on canvas, 30½ x 24⅞ (77.5 x 63.2). James E. Roberts Fund. 41.88.

Sir Joshua Reynolds. *Thomas Bowlby.* 1765. oil on canvas, 29⅞ x 25½ (75.8 x 64.8). Gift of Mr. and Mrs. A.W.S. Herrington. 60.266.

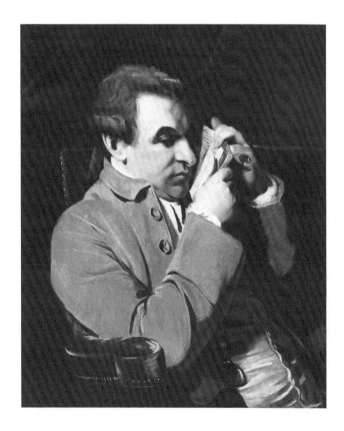

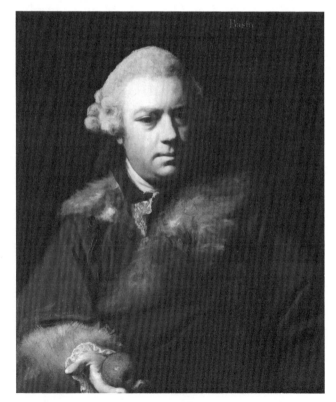

Van Dyck almost surely based *Lord Wharton* on An- tique sculpture—in particular, the Vatican Museum's *"Meleager"* and *Prima Porta Augustus*—as well as such statues' Apollonian descendents in Renaissance art. Reynolds must have intuitively recognized the bor- rowing, for he had certainly seen the same pieces in Rome. During his two years in Italy, Reynolds ab- sorbed the main tradition of Western art from Greece through the Baroque. While it was Van Dyck's work that was critical in the formulation of his mature style following his return to England, Reynolds was to draw inspiration from Classical art and the Old Masters for the remainder of his career, and he often recom- mended following their example—as he did in the IMA's *Thomas Bowlby,* which is reminiscent of both Ti- tian's *Portrait of a Man* and Valentin's *Rafaello Meni- cucci.* To elevate portraiture, he often resorted to poses that were intended to convey noble ideals through their association with the great art of the past. The effect is at first heavy-handed in the portrait of *Charles Churchill* (1755, National Gallery of Canada, Ottawa), which is borrowed directly from the Vatican's famous statue, *"The Apollo Belvedere."* In the portrait of *Charles Brandling,* on the other hand, the reference to Anti- quity is subtler because it was derived indirectly through the intermediary of Van Dyck.

As Edgar Wind pointed out in a brilliant study of English portraiture, allusions of this sort ennobled the sitter by elevating him from an individual to a univer- sal type. This heroic ideal, based on Platonic gener- alization, is closely related to the writings of Samuel Johnson and the theatrical practices of David Garrick, both of whom were Reynolds' close friends. The the- atrical impression made by the portrait of *Charles Brandling* conveys a dramatic moment of heightened sentiment and lofty thought that perfectly exemplifies Reynolds' "public manner" during the first decade after his return from Italy, the busiest years of his career. The approach embodied in this painting an- ticipates the concept enunciated in Reynolds' *Dis- courses* and based on Horace's dictum that art must conform to the example of poetry, be it epic or tragic. Classical theory did not, however, distract Reynolds from his main task of painting a beautiful portrait of Brandling, capturing a good likeness and flattering the sitter while communicating something of his char- acter. Compared to *Lord Wharton, Brandling* has, in fact, a naturalness, even a lyricism, that is closer to Gainsborough than to Van Dyck. It is seen at its height in the IMA version of Reynolds' portrait of *Joseph Bar- etti.*

PROVENANCE: Sir William A. Clavering, Newcastle; M. Knoed- ler & Co., New York; Howard Young Galleries, New York; Clapp and Graham; Harris Hammond; Newhouse Galleries, New York; Thomas Chandler Werbe, Anderson, Indiana.
LITERATURE: A. Graves and W. V. Cronin, *Life of Reynolds,* Lon- don, 1899, I, p. 112. W. Armstrong, *Reynolds,* London, 1900, p. 196. E. K. Waterhouse, *Reynolds,* London, 1941, p. 52. J. Rauch, "Charles Brandling, by Reynolds," *Bulletin,* XL, 1, Apr. 1953, pp. 14-17. Miller, p. 134.

THOMAS GAINSBOROUGH
English, 1727-1788

Portrait of a Lady (Woman in a Mobcap).
 ca. 1763

oil on canvas, 30 x 25 (76.2 x 63.5)
Gift of John G. Rauch
49.1

Thomas Gainsborough was born in the Suffolk town of Sudbury in 1727. He studied in London under the French engraver Hubert Gravelot and at St. Martin's Lane Academy. He married in 1746. Upon his return to Suffolk in 1750, Gainsborough settled in Ipswich. In 1759 he moved to the fashionable resort of Bath, where he set up a studio. He exhibited frequently at the Royal Academy, of which he was a founding member, but did not settle in London permanently until 1774. He died there in 1788.

This portrait of a woman wearing the costume of the chatelaine of a house has been dated by Waterhouse about the time Gainsborough moved from Ipswich to Bath in late 1759. The portraits from the artist's early years in Bath present a direct continuation of the final ones he did in Ipswich, and there is initially little difference in style between the two periods. However, the IMA painting is most closely related in type to a series of oval portraits executed by Gainsborough during the early 1760s, and on that basis should be dated to these same years. The direct glance, sympathetic portrayal and physical presence are also typical of the artist's work at that stage of his career. At the same time, there is a certain formality and dignified reserve, so that the characterization will remind us of Rigaud's *Portrait of a Gentleman.*

Portrait of a Lady still adheres to the straightforward prototypes established in the 1740s by William Hogarth and Thomas Hudson. However, the coalescence of English art into a distinctly native school of portraiture, after centuries of domination by foreigners, was brought about finally by a younger generation of painters possessing a greater genius, including Gainsborough and Reynolds (who had been Hudson's student). They both reassessed Van Dyck's achievement; yet it is evident that they assimilated entirely different lessons from his example. In his eulogy for his great rival, Reynolds aptly summarized the difference between them. Gainsborough, he said, saw with the eye of a painter rather than a poet. What Gainsborough

admired in Van Dyck's portraits was not his elegant manner but his naturalism and ability to handle a brush. Van Dyck's impact is first found in the portraits Gainsborough did in Ipswich during the latter half of the 1750s. Despite more frequent exposure to Van Dyck's paintings in Bath, however, the artist's style changed but little over the decade following *Portrait of a Lady.*

While it is technically as sophisticated as anything painted by Reynolds at the time, *Portrait of a Lady* is provincial in conception when compared to Reynolds' portrait of *Charles Brandling.* Yet its admirable naturalness captures perfectly the easy-going life of the landed gentry who patronized Gainsborough. The artist was plainly uncomfortable with Van Dyck's courtly conventions, which better suited the urban aristocracy to whom Reynolds catered. In fact, Gainsborough's early attempts of the mid-1760s at painting "fancy" portraits are clumsy approximations recalling Reynold's similarly fledgling efforts of ten years earlier. Not until after he settled in London in 1774 did Gainsborough fully master this type.

Portrait of a Lady is a direct expression of the artist's outlook. In both his life and his art, Gainsborough exemplified David Hume's "natural man," who is free of excessive pride or humility. To Gainsborough, the heroic ideal of Reynolds, with its learned philosophy and classical overtones, must have seemed little more than vain pride. Gainsborough himself was a simple and unpretentious man who took his greatest pleasure

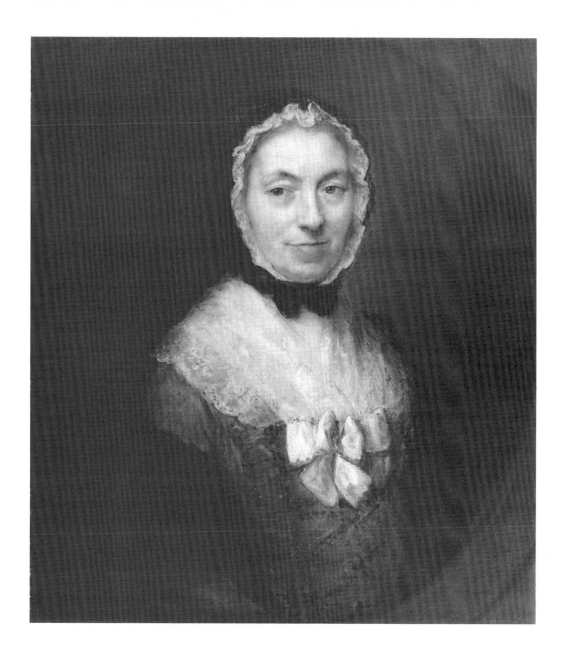

in music and hunting, the same pursuits enjoyed by the people he painted. For that reason, his portraits, such as the one in the IMA, epitomize Hume's idea that painting must incorporate both nature and art. As such, Gainsborough's work is the very antithesis of Reynolds'. Yet the opposition was not so complete as it might seem. *Portrait of a Lady* and *Charles Brandling* are two sides of the same coin. Despite their obvious differences, the painters had much in common, artistically and even philosophically. Both emphasized, albeit in varying degrees, the visual appeal and technical proficiency of their portraits, which likewise share a typically English naturalness. Hume and John-

son were similarly linked by an abiding skepticism. Indeed, Johnson's writings which inspired Reynolds were, if anything, more consistently and bitterly pessimistic than Hume's, which adopted a generally more tolerant and humane system of ethics.

PROVENANCE: Mrs. E. F. Thomson, England; Percy R. Pyne II, Roslyn, L.I.; Christie's, London (sold to "Feldman"); Newhouse Galleries, New York; John G. Rauch, Indianapolis.
EXHIBITION: *Early British Masters*, John Herron Art Museum, Indianapolis, 1941, no. 8.
LITERATURE: R. Cole, "A Portrait by Gainsborough," *Bulletin*, XXXVI, 1, Apr. 1949, pp. 5-7. J. D. Morse, *Old Masters in America*, New York, 1955, p. 78. E. Waterhouse, *Gainsborough*, London, 1958, p. 100, no. 766. Miller, p. 139.

GEORGE STUBBS
English, 1724-1806

Rufus. ca. 1762-1765

oil on canvas, 25⅜ x 30⅜ (51.8 x 77.2)
Gift of Mr. and Mrs. Eli Lilly
47.46

George Stubbs was born in 1724 in Liverpool, England. He studied painting with Hamlet Winstanley, but remained with him for only a few weeks. He worked as a portrait painter in Wigan and Leeds, and then in York in 1744. Stubbs illustrated John Burton's *An Essay Towards a Complete New System of Midwifery* in 1751. He made a brief trip to Italy in 1754-1755. After his return to Liverpool he became engrossed with the study of equine anatomy. He began the dissections and the drawings for his book, *The Anatomy of the Horse,* in Horkstow in 1758, and worked on the engravings for this project in London in 1759. The book was published in 1766. He was an officer of the Society of Artists from 1765 to 1774. In the 1770s he experimented with enamel pigments; this work eventually brought him into contact with the potter Josiah Wedgwood. Stubbs was elected to the Royal Academy in 1781 but never became a full member because he refused to submit the diploma work required for the ratification of his appointment. In 1795 he began another book, *A Comparative Anatomical Exposition of the Structure of the Human Body with that of a Tiger and a Common Fowl,* which remained incomplete at his death in 1806.

As in *Mares and Foals* (1762, Earl Fitzwilliam, Milton, Petersborough), Stubbs has omitted the background in order to concentrate on the horse. Unlike earlier British sporting artists, Stubbs had little interest in capturing the excitement of a race or hunt. Instead, as *Rufus* attests, he was primarily concerned with anatomical accuracy, which is rendered with the explicitness of *Gimrack on Newmarket Heath* (1765, Private Collection). Our painting compares closely with Table III in *The Anatomy of the Horse,* published in 1766 and based on detailed drawings Stubbs had executed during 1758-1759 (Royal Academy of Art, London), which marks an important turning point in English animal painting. Stubbs' objective description was accompanied, however, by an unusually sympathetic understanding of equine character. Thus, *Rufus* is a fully individualized portrait in both appearance and personality.

By about 1770 Stubbs began to invest his paintings of horses and other animals with nearly human action and emotion. Toward the end of his career, moreover, he did a series of drawings for a book comparing the anatomy of man to animals—including one which could well illustrate Plato's remark referring to man as a featherless biped. While clearly distinguishing the differences, Stubbs intended to demonstrate the similarities in physiology and psychology between man and animals. His scientific curiosity and comprehensive approach place him fully in the Enlightenment, which aspired to unite all knowledge into the rational system and coherent philosophy exemplified by Diderot's *Encyclopédie.* As such, Stubbs' art falls outside such convenient categories as Romanticism and Neo-Classicism, though it has greater affinities with the latter.

EXHIBITION: *Romantic Art in Britain, 1760-1860,* Detroit Institute of Arts, 1968, no. 12.
LITERATURE: Miller, pp. 134-135. C.-A. Parker, *Mr. Stubbs the Horse Painter,* London, 1971, pp. 150-152.

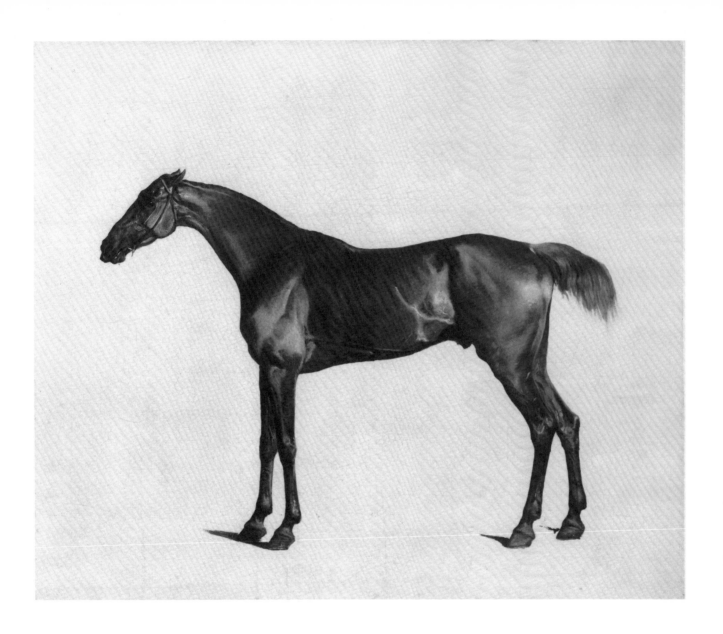

RICHARD WILSON
English, 1713(?)-1782

Apollo and the Seasons. ca. 1768
oil on canvas, 47⅝ x 66¾ (121 x 169.5)
Gift of Mrs. Charlotte Jackson Baldwin
57.46

Richard Wilson was born around 1713 in Montgomeryshire, Wales. He studied in London with Thomas Wright in 1729. A tour of the continent in 1750 took him to Italy where he stayed until 1757 or 1758. One of the founding members of the Royal Academy, he was appointed its librarian in 1776; this position provided the financial security which he never achieved from his painting. He died in Colommendy, Wales, in 1782.

There are several versions of *Apollo and the Seasons* known in engravings ranging in date from 1760 to the late 1770s. The Indianapolis painting is the earliest of three extant canvases and should be dated on the basis of style to around 1768, slightly before the picture in the Viscount Allendale collection. *Apollo and the Seasons* epitomizes Wilson's mature style, when he was at the height of his career, which was later to suffer a serious decline, leaving the artist in dire poverty.

Wilson has freely applied his delicate hues across the large canvas. In contrast, the IMA's *Classical Landscape* of around the same time by George Barret, Wilson's chief rival, is carefully executed in stronger tints but on a much smaller scale, creating a greater intimacy. The comparison reveals Wilson as the finer colorist, one who strove for atmospheric effects that remain true to actual experience. Unlike Barret, who never went abroad, Wilson spent roughly five years in Italy. While there, he presumably made a sketch which formed the basis of *Apollo and the Seasons.* Yet it is evident that, like Barret, he manipulated the topography beyond recognition to make the scene conform in general appearance to prototypes established by Claude Lorrain in such works as *Landscape with Nymph and Satyr Dancing* (Toledo Museum of Art).

The painting corresponds closely as well to a passage in "Summer" from James Thompson's poem *The Seasons,* first published in 1726, which is known to have inspired other landscapes by Wilson. About Apollo, "Parent of Seasons," Thompson writes:

. . .Round thy beaming car,
High-seen, the Seasons lead, in sprightly dance
Harmonious knit, the rosy fingered hours . . .

In validating the aesthetic response to nature through references to the realm of mythology, both the poem and the painting express much the same sensibility found in the writings of Ovid and Vergil, which strongly influenced the attitude held toward nature throughout much of the seventeenth and eighteenth centuries. To heighten the Arcadian associations implicit in the scene, Wilson elaborated the nostalgic

George Barret. *Landscape with Ruins.* oil on canvas, 24 x 36¼ (61 x 91.1). James E. Roberts Fund. 77.54

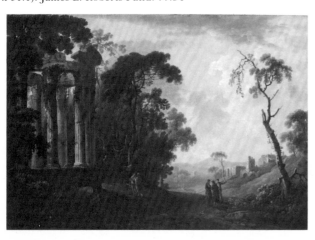

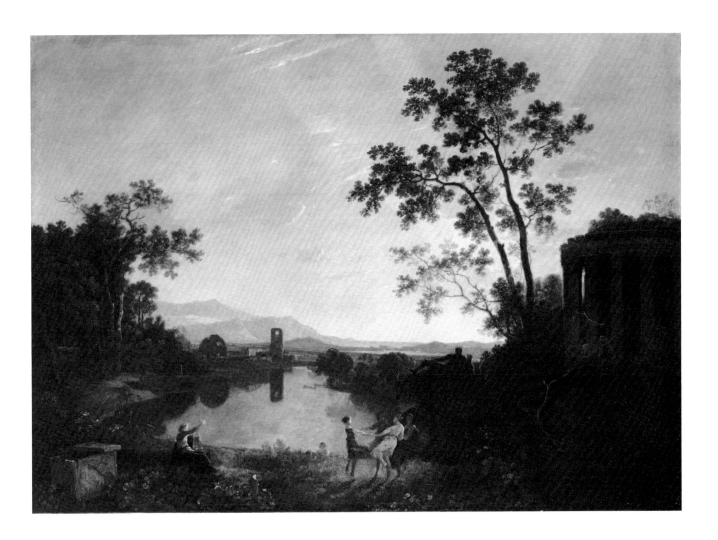

landscape by including a ruined temple in the midst of the dense foliage behind the mythological figures.

Apollo and the Seasons exemplifies the early picturesque landscape in England. As the term implies, the picturesque was a way of looking at nature through the eyes of landscape painters. Beginning in the late seventeenth century, the scenery of Italy and the ideal landscapes by Claude taught the English to appreciate nature by example. In articulating the sentiments inspired by these sources, nature poets such as Thompson were also instrumental in paving the way for the rise of the English landscape school, of which Wilson was the first great representative.

PROVENANCE: Charles Austin, Brampton Hall Estates, Woodbridge; Christie's, London; F. Sabine, London; Leggatt Brothers, London.
LITERATURE: W. G. Constable, *Richard Wilson*, Cambridge, Mass. 1953, p. 167, item 2. W. D. Peat, "A Classical Scene by Richard Wilson," *Bulletin*, XLV, 4, Dec. 1958, pp. 56-58. Miller, pp. 130-131.

BENJAMIN WEST
Anglo-American, 1738-1820

Woodcutters in Windsor Park. 1795

oil on canvas, 28 x 36 (71.1 x 91.4)
signed and dated l.r.: B. West 1795
Gift of Mrs. Nicholas H. Noyes
50.29

Benjamin West was born in 1738 in Springfield (now Swarthmore), Pennsylvania. He was largely self-taught, and succeeded in establishing himself as a sign and portrait painter in Philadelphia by 1756. Between 1760 and 1763 he travelled in Italy, then settled permanently in London. He not only was appointed historical painter to King George III in 1773, but also succeeded Sir Joshua Reynolds as President of the Royal Academy from 1795 until his death in 1820.

This excursion into the picturesque is one of the rare landscapes by West, who was primarily a history painter. The picturesque must be understood in relation to its changing definitions. Although Claude's pastoral landscapes first opened English eyes to the beauty of nature as an aesthetic experience, the picturesque was soon joined by wilder scenes inspired by the paintings of Salvator Rosa. Their appreciation reflected a romantic taste for the sublime—the delicious sense of awe felt before grandiose nature—as defined by Edmund Burke in *Inquiry into the Origin of our Ideas of the Sublime and the Beautiful* of 1756. Landscape painting gave rise to tours in search of picturesque scenery, first to Italy and then to the remoter areas of Great Britain. This enthusiasm for native scenes was recorded in *A Guide to the Lakes in Cumberland, Westmorland, and Lancashire* (1780) by William Gilpin, who for the first time attempted to separate out the picturesque by placing it between the sublime and the beautiful on the grounds that it is neither vast nor smooth but finite and rough. By that time, the picturesque included, in fact if not in theory, a topographical mode pioneered by Paul Sandby, and a rustic mode created by Gainsborough largely from Northern Baroque prototypes. Each landscape type was associated with particular attitudes and moods evoked by conventions of style and appearance.

It is evident that in *Woodcutters in Windsor Park* West did not follow Gilpin's theory except for introducing irregular features into the landscape and restricting the vista in the background. Otherwise, the artist adhered largely to the topographical and rustic modes. In this regard, the painting is symptomatic of the state of development of the picturesque during the mid-1790s. In 1794 Uvedale Price published his *Essay on the Picturesque* inveighing against the artificiality of most landscapes and advocating greater attention to local appearances. Price's theory reflected what had by then become established artistic practice. The picturesque, the sublime and the romantic were already semantically and stylistically distinct. At the same time, it should be noted that while fidelity in the treatment of details and light was to be the foundation of Constable's art, Price himself was a landscape gardener whose designs manipulated nature to conform to artistic examples as freely as picturesque paintings do. Interestingly enough, West depicts man in the middle of just such a shaping process. The woodcutters are making a clearing to provide a view onto the panorama beyond, while leaving only what was deemed the most pleasing part of the woods for the stroller to see. According to Professor Helmut Erffa, the painting shows a view of the Queen's Lodge (destroyed ca. 1820), where King George III, West's early patron and champion, lived with his family.

PROVENANCE: King George III; Earl of Albemarle; Earl of Coventry.

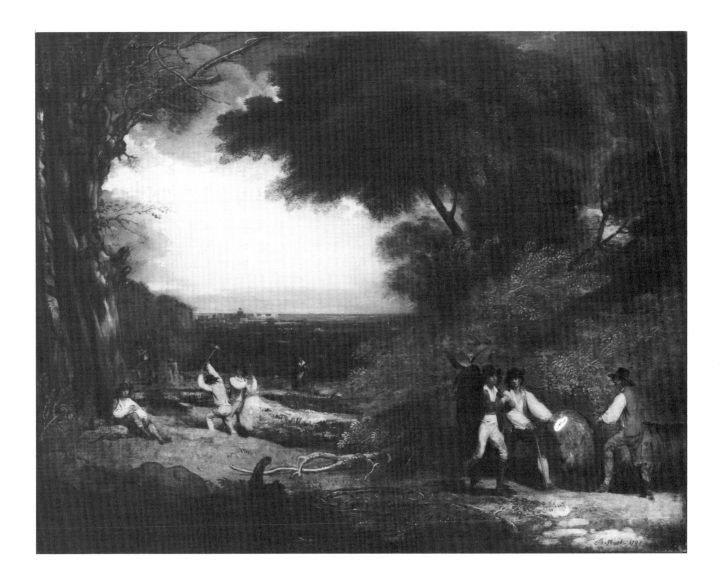

EXHIBITIONS: Royal Academy, London, 1796, no. 189. *Benjamin West*, Graham Gallery, New York, 1962, no. 7. *The Painter and the New World*, Montreal Museum of Fine Arts, 1967, no. 196. *The Growing Spectrum of American Art*, Joslyn Art Museum, Omaha, 1975, no. 82.
LITERATURE: J. Galt, *Life Studies and Works of Benjamin West...*, London, 1820, p. 229. A. Graves, *The Royal Academy of Arts, A Complete Dictionary of Contributors and Their Work...*, London, 1906, VIII, p. 216, no. 189. W. D. Peat, "A Landscape by Benjamin West," *Bulletin*, XXXVIII, 1, Apr. 1951, pp. 3-6. G. Evans, *Benjamin West and the Taste of His Times*, Carbondale, 1959, p. 73, pl. 54. *The Vincent Price Treasury of American Art*, Waukisha, 1972, pp. 25-27.

FRANCISCO JOSE DE GOYA Y LUCIENTES
Spanish, 1746-1828

Portrait of Don Felix Colon de Larreategui. 1794
oil on canvas, 43⅝ x 33⅛ (110.8 x 79.1)
dated on paper in center: Año 1794
Gift of the Krannert Charitable Trust
75.454

Francisco de Goya y Lucientes was born in 1746 in Fuendetodos. His early years were spent almost entirely in Saragossa where he studied in the shop of José Luzán from 1760 to 1764. He went to Madrid and tried unsuccessfully to gain entrance to the Real Academia de San Fernando, competing first in 1763, and again in 1766, when he probably took lessons from Francisco Bayeu. From 1769 to 1771 he travelled in Italy, returning to Saragossa at the end of that journey to work on several commissions. In 1773 he settled in Madrid and began collaborating with Bayeu, whose sister he had wed that same year. In 1774 Goya was summoned to court as a tapestry designer for the Royal Workshop of Santa Bárbara; this appointment occupied much of his time until 1792. He was elected to the Real Academia de San Fernando in 1780 and was made a deputy director in 1785. He was appointed one of the King's Painters in 1786, Court Painter in 1789, and First Painter to the King in 1799. During a prolonged visit to his friend Sebastián Martínez in Cádiz in 1792, he became ill and eventually deaf. He was named Director of Painting at the Academia in 1795, and held that position until 1797. He published the *Caprichos* in 1799, *Disasters of War* during the years 1810 to 1813, the *Tauromaquia* in 1816, and the *Follies* in 1820. He was summoned before the Inquisition in 1815 to explain his painting of the *Naked Maja*. When King Ferdinand VII was restored to power in 1824, Goya emigrated to France and settled in Bordeaux. He visited Madrid briefly in 1826. Goya died in Bordeaux in 1828.

Felix Colon de Larreategui was a man of great distinction. A direct descendent of Christopher Columbus (Colon is the Spanish form of Colombo), he was Lieutenant Colonel of Infantry and First Adjutant of the Regiment in the Royal Spanish Infantry Guards at the time Goya painted his portrait in 1794. Wearing the Badge of a Knight Commander of the Order of Santiago, which he entered that year, Colon is shown with a quill to indicate that he is the author of the seven-volume tome about military justice (*Juzgados militares de España y sus Indias*) seen on the desk behind him. In 1820 he was listed as a member of the Supreme War Council.

To achieve a monumentality appropriate to Colon's accomplishments, Goya has chosen a relatively low vantage point and an unusually dark background which together emphasize the face and thus the character of the sitter. The silver trim and vest also act as foils for the head by providing tonal transitions to the flesh colors. The pose creates a strong profile, but with the exception of the main contours, the forms are not so much delineated as implied by subtle nuances of color and brushwork. While more carefully described than in Goya's later portraits, Colon's features seem to lack definition when seen closely. At normal viewing distances, however, the image fuses to produce a fully modelled likeness conveying a powerful personality.

This extraordinary painting illustrates Goya's supremacy in portraiture. His early portraits of the 1780s have a naive Rococo charm. Not until 1792 did Goya reach maturity as the result of the sojourn in Cádiz which was to prove pivotal to his career. Goya must have received his initial exposure in Cádiz to French Neo-Classicism of the sort found in the IMA's portraits of an elderly man and woman by Robert Lefevre, for during that visit he painted his first great

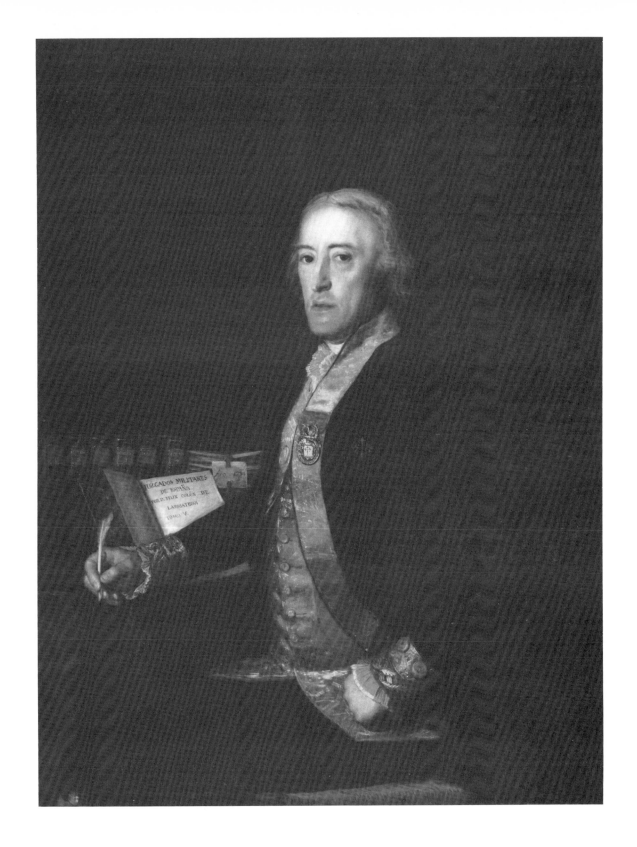

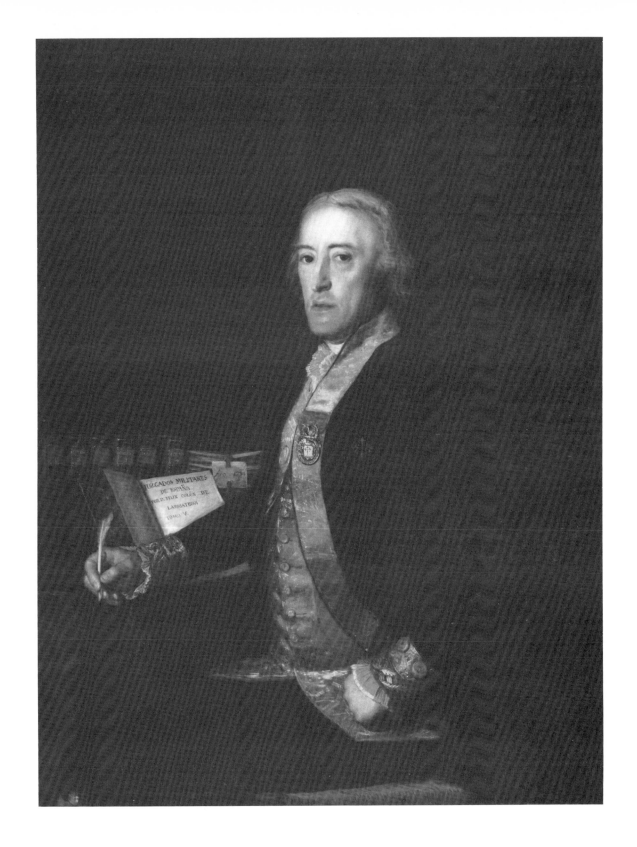

JUZGADOS MILITARES
DE ESPAÑA
POR D. FELIX COLON DE
LARREATEGUI
TOMO V.

portrait under its influence: *Sebastian Martínez y Pérez* (Metropolitan Museum of Art, New York). That portrait also shows changes in Spanish clothing reflecting a taste for the latest French styles, which further allowed the artist to explore new color sonorities. The result was a radical transformation of style.

The portrait of Colon builds directly on that achievement. There can be little doubt from the penetrating characterization of this imposing portrait that Goya knew his sitter well. Like the one of Martínez, Goya's few portraits from these years are drawn almost exclusively from his circle of friends, whose personalities he revealed with new insight.

Ironically, the freedom to develop artistically was the consequence of an illness he contracted on an excursion from Cádiz to Seville. The malady, which was to leave him deaf, relieved him for a while from much of his responsibility as court painter. Although he was soon to adopt a more painterly style, Goya's rapid growth as a portraitist during this period provided the foundation for his later paintings such as *The Family of Charles IV* (1800, Prado, Madrid), which exposes every defect beneath the courtly facade with unflinching honesty. Moreover, it is very possible that during his stay in Cádiz, Goya began to share the liberal desire for much-needed reforms in Spain based on the ideals of the French Enlightenment. Those hopes were to end in bitter disillusionment with Napoleon's brutal conquest of Spain, immortalized by Goya in *The Third of May, 1808* (1814, Prado, Madrid).

PROVENANCE: Conde de Robres, Saragossa; Baron Sangarren, Saragossa; Ricardo Traumann, Madrid; Jose de Santamarina, Paris; Sedelmeyer Gallery, Paris; Wildenstein Gallery, New York (?); J. K. Lilly, Indianapolis.
LITERATURE: F. Zapater y Gomez, *Apuntos historicos-biograficos, Escuela arragonesa de pintura*, Madrid, 1867, p. 39. C. Iriarte, *Goya*, Paris, 1867, p. 145. C. de la Vinaza, *Goya*, Madrid, 1887, p. 241. S. Z. Araujo, *Goya*, Madrid, 1896, no. 254. V. von Loga, *Francisco de Goya*, Berlin, 1903, p. 193, no. 195. K. Vertels, *Francisco Goya*, Munich, 1907, p. 12. A. F. Calvert, *Goya*, London, pl. 158. H. Stokes, *Francisco Goya*, London, 1914, p. 329, no. 76. A. de Beruete y Moret, *Goya*, Madrid, 1916, I, p. 174, no. 126. A. L. Mayer, *Francisco de Goya*, Munich, 1923, p. 189, no. 239 and London, 1924, p. 153, no. 239. R. Gomez de la Serna, *Goya*, Madrid, 1928, p. 269. F. J. Sanchez Canton, *Goya*, Paris, 1930, p. 44. R. Esteve Botey, *Francisco de Goya y Lucientes*, Barcelona, 1944, p. 255. F. G. Desparmet, *L'Oeuvre peint de Goya*, Paris, 1950, II, p. 74, no. 356. F. J. Sanchez Canton, *Vida y obras de Goya*, Madrid, 1955, p. 53. E. G. Trapier, *Goya and His Sitters*, New York, 1964, p. 10. J. Gudiol, *Goya*, New York, 1973, I, pp. 89, 273, no. 331, III, fig. 468.

Robert Lefevre. *Portrait of an Elderly Man.* oil on canvas, 25½ x 21¼ (64.8 x 54). The Orville A. and Elma D. Wilkinson Fund. 72.85.1.

Robert Lefevre. *Portrait of an Elderly Woman.* oil on canvas, 25½ x 21¼ (64.8 x 54). The Orville A. and Elma D. Wilkinson Fund. 72.85.2.

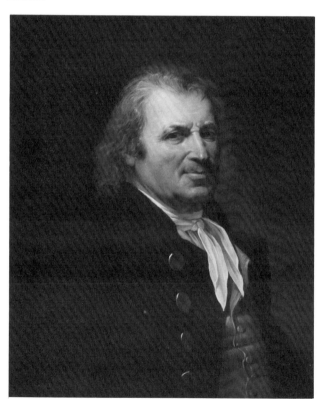 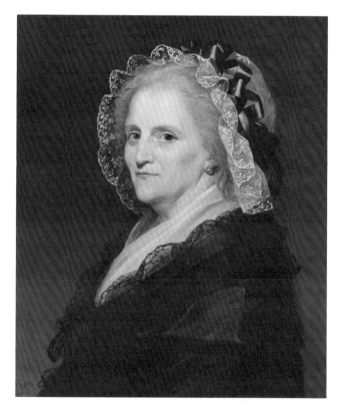

JOSEPH MALLORD WILLIAM TURNER
English, 1775-1851

The Fifth Plague of Egypt. 1800
oil on canvas, 49 x 72 (124.5 x 182.9)
Gift in memory of Evan F. Lilly
55.24

Joseph Mallord William Turner was born in London in 1775. There he was apprenticed to Thomas Malton, a topographical watercolorist who specialized in architectural subjects. In 1789 Turner entered the Royal Academy and in 1790 showed for the first time at the summer exhibition. Between 1791 and 1802 he undertook extensive sketching tours in the British Isles. During this period he frequently worked with the artist Thomas Girtin. In 1802 Turner travelled to France and Switzerland. He was made an Associate of the Royal Academy in 1799 and was elected a full Academician in 1802. In 1807 he was elected "Professor of Perspective," but postponed his first lecture until 1811. He lectured fairly regularly until 1819, then gradually less often, until he finally resigned the appointment in 1838. In 1819 and 1820 he visited Italy for the first time. He returned to the Continent in 1828 to travel in France and Italy. In 1840 he made his last trip to Venice and in 1845 he made his last sketching trip to France. He died in Chelsea in 1851 and was buried in St. Paul's Cathedral in London.

The title of this painting is a misnomer. The picture actually shows the seventh plaque of Egypt. When the canvas was first exhibited at the Royal Academy, the catalogue quoted Exodus IX, 23: "And Moses stretched forth his hands towards heaven and the Lord sent thunder and hail and the fire ran along the ground." The landscape is indebted to the Italian tradition. The composition and color are derived from the late heroic style of Poussin, along with some devices gleaned from Claude Lorrain. On the other hand, the violence of the scene is related to the work of Magnasco. Regardless of its sources, the painting is without parallel in earlier art. Equally unprecedented is the sheer fury of the apocalyptic destruction depicted by Turner.

Done in 1800, *The Fifth Plague of Egypt* represents Turner's first essay in grandiose historical landscapes and marks his rise as a full-fledged Romantic, conveniently at the very beginning of the nineteenth century. During the Enlightenment, artists had generally presented the sublime as pure feeling, and had portrayed the beautiful in a classical style which, because of its historical associations with ancient Greece and Rome, also served as a vehicle for teaching moral lessons based on noble principles. Like the Rococo, Romanticism combined two opposite approaches while transforming their character. As in Magnasco's *Landscape with Gypsies and Washerwomen*, the cataclysmic mood in *The Fifth Plague of Egypt* makes a philosophical statement about man's helplessness before the forces of nature. While Magnasco's painting is linked only in a general way to the moral and religious outlook of the late Baroque, Turner's historical landscape explicitly connects God's cosmic order with His moral laws. But both of these paintings remove the viewer from the realm of rational philosophy to one of subjective faith, and the appeal to the emotions rather than the intellect makes these moral lessons all the more compelling. Absorbed by the rising cult of the individual and sentiment, the Romantic evokes extreme states of mind lying outside the descriptive range of both Neo-Classicism and the picturesque. Turner's success in conveying heightened mood demonstrates why landscape replaced narrative and allegorical painting as the most effective mode of Romantic expression. Although history painting remained the highest aspiration of artists working in the main Western tradition, landscape inspired the Romantics with pas-

sions so exalted that only in the hands of a few geniuses, such as Delacroix, did man equal nature in power as a protagonist.

PROVENANCE: William Beckford, Fonthill; Jeffrey; George Young; Lord Grosvenor (later Marquess of Westminster); Sir J. C. Robinson; Sir Francis Cook; Thomas Agnew and Sons, London; Sir Alexander Korda; E. Speelman, Ltd., London.

EXHIBITIONS: Royal Academy, London, 1800, no. 206. British Institution, 1853, no. 164. *International Exhibition*, Fine Art Department, London, 1852, no. 268. *Exhibition of Works by Old Masters*, Burlington Fine Arts Club, London, 1871, no. 49. Royal Academy, 1871, no. 140. *Old Master Exhibition*, Guildhall, London, 1899, no. 9. *Exhibition of Works by the Old Masters*, Burlington House, Royal Academy, London, 1903, no. 66. *The First One Hundred Years of the Royal Academy*, Burlington House, Royal Academy, London, 1951, no. 167. *Turner in America*, John Herron Art Museum, Indianapolis, 1955, no. 7. *Treasures in America*, Virginia Museum of Fine Arts, Richmond, 1961, p. 72. *Landscape of Art*, Atlanta Art Association, 1962, no. 28. *Masterpieces of Art*, Seattle World's Fair, 1962, no. 21. *Exhibition of Works by J. M. W. Turner*, Museum of Modern Art, New York, 1966, no. 2. *Turner 1775-1851*, Royal Academy, London, 1974, no. 70.

LITERATURE: J. Ruskin, *Modern Painters*, London, 1843, I, pp. 240-241, V, p. 391. J. Burnet, *Turner and his Works*, with a "Memoir" by P. Cunningham, London, 1852, pp. 22, 30, 111, no. 61. G. Waagen, *Treasures of Art in Great Britain*, London, 1854, II, p. 257. W. Thornbury, *The Life of J. M. W. Turner, R.A.*, London, 1852, I, pp. 277, 284, 355, II, pp. 370, 400, 2nd ed., 1877, pp. 415, 570, 598. P. G. Hamerton, *The Life of J. M. W. Turner, R.A.*, London, 1879, p. 64. W. C. Monkhouse, *Turner*, London, 1879, p. 49. C. F. Bell, *A List of Works contributed to Public Exhibitions by J. M. W. Turner, R.A.*, London, 1901, p. 77, no. 93. Sir W. Armstrong, *Turner*, London, 1902, pp. 48, 221. C. Holme (ed.), *The Genius of J. M. W. Turner*, London, 1903, pl. 2. C. Bell, *Liber Studiorum*, London, 1904, XLIV. *Les Arts*, Aug. 1905, p. 18. W. L. Wyllie, *J. M. W. Turner*, London, 1905, pp. 30, 163. A. J. Finberg, *Inventory of the Drawings of the Turner Bequest . . .*, London, 1909, pp. 117, 176, 317. *Liber Studiorum*, London, 1911, p. 25, no. 16. F. Cook and M. W. Brockwell, *Catalogue of the Paintings at Doughty House and Elsewhere in the Collection of Sir Frederick Cook, Bt.*, 1913, I, p. 4, 1915, III, pp. 22-23, pl. 407. A. Graves, *A Century of Loan Exhibitions, 1813-1912*, London, 1914, III, pp. 1333, 1345, 1352. *Hand Catalogue of the Cook Collection*, London, 1914, p. 33. J. Farington, *The Farington Diary, 1793-1821*, London, 1922, I, pp. 240, 13, V, p. 391. H. Townsend, *J. M. W. Turner*, New York, 1923, p. 18. M. W. Brockwell, *Abridged Catalogue of Pictures in the Cook Collection*, London, 1923, p. 10. A. J. Finberg, *The History of Turner's Liber Studiorum with a New Catalogue Raisonné*, London, 1924, pp. 63-65. W. T. Whitley, *Art in England 1800-1820*, London, 1928, pp. 7, 129. C. Mauclair, *Turner*, Paris, 1939, p. 38. C. Clare, *J. M. W. Turner, His Life and Work*, London, 1951, p. 51. T. S. R. Boase, *English Art*, New York, 1959, p. 101. E. Spaeth, *American Art Museums and Galleries*, New York, 1960, pp. 108-109. A. J. Finberg, *The Life of J. M. W. Turner*, Oxford, 1961, pp. 66, 71, 195, 364, no. 61. B. Alexander, *William Beckford, England's Wealthiest Son*, 1962, p. 25. J. Ziff, "Turner and Poussin," *Burlington Magazine*, CV, no. 724, Jul. 1963, p. 315 f. J. Rothenstein and M. Butlin, *Turner*, New York, 1964, pp. 14-16, pl. 14. M. Kitson, *Turner*, London, 1964, p. 13. J. Lindsay, *J. M. W. Turner, His Life and Work, A Critical Biography*, London, 1966, pp. 72, 77, 87. L. Gowing, *Turner: Imagination and Reality*, New York, 1966, pp. 8-9, no. 2. G. Reynolds, *Turner*, London, 1969, pp. 41, 44-45, 61, 64, 78, 88, 94, 165, fig. 28. J. Gage, *Colour in Turner, Poetry and Truth*, London, 1969, p. 136. Miller, pp. 155-157. A. M. Holcomb, "The Bridge in the Middle Distance: Symbolic Elements in Romantic Landscape," *Art Quarterly*, XXXVII, 1974, pp. 47-48, fig. 11. L. Herrmann, *Turner*, London, 1975, pp. 12, 226-267, pl. 23. M. Butlin and E. Joll, *The Paintings of J. M. W. Turner*, New Haven, 1977, I, pp. 9-10, II, pl. 10. A. Wilton, *J. M. W. Turner, His Art and Life*, New York, 1979, pp. 61, 65-67, p. 255, no. P13, pl. 59.

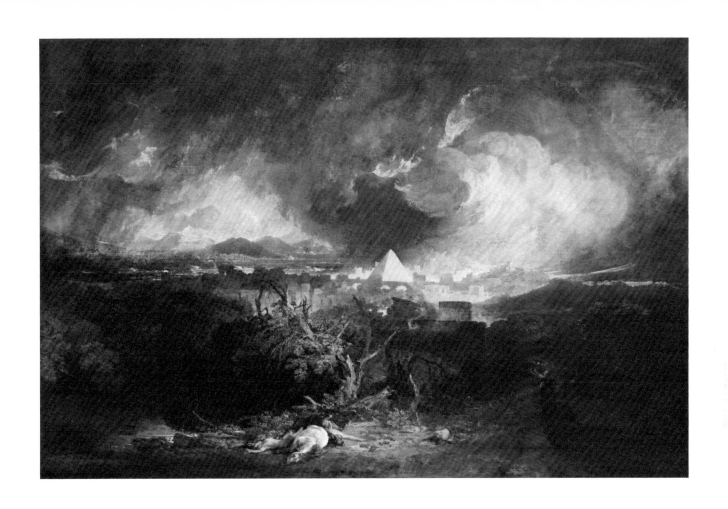

JOSEPH MALLORD WILLIAM TURNER
English, 1775-1851

East Cowes Castle, the Seat of J. Nash, Esq.:
 The Regatta Beating to Windward. 1828
oil on canvas, 36¼ x 48 (42.1 x 121.9)
Gift of Mr. and Mrs. Nicholas Noyes
71.32

East Cowes Castle, The Seat of J. Nash, Esq.: The Regatta Beating to Windward and its pendant, *East Cowes Castle, The Seat of J. Nash, Esq.: The Regatta Starting for Their Moorings* (Victoria and Albert Museum, London), were painted on commission in 1828 for the architect John Nash to commemorate the Royal Yacht Club races at Cowes the previous year, only the second time they had been held there. Turner stayed with Nash at the castle from the end of July to September, 1827. During that time he painted three oil sketches (Tate Gallery, London) for each picture on two three-by-four-feet pieces of canvas he had his father send specially from London to the Isle of Wight. Since they were not derived from any of the known drawings he made outdoors of the races, it is possible that, as Reynolds maintains, the initial oil sketches for both scenes were likewise done from nature, perhaps on a boat moored nearby. While it is difficult to imagine Turner working on such large stretches of canvas under those conditions (the sketches were cut and mounted only around 1905), the hypothesis remains attractive, as it is difficult to otherwise account for the remarkable plein-airism of our painting. Unlike Constable, the artist rarely painted outdoors in oils, and such fidelity to nature is consequently rare in his work. Rather than merely capture the visual appearance of a scene, Turner's intention was to convey the impression made on him by an experience. For him, external reality was far less significant than its subjective impact. The mediator between the two poles of experience was Turner's imagination, which became increasingly independent.

During the first decade of the century, the artist had executed a considerable number of sea and river landscapes which, though they stretch convention, essentially follow the English tradition of marine painting established in the late seventeenth century by William van de Velde the Younger, with a secondary line coming from the French artist Claude Joseph Vernet. Most often tempestuous, these early works by Turner communicate the same sense of man's peril before nature that underlies the IMA's *Fifth Plague of Egypt*. Among the few that appear to be based directly on nature are some Thames scenes of ca. 1809-1810, which derive from sketches made during strolls along the river. From the late 1820s on, Turner's marine paintings became largely epic fantasies, overwhelming the viewer with the sheer power of their author's extraordinary vision. Yet even in these imaginative scenes, personal experience remained central to the artist. In one famous instance, he had himself tied to the mast of a ship for four hours during a blizzard at sea. The resulting picture, *Snow Storm: Steamboat off a Harbour's Mouth* (1842, National Gallery, London), uses the artist's "tinted steam" to preserve the general effect of violent shifts in motion and light, and to vividly express the intense emotions Turner himself must have felt.

The East Cowes paintings occupy a position of considerable significance within this development. On the one hand, they build on Turner's earlier achievements as a marine painter. For example, a pair of canvases showing *Tabley, the Seat of Sir J. F. Leicester, Bart.* (1809, Petworth House and Victoria University of Manchester) likewise juxtaposes a calm morning and a breezy afternoon. On the other hand, the Nash pictures are far superior to those canvases and are without precedent in the artist's *oeuvre*. *The Regatta Starting for Their Moorings* is elevated to a mythological realm nearly comparable with Turner's allegorical *Carthage* scenes (1815, Tate Gallery and National Gallery, London). The artist progressively elaborates the observations in the first sketch to a fantasy which combines elements taken from Dutch seascapes and Claudian landscapes with figures inspired by Watteau's *fêtes*. The IMA *Regatta Beating to Windward*, in contrast, conveys the feel of the race itself by capturing the sensation of light and water perceived at rapid speed. The

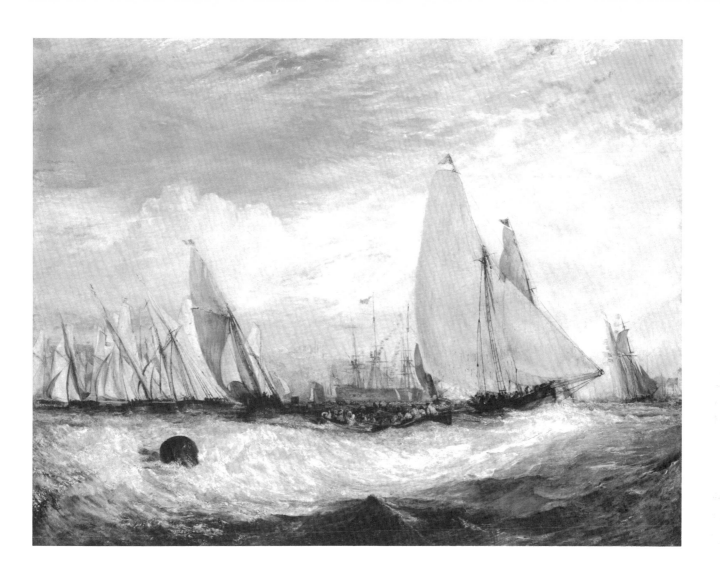

impression of light radiating and reflecting throughout the scene unifies the painting visually and suggests the interdependence of man and nature, but without the pessimism that pervades the apocalyptic *Shipwreck* (1805, Tate Gallery, London).

Despite its convincing naturalism, *The Regatta Beating to Windward* was criticized by some reviewers in 1828 for its departure from reality in the over-sailed yachts, among other things. For many viewers in a seafaring nation where marine paintings were expected to be accurate in every respect, such lapses in factual detail were sufficient to render the canvas fatally flawed. In order to insure the veracity of their pictures, most specialists—including Clarkson Stanfield, who was generally regarded as the leading seascape painter of his day—spent several years in the merchant marine before embarking on their careers. The IMA's *Bligh Sands, Sheerness* of ca. 1820 is characteristic of Stanfield's work in revealing the influence of early seascapes by Turner (indeed, the painting was once attributed to Turner), but the scene is leaden in comparison to *Regatta Beating to Windward*. What separates Turner and Stanfield is Turner's experience of Venice. While its full impact was belated, Turner's first visit to Venice in 1819 was the turning point in his career, for it was there that he first began to understand the interaction of light, air and water fundamental to *Regatta Beating to Windward*. Just how important the Venetian experience was to Turner is further indi-

cated by two Venetian oils he painted in 1833 as a challenge to Stanfield, whom the intensely competitive artist regarded as his rival, along with Constable. Those two pictures precipitated Turner's return to Venice later that year and marked the commencement of a long series of Venetian scenes.

PROVENANCE: John Nash; Christie's, London; Tiffin, London; E. W. Parker, Skirwith Abbey; Christie's, London; Thomas Agnew and Sons, London, jointly with M. Knoedler and Co.; M. C. D. Borden, Philadelphia; Colonel Ambrose Monell; Mrs. Harrison Williams; Max Safron, New York.
EXHIBITIONS: Royal Academy of Art, London, 1828, no. 113. *Exhibition of Old Masters*, Fort Worth Art Center, 1953, no. 17. *Turner in America*, John Herron Art Museum, Indianapolis, 1955, no. 23. *Your New Treasures: Six Years of Collecting*, Indianapolis Museum of Art, 1972, p. 58. *Turner 1775-1851*, Royal Academy, London, 1974, no. 321.
LITERATURE: J. Burnet, *Turner and his Works*, with a "Memoir" by P. Cunningham, London, 1852, p. 115, no. 144, 2nd ed., 1859, p. 101, no. 146. W. Thornbury, *The Life of J. M. W. Turner, R.A.*, London, 2nd ed., 1877, p. 575, no. 150. P. G. Hamerton, *The Life of J. M. W. Turner*, London, 1879, p. 218. C. F. Bell, *A List of Works contributed to Public Exhibitions by J. M. W. Turner, R.A.*, London, 1901, p. 109, no. 157. Sir W. Armstrong, *Turner*, London, 1902, p. 220. C. Mauclair, *Turner*, Paris, 1939, p. 166, no. 88. A. J. Finberg, *The Life of J. M. W. Turner, R.A.*, London, 1939, pp. 307, 487, no. 317. J. Rothenstein and M. Butlin, *Turner*, New York, 1964, p. 92. no. 71. G. Reynolds, *Turner*, London, 1969, p. 123; *idem*, "Turner and East Cowes Castle," *Victoria and Albert Museum Yearbook*, I, 1969, p. 67 f. L. Herrmann, *Turner*, London, 1975, pp. 33, 232, pl. 119. M. Butlin and E. Joll, *The Paintings of J. M. W. Turner*, New Haven, 1977, I, p. 135, no. 242, II, pl. 262. A. Wilton, *J. M. W. Turner, His Art and Life*, New York, 1979, p. 272, no. P242.

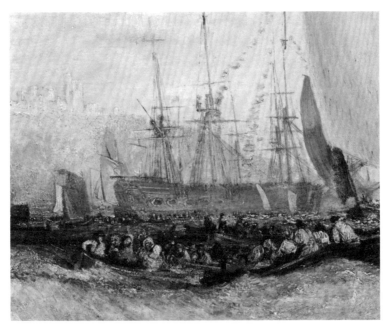

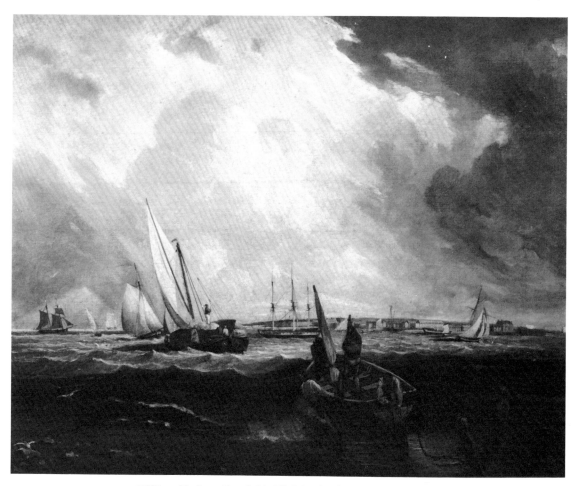

William Clarkson Stanfield. *Bligh Sands, Sheerness*. ca. 1830. oil on canvas, 40¼ x 50 (102.2 x 127). Gift of Mrs. Nicholas H. Noyes. 55.43.

JOHN BRETT
English, 1831-1902

Massa, Bay of Naples. 1864

oil on canvas, 25⅛ x 40⅛ (63.8 x 101.9)
James E. Roberts Fund
64.14

John Brett was born in 1831 in Surrey. In 1854, he began attending the Royal Academy, where he exhibited for the first time in 1856. After his introduction to the Pre-Raphaelites, he exhibited with them in 1857. John Ruskin and Brett were friends until 1865, when they had a scientific disagreement. In 1858 Brett spent the summer in the Italian Alps, to which he returned in the summer of 1861. He then spent the winters of 1861-1862 and 1862-1863 in Florence. He lived the next two winters near the Bay of Naples. He also visited Sicily in the winter of 1870-1871. Brett was elected an Associate of the Royal Academy, and was a Fellow in the Royal Astronomical Society. He died in 1902.

Brett's reputation rests largely on two early masterpieces painted under the influence of John Ruskin and the Pre-Raphaelite Brotherhood: *The Stonebreaker* (1857-1858, Walker Art Gallery, Liverpool) and *The Val d'Aosta* (1858, Sir William H. Cooper). Much of his later output consists of marine paintings which, although popular with collectors in their day, are tedious, despite their competence. Only those which retain some of his youthful inspiration are highly regarded today. Among the finest is *Massa, Bay of Naples,* painted in 1864. In the skillful massing of the composition, meticulous detail, and bracing, sunlit atmosphere, it is strikingly similar to the backgrounds in *The Stonebreaker* and *The Val d'Aosta.*

In 1856 Brett was attracted to the PRB, perhaps through contact with John Everett Millais who had been one of its founders eight years earlier with William Holman Hunt and Dante Gabriel Rossetti. Responding to the revolutionary mood of 1848, these artists wanted to reform social ills through art by painting serious subjects in opposition to the frivolous scenes in conventional English pictures. Much of their inspiration came from the book *Modern Painters* by John Ruskin, Turner's champion who was now to become their chief supporter as well. Ruskin praised the purity of Italian "primitive" painting before the High Renaissance and advocated truth to nature, writing

"Go to nature in all singleness of heart, selecting nothing, rejecting nothing." While these principles were too broad and contradictory, the cornerstone of the Pre-Raphaelite style, except for Rossetti's, remained Ruskinian naturalism and was based on techniques developed by Hunt, Turner, Ford Maddox Brown, John Linnell and the academic artist William Mulready. The Pre-Raphaelite painters applied sharply contrasting, often acidic colors to minutely detailed forms. These pigments were applied over a white ground in order to convey a sense of the sunlight saturating their scenes, which were sometimes painted outdoors.

By the mid-1850s, the PRB began to exercise considerable influence and attracted new adherents, including Edward Burne-Jones and William Morris, as well as Brett. Like many younger followers, however, Brett had only one true Pre-Raphaelite picture in him: *The Stonebreaker.* This work fulfills the group's social and artistic goals while eschewing the archaic mannerisms that often mar their romantic history paintings. Ruskin reviewed *The Stonebreaker* enthusiastically when it was exhibited at the Royal Academy in 1858. Small wonder, for a year earlier Brett had executed *The Glacier of Rosenlaui* (Tate Gallery, London) under the direct influence of Ruskin's *Modern Painters.* A second painting, *The Val d'Aosta,* was actually painted at

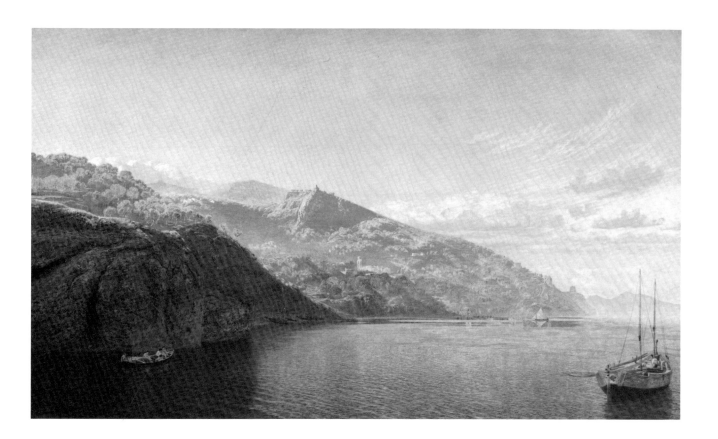

Ruskin's suggestion and under his tutelage. Unfortunately, Ruskin was privately disappointed by the canvas, although he praised it in print. While the painting achieved the perfect naturalism he had espoused, it did so at the expense of the emotional involvement central to Turner's landscapes. *The Val d'Aosta* is nevertheless a masterpiece of its kind, a *tour de force* of almost superhuman accuracy painted with a level of inspiration which Ruskin did not perceive. Despite Ruskin's rejection, Brett never deviated from the principles or style of *The Val d'Aosta. Massa, Bay of Naples* still conveys the freshness of Brett's earlier landscapes, but by 1870 the enthusiasm had gone out of his painting.

PROVENANCE: James Coats, New York.
EXHIBITIONS: Royal Academy, London, 1864. *The Revolt of the Pre-Raphaelites*, Lowe Art Museum, Coral Gables, 1972, no. 76. *The Pre-Raphaelite Era, 1848-1914*, Delaware Art Museum, Wilmington, 1976, no. 3-7.
LITERATURE: C. G. Coley, "Pre-Impressionist Landscapes in the Museum Collection," *Bulletin*, LI, 4, Dec. 1964, pp. 68-75. Allen Staley, *The Pre-Raphaelite Landscape*, Oxford, 1973, pp. 135-136, pl. 71b. W. H. Truettner, " 'Scenes of Majesty and Enduring Interest': Thomas Moran Goes West," *Art Bulletin*, LVIII, 2, June 1976.

GEORGES MICHEL
French, 1763-1843

Approaching Storm. ca. 1820-1825
oil on canvas, 23 x 28½ (58.4 x 72.4)
Delavan Smith Fund
55.221

Georges Michel was born in 1763 in Paris, where he was apprenticed in 1775 to the painter Leduc at the Academy of St. Luke. He worked in various parts of France and Germany to support his large family. Around 1790 he formed a close friendship with the landscape painter Lazare Bruandet. Michel exhibited at the Salon between 1791 and 1814. In 1800 he began working at the Louvre as a copyist and restorer, specializing in Dutch landscapes. For a brief period around 1808, he opened his own art school. He became a recluse from 1821 until his death in Paris in 1843.

Approaching Storm should be dated to the 1820s, when Michel was at the height of his powers. (Compare *The Storm,* 1820-1830, Musée des Beaux-Arts, Strasbourg.) While it relies on Michel's observation of nature, which remained the foundation of his art, the painting is indebted for its inspiration to landscapes by Jan van Goyen, Jacob van Ruisdael, Phillips Koninck and Rembrandt. Although he was born in 1763, Michel did not develop as an artist until the 1790s when, with his friends Lazare Bruandet and Jean Louis Demarne, he became an enthusiast of Northern Baroque landscape painting. His use of Dutch sources was of great importance, for it signalled the rise of Romanticism as an alternative to the Neo-Classicism which ruled French landscape painting until about 1820. The primary difference between the two schools was that whereas the Neo-Classicists subjected landscape to preconceived ideas of beauty and linked it to historical subjects, the Romantics remained truer to the appearance of nature, modifying the impression of a scene according to impulses of the imagination in order to evoke a heightened state of mind.

Michel was a direct precursor of the Barbizon school in spirit if not always in style, for he shared the emotional pantheism underlying all Romantic landscape painting. During the second and third decades of the nineteenth century, Michel's vision of the divine presence in nature became increasingly subjective. As Jean Bouret has observed:

> It was at this period, and for the remaining twenty years of his life, that he parted decisively with the prevailing fashion. The effects became broader, the handling more spirited, the style more powerful. Form was to some extent sacrificed in favor of greater expressive force. The dramatic pitch was intensified in the search for a pantheistic communion, as in Turner, or the German Caspar David Friedrich, although Georges Michel was guided solely by instinct.

Michel's visionary intensity is well conveyed by a statement he made to friends from his deathbed:

> Do not pity me. If you only knew what magnificent landscapes I see, even though my eyes are weak. If my arm had the strength I would paint things the like of which have never been seen.

(Quotes from J. Bouret, *The Barbizon School,* Greenwich, 1973, pp. 31-32)

PROVENANCE: James S. Inglis, New York; American Art Galleries, New York; William H. White Collection; Parke-Bernet Galleries, New York.
LITERATURE: Miller, p. 151.

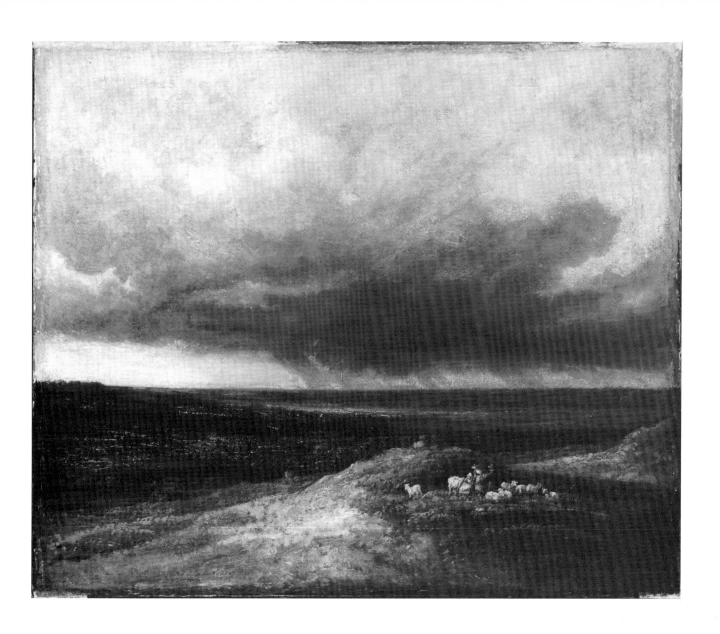

JEAN FRANÇOIS MILLET
French, 1814-1875

Peasant with a Wheelbarrow. 1848-1852

oil on canvas 14⅞ x 17⅞ (137.8 x 45.4)

signed l.r.: J. F. Millet

James E. Roberts Fund, and Gift of the Alumni
 Association of the John Herron Art School

49.48

Jean François Millet was born in 1814 at Gruchy near Greville on the coast of Normandy. He studied in Cherbourg with Mouchel in 1833 and with Langlois in 1835. Between 1837 and 1839 he attended the Ecole des Beaux-Arts in Paris, studying under Paul Delaroche. Millet married Pauline Virginie Ono in 1841; she died two years later. He entered the circle of Barbizon painters in 1846-1847, and moved to Barbizon in the forest of Fontainebleau in 1849. A state commission he received in 1852 provided funds which enabled him to stay in Barbizon. In 1853 he married his longtime companion, Cathérin Lemaire. That same year he won a medal at the Salon, followed by another medal at the Salon of 1864. He exhibited a large number of paintings at the Exposition Universelle of 1867. Millet was made a Knight of the Legion of Honor in 1868. During the Franco-Prussian War of 1870-1871, he travelled to Cherbourg and Greville. During that period, Durand-Ruel became his dealer. Millet fell ill in 1874 and died in Paris in 1875.

Peasant with a Wheelbarrow was begun in 1848 but was finished only in 1852, when Millet's agent, Alfred Sensier, was at last able to find a buyer for it, although the sale fell through. The artist repeated the main motif in several variants over the next few years, notably in an etching of 1855. Small works such as this reveal the more poetic side of Millet through their greater concern with the finish of the surface, inviting the viewer to admire the visual qualities of the painting. Despite its intimacy, *Peasant with a Wheelbarrow* presents a transition to the heroic vision of *The Sower* (Museum of Fine Arts, Boston) and the other epic canvases Millet executed for the French Salon in the 1850s. It is closely related as well to *The New Born Calf* (1864, Art Institute of Chicago), the last major figure painting Millet ever exhibited.

The Revolution of 1848 had elevated the Romantics, including the Barbizon School of which Millet was a member, to a new prominence while paving the way for a younger generation of Realists. As with Courbet's *Stone Breakers* (1849, Staatliche Gemäldegalerie, Dresden; destroyed), the choice of subject in *Peasant with a Wheelbarrow* was inherently radical because of its social implications. Millet treats this rural genre scene with the same seriousness normally accorded a classical subject. Although he disdained the ideal of history painting, the artist learned from the classical tradition how to monumentalize his figures, while adding Romantic overtones largely absent from Courbet's canvases. In this way, the peasant in the Indianapolis picture becomes a timeless symbol of a rapidly disappearing rural way of life idealized by Millet because of its closeness to nature and God, in contrast to the decadence of urban society.

PROVENANCE: Mrs. C. J. Morrill, Boston; Miss A. W. Morrill, Boston; William Heinnemann, London (?); R. Vose Galleries, Boston; Howard Young; John Levy Galleries, New York; Frederick T. Haskell, Chicago; E. and A. Silberman Galleries, New York.
EXHIBITIONS: Museum of Fine Arts, Boston, 1905. *Notable Paintings from Mid-Western Collections,* Joslyn Art Museum, Omaha, 1956. *The Great Century in France, 1800-1900,* Notre Dame University Art Gallery, South Bend, 1959. *Romantics and Realists,* Wildenstein Galleries, New York, 1966, no. 60. *Jean-François Millet,* Grand Palais, Paris, 1976, no. 68, and Hayward Gallery, London, 1976, no. 44.
LITERATURE: Léonce Bénézit-Constant, *Le livre d'or de J.-F. Millet par un ancien ami,* Paris, 1891, p. 55. E. Moreau-Nélaton, *Millet raconté par lui-même,* Paris, 1921, I, pp. 107-108, fig. 64. R. Cole, "Peasant with a Wheelbarrow, by Millet," *Bulletin,* XXXVII, 1, Apr. 1950, pp. 4-6. Miller, pp. 168-169.

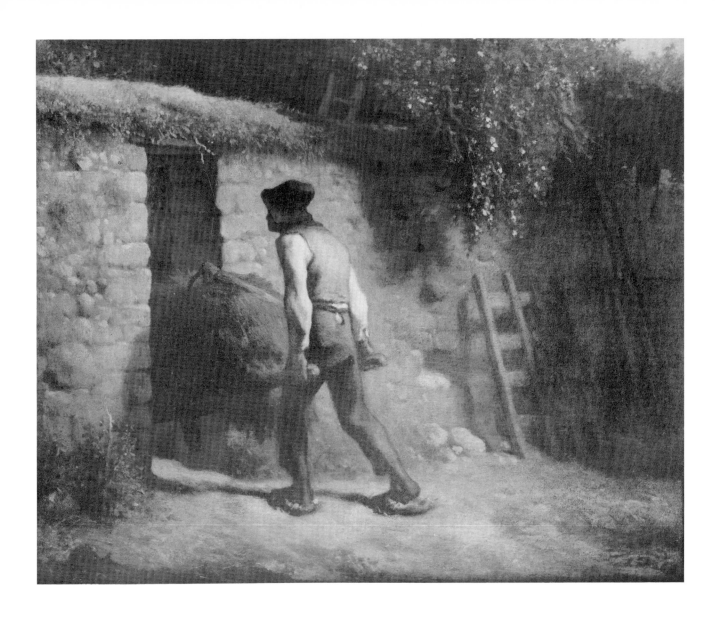

GUSTAVE DORÉ
French, 1832-1883

Torrent in the Highlands. 1881

oil on canvas, 20 x 35½ (50.8 x 90.2)
signed and dated l.r.: G Doré/ 1881/G. Doré (falsely)
Gift of the Shaw-Burckhardt-Brenner Foundation,
 Inc.
72.17

Gustave Doré was born in 1832 in Strasbourg. His family moved in 1834 to Bourg-en-Gresse, where he studied at Olivier College and won the drawing prize in 1846. In 1848 he went to Paris to work with Henry Scheffer and for the publisher Philipon. He illustrated the first of many books in 1847, and began exhibiting at the Salon the following year. He travelled to Spain in 1855. During the 1860s Doré was at the height of his career as an illustrator, but his paintings were poorly received. He travelled during most of the summers in Italy and Switzerland. In 1868 he went to England to open the Doré Gallery; he returned to Britain in 1871, as well as in 1873 and 1874 when he also visited Scotland. He died in Paris in 1883.

Doré visited Scotland in 1873 and again the following year. His enthusiasm for the region is reflected in a letter he wrote to Amelie Edward after his first trip there: "Henceforth, when I paint landscapes, I believe that five out of every six will be reminiscences of the Highlands . . ." And, indeed, many of the landscapes from the last decade of his career show views of the Scottish Highlands. It is hardly surprising that he was attracted to them. His earlier Alpine scenes are filled with the romantic sense of the sublime, that delicious sense of awe experienced before grandiose views of nature so closely related to the picturesque. Scotland had inspired the picturesque landscapists of the eighteenth century, and, with its striking scenery and strange mythology, continued to provide a source of images and ideas for nineteenth-century Romantics.

Doré's landscapes exemplify the same mentality as his illustrations for numerous books—including the Bible, Dante's *Divine Comedy* and Milton's *Paradise Lost.* They reveal an endlessly fertile imagination that was fascinated by the supernatural. Equally macabre are many of the ambitious history paintings he sent to the Salon throughout his career, despite the critical disdain they constantly received. This affinity for the bizarre, which was shared by Romantics from Eugène Delacroix through Gustave Moreau and the Symbolists, helps to explain why *Torrent in the Highlands* has little in common with contemporary Barbizon and Impressionist landscape painting in France. He was moved not by nature's intimacy but by her grandeur, which he captured in *Torrent in the Highlands* by imposing the striking effects and eerie moods found in landscapes by contemporary Scottish artists, such as Alfred Glendening and Alfred de Breanski, and in earlier paintings by Phillipe de Loutherbourg, Doré's fellow countryman who worked in England toward the end of the previous century.

PROVENANCE: Private Collection, Paris; Couper Gallery, London; H. Shickman Gallery, New York.
EXHIBITION. *Your New Treasures: A Six Year Exhibition,* Indianapolis Museum of Art, 1972, p. 62.

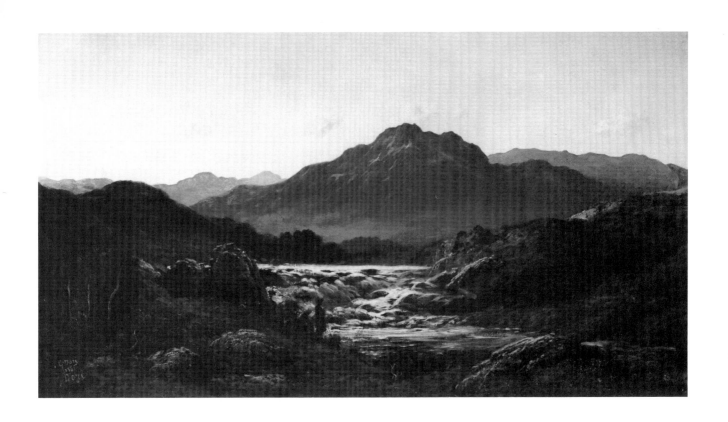

CAMILLE PISSARRO
French, 1830-1903

The Banks of the Oise near Pontoise. 1873
oil on canvas, 15 x 22¾ (38.1 x 57.8)
signed and dated l.l.: C. Pissarro 1873
Gift of James E. Roberts
40.252

Camille Pissarro was born in 1830 in St. Thomas in the Danish West Indies. He spent several school years in Paris before he was called back in 1847 to his native St. Thomas. From there he went to Caracas, Venezuela, in the company of a painter from Copenhagen, Antoine Melbye. In 1855 Pissarro returned to Paris to study at the Ecole des Beaux-Arts and the Académie Suisse. In 1863 he exhibited at the Salon des Refusés. Because of the Franco-Prussian War, Pissarro fled to England in 1870; that same year he married Julie Vellay. In 1871 he returned to France, and settled in Pontoise during the following year. Pissarro participated in all the Impressionist exhibitions between 1874 and 1886. In 1875 he helped establish a new artists' association, L'Union, from which he resigned in 1877. In 1882 he moved to Osny near Pontoise. His first one-man show at Durand-Ruel was held in 1883. The following year he moved to Eragny near Gisors. In 1885 Pissarro met Signac and Seurat, and soon adopted their Neo-Impressionist style. He exhibited in Belgium with Les XX in 1887 and 1890. In 1889 he developed a chronic eye infection which forced him to paint behind closed windows. By 1890 Pissarro had abandoned Neo-Impressionism. That year he went to London to visit his son, Lucien, who had settled there. He returned to London again in 1892 and 1897. From 1896 on, he divided his time between Eragny, Rouen, and Paris. He died in Paris of blood poisoning from an infection in 1903.

Dated 1873, *Banks of the Oise near Pontoise* was painted during the most consistently satisfying phase of Pissarro's career. The turning point in his development came in 1870-1871 when he fled to London to escape the Franco-Prussian war. There he was joined by his friend and early champion, Charles François Daubigny, as well as by Alfred Sisley and Claude Monet, for whom the London sojourn proved equally pivotal. As the result of this close contact, Pissarro's style matured rapidly, and his paintings acquired a highly individual character which the critic Theodore Duret aptly described in 1873: "You haven't Sisley's decorative feeling nor Monet's fanciful eye, but you have what they have not, an intimate and profound feeling for nature and power of brush, with the result that a beautiful picture by you is something absolutely definitive." His paintings of these years are notable for their firm construction, placing them second only to the compositions by his friend Paul Cézanne in strength. This underlying structure provided the framework for securely placing each brushstroke within landscapes that are often remarkably rich and complex.

As in several of Pissarro's landscapes from 1872-1873, *Banks of the Oise near Pontoise* has a flatness otherwise rare in his work. This flatness allowed Pissarro to concentrate primarily on capturing the vast expanse of sky and the effect of its silvery light across the landscape.

Banks of the Oise near Pontoise also documents the altered relation between man and nature that emerged in France during the middle of the nineteenth century. Significantly, the artist has included a boat and smokestack, but with such casualness that they seem as natural a part of the landscape as the trees. Such manifestations of industrialization were shunned by the Romantics and the Realists, and were generally edited out by the other Impressionists, although they do appear occasionally in works by Degas and Monet. Yet they are a regular feature of Pissarro's

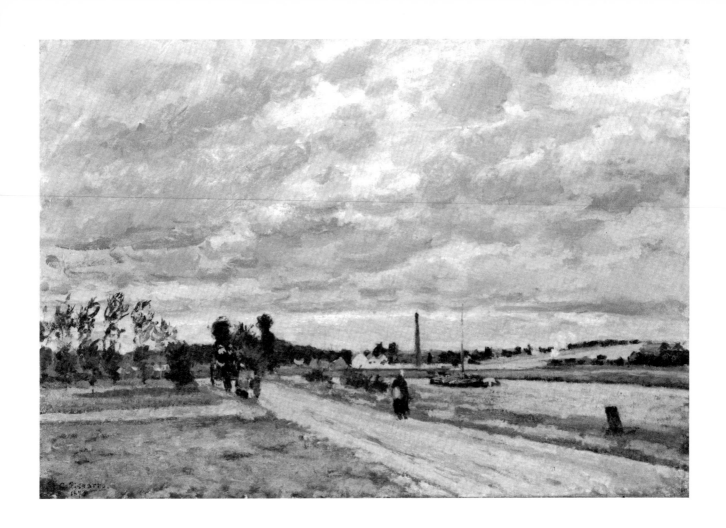

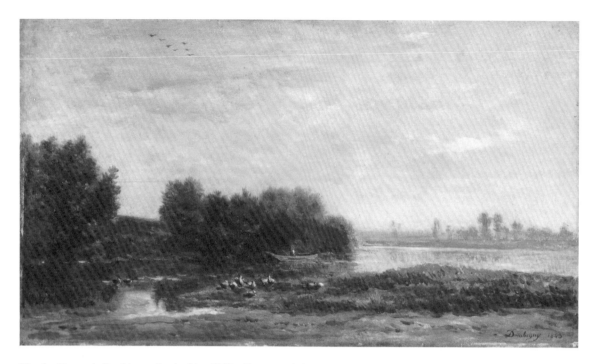

Charles François Daubigny. *On the Oise.* 1863. oil on panel. 9 x 15 (22.9 x 38.1). Gift of William H. Thompson. 39.79.

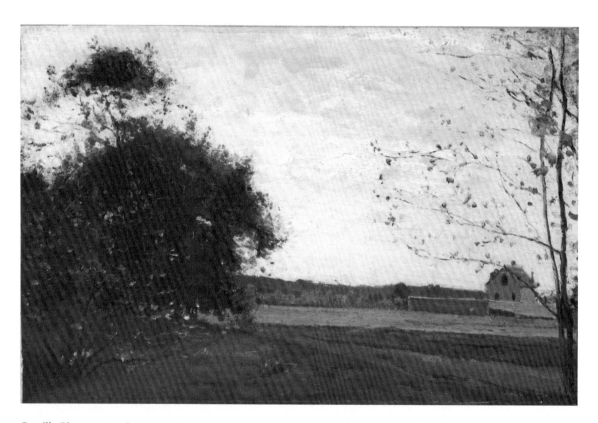

Camille Pissarro. *Landscape.* ca. 1865. oil on canvas, 11¼ x 17⅜ (28.6 x 44.2). Gift of Mrs. Joseph E. Cain. 75.981

scenes and appear in nine other paintings of the same locale executed by him in 1872-1873 (see, for example, *The Oise Near Pontoise*, Francis and Sterling Clark Institute, Williamstown). Despite the fact that the Impressionists often painted cityscapes, there was otherwise no strong interest in depicting the industrial landscape until the 1890s, when Neo-Impressionists such as Maximilien Luce often focused their attention on factories (compare *The Hills at Charleroi* in the IMA). Like Luce, Pissarro was an Anarchist by persuasion, but his paintings are not overtly political statements. The figures in *Banks of the Oise near Pontoise* exist pictorially without further comment.

Banks of the Oise near Pontoise forms an enlightening comparison with the IMA's *On the Oise* done ten years earlier by Daubigny, one of many such scenes painted by the artist after 1857 along this and other French rivers from his boat, *Le Botin*. Daubigny's picture has a plein-air freshness and sketch-like immediacy that anticipates, indeed influenced, Impressionism. Yet it is obvious at a single glance that Pissarro's brushwork is freer, his tonality lighter. Under the influence of optical discoveries made earlier in the century by Chevreuil and other scientists, the Impressionists treated shadows as colored light. This approach led them to omit the dark hues traditionally used to establish the tonal contrast with the lightest colors and thus to provide a reference point for all intermediate pigments in a painting. Hence, the palette in *Banks of the Oise near Pontoise* is correspondingly higher in key

than in Pissarro's earlier *Landscape* of ca. 1865 in the IMA, which is similar in its coloration to Daubigny's picture. The sketching technique captures the immediacy of the artist's visual and personal response to nature in *Banks of the Oise near Pontoise*, and the broad brush weaves a rich tapestry of senuous color, adapted from the work of Delacroix, to overcome the flatness of the surface. While the subject and color testify to his identification with nature, Pissarro's humility before her—which he shared with Corot and Daubigny—led him to record *Banks of the Oise near Pontoise* with an objectivity akin to the positivism of nineteenth-century science and philosophy. Missing therefore is the passionate projection of self into nature found in Michel's *Approaching Storm*, the atmospheric poetry of Daubigny's *On the Oise* or the glorification of rural life by Millet's *Peasant with a Wheelbarrow*. It is only when *Banks of the Oise near Pontoise* is compared to John Brett's *Massa, Bay of Naples* that the subjective latitude of Pissarro's naturalism becomes fully apparent.

PROVENANCE: Durand-Ruel Galleries, Paris; M. de la Chapelle, Paris; Lefevre Galleries, London; Dr. Honeyman, Scotland; Theodore Schempp, New York.
EXHIBITION: *Delacroix à Dufy*, Montreal, 1938, no. 24.
LITERATURE: L. Venturi and L. R. Pissarro, *Camille Pissarro, Son Art, Son Oeuvre*, Paris, 1931, I, p. 110, no. 222. R. Tschaegle, "The Banks of the Oise, Near Pontoise," *Bulletin*, XXVIII, 1, Feb. 1941, pp. 7-13. Miller, p. 179.

PAUL CÉZANNE
French, 1839-1906

House in Provence. ca. 1885

oil on canvas, 25½ x 32 (64.8 x 81.3)

Gift of Mrs. James W. Fesler in memory of Daniel
 W. and Elizabeth C. Marmon

45.194

Paul Cézanne was born in 1839 in Aix-en-Provence, where he attended Joseph Gilbert's art classes at the Ecole des Beaux-Arts in 1856-1858. At his father's insistence, he studied law in Aix from 1858 to 1861. After quitting law school, Cézanne went to Paris in 1861 to study at the Académie Suisse. That same year he became discouraged and returned to Aix to work in his father's bank. In 1862 he was once again in Paris where he apparently failed the entrance examinations for the Ecole des Beaux-Arts. By this time he had met the painters who would later be known as the Impressionists. In 1863 Cézanne exhibited at the Salon des Refusés. In order to avoid the draft, he went to L'Estaque in 1870 and 1871. For a brief period in 1871 he was in Paris before settling in Auvers-sur-Oise with Dr. Paul Gachet in 1871. Between 1872 and 1874 he often painted with Pissarro at Pontoise. He participated in the first group exhibition of the Impressionists but refused to be in the second one. During 1875 to 1879 he lived primarily in Paris. From May to October of 1881, Cézanne was in Pontoise with Pissarro, who introduced him to Gauguin. In 1882 he participated in his first and only Salon. From that time on, he lived in Aix. He wed his long-time companion, Hortense Fiquet, and became financially independent after inheriting his father's fortune in 1886. In 1890 he exhibited with Les XX in Brussels, and had his first one-man show at Ambroise Vollard's gallery in Paris. He sold his house in Aix in 1899, and although his wife and son went to live in Paris, he remained in Aix. In 1899 and 1901 he exhibited at the Salon des Indépendants. Despite his growing fame, he was refused the Legion of Honor in 1902. An entire room was given to his paintings, however, at the Salon d'Automne in 1904. At the time of his death from pneumonia in 1906, he was the undisputed master of the new generation of artists.

House in Provence, painted around 1885, is a classic example of Cézanne's mature style. Even more boldly than in *The Artist's House, Petite Place, Argenteuil* of 1874 by Alfred Sisley in the IMA, the essential forms underlying nature are treated as abstract geometric shapes which have been distributed across the surface in a series of horizontal lines punctuated by carefully placed vertical accents. The result is a subtle tension between two- and three-dimensional space which is most apparent in the house, as well as in the nearby paths, where there are numerous slight but important adjustments in forms and their visual relationships. Color is treated as an integral part of the overall design as well. Each hue suggests a different layer of depth but is carefully harmonized with the other pigments to help integrate the surface.

Since the Renaissance, the problem of two-dimensional design *versus* three-dimensional depth has been central to the traditionally illusionistic pictorial space of Western art. In the 1850s and 1860s, however, Courbet and especially Manet had posed the dilemma anew by radically flattening forms and, consequently, space. To overcome the difficulty posed by this flatness, the Impressionists wove an increasingly decorative tapestry of color. Although he was of the same generation as the Impressionists and associated with them, Cézanne was a recluse who pursued an independent path. In personality he was as astringent as the scenery he often favored. His response to nature was slower, more deliberate than Monet's, so that his paintings lack the immediacy, his color the optical qualities of Impressionism. Cézanne stated that he

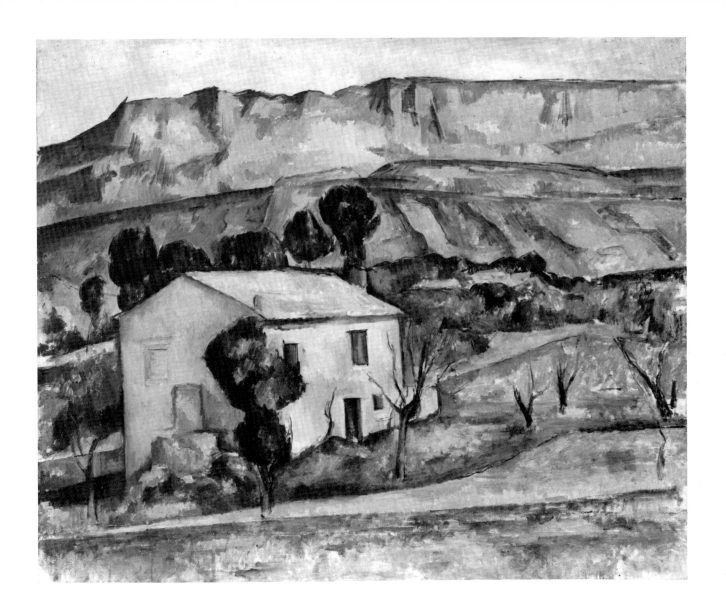

wanted "to make of Impressionism something solid and durable, like the art of the museums." Finding naturalism insufficient to this task, he investigated fundamental problems of form, composition and space in order to reduce undifferentiated nature to its visual essence—based on the cone, the sphere and the cylinder—in a way that is aesthetically and ex- pressively satisfying. Despite the formalism and complexity of his paintings, Cézanne's analytic approach was intuitive rather than rational. Like his other great works, *House in Provence* reveals an underlying poetry which was the real goal of his art.

Alfred Sisley. *The Artist's House, Petite Place, Argenteuil.* 1874. oil on canvas, 18⅛ x 15 (46 x 38.1). James E. Roberts Fund. 52.33.

PROVENANCE: Henri Bernstein Gallery, Paris; Ambroise Vollard, Paris; Auguste Pellerin, Paris; Paul Cassirer, Berlin; Dr. J. F. Reber, Lausanne; Marie Harriman Gallery, New York; Mrs. James W. Fesler, Indianapolis.

EXHIBITIONS: *Internationale Kunstausstellung,* Dresden, 1926, no. 79. *Cézanne-Gauguin,* Toledo Museum of Art, 1936, no. 19. *Cézanne,* San Francisco Museum of Art, 1937, no. 19. *Art as Expression of Emotion,* San Francisco Museum of Art, 1939. *Seven Centuries of Painting,* California Palace of the Legion of Honor, San Francisco, 1940, L-106. *The Art of the Third Republic; French Painting, 1870-1940,* Worcester Art Museum, 1941, no. 7. *Tribute to Caroline Marmon Fesler,* John Herron Art Museum, Indianapolis, 1961, no. 11.

LITERATURE: L. C. Bourgmeyer, "The Master Impressionists," *Fine Arts Journal,* XXIX, 2, Dec. 1913, p. 458. A. Vollard, *Paul Cézanne,* Paris, 1914, pl. 47. C. Bell, *Art,* London, 1914, pl. opp. p. 199. J. Meier-Graefe, *Cézanne und Sein Kreis,* Munich, 1922, p. 205, English ed. London, 1927, pl. LXX. L. Venturi, *Il Gusto dei Primitivi,* Bologna, 1926, pl. 88. K. Pfister, *Cézanne, Gestalt-Werk-Mythos,* Potsdam, 1927, pl. 85. Ozenfant and Jeanneret, *La Peinture Moderne,* Paris, 1927, p. 30. G. Riviere, *Cézanne, Le Peintre Solitaire,* Paris, 1933, p. 105. F. J. Mather, *Concerning Beauty,* Princeton, 1935, pl. before p. 201. L. Venturi, Jr., *Cézanne, Son Art, Son Oeuvre,* Paris, 1936, I, p. 55, II, pl. 125, no. 433. J. Rewald, *Cézanne et Zola,* Paris, 1936, pl. 56. F. Novotny, *Cézanne und das Ende der Wissenschaftlichen Perspektive,* Vienna, 1938, figs. 7, 8. *idem, Cézanne,* New York, 1939, pl. 51. R. Cogniet, *Cézanne,* New York, 1939, pl. 60. *The Marmon Memorial Collection of Paintings,* John Herron Art Museum, Indianapolis, 1948, pp. 26-31. J. M. Carpenter, "Cézanne and Tradition," *Art Bulletin,* XXXIII, 3, Sep. 1951, p. 174 f. M. Schapiro, *Paul Cézanne,* New York, 1952, p. 71. H. W. and D. J. Janson, *The Picture History of Painting,* New York, 1957, p. 259, no. 413. P. Beam, *The Language of Art,* New York, 1958, p. 140, fig. 80. K. S. Champa, "Modern Drawing," *Art Journal,* XXV, 3, Spring 1966, p. 231. Miller, pp. 186-188. C. Ikegami, *Cézanne,* Tokyo, 1972, pl. 33. N. Wadley, *Cézanne and his art,* London, 1975, p. 39, pl. 38. G. Hubbard and M. J. Rouse, *Art: Choosing and Expressing,* Westchester, Ill., 1977, p. 21.

PAUL GAUGUIN
French, 1848-1903

Landscape near Arles. 1888

oil on canvas, 36 x 28½ (91.4 x 72.4)
Gift in memory of William Ray Adams
44.10

Paul Gauguin was born in Paris in 1848. He was successfully employed by a brokerage firm in 1873 when he began to paint. One of his paintings was accepted for the Salon of 1876. Through Pissarro, Gauguin was introduced to the Impressionists, and exhibited in their group shows between 1879 and 1886. By 1883 Gauguin, confident of his ability to succeed as a painter, left the brokerage firm. He moved his family to Copenhagen, the home of his wife, and worked there until 1885, when he left his family and returned to France. He was active primarily in Brittany between 1886 and 1890, except for a trip to Martinique in the Antilles in 1887 and a short stay in Arles with Van Gogh in 1888. He moved to Tahiti in 1891 but returned to France in 1893. In 1895 he was back in Tahiti, living first at Papeete, then at Dominique in the Marquesas archipelago. He died at Atuana in 1903.

The vegetation identifies the locale as Arles, rather than Brittany as had been thought before, and therefore dates the painting to the two months from October 20 until December 25, 1888 Gauguin spent there with Van Gogh. The canvas is of exceptional quality and interest. Save for some of the more acid hues and broken brushwork, there is little to suggest Van Gogh's presence. On the contrary, the style is clearly indebted in the main to Cézanne (compare the IMA's *House in Provence* of a few years earlier), from whom the artist assimilated a great deal during the mid-1880s. Cézanne's influence reflects Gauguin's interest in formal problems of shape and composition. The re-emergence of that concern in late 1888 is, however, both curious and significant.

During his visit to Martinique in the previous year, Gauguin had begun to define the decorative approach to painting he had been seeking, a tendency which was reinforced decisively upon his return to Pont-Aven, Brittany, in early 1888 and his renewed acquaintance there with Emil Bernard. Bernard had formulated a series of theories growing out of experiments he had run with Louis Anquetin. These theories were then appropriated by Gauguin as his own and developed further by him. Reacting against naturalism's acceptance of the visible world, they treated nature at a remove by freely altering her appearance in order to inject the artist's responses and to suggest hidden spiritual meaning. By treating nature in a decorative manner with abstract forms, flat space and unnatural colors; they turned their pictures from representations of the external world into aesthetic objects projecting personal states of mind. Gauguin and the Pont-Aven group were among numerous artists who participated in Symbolism (as this late form of Romanticism came to be called), which was by no means confined to a Post-Impressionist style. Symbolism, in art as in literature, was not a movement as such, since its content permitted a wide variety of stylistic solutions. The sympathy between the Pont-Aven painters and the Symbolist poets is indicated, however, by the fact that the writer G. Albert Aurier defined Symbolism in a long article published in April, 1892, in which he insisted on Gauguin's leadership.

The reversion to a Cézannesque style in *Landscape near Arles* would seem at face value to represent a retrenchment. In reality, it indicates Gauguin's need to put his art on a firmer foundation by reconsidering the lessons he had absorbed from Cézanne's example. Every form, color and brushstroke has been carefully placed within a composition which is remarkable for its structural severity. The result successfully inte-

grates the divergent approaches of *Jacob Wrestling with the Angel* (National Gallery of Scotland, Edinburgh) and *The Swineherd, Brittany* (Norton Simon Museum, Los Angeles), which were painted the previous summer. The importance of this achievement emerges even more clearly in *The Red Cow* (Los Angeles County Museum of Art), *The House at Pan Du* (Armand Hammer Collection, Los Angeles County Museum of Art) and *Farm at Poldu* (Emery Reves Collection). Done in Brittany in 1890, they pursue the same goal still further. But perhaps the most telling consequence is seen in *The Yellow Christ* (1890, Albright-Knox Gallery, Buffalo), which elides the distinction between the physical and spiritual worlds by setting the icon-like subject against a landscape similar to *Landscape near Arles*. These paintings inform us that Gauguin could admire but not share the simple Christian piety of the Bretons or the intense pantheism of Van Gogh. In the end, he believed it was man who gave meaning to nature. Only in Tahiti did the artist finally discover that his answer to the spiritual bankruptcy of modern civilization lay in primitive magic, which through psychological projection invests the world with demons personifying every aspect of nature—and of man himself.

PROVENANCE: Justin Tannhäuser, Munich; Baron August von der Heydt, Elberfeld, Switzerland; Neumann Barmen; Captain Ernest Duveen, London; Hugo Perls, New York; M. Knoedler and Co., New York.

EXHIBITIONS: *Bâtiments des Expositions Libres*, Copenhagen, 1893, no. 156. *Masters of French 19th Century Painting*, New Burlington Galleries, 1936, no. 97. *French Art of the XIXth and XXth Centuries*, Rhode Island School of Design Museum, Providence, 1942, no. 28. *The Springtime of Impressionism*, Columbus Gallery of Fine Arts, Ohio, 1948, no. 9. *Paul Gauguin: His Place in the Meeting of the East and West*, Museum of Fine Arts of Houston, 1954, no. 11. *Exhibition of Paintings, Engravings and Sculptures of Gauguin*, Scottish Academy, Edinburgh, and Tate Gallery, London, 1955. *Gauguin*, Art Institute of Chicago, 1959, no. 14. *Cent Oeuvres de Gauguin*, Galerie Charpentier, Paris, 1960, no. 39. *Paul Gauguin*, Haus der Kunst, Munich, 1960, no. 38. *Cézanne, Gauguin, Van Gogh, Seurat*, Kunstverein, Hamburg, 1963, no. 44. *Olympian Progeny: French Impressionist and Post-Impressionist Paintings*, Wildenstein Gallery, New York, 1965, pl. 52. *The Early Work of Paul Gauguin*, Cincinnati Art Museum, 1971, no. 19.

LITERATURE: C. G. Heise, *Die Sammlung des Feiherren August von der Heydt*, Elberfeld, 1918, no. 93. J. de Rotonchamp, *Gauguin*, Paris, 1925, pp. 66-67. J. Rewald, *Gauguin*, New York, 1938, pl. 65. H. Read, *Gauguin*, New York, 1951, p. 7. G. Bazin, *L'Epoque Impressioniste*, Paris, 1953, p. 113. G. Wildenstein, *Gauguin*, Paris, 1964, pp. 114-115, no. 308. R. Huyghe et al., *Paul Gauguin*, Paris, 1961, p. 116. H. Platte, *Die Maler des grossen Lichtes*, Brunswick, 1967, p. 114. F. Cachin, *Gauguin*, Paris, 1968, fig. 57, p. 129. Miller, pp. 192-193.

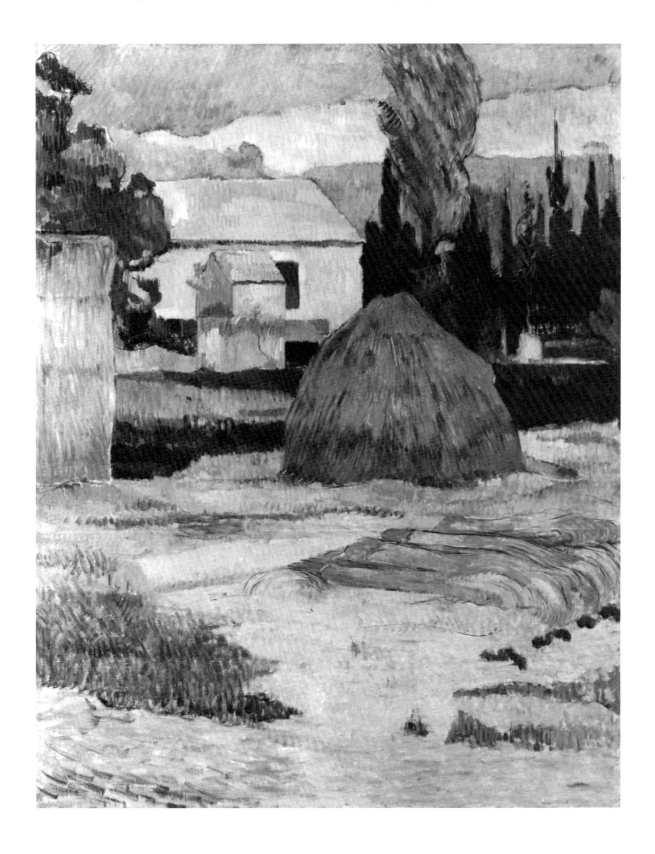

185

VINCENT VAN GOGH
Dutch, 1853-1890

Landscape at Saint-Rémy (The Ploughed Field). 1889
oil on canvas, 29 x 36¼ (73.7 x 92.1)
Gift in memory of Daniel W. and Elizabeth C. Marmon
44.74

Vincent van Gogh was born in 1853 in the village of Groot-Zundert in the Dutch Brabant. In 1869 he began working at The Hague office of the French art dealers Goupil and Co. The company transferred him to London in 1873 and to Paris in 1875, but dismissed him in 1876 as incompetent. He spent most of 1876 and 1877 in England, then worked briefly in Dordrecht as a bookseller. He began studying for the ministry in 1877 in Amsterdam but gave up before taking the examinations. In 1878 he enrolled in a training school for lay preachers in Brussels and was once again unsuccessful. In 1879 he went to the coal-mining region in southern Belgium called Borinage. He preached there, as an unsponsored lay minister, in Wasmes and Cuesmes. In 1880 he began drawing and moved to Brussels. He lived in The Hague from 1882 to 1883 and then spent the following two years living with his parents in Nuenen. In 1885 he moved to Antwerp for a brief time and enrolled in formal art classes. After moving to Paris in 1886 to live with his brother, Theo, he met the Impressionists and Post-Impressionists. He developed a lasting friendship with Camille Pissarro. In 1888 he moved to Arles, where he was joined for several months by Paul Gauguin. There he suffered his first attack of mental illness and was hospitalized. In 1889 he was transferred to the Saint-Rémy Hospital. In the spring of 1890 he settled at Auvers-sur-Oise to be near Dr. Paul Gachet but committed suicide in July of that year.

Datable to mid-October, 1889, *Landscape at Saint-Rémy (The Ploughed Field)* belongs to a group of ten canvases showing the same wheat field. All were executed by Van Gogh between June, 1889 and the spring of 1890 while he was convalescing at the Saint-Paul Asylum after suffering a nervous breakdown in Arles the previous Christmas Eve. Ours is closest to two paintings in the Kröller-Müller Museum, Otterloo, and the Museum Folkwang, Essen. A photograph confirms that the painting depicts the view from his hospital room which he described in a letter of late May, 1889 to his brother Theo concerning an earlier *Mountainous Landscape* (National Museum, Copenhagen):

> I am working on two canvases . . . One is the country I see from the window of my bedroom. In the foreground, a field of wheat ruined and hurled to the ground by a storm. A boundary wall and beyond the gray foliage of a few olive trees some huts and the hills. (*Complete Letters*, no. 594)

In the few months separating the two canvases, Van Gogh made rapid artistic strides, and *Landscape at Saint-Rémy* must be included among his finest masterpieces.

As a series of letters to Theo and Emile Bernard makes clear, *Landscape at Saint-Rémy* was painted as a kind of pendant to complement *The Reaper* (V. W. van Gogh, Laren), which shows the same field, although the composition and palette are very different:

> I have just brought back a canvas on which I have been working for some time representing the same field as in the "Reaper." Now it is clods of earth and the background of sky with a little white and violet cloud. In the foreground a thistle and some dry grass. A peasant dragging a truss of straw in the middle.
>
> It is again a harsh study and instead of being almost entirely yellow, it makes a canvas al-

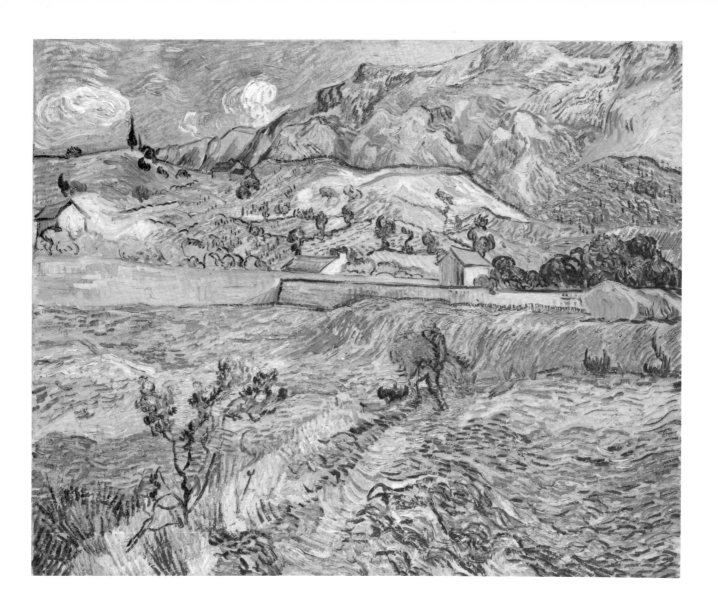

most entirely violet. Blended violet and neutral tints. But I am writing to you because I think this will complete the "Reaper" and will make clearer what it is. For the "Reaper" looks as though it were done at random and this will give it balance. . . .
(*Complete Letters*, no. 619)

Today I sent off some canvases, as follows: "Ploughed Field," with background and mountains—it is the same field as the reaper's of last summer and can be a pendant to it; I think that one will set off the other.
(*Complete Letters*, no. 621)

I have been more master of myself in these last studies because my health has steadied. For instance there is also a size 30 canvas with ploughed fields, broken lilac and a background of mountains rising to the very height of the picture; so nothing but rough fields and rocks with a thistle and some dried grass in a corner, and also a little fallow, violet and yellow.
(*Complete Letters*, III, p. 520)

Much has been made of Van Gogh's unstable personality, but it should be kept in mind that, as the preceding letter attests, he was unable to work effectively during his bouts of insanity. *Landscape at Saint-Rémy* nevertheless demonstrates the artist's volatile character and, more important, his visionary intensity.

If *The Reaper* can be regarded as a symbol of death, *Landscape at Saint-Rémy* seems hardly less pessimistic. Both convey as bleak a message as I Peter 1:24: "For all flesh is as grass, and all the glory of man as the flower of Grass. The grass withereth, and the flower thereof falleth away." As in the same Epistle, however, there is the hope of eternal life, implied by the meaning Van Gogh attached to certain colors. The artist had learned about Impressionist color from Pissarro, but his private color symbolism was probably stimulated most by discussions with Gauguin at Arles. Yellow, for example, meant faith or triumph or love to Van Gogh, while carmine was a spiritual color, cobalt a divine one. Red and green, on the other hand, stood for the terrible human passions. To build a literal interpretation of *Landscape at Saint-Rémy* on the basis of color symbolism alone would be a mistake. Yet it is apparent that by interviewing his color in such a complex fashion, Van Gogh created a constant play of contrasting emotions which are symphonic in their harmony. The universe pulsates with an inner life, communicated by the colors and by the graphic brushwork animating the surface. Perceived in an exalted state of mind, this cosmic vision transcends the limits of human existence.

Although he was not a Christian in a strict sense, Van Gogh's belief in a living God and his admiration for Christ were the cornerstones of his spirituality, which grew out of his deep concern for humanity. His experience as a lay minister had reinforced his powerful religiosity, which carried such conviction that it rose above doctrine. While his pantheism is typically Romantic in its emotionalism, Van Gogh's paintings have a profundity rare in the history of landscape.

PROVENANCE: Eleanor and Francesco von Mendelssohn-Bartholdy, Berlin; Giuliette Mendelssohn-Bartholdy, Berlin; Paul Rosenberg and Co., New York and Arnold Seligman, Rey and Co., New York; Mrs. James W. Fesler, Indianapolis.
EXHIBITIONS: National Galerie, Berlin, 1921. *Erste Sonderausstellung in Berlin*, Künstler Haus, Berlin, 1927, no. 112. *European and American Paintings, 1500-1900*, New York World's Fair, 1940. *Paintings by Vincent van Gogh*, Baltimore Museum of Art, 1942, no. 23. *The Art and Life of Vincent van Gogh*, Wildenstein & Co., New York, 1943, no. 51. *Tribute to Caroline Marmon Fesler*, John Herron Art Museum, Indianapolis, 1961, no. 9.
LITERATURE: J. B. de la Faille, *L'Oeuvre de Vincent Van Gogh, Catalogue Raisonné*, Paris, 1928, rev. ed., Amsterdam, 1970, no. 641. *Further Letters of Vincent van Gogh to His Brother, 1886-1889*, London, 1929, pp. 399-400, no. 610, p. 424, no. 621. W. Scherjon, *Catalogue des Tableaux par Vincent van Gogh, Periodes: St.-Rémy et Auvers*, Utrecht, 1932, p. 64. no. 58. Vincent van Gogh, *Letters to Emile Bernard*, New York, 1938, no. 20. J. B. de la Faille, *Vincent van Gogh*, London, 1939, p. 447, no. 649. *The Marmon Memorial Collection of Paintings*, Indianapolis, 1948, no. 32. P. Lecaldano, *L'Opera pittorica completa di Van Gogh*, Milan, 1966, II, pp. 222-223, no. 716. Miller, pp. 195-197.

GEORGES SEURAT
French, 1859-1891

The Harbor of Gravelines. 1890

oil on canvas, 29 x 36¾ (73.7 x 93.3)

signed l.r. on border: Seurat

Gift of Mrs. James W. Fesler in memory of Daniel
 W. and Elizabeth C. Marmon

45.195

Georges Pierre Seurat was born in 1859 in Paris. In 1874 he began attending classes at an art school run by the sculptor Justin Lequien.There he met Edmond Aman-Jean, who entered the Ecole des Beaux-Arts with him. Together they studied under Henri Lehmann, a pupil of Ingres. Seurat served a term in the army at Brest from 1879 to 1880. In 1880 and 1881 he travelled around France with Aman-Jean. In 1884 his first large canvas, *Une Baignade à Asnières,* was rejected by the Salon. This incident led him to help organize the Société des Artistes Indépendants, whose purpose was to exhibit works of all members. Many of the members of the Société soon became followers of Seurat. In 1885 Seurat began painting *La Grande Jatte;* that year he also began his first major landscapes at Grandcamp along the channel coast where he spent most of the following summers. In 1885 and 1886, Signac and Pissarro adopted Seurat's divisionist technique. Seurat met the mathematician Charles Henry in 1886. During 1887 he spent the summer in the army, and exhibited with Les XX in Belgium. Seurat was also included in Les XX exhibitions in 1889 and 1891. He died in Paris in 1891 of acute diptheria.

The Harbor of Gravelines is one of Seurat's supreme landscapes. It was done during the summer months of 1890, when the warm temperature was conducive to plein-air painting and when the light had a transparency more to the artist's liking than the denser, more subdued atmosphere of winter. The landscape derives from a small oil study (Dorra-Rewald no. 204, sold at Sotheby's, London, December 6, 1978), which adds to the foreground a sailboat, found also in a related drawing (Dorra-Rewald 204a, Solomon R. Guggenheim Museum, New York). An admirer of Monet, Seurat painted the same kinds of scenes as the Impressionists and expressed his allegiance to the earlier movement by adopting the term Neo-Impressionism for his style. Like Cézanne, however, he wanted to make a new "museum art" by putting painting on a firmer foundation than Impressionism provided. Thus, he faced many of the same problems of form, composition, space and color as Cézanne, but created very different solutions.

The Harbor of Gravelines embodies the approach Seurat put into practice in *The Grand Jatte* (1886, Art Institute of Chicago). There is a dignity and simplicity in the painting suggesting a new classicism, but it is a distinctly modern classicism based on scientific theory. Following the laws of color discovered by Eugène Chevreul, O.N. Rood and David Sutter, Seurat juxtaposed dots of complementary colors which in theory are supposed to fuse optically when viewed at the proper distance, but which in practice deliberately establish a subtle oscillation. At the very least, this technique, called divisionism or pointillism, achieved a more transparent luminosity than was possible with the opaque pigments used by the Impressionists.

Seurat's adaptation of optical physics was part of a comprehensive approach to art. With the help of his friend Charles Henry (who was, like Rood and Sutter, an American), he formulated a series of artistic "laws" based on early experiments in the psychology of man's visual perceptions of colors, forms, movements and compositions. These principles, which were further elaborated by his disciple Paul Signac, allowed Seurat to control every aesthetic and expressive aspect of his paintings.

The Harbor of Gravelines is based on Seurat's concept of calmness. In simplified terms, the composition has a strong horizontal thrust with offsetting verticals balanced above (gay) and below (sad) it. The predominantly light tonality (gay) consists of equal amounts of warm (gay) and cool (sad) colors within a contrasting, predominantly dark (sad) frame. The different color zones also help to create a sense of spatial depth behind the surface, although the picture seems at first glance like a jigsaw puzzle made up of flat shapes which have been reduced through a process of abstraction to a simpler geometry. These shapes are comparable with the figures in Seurat's *La Grande Jatte* (Art Institute of Chicago), which are distinctly reminiscent of the forms found in works by the great Renaissance artist Piero della Francesca, as well as in ancient primitive and oriental art, for which the Neo-Impressionists held great enthusiasm.

Seurat's lucid approach has the same logic as modern engineering, which he and such theorists as Charles Blanc hoped would transform society in a rational and beneficial way. Far from being contradictory, his social and artistic outlook was, in fact, quite unified. This social consciousness was allied to Anarchism and contrasted sharply with the political indifference of the Impressionists, who were generally passive in accepting the conditions of society around them. Thus, the machine-like quality of Seurat's forms expresses a peculiarly modern outlook leading to Futurism (compare Leger's *Man and Woman* in the IMA). For all of his theories, however, *The Harbor of Grave-* *lines* demonstrates that ultimately the success of Seurat's painting rests on his artistic sensitivity.

PROVENANCE: The Artist's Estate; Leon and Leopold Appert, Paris; D. W. T. Cargill, Lanark; Lefevre Gallery, London; Bignou Gallery, New York; M. Knoedler and Co., New York; Daniel W. and Elizabeth C. Marmon, Indianapolis.

EXHIBITIONS: *Les XX*, Musée Moderne, Brussels, 1891, no. 6. *Société des Artistes Indépendants*, Paris, 1891, no. 1105. *Exposition des Peintres Neo-Impressionistes*, Salon de l'Hôtel Brebant, Paris, 1892, no. 50. *Trente Ans d'Art Indépendant Retrospective, Société des Artistes*, Grand Palais, Paris, 1926, no. 3217. *Exhibition of French Art*, Burlington House, Royal Academy of Art, London, 1932, no. 559. *French Art*, Walker Art Gallery, Liverpool, 1933, no. 586. *Loan Exhibition of Paintings*, Art Gallery, Toronto, 1935, no. 194. *Seurat and His Contemporaries*, Wildenstein Galleries, London, 1937, no. 32. *French Art of The Nineteenth and Twentieth Centuries*, Rhode Island School of Design Museum of Art, Providence, 1942, no. 64. *Old Masters of Modern Art*, The Memorial Art Gallery, Rochester, 1944.

LITERATURE: J. Meier-Graefe, *Entwicklung der Modernen Kunst*, Stuttgart, 1904, I, p. 232. G. Coquiot, *Des Peintres Maudits*, Paris, 1924, p. 222. R. Fry, *Transformations*, London, 1926, p. 195. *Cahiers d'Art*, Paris, Oct. 1926, p. 209. no. 8. Ozenfant and Jeanneret, *La Peinture Moderne*, Paris, 1927, p. 33. J. Rewald, *Georges Seurat*, New York, 1943, p. 115, no. 34, p. 141. J. de Laprade, *Georges Seurat*, Monaco, 1945, p. 60, Paris (1951), p. 82. *Marmon Memorial Collection of Paintings*, John Herron Art Museum, Indianapolis, 1948, pp. 36-39. B. Taylor, *The Impressionists and Their World*, London, 1953, p. 84. J. Cassou, *Les Impressionistes et Leur Epoque*, Paris, 1953, pl. 84. J. Rewald, *Post-Impressionism from Van Gogh to Gauguin*, New York, 1956, p. 123. R. L. Herbert, "Seurat in Chicago and New York," *The Burlington Magazine,* May, 1958, p. 155. H. Dorra and J. Rewald, *Seurat*, Paris, 1959, pp. cii, 267, no. 205, fig. 39. C. M. de Hauke, *Seurat et Son Oeuvre*, Paris, 1961, I, p. 207, no. 208. R. Fry and A. Blunt, *Seurat*, London, 1965, pp. 21, 84-85, pl. 44. P. Courthion, *Seurat*, New York, 1968, p. 154. Miller, pp. 198-199. N. L. Prak, "Seurat's Surface Pattern and Subject Matter," *Art Bulletin*, LIII, 3, Sep. 1971, pp. 372, 376, fig. 13.

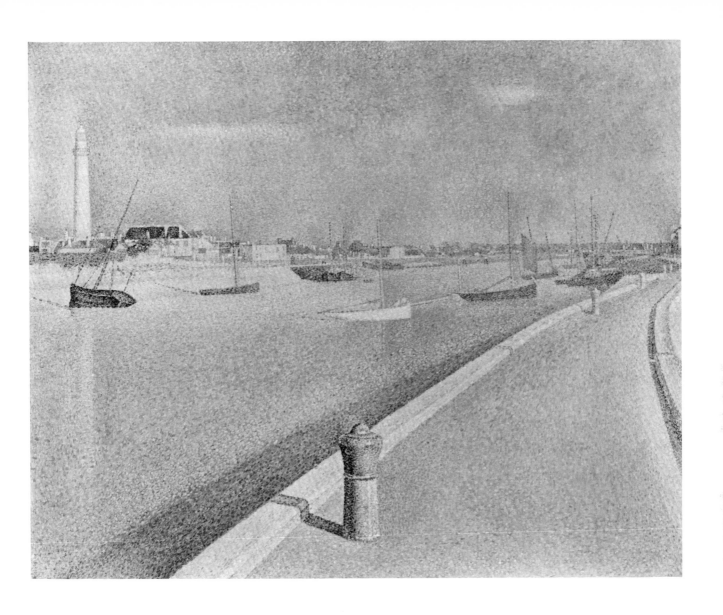

MAXIMILIEN LUCE
French, 1858-1941

La Rue Mouffetard. ca. 1889-1890
oil on canvas, 31⅝ x 25¼ (80.3 x 64)
signed l.r.: Luce
The Holliday Collection
79.311

Maximilien Luce was born in 1858 in Paris, where he was apprenticed to the wood engraver Hildebrand from 1872 to 1876. He then worked sporadically for Eugène Froment until 1885. He studied with Charles Carolus-Duran at the Ecole des Beaux-Arts in 1877 and 1878. After a brief period in the army in 1879 and 1880, he resumed his studies with Carolus-Duran until 1885. Around that time he had met the other Neo-Impressionists and exhibited with them at the Société des Artistes Indépendants from 1887 on. He also exhibited with Les XX in Belgium from 1889 to 1892. Luce was imprisoned in 1894 for associating with Anarchists. In 1895 he began visiting the "Black Country" of Belgium, and spent time there in Charleroi and the Sambre Valley. He was vice-president of the Société des Artistes Indépendants from 1910 to 1935, when he became President. He retained this office until his death in Paris in 1941.

With its elaborate theory, rigorous abstraction and mechanical technique, Neo-Impressionism was a reaction in the name of modernity against the transient effects, naturalism, personal response and sensuous canvases of the Impressionists. But as the broad range of style in the recently bequeathed Holliday Collection makes abundantly clear, Neo-Impressionism permitted a surprising latitude for the artistic expression of individual character. That diversity arose partly because of dissension within the movement that began even before Seurat's death in 1891, when there was already a growing tendency to adapt the principles of Neo-Impressionism to individual taste. Moreover, within a few years Signac, responding to elements inherent within Seurat's oil sketches, initiated a second phase of Neo-Impressionism distinguished by its mosaic of brilliant color (compare the IMA's *Rainbow* of 1899) and often decorative line approximating the arabesque patterns of Art Nouveau. Finally, there was increasing room for more naturalistic representation, exemplified by the paintings of Maximilien Luce who, with Henri Edmond Cross, ranks just behind Seurat and Signac as the most important Neo-Impressionist.

Luce's art cannot be separated from his background and character. Because of his experience as a craftsman, he was a highly independent individualist whose gruff directness concealed a humaneness and sensitivity revealed only to his friends. Luce's sensitivity is discovered in his landscapes, especially those of the Bièvre river and the Seine at Herblay, where he spent his summers. The other side of his personality is expressed in his views of Montmartre, as well as his industrial landscapes of Belgium's "Black Country" (such as the IMA's *Hills at Charleroi* of 1898).

Montmartre was a market and working-class district which had mushroomed during the rapid growth of Paris after 1850. By nature and political persuasion Luce felt at home in these proletarian surroundings, which he documented over the course of his long career. Like most Neo-Impressionists he was an Anarchist, but no other artist of the movement was so devoted to painting the urban-industrial scene as he was. Broadly speaking, the Anarchists rejected capitalism and the modern state for monopolizing resources in the hands of the wealthy few at the expense of the masses. They sought instead a system of voluntary associations at all levels based on rational understanding and mutual ethics. Modern science was to be important in providing an intellectual basis and practical aid for a new society, one which would enable every

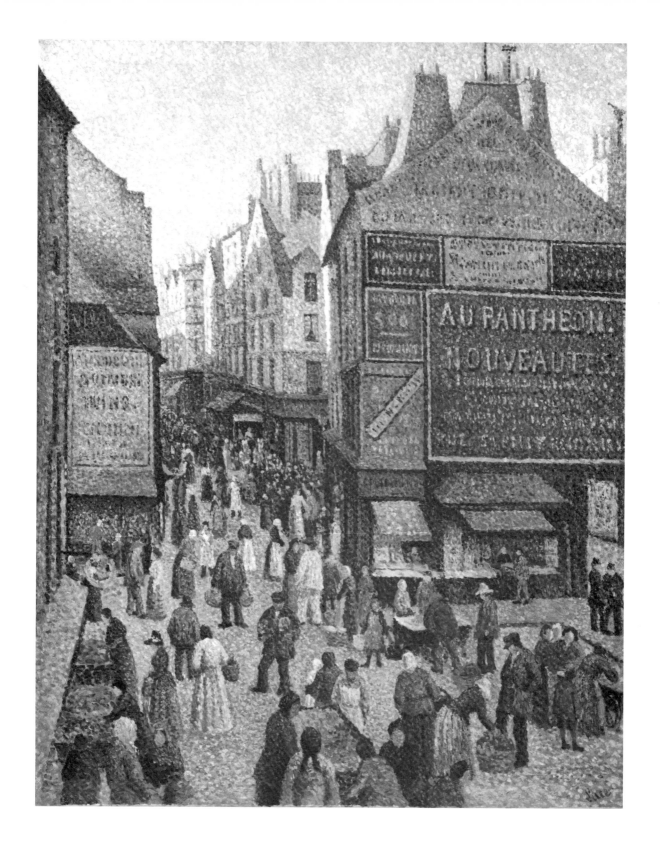

Maximilien Luce. *The Hills at Charleroi.* 1898. oil on canvas, 21½ x 28¾ (54.6 x 73.1).
Gift of Mr. and Mrs. B. Gerald Cantor. 71.204.2

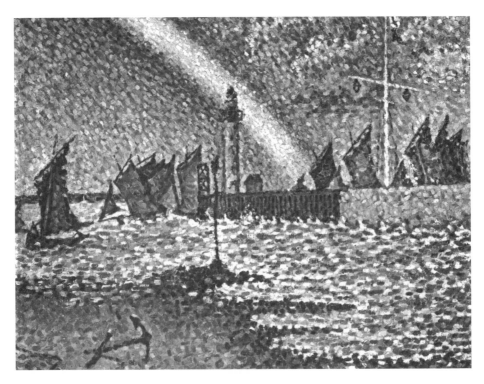

Paul Signac. *The Rainbow.* 1899. oil on canvas, 16 x 19¾ (40.7 x 50.2).
The Holliday Collection. 79.292.

man to develop his faculties to their fullest. Given his background and personality, Luce could hardly have failed to be highly sympathetic to such an outlook.

La Rue Mouffetard is one of Luce's classic statements. The street was located not far from Luce's studio on the rue Cortot and was also close to the offices of *La Révolte,* the Anarchist review to which he and other Neo-Impressionists regularly contributed illustrations. The picture shows the view opposite the church of Saint-Medard, depicted by Luce in a contemporaneous painting now in the collection of B. E. Bensinger, Chicago. *La Rue Mouffetard* is based on a large study in pastel and colored pencil (offered but not sold at an auction held in 1976 at the Hôtel George V, Paris), which differs mainly in the placement of the figures. Our canvas must have been executed in the latter part of 1889, for it surely influenced Lucien Pissarro's *Rue Saint-Vincent, Winter Sun* (formerly Hirschl and Adler Galleries, New York) showing another view of Montmarte done in the final months of that year. Luce had developed a close relationship with Lucien's father, Camille Pissarro, who had converted to Neo-Impressionism and who likewise held Anarchist beliefs. The two, moreover, shared a deep reverence for the art of Corot. Pissarro's influence on Luce is felt in the cubic treatment and organization of the architecture, as well as in the bustling activity, features which are found in the older artist's painting of Rouen around 1883.

Luce's palette was unusual among the Neo-Impressionists in emphasizing the purple that pervades *La Rue Mouffetard.* In the pale yellow sunlight of late afternoon, the indirect blue light takes on a greater prominence, which intensifies the purple tones. The purple is broken down into dots of its components, blue and red placed throughout the canvas and diluted with varying amounts of white to alter their values. The juxtaposition of intense green in the foreground further strengthens the purples through complementary contrast with red, its color opposite. The complexity of the palette is further enhanced by a great variety of intermediate colors. Despite its idiosyncratic color, Luce's scheme is essentially consistent with Neo-Impressionist theory. It is readily apparent that the color dots establish an optical vibration which, rather than depicting visual reality, is intentionally anti-naturalistic, for the Neo-Impressionists believed that their "scientific" approach was true to a higher reality. Yet the painting is wonderfully atmospheric and captures the feel of the street market filled with shoppers coming home from work. While lacking the pointillist precision that lends Seurat's work its purity, Luce's broader brush allows the color to act more evocatively and thus create the mood which renders *La Rue Mouffetard* so convincing, despite its schematic forms. Indeed, the energy of the color and the dots seems perfectly suited to the bustling scene.

PROVENANCE: Palais Galliera, Paris; Hammer Galleries, New York.
EXHIBITIONS: *Salon des Indépendants,* Paris, 1890, no. 493. *Neo-Impressionism,* Solomon R. Guggenheim Museum, New York, 1968, no. 41. *40th Anniversary Loan Exhibition,* Hammer Galleries, New York, 1969, p. 36.
LITERATURE: J. Sutter and R. Herbert, *Les Neo-Impressionistes,* Neuchatel, 1970, p. 193. *Recent Additions to the W. J. Holliday Collection,* Indianapolis, 1971, n.p.

CAMILLE PISSARRO
French, 1830-1903

Woman Washing Her Feet in a Brook. 1894
oil on canvas, 13⅛ x 16¼ (33.3 x 41.3)
signed and dated l.l.: C. Pissarro 94
Gift of George E. Hume
48.17

This enchanting picture of 1894 exemplifies Pissarro's second Impressionist phase. Disappointed with Impressionism's unsystematic approach, the artist adopted Neo-Impressionism in 1886 but within five years he abandoned Seurat's divisionist technique as too laborious and reverted to his own style of the early 1880s.

Like Cézanne, Pissarro turned to figure painting in the 1890s, despite the fact that he could find no models to pose for him even against his wife's objections. In 1895 he did two other versions of *Woman Washing Her Feet*. One (Nathan Cummings, Chicago) is nearly identical to the IMA painting. The other (Metropolitan Museum, New York), showing the girl without clothes, elucidates the meaning of our canvas. (A similar nude is on the back of a picture dated 1876 but appears to have been painted also around 1895). Closely related to the groups of bathing women found in other Pissarro paintings of the same period, the nude is a counterpart to the figures of Venus, Diana, Musidora and Susannah popular with such Rococo artists as François Boucher.

Another source of Pissarro's inspiration lies in nineteenth-century art, specifically Millet's *Goose Girl* (1863, Walters Art Gallery, Baltimore), whose pose and landscape surroundings are echoed in the Metropolitan picture. *The Goose Girl* is a belated example of the romantic nudes Millet had painted in the 1840s, and in typical fashion translates a traditional motif into more mundane terms. In this case, Millet evidently had in mind Michelangelo's *Leda and the Swan* (copy in the National Gallery, London) and perhaps the well-known engraving by Milan and Boyvin after Rosso's *Nymph of Fontainebleau*.

While he was hardly as self-conscious about tradition as was Millet, Pissarro, like most other French artists of the period, must have habitually visited the Louvre and Fontainebleau. That he was not completely unaware of such sources for *The Goose Girl* is suggested by the fact that his groups of nudes bathing in streams have much in common with Mannerist prototypes, such as Rosso's *Challenge of the Pierides* in the Louvre or Jean Mignon's etching of *Women Bathing* after Luca Penni. The process by which these works became connected in Pissarro's mind must have been an imaginative rather than an intellectual one. Such rich associations are by no means unusual in the late work of Impressionists, for example the figure paintings done by Renoir and Cézanne in their old age.

Although these traditional overtones surround our figure, in her present guise the *Girl Washing Her Feet* is closer kin to Corot's forest muses, with their picturesque peasant costumes. The sonorous color and lush scenery evoke an enchanted realm from within the artist's imagination, and we become a poet rapt in an Arcadian dream. Instead of spying on her voyeuristically like Acteon on Diana, we have been granted the privilege of entering the sacred grove to witness this mythological creature. Lost in her thoughts, she remains completely unaware of our presence. An ephemeral vision, the girl would disappear if she felt our presence, for the spell of the magical moment would be broken.

PROVENANCE: M. Fauré, Paris; Martin Birnbaum, New York; Lillie P. Bliss, New York; Museum of Modern Art, New York; Durand-Ruel Galleries, New York; M. Knoedler and Co., New York; William M. Hume, San Francisco.
EXHIBITIONS: *The Lillie P. Bliss Collection*, Museum of Modern Art, New York, 1934, no. 49. *Corot and His Contemporaries*, Museum of Fine Arts, Houston, 1959. *The Grand Century in France, 1800-1900*, Notre Dame University Art Gallery, South Bend, 1959.
LITERATURE: L. Venturi and L. R. Pissarro, *Camille Pissaro, Son Art, Son Oeuvre*, Paris, 1931, I, p. 206, no. 901, II, pl. 183. J. Rewald, *Camille Pissarro, Letters to His Son Lucien*, New York, 1943, p. 252. R. Parks, "A Late Painting by Pissarro," *Bulletin*, XXXV, 2, Oct. 1948, pp. 23-24. J. Rewald, *Camille Pissarro*, London, 1963, p. 140. C. Sterling and M. Salinger, *French Paintings in the Collection of the Metropolitan Museum, The Impressionists*, New York, 1967, p. 19. Miller, pp. 177-178.

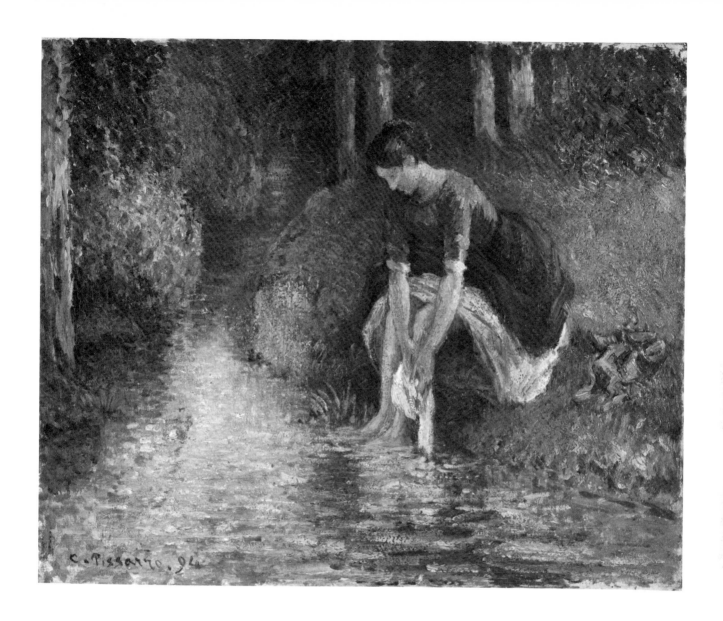

ODILON REDON
French, 1840-1916

The Yellow Sail. ca. 1905

pastel on paper, 23 x 18½ (58.4 x 47)
signed l.r.: Odilon Redon
The Lockton Collection
70.78

Odilon Redon was born in 1840 in Bordeaux. He first took lessons there from the watercolorist Stanlislas Gorin in 1855-1857. At the insistence of his father, he then studied architecture (as well as sculpture for a year) and went to Paris in 1862 but returned home after failing the entrance exams in architecture at the Ecole des Beaux-Arts. It was around this time that he became the protégé of the printmaker Rodolphe Bresdin. In 1864 Redon was again in Paris, where he studied briefly with Jean-Léon Gérôme before once more flunking the entrance examination to the Ecole, this time in painting, and returning to Bordeaux. Four years later he nevertheless settled in Paris and spent the rest of his life there, except for participating in the Franco-Prussian war of 1870 and taking a few trips later on. In 1868 he began publishing articles in *La Gironde* and entered the circle of Camille Corot. He spent part of 1875 painting landscapes in Barbizon and Brittany, although his work was otherwise largely figural. Married in 1880, Redon became a co-founder of the Société des Artistes Indépendants in 1884. In the mid-1890s he underwent a deep spiritual crisis. By 1900 he achieved considerable fame as an artist. He died in Paris in 1916.

Done around 1905, *The Yellow Sail* is a product of Redon's late career. After decades of executing mystic and hallucinatory images in black-and-white lithographs, the artist returned to the greater use of color in a Post-Impressionist manner. The shift in style was accompanied by a change in subject matter. While oriental mysticism remains central to Redon's *The Gothic Window* in the IMA, a work depicting the soul in spiritual contemplation of flowers as symbols of universal life, such pictures as *The Birth of Venus* (1912, Stephen Higgons, Paris) and *Aurora* (Private Collection, New York) transform tradition into a thoroughly contemporary idiom. A well-read man, the artist was open to literary suggestion, but avoided the self-conscious posturing of many Symbolists. Indeed, he stated that his images were not intended for specific literary interpretation and should speak for themselves. He invested his art with deeper meaning by imbuing mythological scenes with a poetry born of dreams rich in psychological overtones which transcend merely literary associations.

The Yellow Sail may have been inspired distantly by contemporary writings, such as Victor Hugo's *Toilers of the Sea* or Darwin's *Voyage of the Beagle*, but it owes much more to art. The canvas must have been executed in nearly the same breath as *Red Boat with Blue Sail* (J. Jägli-Hahnloser, Winterthur), which takes up the traditional Romantic theme of the beached boat as a metaphor of the soul at the end of its life's journey. Whereas Courbet had stripped this motif of its allegory by treating it in objective terms in *Stormy Sea* (1870, Louvre, Paris), Redon reasserted it as a dream image in *Red Boat with Blue Sail* by recasting it in patently unnaturalistic terms.

In *The Yellow Sail*, the artist adopted a modified version of Gauguin's style, which provided the artistic vocabulary for much of Symbolist art. The abstract forms, flat composition and odd color remove the scene from the everyday world and transform the picture into an aesthetic object capable of acting as a suggestive symbol. Yet these are only the means. The end is the subject itself. Between ca. 1897 and ca. 1907

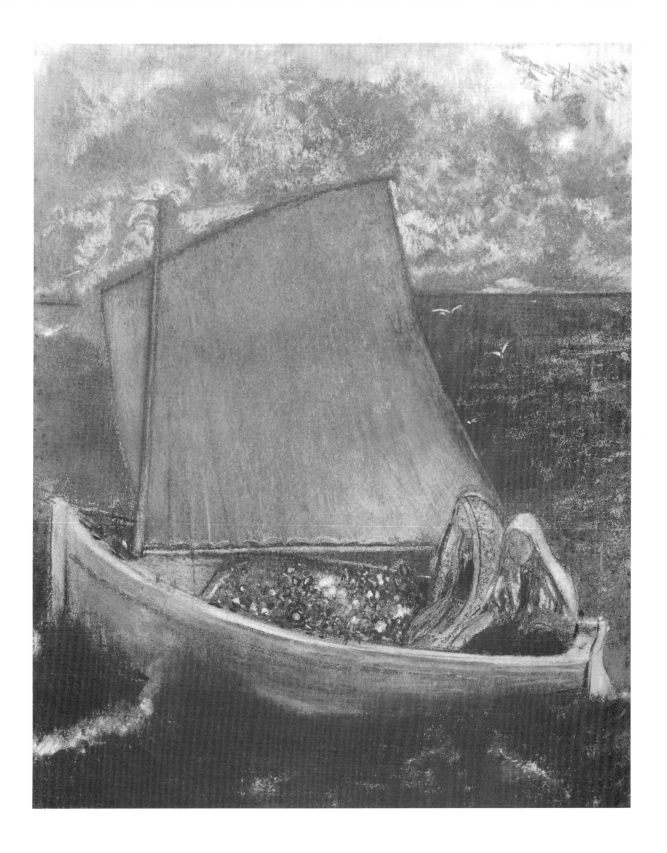

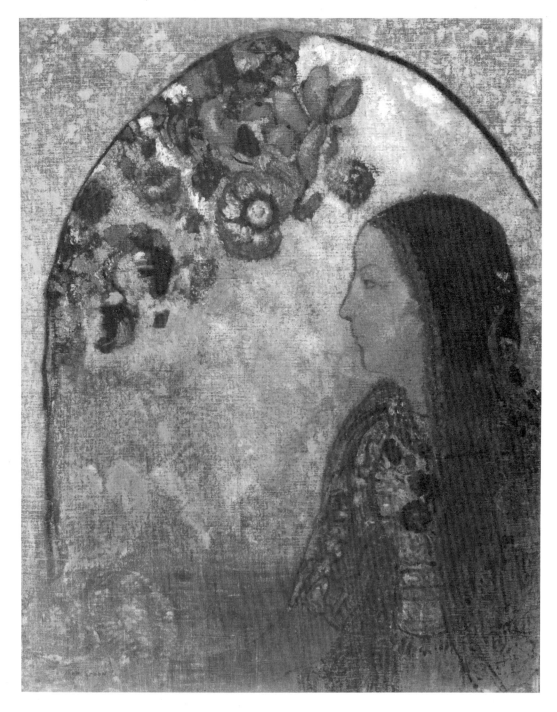

Odilon Redon. *Gothic Window.* 1900. oil on canvas, 24¾ x 19¼ (62.9 x 48.9). The Lockton Collection. 70.79.

Redon executed some ten pastels of boats, seven of them with one or two seated "holy women" whose meaning is elusive. *The Yellow Sail,* which is the finest of the series, proceeds from a similar canvas of 1905 in the David Rockefeller Collection. In that picture, however, the two figures are non-descript generalizations sitting near the mast and looking toward the stern of the empty boat, which hardly seems to move at all in the still water. With its two women steering the boat laden with its precious cargo of jewels in silent melancholy across the turbulent sea, our painting has an uncommon urgency and tragic aura.

The enigmatic subject and stylized treatment are vehicles for conveying a profound insight in *The Yellow Sail.* While it permits several interpretations, the canvas would seem to arise out of a kind of dream experienced by many people, in which they search for an ultimate meaning in purely intuitive terms by grappling with the complexities of life and the premonition of their inevitable death. Redon's pastel represents the final journey of the soul, symbolized by the gems, across the divide between life and death, signified by the Styxian water. The two "holy women" are psychological presences who attend the soul as guardian figures. They generally conform to Carl Jung's concept of the anima, the personification of all feminine psychological tendencies in man's psyche, who acts as guide to his inner world. Following his religious crisis during the mid-1890s, women in Re-don's late pastels often acquire a spiritual purity that perfectly complements their sensuousness in other pictures by him, a configuration exemplifying Jung's second developmental stage of the anima.

Such an interpretation is consistent with the solemn mood of this eerily poetic canvas. Redon seems to have realized in some way that the stylistic and literary conventions of symbolic images often mask psychological archetypes. Through his less esoteric subject matter and the new use of color and form, he tried to make the archetype more accessible than in the generally more obscure, literary references of his black-and-white lithographs. It can hardly be a coincidence that this discovery was made around the same time that Edvard Munch was exploring different states of anxiety in his paintings. In their art Redon and Munch raised fundamental questions about man's emotional existence at the very moment Sigmund Freud and Josef Breuer were undertaking the analysis of dreams which provided the foundations of modern psychology.

PROVENANCE: Mme. Van Gogh Bonger, Almen, Holland; Dur-and-Matthieson, Geneva; Helen Serger Fine Arts, Inc., New York; Larry Aldrich, New York; Parke-Bernet Galleries, New York; Mr. and Mrs. Richard C. Lockton, Indianapolis.
EXHIBITIONS: *Modern French Painting,* Rose Art Museum, Brandeis University, 1962, no. 51. *Your New Treasures: A Six Year Exhibition,* Indianapolis Museum of Art, 1972, pp. 52-53.

GILBERT STUART
American, 1755-1828

Portrait of a Young Woman. ca. 1802-1804

oil on canvas, 29 x 24 (73.7 x 60.9)
Gift of Mr. and Mrs. William H. Ball
77.426

Gilbert Stuart was born in 1755 in North Kingston, Rhode Island. His family moved in 1761 to Newport where he studied with Cosmo Alexander. In 1772, he and Alexander travelled to Edinburgh, but Alexander's death there forced him to return to the United States. In 1775 he went to London, where he struggled as an unsuccessful portrait painter until he entered the studio of Benjamin West in 1777. He remained with West until 1782, and from that year until 1787 he was successful in London. After accumulating a number of debts, he fled to Dublin and from there returned to the United States in 1792. He worked in New York City until 1794, then lived in Philadelphia and Germantown through 1803, when he moved to Washington, D. C. In 1805 he finally settled in Boston, where he died in 1828.

Gilbert Stuart. *Marianne Walker.* oil on canvas, 29⅛ x 24⅛ (74 x 61.3). Gift of Mrs. Nicholas H. Noyes. 52.6

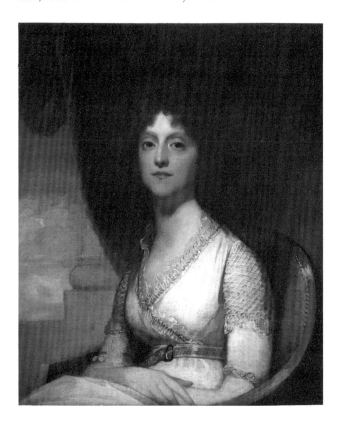

The sitter has been identified incorrectly as Nellie Custis on the basis of the erroneous provenance supplied with the picture and borrowed largely from the historical background of a portrait of her executed by Stuart around 1799 after she had married Laurence Lewis (National Gallery, Washington). The features of the girl in the IMA painting are quite different from—and certainly younger than—those of Mrs. Lewis; yet the costume indicates that our canvas must be dated several years later. Despite these problems, the IMA portrait is certainly by Stuart. It conforms in every detail to his authentic works of ca. 1802-1804, when he was active in both Washington and Philadelphia. In style it compares most closely with two paintings of *Mrs. Perez Morton,* "The American Sappho" (ca. 1802, Museum of Fine Arts, Boston, and The Henry Francis Du Pont Winterthur Museum).

In addition to its superb execution, the painting is astonishing because of the youthful sitter's ravishing beauty, so rarely found in Stuart's portraits. Most of his female sitters were mature women whose appearance and character he revealed quite directly. He had the rare ability to suggest flaws while producing a flattering likeness. A notorious reprobate, the artist must have welcomed the chance to paint the girl in the IMA picture. She has the fresh loveliness of *Anne Penington* (1805, The Powell House Collection, Philadelphia)

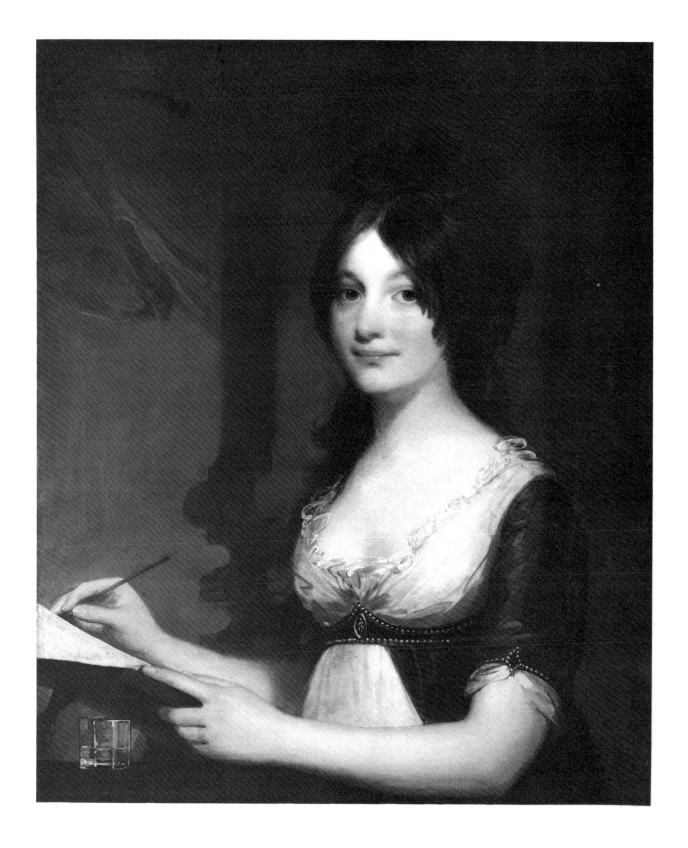

and the self-possession of *Miss Lydia Smith* (ca. 1807, Collection of Mrs. George Robert Russell Rivers) rather than the lively personality of *Mrs. Perez Morton* or the wistful tenderness of *Mrs. Laurence Lewis*.

While no doubt suggestive of her character, the girl's uncommon serenity can be attributed partly to the influence of Neo-Classicism, which often idealized feminine beauty at the cost of a certain blandness. Stuart was the preeminent portraitist of the Federalists, the Pro-British conservatives led by Alexander Hamilton, to whom he was virtually "court" painter. His Federalist portraits, exemplified by the IMA's *Marianne Walker*, were done in the high English manner he assimilated during his years in Great Britain. In *Portrait of a Young Woman*, however, he modified his style to incorporate elements of the Napoleonic portrait style of Jacques Louis David and his school.

(Compare the Metropolitan Museum's portrait of *Charlotte du Val d'Ognes* rather dubiously attributed to Constance Charpentier.) Like the girl's dress and coiffure, this Empire style reflected the taste of the new American aristocracy anxious to forget its revolutionary past, for it conferred instant legitimacy through historical associations reaching back to antiquity. This phase of Stuart's career lasted only briefly. With Federalist power already on the wane, the artist moved to Boston in 1805 after Alexander Hamilton's death. There the well-established class of Brahmins had no need of such artifices to proclaim their obvious aristocratic heritage, which was so well established that it was taken for granted.

PROVENANCE: Max Safron, New York.

JOSHUA SHAW
Anglo-American, 1776-1860

The Pioneers. ca. 1838

oil on canvas, 19 x 27 (43.8 x 68.6)
James E. Roberts and Emma Harter Sweetser Funds
79.328

Shaw was born about 1776 in Bellingborough, Lincolnshire, England, where he apprenticed to a sign painter and earned his living at that trade while studying art. He worked as a landscape painter from 1802 to 1817 in Bath, exhibiting occasionally at the Royal Academy and the British Institution in London, where he became acquainted with Benjamin West. In 1817 Shaw brought West's *Christ Healing the Sick* (Pennsylvania Academy of the Fine Arts, Philadelphia) to Philadelphia, where he settled. M. Carey and Son of Philadelphia published *Picturesque Views of American Scenery* in 1820-1821 with ten engravings by John Hill after Shaw's drawings; Shaw's *A New and Original Drawing Book* was also published in 1819. By 1834 he was experimenting with firearms and was honored in this country and Russia for his work on the percussion cap and priming devices. He moved in 1843 to Bordentown, New Jersey. Shaw stopped painting landscapes in 1853 because of illness. He died in Burlington, New Hampshire, in 1860.

The Pioneers is nearly identical to a canvas (Victor Spark, New York) signed and dated 1838, which differs primarily in its more tempestuous atmosphere and substitutes two women on horseback greeting another woman tending two cows. Both prime examples of Shaw's work, they were done a year before *On the Susquehanna* (M. and M. Karolik Collection, Museum of Fine Arts, Boston), the only landscape by this much neglected artist to have received broad exposure.

Shaw was highly esteemed as a landscapist in his own day, especially for his *Picturesque Views of American Scenery,* published in 1820 and compiled from material gathered largely during a long journey through the South which he undertook shortly after settling in Philadelphia in 1817. The foreword to the first issue testifies to his pioneering spirit and represents an artistic manifesto taken up in 1825 by William Cullen Bryant and Thomas Cole:

> In no quarter of the globe are the majesty and loveliness of nature more strikingly conspicuous than in America. The vast regions which are comprised in or subjected to the republic present to the eye, every variety of the picturesque and sublime. Our lofty mountains and almost boundless prairie, our broad and magnificent rivers, the unexampled magnitude of our cataracts, the wild grandeur of our western forests, and the rich and variegated tints of our autumnal landscape are unsurpassed by any of the boasted scenery of other countries. Striking, however, and original as the features of nature undoubtedly are in the United States, they have rarely been made the subjects of pictorial delineation. Europe abounds with picturesque views of its scenery . . . while America only of all the countries of civilized man is unsung and undescribed.

Although it was painted many years later, *The Pioneers* illustrates Shaw's text perfectly. It includes lofty mountains, a broad and magnificent river, and a cataract, all within one striking scene that is both picturesque and sublime.

There is no evidence that Shaw ever travelled farther west than Pennsylvania, and the setting of *The Pioneers* suggests the area of the Delaware Water Gap. Shaw's European vision nevertheless casts *The Pioneers* in a thoroughly picturesque mode. Indeed the painting is remarkably similar to Daniel Williamson's *Looking into St. John's Vale, Cumberland* (1840, sold recently

at Sotheby's, London). Shaw has adhered strictly to the theoretical principles and visual formulas prescribed in William Gilpin's *Three Essays* (London, 1792). Even the mountain ridges in *The Pioneers* take on the shapes of old ruins! The composition and pastoral mood are further indebted to landscapes by Gainsborough and Phillip de Loutherbourg, both of whose works Shaw is known to have copied while he was living in Bath. More generally, the landscape is painted in the manner of Julius Caesar Ibbetson, on whose style Shaw based his own to a considerable degree.

Finally, *The Pioneers* invites comparison with Benjamin West's *Woodcutters in Windsor Park*, and the similarity between the figures may not be entirely fortuitous. Shaw, after all, knew West, and it is not impossible that he saw the picture in the artist's studio before leaving for the United States. There is a drawing of the axemen inscribed, evidently by a later hand, as having been sketched from nature (Museum of Science and Industry, Chicago), a claim which cannot be substantiated. If the idea of incorporating such figures, which were admittedly common in English painting, into *The Pioneers* was derived in some way

from *Woodcutters in Windsor Park*, the fact remains that they have a very different meaning. *The Pioneers* marks one of the first appearances of axemen in American landscapes as symbols of the settling of America, a motif which was to become ubiquitous in Hudson River School painting by mid-century as a means of denoting the steady advance of civilization.

The Pioneers is characteristic of Shaw's paintings in forcing the scenery of the New World to conform to the conventions of the English picturesque. Other English immigrants likewise consistently imposed their European conception of nature onto American landscapes—for example, *View of the Potomac* by William Winstanley (1798, Munson-Williams-Proctor Institute, Utica), which is hardly distinguishable from scenes of the English Lake Region. Not until the Hudson River School adopted a more topographical form of the picturesque to express Romantic attitudes toward nature did landscape painting in the United States acquire a distinctly American appearance and outlook.

PROVENANCE: Robert Rice Gallery, Houston.

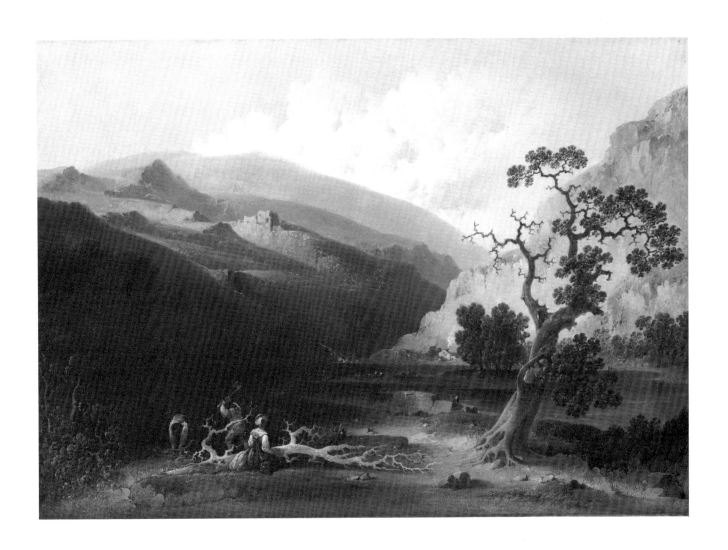

ASHER BROWN DURAND
American, 1796-1886

Landscape with Covered Wagon. 1847
oil on canvas, 26 x 36⅜ (66.1 x 92.4)
signed and dated l.r. on rock: A. B. Durand/1847
Gift of Mrs. Lydia G. Millard
12.17

Durand was born in 1796 in Jefferson Village (later Maplewood), New Jersey. From 1812 till 1817 he was apprenticed in Newark to the engraver Peter Maverick. He then became Maverick's partner, opening a branch in New York where he set up his own business after the partnership was dissolved in 1820. Durand helped organize the New York Drawing Association in 1825 and, a year later, the National Academy of Design, which he served as president from 1845 until 1861. By the mid-1830s he turned his attention increasingly to landscape painting in the style of his good friend Thomas Cole, the leader of the Hudson River School, whom he often joined in the Catskills in search of new material. In 1840 he went to Europe with his former apprentices and fellow Hudson River School painters John W. Casilear, John F. Kensett and Thomas P. Rossiter, but the trip had surprisingly little effect on his art. Durand retired in 1869 to Maplewood, New Jersey, where he died in 1886.

Landscape with Covered Wagon is one of three closely related paintings known to have been executed by Durand (the other two of 1839 and 1844 have not been located). The theme of emigrants settling the New World was a popular one in American art during the late 1840s. It was treated, for example, by Thomas Cole's pupil Frederic Edwin Church in *The Hooker Party* (1846, Wadsworth Atheneum, Hartford). The vigorous civilization emerging in the United States was seen as the natural successor to the faded glory of Europe in the great cycle of history because of the ethos of America as nature's nation. While it underlay all Romantic landscape painting in the nineteenth century, pantheism virtually amounted to a national religion in this country between roughly 1825 and 1875. Its chief spokesman was the poet William Cullen Bryant, who was a close friend of both Cole and Durand. According to this view, God was immanent in nature and His laws could best be seen at work in the unspoiled wilderness of the New World, in contrast to the decadent civilization of the long-inhabited, largely deforested Continent.

Durand took up landscape in the mid-1830s under the influence of Thomas Cole and succeeded him as the leader of the Hudson River School. The style of

Landscape with Covered Wagon is much indebted to his exemplar's. The Claudian composition, too, is of a type favored by Cole in his more allegorical pictures, and its appearance here signifies a similar intent on Durand's part. However, the composition is also heavily modelled on English picturesque prototypes, such as the forest scenes by Paul Sandby. The difference in appearance between the landscapes of Cole and Durand reflects a fundamental difference in temperament beneath their otherwise similar outlooks. Cole's paintings, such as *Crawford's Notch* (1839, National Gallery, Washington), typically have the sweep and grandeur found in Emerson's ecstatic visions. In contrast, Durand's often retreat, as here, to the forest or its outskirts, and incorporate a wealth of carefully observed detail. This more reverential attitude toward nature, which was shared by Thoreau, sees God's design in even the smallest details of His creation.

Despite its apparent naturalism, *Landscape with Covered Wagon* is essentially a metaphor of America. The wagon winding its way between the primeval forest and the more hospitable open terrain establishes a long time frame of past, present and future. The sense of harmony in this brooding wilderness scene suggests that man has a rightful place in the New World. Un-

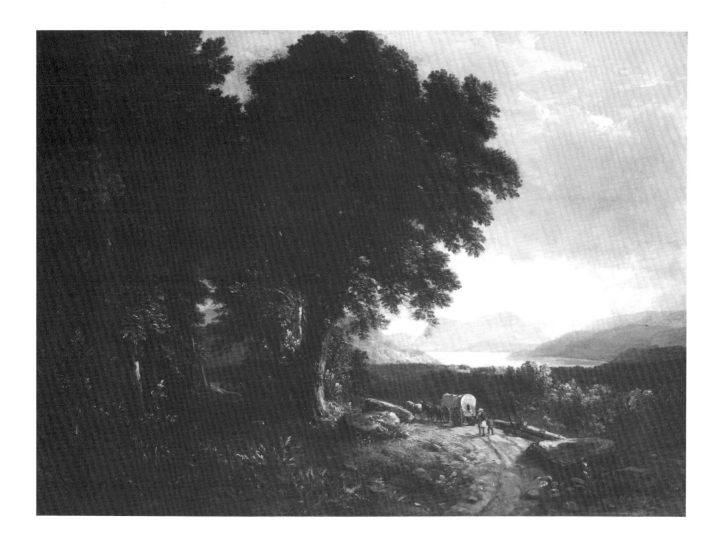

derlying that belief, however, is an ambivalence that is still with us today. On the one hand there are the spiritual lessons to be learned from nature in its purest state, which is at once a haven for meditation and an alien realm. On the other hand there are the benefits of settling the unspoiled country. Durand's pictures strive to maintain the equilibrium between the New Eden and the Promised Land well into the 1850s. It is nevertheless significant that during the 1840s, when this landscape was painted, the precarious balance between nature and civilization was seriously undermined by changes being made in the name of progress, changes which were to prove crucial for the economic and industrial development of the United States. The shift did not pass unnoticed by such landscapists as Jasper Cropsey, whose *American Harvesting* (1846, Indiana University Art Museum, Bloomington) testifies to the rapid disappearance of nature before the axes of men carving out homesteads in the wilderness.

LITERATURE: D. B. Lawall, *Asher Brown Durand: His Art and Art Theory in Relation to His Times*, New York, 1977, p. 259, fig. 89.

WORTHINGTON WHITTREDGE
American, 1820-1910

View of Kallenfels (Summer Pastorale). 1853
oil on canvas, 38 x 32 (96.5 x 81.3)
signed l.l.: T. W. Whitridge/1854
Daniel P. Erwin Fund
54.173

Worthington Whittredge was born in 1820 near Springfield, Ohio. In 1837 he went to Cincinnati, where he was apprenticed as a sign and portrait painter to his brother-in-law, Almon Baldwin. Whittredge had unsuccessful partnerships as a portrait photographer in Indianapolis around 1840 and as a portrait painter in Charleston, West Virginia, around 1843. Whittredge devoted himself exclusively to landscape painting by 1845. In 1849 he decided to study in Europe. After spending the summer touring London, Brussels and the Rhine, he worked briefly in Paris before settling in Düsseldorf. There he became a student of Andreas Achenbach and Carl Friedrich Lessing. In 1856, he moved to Rome and returned to the United States three years later. He was elected an Associate of the National Academy of Design in 1860 and became a full member in 1862. Whittredge toured Colorado and the West in 1866 with General John Pope, in 1870 with John Kensett and Sanford Gifford, and by himself in 1871. He wed Euphemia Foote in 1867. He was President of the National Academy of Design for two terms from 1874 to 1877, and was the head of the New York Artists' Delegation to the Centennial Exposition in Philadelphia in 1876. Whittredge settled in Summit, New Jersey, in 1880, and died there in 1910.

Showing a small town near the Nahe River, *View of Kallenfels* is arguably the finest landscape Whittredge executed during his seven-year stay in Germany. It is one of a trio of important paintings recorded in his European account book on April 23, 1853 (Archives of American Art, Washington). The others include *Landscape with Knights* (formerly Berry-Hill Galleries, New York) and *Landscape in the Harz Mountains* (High Museum of Art, Atlanta; smaller replica in the Detroit Institute of Arts). Although the canvas is inscribed 1854, the artist regularly postdated his pictures. In this case, the landscape was sent to E. J. Matthews of Cincinnati to fulfill an open commission that was recorded on May 8, 1853. Whittredge evidently decided to wait some time before sending the painting, hence the later date below the signature.

Despite the fact that he had evolved a highly successful variant of the Hudson River style, Whittredge left Cincinnati for Europe in 1849 to improve his artistic training. After settling in Düsseldorf, he soon converted completely to the prevailing style of the local school by assimilating in rapid succession the manners of his mentors, Andreas Achenbach and Carl Friedrich Lessing. Moreover while he pointedly fails to mention Johann Schirmer in his autobiography (Archives of American Art, Washington), *View of Kallenfels* is largely indebted to that artist's work (compare *Landscape with Forge*, 1854, Museum Folkwang, Essen), especially in the treatment of light. The composition itself is an amalgam of several motifs. The view of the town against the mountains, for example, is repeated with minor variations in a smaller canvas (Cincinnati Art Museum). The plein-air light and atmosphere, however, help to unify the scene by evoking a convincing impression of spontaneous, direct observation, without resorting to the brooding Romanticism preferred by the older generation of German artists. The skills learned in Düsseldorf were to prove decisive for the works Whittredge painted after his return to the United States in 1860, such as the IMA's *Shawungunk River* of 1863. For all the obvious differences in appearance, the two canvases are

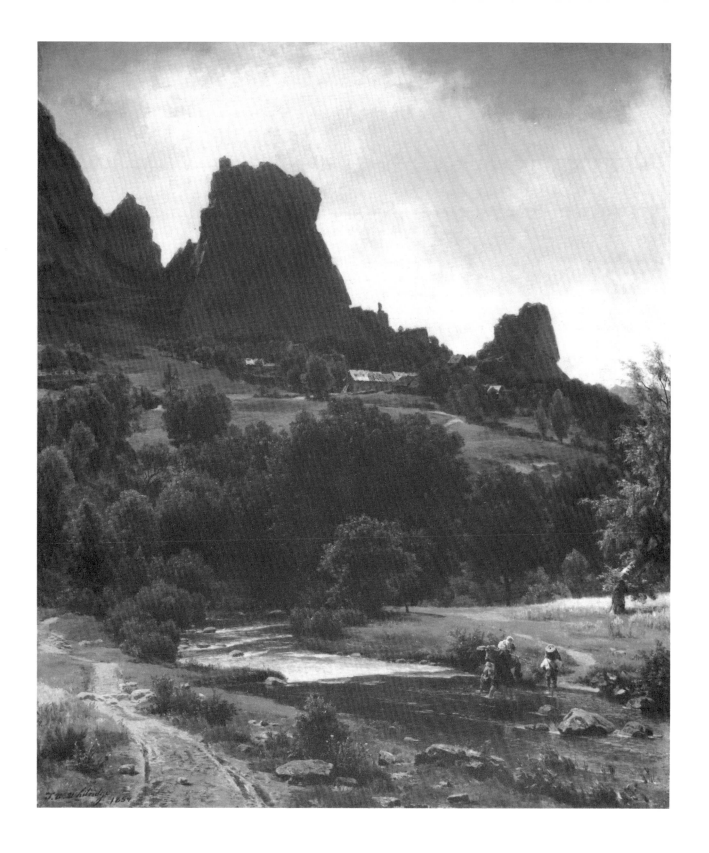

Worthington Whittredge. *Shawungunk River.* 1863. oil on canvas, 12⅞ x 24¾ (32.7 x 62.9). Gift of Newhouse Galleries. 44.82.

marked by the same fidelity to light and mood, effectively conveying the artist's direct experience of nature.

PROVENANCE: Mrs. Buckner W. Anderson, Cincinnati; Paul H. North, Jr., Columbus, Ohio.

EXHIBITION: *Worthington Whittredge,* Munson-Williams-Proctor Institute, Utica, 1969, no. 8.
LITERATURE: E. Dwight, "Summer Pastorale by Whittredge," *Bulletin,* XLII, 1, Apr. 1965, pp. 14-16. A. F. Janson, "Two Landscapes by Worthington Whittredge," *Detroit Institute of Arts Bulletin,* LV, 4, Winter 1977, p. 208, note 30.

ALFRED THOMPSON BRICHER
American, 1837-1908

Morning at Grand Manan. 1878
oil on canvas, 25 x 50 (63.5 x 127)
signed and dated 1.1.: AT BRICHER. 1878
Martha Delzell Memorial Fund
70.65

Alfred Thompson Bricher was born in 1837 at Portsmouth, New Hampshire. Three years later his family moved to Newburyport, Massachusetts. He became a student at the Lowell Institute in 1851. Bricher opened his own studio in Newburyport in 1858, but moved to Boston in 1860 and opened another studio. In 1863 he met Ralph Waldo Emerson. In 1866 he travelled throughout the West. Between 1870 and 1884 he lived in New York City. His first trip to Grand Manan took place in 1874. It is possible that he visited England in 1876. He became an Associate of the National Academy of Design in 1879, wed Alice L. Robinson in 1881, and became a member of the Art Union in 1884. He died in New Dorp, Staten Island, in 1908.

One of four major paintings by Bricher from the late 1870s, *Morning at Grand Manan* is arguably his last true masterpiece. It is closely related to *Sunrise at Narragansett Pier, Rhode Island* (1873, Private Collection), *Time and Tide* (ca. 1873, Dallas Museum of Fine Arts), and *A Lift in the Fog, Grand Manan* (1876, Private Collection). Perhaps as the result of his apparent visit to England two years earlier, the composition is indebted to mid-century Scottish marine painters, whose dramatic scenes enjoyed considerable influence on American art, while the spectacular lighting suggests the impact of Turner, presumably as the result of Ruskin's writings which were highly popular on this side of the Atlantic. In execution, however, the canvas is similar to marine paintings by such members of the Hudson River School as Jasper Cropsey, whose style reflects a similar combination of influences. And like Hudson River School works, *Morning at Grand Manan* is typical of American Romantic landscape painting in establishing a poetic mood to suggest the harmony of the cosmos.

Bricher's landscapes have often been considered examples of American Luminism. Although he was largely self-taught, he became a sophisticated artist who shared little of the primitive vision considered the hallmark of the Luminist tradition. Indeed, his mature paintings differ considerably from the sea-scapes of Fitz Hugh Lane, the paradigm of American Luminism, whose work Bricher undoubtedly knew during his Boston years. Lane's style represents an American counterpart to an alternate marine tradition which was practiced in Scotland and other provincial ports in Great Britain and which was transmitted to these shores by his teacher Robert Salmon. (Compare the IMA's *A British Packet Ship on the Clyde,* painted in 1817 when Salmon was active in Greenoch, Scotland.) Strictly speaking, however, Luminism was hardly unique to a particular school. The concern with the interaction of light, atmosphere and water was a fundamental aspect of Romantic landscape painting everywhere. In fact, Luminism has been claimed with equal justification as the native school of landscape in France, Germany and England during the nineteenth century. Thus, *Morning at Grand Manan* participates in a tendency that was truly international. Moreover, the artist himself was devoid of self-conscious literary pretensions and theoretical posturing, least of all the Transcendentalism that is often deemed fundamental to American Luminism, although he had met Emerson in 1863. Instead, like any good landscapist, he was concerned foremost with painting a scene of strong visual appeal and expressive impact. In a letter of June 26, 1878 (which includes a six-inch drawing of the painting) to his dealer, Seth

Robert Salmon. *A Packet Ship on the Clyde.* 1817. oil on canvas, 15 x 24⅝ (38.1 x 62.5).
Emma Harter Sweetser Fund. 78.5

Vose of Boston, Bricher summed up very simply the landscape and the effect it was intended to produce: "It is very picturesque."

PROVENANCE: Vose Galleries, Boston.
EXHIBITIONS: *19th-Century America, Paintings and Sculpture,* Metropolitan Museum of Art, New York, 1970, no. 153. *Your New Treasures: A Six-Year Exhibition,* Indianapolis Museum of Art, 1972, pp. 16-17. *Alfred Thompson Bricher,* Indianapolis Museum of Art, 1973, no. 44. *Our Land, Our Sky, Our Water,* Expo 74, Seattle, 1974, no. 108. *The Natural Paradise: Painting in America 1800-1950,* Museum of Modern Art, New York, 1976, p. 152. *American Light: The Luminist Movement, 1850-1875,* National Gallery, Washington, 1980, pp. 52-53, fig. 55.
LITERATURE: J. Wilmerding, *American Art,* New York, 1976, p. 90, pl. 102. M. Baignell, *Dictionary of American Art,* New York, 1979, p. 45.

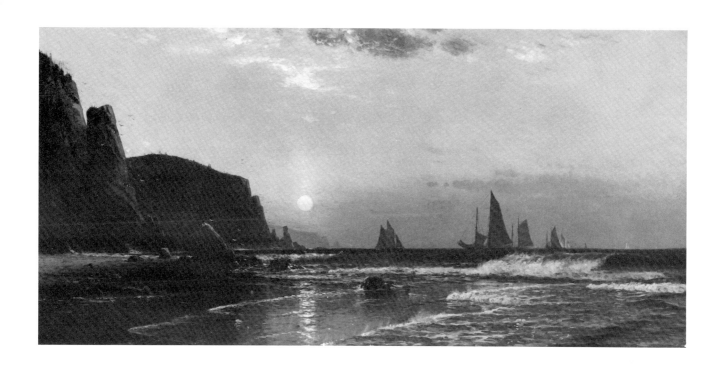

WILLIAM BRADFORD
American, 1823-1892

Whaler and Fishing Vessels near the Coast
 of Labrador. ca. 1880
oil on canvas, 18 x 30⅛ (45.7 x 76.5)
signed l.r.: Wm. Bradford N.Y.
Gift of Delavan Smith
13.325

William Bradford was born in 1823 at Fairhaven, Massachusetts. He began painting ship portraits in 1855 under the influence of Fitz Hugh Lane, and soon began collaborating with Albert van Beest. He moved to Boston around 1860, and the following year made his first excursion to the Arctic (including Labrador), where he spent most of his summers through 1869. In 1868 he settled in the Tenth Street Studio Building in New York City. From 1872 to 1874 he was in England. Upon his return to New York, he was elected to the National Academy of Design. He travelled extensively in the United States during the summers of the 1870s. Throughout the 1880s he gave numerous lectures. He died in 1892.

This scene off the coast of Labrador, which can be dated to the late 1870s or early 1880s, is a fine example of Bradford's mature work. After the death of his teacher Albert van Beest, Bradford visited Labrador every summer from 1861 to 1869. The sketches and photographs he accumulated there provided an un-

Albert Bierstadt. *Alaska.* oil on canvas, 14 x 20 (35.6 x 50.8). Gift of Mrs. Addison Bybee. 11.78.

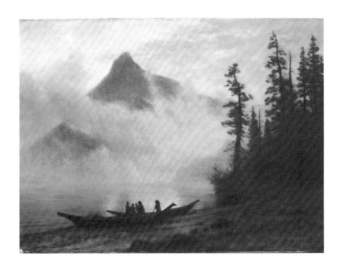

ending supply of motifs which he was to mine for the remainder of his highly successful career. To capture his experiences in appropriate terms, Bradford gradually abandoned the Anglo-American marine tradition of Robert Salmon and Fitz Hugh Lane, the style he had learned under Van Beest in Fairhaven during the mid-1850s. The IMA painting demonstrates that he was strongly affected by the Rocky Mountain landscapes of Albert Bierstadt, who also hailed from New Bedford and likewise had quarters in the Tenth Street Studio Building in New York throughout the 1860s and 1870s.

The American fascination with the Arctic region was initially stimulated by explorers' expeditions, which often ended in tragedy, and was further whetted by popular books describing the North. The Romantic imagination was enthralled by the exotic, and a growing number of artists travelled to faraway places to satisfy the appetite for strange, new experiences enjoyed vicariously by an enthusiastic public. Bradford himself gave numerous popular lectures and published a book, *The Arctic Regions* (London, 1873), with 125 photographs by him and the professional photographers he regularly took with him on his journeys.

The Arctic was further popularized by **Frederic**

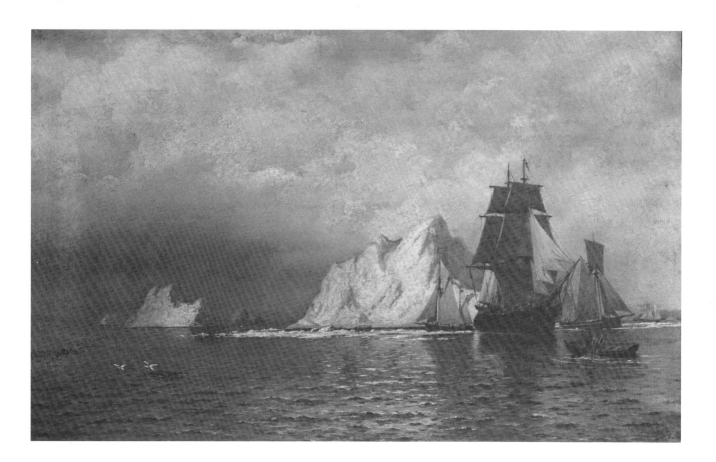

Edwin Church, whose chromolithograph *The North (Icebergs)* (the recently rediscovered original painting is now in the Dallas Museum of Fine Arts) was widely distributed. In 1861, as Bradford was making his first visit to the Arctic, Church participated in a long exploratory cruise through northern waters. The artist was accompanied by the Reverend Louis Noble, the friend and biographer of Church's teacher Thomas Cole. That same year, Noble wrote a well-received account of the trip, *After Icebergs with a Painter.* It is typical of the period in using observations gained on scientific expeditions as evidence to support the prevailing philosophies of nature and society. Noble's book tells us in words what Church's *The North (Icebergs)* informs us in visual terms: that icebergs are quintessential symbols of the Creation and Apocalypse all in one because of the perpetual process of formation and destruction that molds their almost protean substance into strange, nearly supernatural shapes. The Arctic thus confirmed the American belief in God's benificent order and, with it, man's place in the cosmos.

Whaler and Fishing Vessels near the Coast of Labrador

further embodies the world view of late American Romanticism. Through the silvery tonality, which visually unites heaven and earth in one vast expanse, the sense of endless space assumes cosmic proportions. The harmonious palette lends a surprising serenity to the sublime landscape. The scene includes the presence of man, whose vessels are, significantly, on almost the same scale as the icebergs behind them. Far from being crushed by this hostile environment, the calm fishermen exist on equal terms with nature, which the deity has provided to meet man's needs. This American outlook contrasts sharply with the attitude found in the first great Arctic shipwreck scene, *The Wreck of the Hope* painted by the German artist Caspar David Friedrich in 1824 (Kunsthalle, Hamburg), which emphasizes man's powerlessness before the overwhelming forces of nature, seen as part of a larger tragic vision of human existence. Even Bradford's *Crushed in the Ice* (ca. 1872, sold at Sotheby Park-Bernet auction in October, 1979), showing a whaler wrecked on an ice floe, is cast as an adventure within magnificent scenery.

GEORGE COCHRAN LAMBDIN
American, 1830-1896

The Consecration-1861. 1865

oil on canvas, 24 x 18¼ (60.1 x 46.4)
signed and dated l.l.: Geo. C. Lambdin 1865
inscribed on panel behind canvas:
 "THE CONSECRATION - 1861" Geo. C. Lambdin/
 Philadelphia 1865/Owner Geo. Whitney
James E. Roberts Fund
71.179

George Cochran Lambdin was born in 1830 in Philadelphia, where he trained under his father, James R. Lambdin, who was a successful miniaturist. With the exceptions of a stay in New York between 1868 and 1870, and visits to Europe in 1855 and 1870, he spent his career working in his native city. Lambdin specialized in still-life and genre painting. He died in Philadelphia in 1896.

In addition to the reportage by Winslow Homer—and occasionally Albert Bierstadt and Eastman Johnson—the Civil War inspired a considerable number of sentimental genre paintings, sometimes executed considerably after the fact. Such a work is *The Consecration* by George Lambdin which, although it is set in 1861, was painted a good four years later. It shows a young woman kissing the sword of an officer as he is about to leave for war. Departure, as well as homecoming, scenes originated with Antique subjects done by French Neo-Classical painters in the last quarter of the eighteenth century, when they held patriotic and moral overtones. These themes were continued by early Romantics, who glorified modern heroes preparing to risk their lives for the good of their country. In between such elevated prototypes and Lambdin's painting lies popular art. Romantic painters often appropriated popular subjects, adapting them to the style of "high" art with few qualms, for Romantic art itself was largely a creature of popular taste aimed at the upper middle-class. Thus it is hardly surprising that *The Consecration* is calculated to appeal to the widest possible audience by playing on the public's sentimentality while catering to the prevailing taste for highly finished, genteel paintings in an academic manner.

The Consecration seems maudlin today. Even in his own time, Lambdin's painting had its critics. The reliable Henry Tuckerman noted, for example:

"There is an evident lack of discipline in the technical details; we can easily imagine a mature training would develop memorable results; the superstructure, but not the foundation of *genre* art is manifest. We feel and know that the painter has something very definite and touching to say on canvas, and he says it, but not always with the clear and complete emphasis which comes from accuracy and disciplined aptitude."

What the artist had to say was never criticized seriously, however, since it accorded perfectly with the tenor of the times. Tuckerman continued:

Amateurs have liberally recognized the genuine sentiment of Lambdin's best pictures. In a picture by Lambdin, selected for the Paris exposition . . . , foreign critics have recognized great pathetic expression.

PROVENANCE: George Whitney, Philadelphia; John Levy, New York; Parke-Bernet Galleries, New York; Berry-Hill Galleries, New York; Private Collection, New York; Parke-Bernet Galleries, New York; Hamilton Gallery, New York.
EXHIBITIONS: *42nd Annual Exhibition*, Pennsylvania Academy

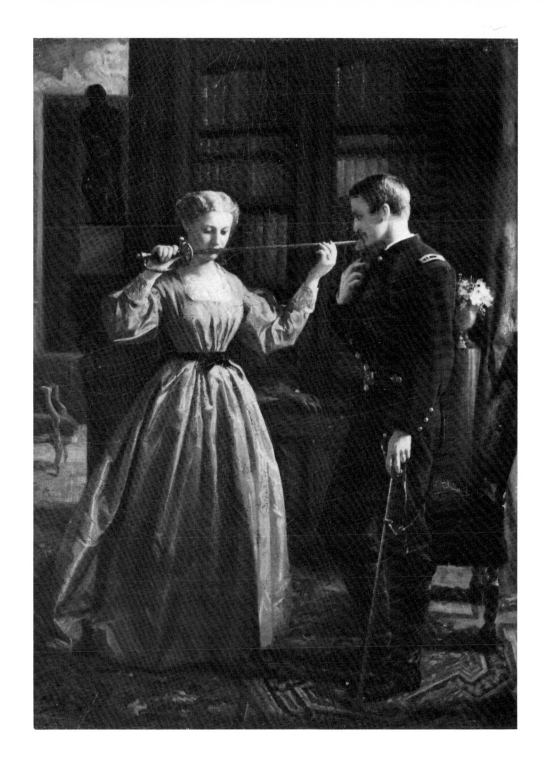

of the Fine Arts, Philadelphia, 1866, no. 622. *First Winter Exhibition,* National Academy of Design, New York, 1867, no. 675; *Of Other Days,* The Newark Museum, 1957; *A Hundred Years Ago,* American Federation for the Arts, New York, 1958, no. 24; *The Civil War, The Artist's Record,* Corcoran Gallery, Washington, 1961, no. 13; *Your New Treasures: A Six-Year Exhibition,* Indianapolis Museum of Art, 1972, cat. p. 13; *The Painter's America, Rural and Urban Life, 1810-1910,* Whitney Museum of American Art, New York, 1974, pp. 65, 68, ill. 81.

LITERATURE: H. Tuckerman, *Book of The Artists, American Artist Life,* New York, 1867, pp. 450-451; H. W. Williams, Jr., *Mirror to the American Past,* Greenwich, 1973, p. 174. idem, "Nineteenth-century American genre painting," *Antiques,* CV, 2, Feb. 1974, p. 379. fig. 10.

WINSLOW HOMER
American, 1836-1910

The Boat Builders. 1873

oil on mahogany panel, 6 x 10¼ (15.2 x 26)

signed and dated 1.1.: HOMER 1873
 (date no longer visible)

Martha Delzell Memorial Fund

54.10

Winslow Homer was born in Boston in 1836. His family moved to Cambridge, Massachusetts, around 1842. Homer was apprenticed to the Boston lithographer J. H. Bufford until 1857, when he became a free-lance illustrator. He moved to New York City in 1859, and attended the drawing school at Brooklyn around 1860. In 1861, he studied at the National Academy of Design and with Frederic Rondel. He covered the Civil War for *Harper's Weekly* between 1862 and 1865. Homer was elected to the National Academy of Design in 1866 and travelled to France that year. Upon his return, he worked in Boston. He spent the years 1881 and 1882 at Tynemouth, England, and then settled at Prout's Neck, Maine. In 1885 he visited the West Indies. Homer suffered a stroke in 1908 and died in 1910 at Prout's Neck.

Homer's early activity as an illustrator prepared him well for his career as a genre painter. Many of America's leading artists had followed a similar path. Unlike them, however, Homer did not abandon illustration, and continued to produce designs for *Harper's Weekly* on a regular basis. His graphic work remained separate from his paintings until about 1870. Then, over the next four years, his canvases often provided the basis for his magazine prints, and many of his pictures may have been done with both media in mind. In any case, working simultaneously in the two had a distinct effect on his style of the early 1870s, which is characterized by strong sunlight and simple, clear compositions. Significantly, there is a subtle but noticeable change in Homer's style after 1874, when his output as an illustrator fell off drastically except for a handful of etchings from the mid- and late 1880s.

In 1873 and 1874 Homer executed a considerable number of paintings devoted to childhood which were translated into wood engravings for *Harper's Weekly*. *Building Boats* is so similar in size and subject to his prints of boys in Gloucester that, if it was not actually painted with an engraving in mind, it at the very least represents a direct outgrowth of their designs. A sim-

ilar landscape appears in *Sea-Side Sketches—A Clam-Bake* (*Harper's Weekly*, August 23, 1837), which is based largely on a watercolor of the same year in the Cleveland Museum of Art while incorporating a motif from another watercolor owned by A. Altschul, New York. By the same token, the two boys in the IMA painting reappear (along with a group of youths borrowed from a watercolor of *Boys on a Beach*, Collection of John Davis Hatch, Jr.) in the print *Ship-Building, Gloucester Harbor* (*Harper's Weekly*, October 11, 1873), which is otherwise taken directly from an oil painting of 1871 (Smith College Museum of Art, Northampton, Mass.). These ideas are gathered into a single design which was first established in a drawing dated June, 1873 (Private Collection). The IMA painting follows the sheet very closely but omits unessential strips from the right and bottom edges of the composition, much to its improvement.

The Gloucester series occupies a position of special importance in Homer's output as his last major body of graphic work, and also represents his largest contribution to a favorite American theme, that of youth. Although they are genre scenes, it is evident that these are not truly scenes of everyday life, despite their fresh appeal. While they lack the humor of William

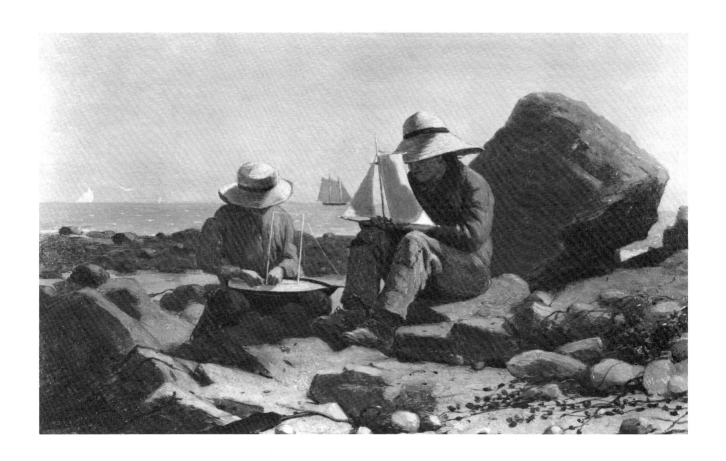

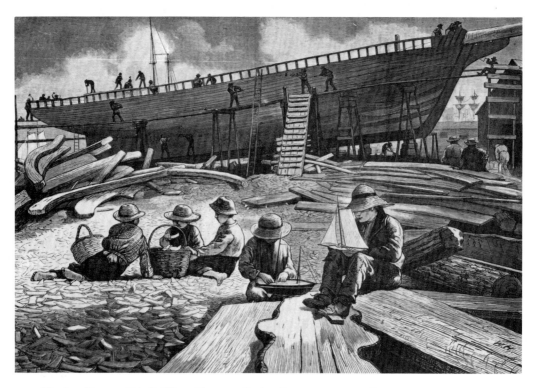

Winslow Homer. *Ship Building, Gloucestor Harbor.* From *Harper's Weekly,* November 11, 1873. wood engraving, 8 1/16 x 13⅝ (20.5 x 34.7). Director's Discretionary Fund. 73.169

Sidney Mount or the sentimentality of John George Brown, they are idealizations nonetheless. The idyllic Gloucester series shares a picturesque flavor with Mark Twain's *Adventures of Tom Sawyer* that is subtly nostalgic. Like Twain's novel, which was published only a few years later in 1876 but is set in the United States of the 1840s, the painting harks back to a simpler era. Homer captures to perfection the nation's yearning to return to a mythical innocence that had been lost during the Civil War.

The seriousness underlying the light-hearted air of *The Boat Builders* is demonstrated by *Ship-Building, Gloucester* for *Harper's Weekly.* By showing the same two boys imitating grown-ups building a real ship as a harbinger of adulthood the print makes explicit what is implied in the painting by the visual device of the toy model interrupting the schooner on the horizon: the continuity of adulthood and childhood, work and play, reality and fantasy. While cast in distinctly Amer-

ican terms, these associations make Homer's painting a variation on the boat as a Romantic metaphor in which the ship of the soul sets out at birth across the sea of life until it reaches the end of its journey and its ultimate destination in death.

PROVENANCE: Dr. Alexander Humphreys; Mrs. R. E. Turnbull; M. Knoedler and Co., New York; Macbeth Galleries, New York; Edward Ward McMahon; Hirschl and Adler Galleries, New York.
EXHIBITIONS: *Homer and the Sea,* Virginia Museum of Fine Arts, Richmond, 1964, no. 5. *The American Scene 1820-1900,* Indiana University Art Museum, Bloomington, 1970, no. 97. *Winslow Homer,* Whitney Museum of American Art, New York, 1973, no. 21A. *Kaleidoscope of American Painting, Eighteenth and Nineteenth Centuries,* Nelson Gallery-Atkins Museum, Kansas City, 1977, no. 73.
LITERATURE: L. Goodrich, *The Graphic Art of Winslow Homer* (exhibition catalogue), Whitney Museum of American Art, New York, 1968, cat. 80c, fig. 74. J. Wilmerding, *Winslow Homer,* New York, 1972, p. 91, ill. 3-31. G. Hendricks, *The Life and Work of Winslow Homer,* New York, 1979, pp. 486-487, no. CL-123.

GEORGE INNESS
American, 1825-1894

The Rainbow. ca. 1868

oil on canvas, 30¼ x 45¼ (76.8 x 114.9)
signed l.r.: Inness
Gift of George E. Hume
44.137

George Inness was born in 1825 near Newburgh, New York, but his family moved to Newark, New Jersey, in 1829. Although he studied landscape painting with Regis Gignoux in New York City, Inness was largely self-taught. He toured England and Italy in 1847. He married in 1850, but his wife died within a few months of the wedding. Inness was elected an Associate of the National Academy of Design in 1853 and became a full member in 1868. He was in France, at Fontainebleau, from 1853 to 1855, and then settled in Medfield, Massachusetts. He moved to Eagleswood, New Jersey, in 1864 and Brooklyn, New York, in 1867. From 1870 to 1872 he was in Rome. He worked in Boston for a while before another trip abroad to Normandy in 1873 and 1874. Inness was in New York City from 1875 to 1878, then settled in Montclair, New Jersey. In 1894 he undertook a trip to Scotland, where he died suddenly at Bridge-of-Allen.

The Rainbow is very similar to *After the Storm* (1868, formerly Henry Schultheis Galleries, New York) and must have been painted a short time afterward. This work forms part of a series of pastoral storm scenes, some with rainbows, which abound in Inness' work of the later 1860s and early 1870s. In style they are indebted to the Barbizon school of Theodore Rousseau and his followers, who exercised a decisive influence on Inness during his second visit to Europe in 1854. *The Rainbow* is comparable, for example, with Millet's *Spring* of around the same time (ca. 1868-1873, Louvre, Paris); yet the attitude remains peculiarly American. The contrast of nature's beneficence with the tumultuous sweep of cosmic forces dwarfing the cows below is typical of Hudson River School artists, notably Thomas Cole (compare *The Ox-Bow,* Metropolitan Museum of Art, New York).

Inness was, in fact, an exact contemporary of the second generation of Hudson River painters and often resorted to their style. From the beginning of his career, however, Inness' landscapes show his tendency to freely rearrange nature according to artistic formulas used as an index to personal feelings. His basic outlook nevertheless had strong affinities with

the Hudson River School's, for he was deeply affected by the theology of his friend and patron, the Reverend Henry Ward Beecher, who shared much the same Romantic pantheism as William Cullen Bryant. A deeply religious man, Inness imbued his landscapes with a sense of the divine presence in nature, rather than merely transcribing her appearance. For that reason, he was attracted by the art of Rousseau, whose vision was equally personal. But after moving to Eagleswood, New Jersey, in 1863 or 1864, Inness was introduced by his neighbor, the artist William Page, to the Spiritualism of Emmanuel Swedenborg. The originator of seances, Swedenborg believed in an immaterial but light-filled realm inhabited by departed souls which is visually similar and parallel to our world. While only a few of Inness' landscapes are specifically Swedenborgian in their symbolism, Spiritualism confirmed and intensified the artist's personal approach, which relied increasingly on light and color to evoke his vision of a deeper reality lying hidden from our eyes but not to our souls.

It was because of the personal mode of expression in such landscapes as *The Rainbow* that Inness emerged as the leader of American Barbizon painting

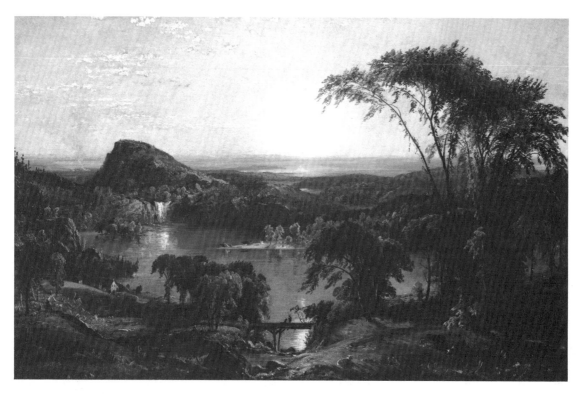

Jasper F. Cropsey. *Summer, Lake Ontario.* 1857. oil on canvas, 15 x 24 (38.1 x 61). Gift of the Friends of the Museum. 71.13.

after the Civil War. Faith in America as nature's nation was fatally undermined by the disillusionment and industrialization that followed in the wake of the Civil War, as well as by Darwinism and Hegelian Idealism. (Significantly, *The Rainbow* is a pastoral scene with a thriving town in the distance, in contrast to the Arcadian landscape found in Jasper Cropsey's *Summer, Lake Ontario* of 1857 in the IMA.) Nature thus ceased to be a teacher of manifest moral truths; but it retained a spiritual significance of an entirely personal sort requiring the poetic vision of Barbizon painting, not the nationalistic rhetoric of the Hudson River School, which consequently stagnated after 1870.

PROVENANCE: H. Wheeler Bond (purchased from the artist); Mrs. Edward Carroll Sibley, St. Louis; Max Safron, St. Louis; J. Lonsway, St. Louis.

EXHIBITIONS: *George Inness Centennial Exhibition*, Buffalo Fine Arts Academy, 1925, p. 12. *A Retrospective Exhibition of Paintings by George Inness*, Paine Art Center, Oshkosh, 1962, no. 14. *The Paintings of George Inness*, University of Texas Art Museum, Austin, 1966, no. 32. *A Century and a Half of American Art*, National Academy of Design, New York, 1975, pp. 80-81. *Two Hundred Years of American Painting*, Baltimore Museum of Art, 1976, no. 20.

LITERATURE: L. Ireland, *The Works of George Inness*, Austin, 1965, p. 120, no. 497. J. T. Flexner, *Nineteenth-Century American Painting*, New York, 1970, p. 172. N. Cikovsky, *The Life and Work of George Inness*, New York, 1977, p. 206, fig. 60.

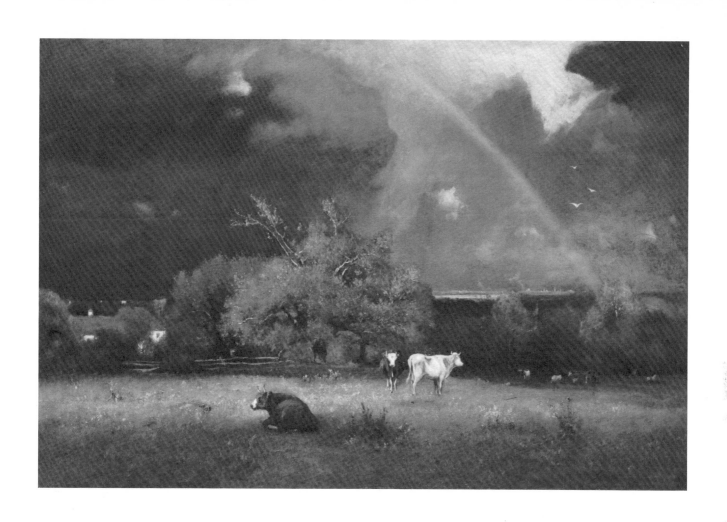

JOHN HENRY TWACHTMAN
American, 1853-1902

A Summer Day. ca. 1900
oil on canvas, 25 x 30⅛ (63.5 x 76.5)
signed l.r.: J. H. Twachtman
John Herron Fund
07.3

John Twachtman was born in 1853 in Cincinnati, where he studied at the Ohio Mechanics Institute from 1868 to 1871. Later he went to the McMicken School of Design, and studied with Frank Duveneck from 1874 to 1875. That year he and Duveneck went to Munich, where he studied with Ludwig von Loefftz until 1877. Duveneck, Chase and he went to Venice in 1877. Twachtman returned to Cincinnati in 1878, then moved for a brief period in 1879 to New York, where he became a member of the Society of American Artists. He returned to Cincinnati and taught at the Women's Art Association. In 1880, after spending some time in the East, Twachtman went to Venice to study at Duveneck's school. In 1881 he returned home to marry Martha Scudder, and took her back to Europe that same year. In 1882 he was briefly in Cincinnati. Upon his return to France, he stayed in Paris, Honfleur and Arque-La-Bataille until 1885. That year he went to Venice with Duveneck. In 1889 he purchased a farm on Round Hill Road, Greenwich, Connecticut. Around 1894 he was in Buffalo, New York. Later he taught at Cooper Union in New York, and helped establish the group of artists known as The Ten. He died at Gloucester, Massachusetts, in 1902.

A Summer Day, executed by Twachtman around 1900, represents American Impressionism at its finest. It is one of numerous canvases showing the hemlock lake on the artist's farm in Connecticut. The painting has the idleness of Renoir's leisure scenes and the youthful innocence of Homer's *Boat Builders* in the IMA. The canvas is united visually and expressively by the masterful color and brilliant sunlight, which are used compositionally across the picture plane and establish the dreamy mood. The poetic effect is fully comparable with Monet's best productions of the same period.

When transplanted to American shores, Impressionism necessarily acquired a substantially different character than in France because of the altered context of time and place. As in Germany or England, Impressionism in America was quite eclectic, drawing on diverse sources which changed its original character. The interaction of the Munich school painters, Frank Duveneck and William Merritt Chase, with such French-trained artists as Frank Robinson had a considerable impact on the style of Impressionism in this country. Moreover, it is arguably the case that most

Americans misunderstood French Impressionism. Only Childe Hassam managed to successfully imitate the color and brushwork of Monet (compare Hassam's *Cliff Rock—Appledore* of 1903 in the IMA with Monet's *Etretat,* 1886, Metropolitan Museum of Art, New York). The other Americans for the most part adapted Impressionism to suit the taste and outlook of the United States. Finally, Impressionism in America was often identified with Barbizon painters, for example Dwight Tryon. Although it is essentially a tonal painting, Tryon's *November Morning* of 1901-1902 in the IMA is reminiscent of Monet's landscapes with poplars from the early 1890s. The intentions of the two artists were radically different, however, and Tryon detested French Impressionism, which he felt sacrificed poetry for the sake of naturalism. Indeed, many Americans did not comprehend that Monet's naturalism permitted a great deal more personal expression than is often realized even today. Be that as it may, American Impressionism was strongly affected by Barbizon painting and is frequently tinged with a similarly poetic outlook.

Twachtman himself had a highly varied back-

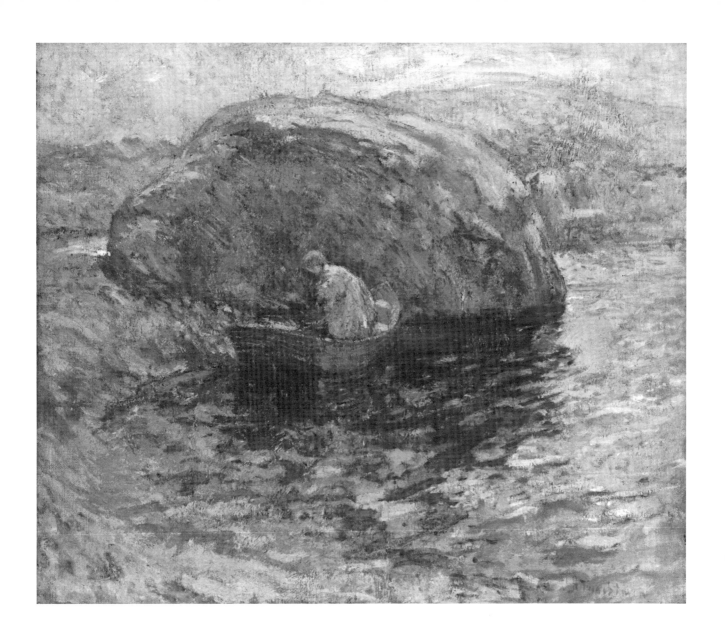

ground. A protégé of Duveneck and likewise a product of the Munich School, he also spent the summer months during his 1883-1885 stay in France painting along the coast of Normandy with Robinson and Hassam, although his landscapes from those years are largely in a Barbizon style with *Japoniste* overtones. After his return to this country, Twachtman moved in the broad circle of American Impressionists and exhibited regularly with them, as well as once with Winslow Homer. Only around 1890 did he come to fully understand Monet's aesthetic, which he translated into individual terms of considerable originality in *A Summer Day* by weaving together the separate strands of his career into a consistently poetic fabric.

EXHIBITIONS: *101st Annual Exhibition*, Pennsylvania Academy of the Fine Arts, 1906, no. 242. *Inaugural Exhibition*, John Herron Art Institute, 1906, no. 195. *John Henry Twachtman, A Retrospective Exhibition*, Cincinnati Art Museum, 1966, no. 80. *Celebration*, Carnegie Institute, Pittsburgh, 1974, no. 26.
LITERATURE: J. D. Hale, *The Life and Creative Development of John W. Twachtman*, Ohio State University, Columbus, 1957, pp. 220, 497, fig. 33, no. 608b. R. Boyle, *John Twachtman*, New York, 1979, p. 72, pl. 26.

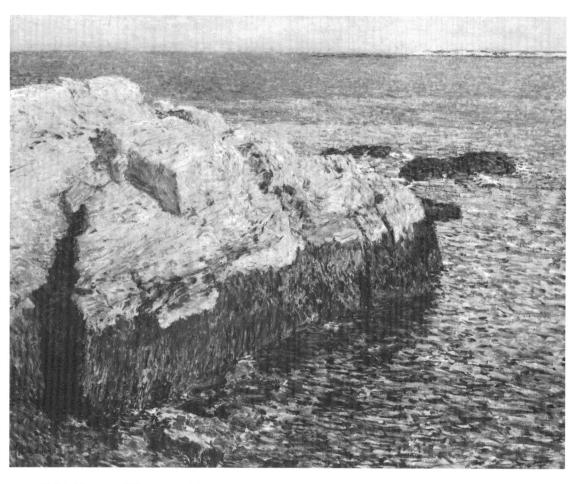

Childe Hassam. *Cliff Rock - Appledore.* 1903. oil on canvas, 29 x 37 (73.7 x 94). John Herron Fund. 07.1.

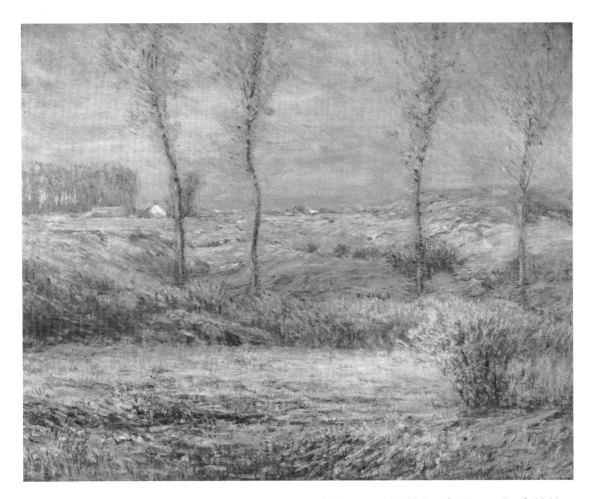

Dwight W. Tryon. *November Morning*. 1901-1902. oil on panel, 26 x 32½ (66 x 82.6). John Herron Fund. 02.32.

JACOB ATKINSON
American, 1864-1938

Souvenir of the Columbian Exposition. 1893
oil on canvas, 12 x 16⅛ (30.5 x 41)
signed and dated l.r.: Jacob Atkinson/1893
James E. Roberts Fund and Martha Delzell
 Memorial Fund
75.97

Jacob Atkinson was born in 1864. His main occupation was as a Philadelphia letter carrier, and painting seems to have been only an avocation. He died in 1938.

Until a similar "deception" of two years earlier surfaced recently at the Philadelphia dealer Frank S. Schwarz and Son, *Souvenir of the Columbian Exposition, 1893* was the only known work by Jacob Atkinson. This Sunday painter mined a vein of *trompe l'oeil* painting which flourished in Philadelphia during the last quarter of the nineteenth century in the work of such better-known artists as William Harnett and John Peto. Raphaelle Peale had executed *A Deception* (formerly Kennedy Galleries, New York) there as early as 1802, but much of the impetus came from Munich, which revived Edward Collier's card rack in the IMA and similar Dutch prototypes. Philadelphia proved highly receptive to this kind of realism, which was practiced at the Pennsylvania Academy of the Fine Arts under the German-born Christian Schussele, and Harnett began to paint *trompe l'oeils* in that manner several years prior to his departure in 1880 for Munich, where he was to spend six years before settling in New York. Atkinson was clearly a skilled practitioner in the same international tradition. To it, however, he lent a distinctly American character through his specific choice of objects. Moreover, while Atkinson can hardly be called a true primitive, the hard-won realism is typical of naive artists in the United States. Souvenirs enjoyed a certain vogue among such painters who, like Atkinson, often imbued them with a highly personal note which, in its idiosyncracy, has an irresistible appeal.

In addition to being a first-class example of American still-life painting, our picture is a cultural document of a bygone era. The World's Columbian Exposition, held in Chicago in 1893, was the most lavish fair of its kind in the United States up to that time. It surpassed even the Philadelphia Centennial in grandiose scale and had nearly as great an impact on the American imagination and taste. The Centennial demonstrated to a surprised nation that during the brief span of Reconstruction the gap between European and American culture had become insignificant in kind and that the difference was one of degree only. No longer able to lay claim to a distinctive "new" civilization, the United States strove to equal or surpass the European achievement. The Columbian Exposition seemed to provide evidence that art and industry, working hand in hand, had reached that goal, if nothing else than through the successful imitation of the Beaux-Arts style, which was used to beautify everyday objects for the "moral improvement" of the common man.

LITERATURE: A. Frankenstein, *After the Hunt*, Berkeley, 1953, p. 156.

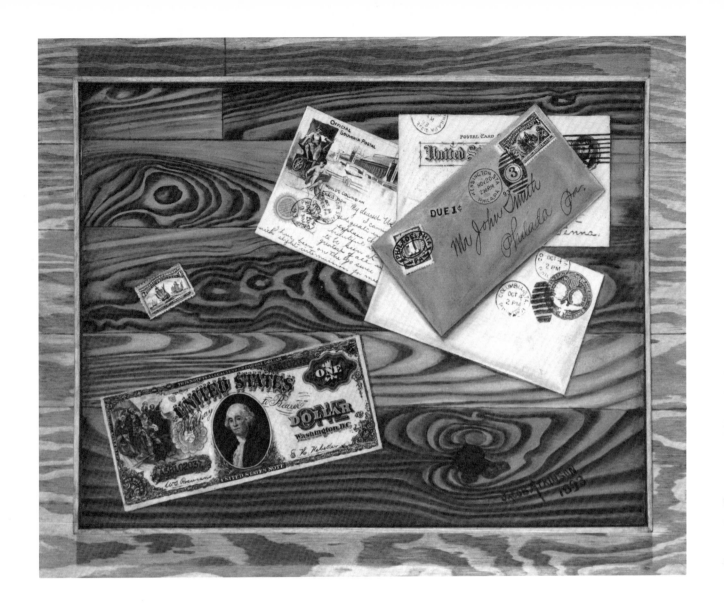

WILLIAM MORRIS HUNT
American, 1824-1879

Ideal Head. ca. 1865-1866

oil on paper mounted on canvas,
 22⅛ x 18⅛ (56.2 x 46)
signed c.l.: WMH
Daniel P. Erwin Fund
23.4

William Morris Hunt was born in 1824 at Brattleboro, Vermont. His early years were spent in New Haven, Connecticut. He attended Harvard University for three years. At nineteen he went to Europe, where he studied under the sculptor H. K. Brown in Rome, and at the Düsseldorf Academy. After moving to Paris in 1847, he was a pupil of Thomas Couture before becoming associated with Jean François Millet for a two-year period. He returned to the United States in 1855, and was married that year. Hunt worked in Boston and Newport before settling permanently in Boston in 1862. He travelled extensively, including trips to the Azores in 1857 and 1858, Europe in 1866-1868, and Mexico in 1875. A studio fire in 1872 destroyed much of his work. In 1878 he began a series of murals for the New York State Capitol at Albany. He died in Boston in 1879.

Hunt can be regarded as the successor to Washington Allston in shaping the taste of Boston, on which he exercised an enormous influence. Although he was an important landscape painter in the Barbizon style and executed an ill-fated cycle of allegorical scenes for the state capitol in Albany, much of his output was in portraiture, an area in which he was one of America's leading masters. The IMA *Ideal Head* is not so much a portrait, however, as a study in romantic mood, which is further evoked by association through the Renaissance costume and hair style. Professor Martha Hoppin has kindly informed us that Hunt did a full-scale charcoal drawing for the composition which is now known only in an old photograph of the 1879 Hunt Memorial Exhibition (on file in the Museum of Fine Arts, Boston). The painting bears a considerable resemblance to *The Gleaner* (Museum of Fine Arts, Boston), dated 1865, and the two must have been done around the same time, perhaps even from the same model. *Ideal Head* is nevertheless unusual in Hunt's *oeuvre*. The only other comparable work is a later *Ideal Head of a Woman* (ca. 1872, Brooklyn Museum of Art), which is based on a portrait incorrectly identified as *Mary B. Claflin* (ca. 1872, Museum of Fine Arts, Boston).

Although unprecedented in Hunt's paintings, *Ideal Head* is directly indebted to similar studies by Thomas Couture. *The Gleaner,* on the other hand, reverts to the example of Millet, which Hunt had also followed in *The Marguerite* of 1853 (Museum of Fine Arts, Boston). Thus the two canvases reflect the lessons Hunt had absorbed from his teachers of more that a decade earlier. In spite of their differences, Couture and Millet provided the artist with a range of prototypes and techniques which he combined at will. In fact, *Ideal Head* synthesizes those divergent, yet complementary, approaches. The generalized treatment of the features in *Ideal Head* (which are actually far less classical in their idealization than those of *The Gleaner*) owes at least as much, if not more, to Millet that to Couture. In contrast to the vigorous brushwork and strong color in *Mother and Child* (*Mrs. Richard Morris Hunt*) (ca. 1865, Museum of Fine Arts, Boston), which still adheres fully to Couture's style, *Ideal Head* is veiled by a *sfumato* derived via Millet from Leonardo and Correggio, whose art Hunt is known to have admired. This soft portrait mode also appears at irregular intervals over ten years in such other works as *Girl with Cat* (1856, Museum of Fine Arts, Boston) and *Mrs. Samuel Hammond* (1865, Private Collection). The *sfu-*

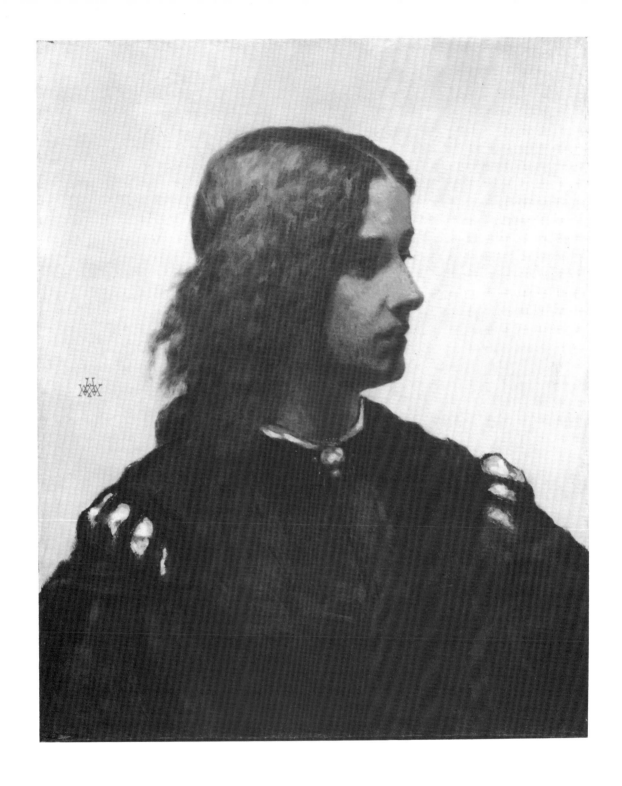

mato is used here to heighten the introspective contemplation established by the pose and facial expression of the *Ideal Head*. The result transforms what might otherwise be a dry academic study into a poetic reverie of suggestive, yet elusive meaning.

PROVENANCE: John Levy, New York; Anderson Galleries, New York; R. C. Vose Gallery, Boston.
EXHIBITION: Albright Art Gallery, Buffalo, 1923.

FRANK DUVENECK
American, 1848-1919

Self-Portrait. 1878

oil on canvas, 19⅝ x 15⅝ (49.8 x 39.7)

inscribed l.r.: Self-Portrait by Frank Duveneck
 Munich 1878/ Attested W. Forsyth/ 1921

inscribed on back: Self-Portrait of Frank Duveneck
 about 1878 from the artist to C. M. Moore to
 Mrs. J. N. Carey. W. Forsyth, Indianapolis,
 July 19, 1920

Gift of Mrs. John N. Carey

38.37

Frank Duveneck was born in 1848 in Covington, Kentucky, where he was working as an artist by 1862. He went to Munich in 1870 to study with Wilhelm von Diez but was more heavily influenced by Wilhelm Leibl. In 1874 and 1875 he was back in Cincinnati, and spent some time in Boston. He soon returned to Munich, where he stayed until 1877. That year he travelled to Venice, where he remained for one year. He returned to Munich where, in 1878, he set up his own art school; the following year he moved his school to Florence. He taught and painted in Florence and Venice until his wife's death in 1888. Then he returned to Cincinnati where he was on the faculty at the Cincinnati Art Association. After 1900 he began teaching at the Cincinnati Art Academy, of which he became Chairman five years later. He was elected an Associate of the National Academy of Design in 1905, when he also undertook a final visit to Italy. He died in Cincinnati in 1919.

Duveneck's *Self-Portrait* is reminiscent of the Clowes self-portrait by Rembrandt as a study in expression. The spontaneity and vigorous brushwork, however, were inspired more directly by the paintings of Frans Hals, such as *Malle Babbe* (Metropolitan Museum of Art, New York) which Duveneck is known to have copied (ACA Heritage Gallery, New York). Strikingly romantic in effect, the IMA picture was done in 1878 during Duveneck's second sojourn in Munich. It participates in the style of Wilhelm Leibl and his circle, of which Duveneck and William Merritt Chase were members. In particular, the treatment has strong affinities with the work of Theodore Alt and Wilhelm Trübner.

In the 1850s and 1860s Munich emerged as Germany's leading art center under Karl von Piloty, who cultivated a highly refined style based on French academicism and the "little masters" of the Dutch Baroque, especially the Leiden school. Courbet's stay in Munich in 1869 had a decisive impact on the young Leibl, who visited Paris later that year. There he absorbed the Realists' enthusiasm for the painterly style of Hals and Velazquez. As Duveneck's *Self-Portrait* attests, the Leibl group was concerned with pure painting but had little interest in formal aesthetic problems. Instead, they transcribed appearances as directly as possible. Their approach was thus similar to early Impressionism, but they never became recorders of light as such, and their landscapes (such as Duveneck's *Polling Landscape* of 1881 in the IMA) are actually closer in style to Barbizon painting, especially Daubigny.

PROVENANCE: The Artist; C. M. Moore.
EXHIBITIONS: *Triumph of Realism*, Brooklyn Museum, 1967, no. 47. *William Merritt Chase in the Company of His Friends*, Parrish Art Museum, Southampton, L.I., 1979, pp. 39, 46.
LITERATURE: J. T. Flexner, *Nineteenth Century American Painting*, New York, 1970, p. 160. M. S. Young, "Duveneck and Henry James: A Study in Contrasts," *Apollo*, Sep. 1970, pp. 210-217, fig. 15.

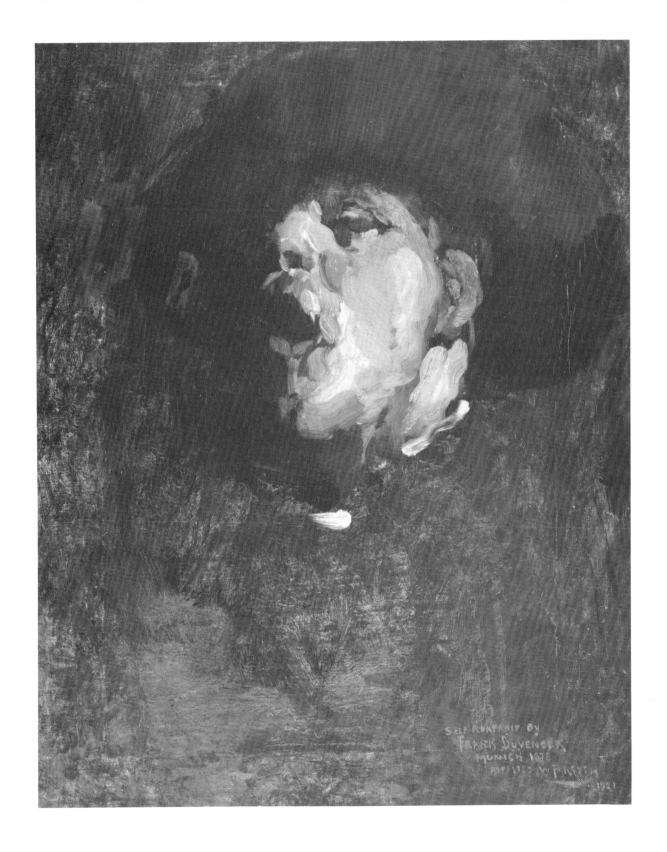

Self portrait by
FRANK DUVENECK
MUNICH 1878
ATTESTED W. F. PRITCH
1921

Frank Duveneck. *Polling Landscape*. 1878. oil on canvas, 16 x 24 (40.7 x 61). Gift of Mrs. Charles P. Mattingly. 72.136.

THOMAS EAKINS
American, 1844-1916

The Pianist (Stanley Addicks). 1896

oil on canvas, 24 x 20 (61 x 50.8)
signed and dated l.r.: Eakins/1896
James E. Roberts Fund
40.09

Eakins was born in 1844 in Philadelphia, where he began studies at the Pennsylvania Academy of the Fine Arts about 1861 and attended anatomy classes at Jefferson Medical College. In 1866 he entered the Ecole des Beaux-Arts in Paris, becoming the pupil of the painters Jean Léon Gérôme and Léon Joseph Florentin Bonnat and of the sculptor Augustin Alexandre Dumont. In 1868-1869 he travelled in Italy and Germany, then spent the winter in Spain before returning to Philadelphia in 1870. Eakins taught the life class at the Pennsylvania Academy from 1876 on and became its director in 1882. Two years later he married his student Susan Hannah MacDowell. When he resigned his position at the Academy in 1886, Eakins and his students formed the Philadelphia Art Students League. From 1888 to 1894 he also taught at the National Academy of Design in New York, to which he was elected in 1902. He died in Philadelphia in 1916.

Eakins is widely recognized as the greatest American artist of the nineteenth century. His reputation rests today primarily on his masterpiece, *The Gross Clinic* (1875, Jefferson Medical College, Philadelphia), as well as on his genre scenes depicting such favorite masculine pastimes as boating and boxing, although the most common theme in his paintings was music, for which he had an abiding love. Eakins was also the finest portraitist of the age, and the bulk of his output, particularly after 1890, consists of works like *The Pianist.*

The painting derives its modern title from the fact that the sitter, Stanley Addicks, was a pianist. It is a pendant to a portrait (Columbus Gallery of Fine Arts) of his wife, Weda Cook, whom Eakins immortalized in *The Concert Singer* (1892, Philadelphia Museum of Art). Both musicians belonged to the circle of friends from whom Eakins drew the majority of his subjects, and the artist has captured Addick's sensitive, retiring personality with understanding and sympathy. Although he no doubt posed in Eakins' attic studio, it is easy to imagine Addicks rapt in music at the piano. Yet *The Pianist* is much more than a study in mood.

Eakins adhered to the manner of Léon Bonnat, from whom he received a thorough technical training, and like William Morris Hunt he was influenced by Thomas Couture as well. But although the French academic style was favored in Philadelphia, Eakins dispensed with the ingratiating conventions of fashionable portraiture, neither flattering his sitters nor enhancing the visual appeal of his paintings. He adopted instead a blunt approach of uncompromising honesty which suggests that he also responded to the Realism of Gustave Courbet (compare Courbet's *Portrait of Urbain Cuenot,* 1846, Pennsylvania Academy of the Fine Arts, Philadelphia), who likewise admired Spanish and Dutch Baroque portraiture. Thus, unlike Hunt's *Ideal Head,* which is veiled in a poetic atmosphere, *The Pianist* has an astringent surface and sober color which deliberately force a confrontation with the solemn image, making it impossible to avoid Addicks' haunted expression which becomes increasingly disturbing upon repeated viewing.

In his late portraits Eakins consistently imposed a tragic sense of defeat bespeaking a profound alienation on the artist's part. His years at the Pennsylvania Academy were filled with controversy over his life classes, which shocked prudish Philadelphians. And although he was respected by many fellow artists and by a few discerning patrons, his career was marred by

failure to gain until late in life the recognition that was his due. The inability of his wife to bear children was a major disappointment as well. The consequence of these professional and personal setbacks became manifest in Eakins' peculiar behaviour—including a component of typically Victorian sexual tension—which is too well documented to ignore, despite the fact that at face value he led what was for the most part an average existence.

Precisely because he was a misfit out of step with his times, Eakins was able to provide perhaps the most penetrating commentary on the late Victorian era. In *The Pianist* he seems to lay bare the soul of Stanley Addicks and, with it, the entire age. Beneath the facade of prim respectability Eakins discovered the pathos of existence in Victorian America, which he expressed in terms rivalling the late portraits of Rembrandt, Hals and Goya. It is significant that many of the great painters after the Civil War—including George Inness, Homer Martin, Alexander Wyant, Ralph Blakelock, Albert Pinkham Ryder and even Winslow Homer, besides Eakins himself—suffered from physical disabilities or psychological problems which placed them outside the mainstream of American life. In contrast, the generation of Romantic artists, such as Asher B. Durand, had generally shared the same values and had often moved in the same circles as their patrons. While painters such as William Merritt Chase continued to gain fame by appealing to the fashionable tastes and social norms of the period, Eakins' portrait of Stanley Addicks demonstrates the changing role of the artist in the United States from a definer of the national ethos to a revealer of deeper truth through an entirely personal vision.

PROVENANCE: Mrs. Thomas Eakins, Philadelphia; Stanley Addicks, Philadelphia; American Art Association Anderson Galleries, New York; Babcock Galleries, New York.
LITERATURE: L. Goodrich, *Thomas Eakins, His Life and Work*, New York, 1933, p. 180, no. 278. W. D. Peat, "The Pianist by Thomas Eakins," *Bulletin*, XXVII, 2, Jul. 1940, pp. 28-31. R. McKinney, *Thomas Eakins*, New York, 1942, ill. p. 34. G. Hendricks, *The Life and Work of Thomas Eakins*, New York, 1974, pp. 194, 326, no. CL-121.

ABBOTT HANDERSON THAYER
American, 1849-1921

Margaret MacKittrick. ca. 1903

oil on canvas, 24⅛ x 23 (61.3 x 58.4)
signed u.r.: Abbott H. Thayer
Gift of the Friends of American Art
25.312

Abbott H. Thayer was born in 1849 in Boston. He spent most of his childhood near Keene, New Hampshire. Around 1865 he studied with H. D. Morse in Boston, then went to New York to study at the Brooklyn Art School and at the National Academy of Design. He set up a studio in Brooklyn in 1869. In 1875 he went to Paris, where he studied at the Ecole des Beaux-Arts and with Jean-Léon Gérôme. He returned to New York in 1879, and remained there until 1901. That year he moved to Dublin, New Hampshire, where he died in 1921.

The inception of *Margaret MacKittrick* can be dated to the summer of 1903 on the basis of existing documentary evidence. On September 16th of that year Thayer wrote two letters to his patron Charles Freer of Detroit requesting a "mortgage" against several paintings. The first lists four pictures, including "a head and down to waist of a red haired girl whom I worship here, lifesize," whom he identifies in the second letter as a Margaret MacKittrick. Our painting was not accepted by Freer and probably remained in the artist's hands, since it was sold to the Friends of American Art at the Herron Museum only in 1925, most likely by Macbeth Gallery of New York, which handled the Thayer Estate. There is some evidence that *Margaret MacKittrick* had not been finished as of the winter of 1903. On December 19th he wrote to his wife, "The Whelpleys have made a beautiful copy of a part of Margaret McKittrick." Phillip Whelpley and his wife were among several young artists employed by Thayer to make copies of his unfinished canvases. Thayer discovered that his creativity was generally confined to three-day bursts, after which he found it difficult to complete a painting; yet he often labored on his pictures over a period of many years. He would wait for his inspiration to return, then work on the copy to test his ideas before touching the original painting. Although the fate of the Whelpley replica is unknown, this procedure explains the magnificent breadth of handling in *Margaret MacKittrick*, which retains the excitement of Thayer's original inspiration but was most likely brought to completion only much later.

Margaret MacKittrick recalled the sittings in a letter written to the Indianapolis artist Olive Rush on May 27, 1926 from Santa Fe, where she spent most of her life working with Indians:

> The Thayers were our neighbors at Dublin, New Hampshire, where we spent all our summers. My brother and I played with Gerald and Gladys Thayer, and naturally I regarded posing as merely a dull incident among all the really important affairs of childhood. The frame was put on by the Ainslees Galleries when they took the picture on consignment. I do remember that Mrs. Thayer used to read aloud some of the time that I was posing, but aside from that the whole incident has faded completely from mind.

Margaret was approximately the same age as the Thayer children, i.e. about fifteen years old. Our portrait was probably done in almost the same breath as a similar one of *Gladys* (no. 60 in Metropolitan Museum Thayer Memorial Exhibition, 1922; perhaps no. 13 in Macbeth Gallery Exhibition, 1931, and similar to no. 12 in the same show; the present location is unknown). In treatment it can also be compared with a portrait of the artist's nephew, Henry Thayer Whit-

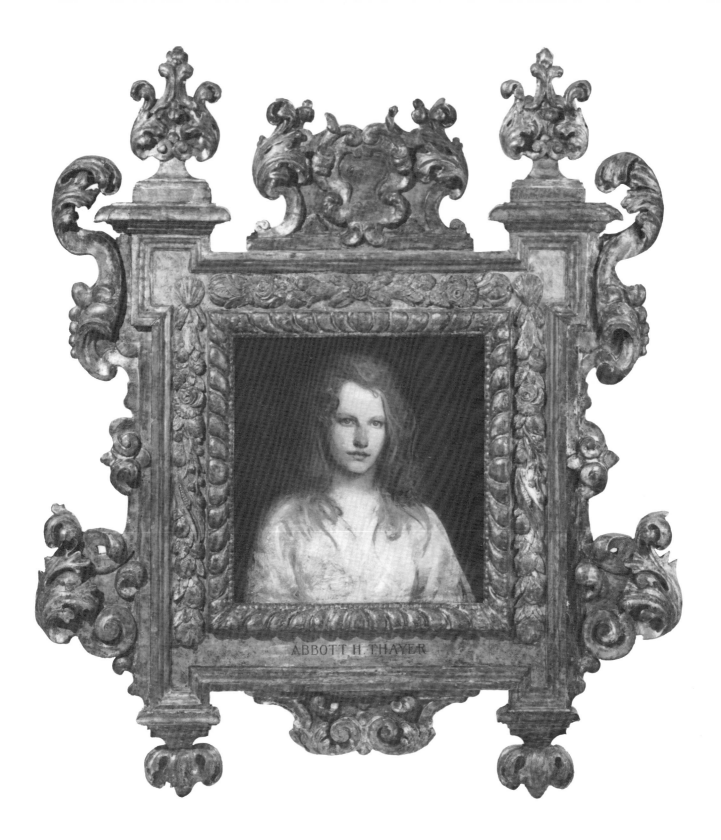

ABBOTT H. THAYER

ing (1905, formerly Collection of Mrs. E. M. Whiting; no. 61 in Metropolitan Thayer exhibition; similar painting in the Art Institute of Chicago). These paintings belong to a large group of canvases showing family and friends which, together with occasional still lifes such as the IMA's *Peonies and Pewter,* predominate in Thayer's work between about 1900 and the outbreak of World War I, when he became largely preoccupied with camouflage painting.

The portraits of *Margaret MacKittrick* and *Gladys Thayer* are among the idealized pictures of women (compare, for example, *Young Woman in White,* ca. 1902, Metropolitan Museum, New York) in which he tried to capture the sitter's soul in the same ethereal terms found in his allegorical figures of Charity, angels and the like. *Margaret MacKittrick* is nevertheless exceptional in his *oeuvre* for its obvious debt to Whistler. The picture is certainly modelled on Whistler's extraordinary paintings of the late 1890s showing young girls, for example *The Little Rose of Lyme Regis* (1895, Museum of Fine Arts, Boston) and *Lillie in Our Alley* (ca. 1898, National Gallery of Canada, Ottawa). As in Whistler's paintings, there is an intriguing mixture of innocence and surprisingly mature sensuousness. The reflectiveness is all the more astonishing in light of Margaret MacKittrick's letter to Olive Rush. It is evident that Thayer imposed the introspective mood and rare beauty as an interpretation of her emerging adolescence. Thayer endowed *Girl Arranging Her Hair* (ca. 1909, reworked 1921, Art Museum of the New Britain Institute), showing Gerald Thayer's wife as an almost sirenian classical figure, with a similar appeal.

The kinship between *Margaret MacKittrick* and Whistler's paintings is by no means a coincidence. Thayer expressed his admiration for the expatriate painter in one of his letters of September 16, 1903 to Freer, who was a close friend and major patron of both artists:

> Whistler, in those great portraits, is to me, of course, the exquisite great painter without a rival. When one says that, he always feels a sort of duty to his own muse to reflect that one can never judge to how great an extent one's own pictures make up, in their own way, for what they lack in Whistler's way; but I long for his exquisite flower-like beauty, and loathe my clumsier aspect.

Whistler's aestheticism was in harmony with the refined sensitivity and Emersonian idealism of Thayer and the Boston school arising out of William Morris Hunt, whose *Ideal Head* in the IMA has obvious affinities with *Margaret MacKittrick.*

Another point in common between Thayer and Whistler can be found in their preference for elaborate frames, although of different kinds. *Margaret MacKittrick* owes much of its impact to the striking Renaissance frame, which lends the painting an imposing visual, not to mention physical, presence. Thayer often used Italian Renaissance and similar frames supplied by the framemaker George Of and by his other major patron John Gellatly, who tried to use them as a means of inducing the artist to paint new pictures for him in 1903. As her letter to Olive Rush indicates, Margaret MacKittrick's portrait was not painted for this specific frame, which may have come from Of, but the frame serves an important purpose: to help remove the image from the mundane world to the timeless realm of idealized womanhood that obsessed the artist's imagination.

LITERATURE: N. C. White, *Abbott H. Thayer, Painter and Naturalist,* Hartford, 1951, p. 108.

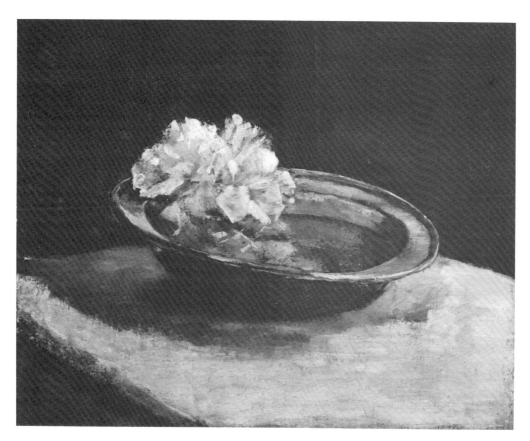

Abbott H. Thayer. *Peonies and Pewter.* oil on canvas, 14⅞ x 18⅝ (37.8 x 47.4).
Gift of the Gamboliers. 36.7.

WILLIAM MERRITT CHASE
American, 1849-1916

Dorothy. 1902
oil on canvas, 72 x 36 (182.9 x 91.4)
signed 1.1: Wm. M. Chase
John Herron Fund
03.4

William Merritt Chase was born in 1849 in Franklin Indiana. After serving in the Navy, he turned his attention to art and began by studying in Indianapolis with Benjamin Hayes from 1867 to 1869. He attended the National Academy of Design in New York and later studied with L. E Wilmarth. In 1871 a group of art patrons from St. Louis provided funds for him to study in Europe. Chase went to Munich in 1872, and studied there under Alexander Wagner and Karl von Piloty. He was heavily influenced by Wilhelm Liebl and shared a studio in Munich with Frank Duveneck. He visited Venice in 1877 with Duveneck and John Twachtman. In 1878 Chase settled in New York, where he taught at the Art Students League. He returned to Europe in 1881 and met Whistler in London in 1885. He married Alice Gerson in 1886. Chase was elected a member of the National Academy of Fine Arts. Upon Twachtman's recommendation, he was invited in 1902 to join the group of artists known as The Ten. In 1914 he visited Europe for the last time. He died in New York in 1916.

This portrait of the artist's daughter Dorothy is one of the largest and most formal canvases showing members of his family, who are generally seen in impromptu studies. It was painted in 1902 over a similar portrait of a young woman in a shawl which was uncovered some years ago during restoration and is still clearly visible in radiograph. A *tour de force*, this painting fully displays the brilliant technique and cosmopolitan sophistication that made him one of America's leading painters in the later nineteenth century. Although he began as a disciple of Wilhelm Liebl, *Dorothy* is indebted largely to *Harmony in Grey and Green: Miss Cicely Alexander* (1872-1874, Tate Gallery, London) and other works by James McNeill Whistler, with whom Chase enjoyed a brief friendship in 1885 until their falling-out over his famous portrait of Whistler in the Metropolitan Museum. The facile brushwork and idealized beauty also betray the influence of John Singer Sargent, the most fashionable portraitist of the late nineteenth century. The IMA painting masters every artistic problem with ease. At the same time, it has a charm which communicates Chase's affection for his daughter in a most engaging manner.

PROVENANCE: The Artist (direct purchase from 1903 exhibition)
EXHIBITIONS: *Exhibit of Indiana Art*, Tomlinson Hall, Indianapolis, 1903, no. 72. *Seven Centuries of Painting*, California Palace of the Legion of Honor and the M. H. de Young Memorial Museum, San Francisco, 1939, no. L-151. *Chase Centennial Exhibition*, John Herron Art Museum, Indianapolis, 1949, no. 48. *William Merritt Chase, A Retrospective Exhibition*, Parrish Art Museum, Southampton, L.I., 1957, no. 85.

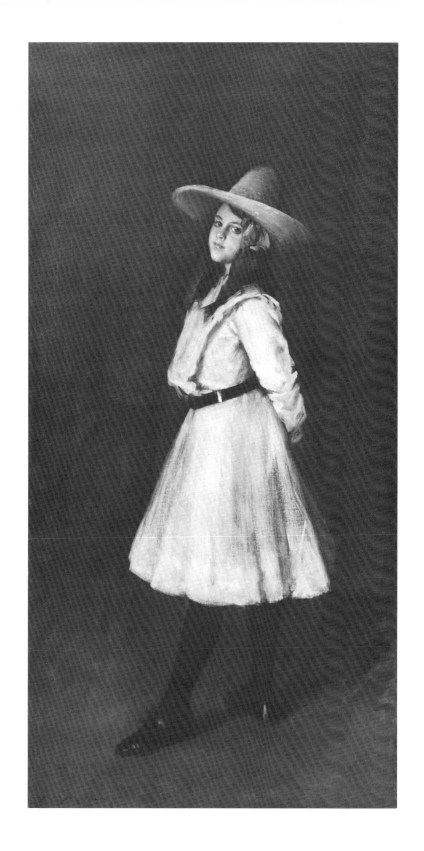

WILLIAM MERRITT CHASE
American, 1849-1916

Woman in White. ca. 1910

oil on canvas, 29 x 19 (73.7 x 48.3)
signed l.c.: Chase
Gift of Mrs. Albert E. Metzger
45.241

A completely different mood prevails in *Woman in White* showing Alice Dieudonee, Chase's oldest daughter, who appears in many other paintings by the artist, including his masterpiece showing her with a feather boa when she was about fifteen years old (ca. 1902, Parrish Art Museum, Southampton, L.I.). Our canvas captures her as a mature young woman in her early twenties and was probably done around 1910, a date confirmed by the costume and style. The fashionable hat and blouse provided the pretext for investigating

William M. Chase. *Study of a Spanish Girl.* oil on canvas, 32 x 25 (81.3 x 63.5). Gift of Mrs. John N. Carey. 38.34.

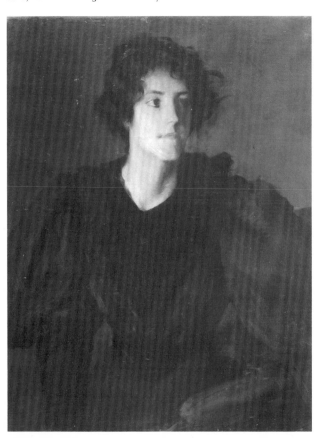

aesthetic problems of light and color, which are treated with Chase's customary aplomb.

The result is in striking contrast to the treatment in the IMA's *Spanish Woman*, which is much more typical of Chase's work. *Woman in White* is most notable for the way the contrast between light and shadow in the two halves of the painting evokes the reflective mood signified by the pose. Unlike the sentimental pictures of day-dreaming women which abound around the turn of the century, the exquisite features of Alice Dieudonnee are bathed in a poetic reverie tinged with the melancholy found in Eakins' late portraits but without their pathos (compare the IMA's *Pianist*). Such pensiveness is rare in Chase's work. It is found, interestingly enough, in *Meditation* (ca. 1884, Jackson Chase Storm Collection), showing Alice Gerson shortly before he married her. The pictures of wife and daughter make a fascinating comparison. Despite the subtler modelling achieved through the use of pastels in *Meditation, Woman in White* conveys much the same character. Alice Dieudonnee was described in a contemporary news clipping as "a charming young woman, typically American, and characterized by an alert mentality tempered by gracious womanliness. From her father she inherits her marked artistic ability, while her literary skill is an inheritance from her mother's people." She was also a "skillful amateur actress" whose "effects in costuming and posing are worthy of a professional" (R. G. Pisano, *William Merritt Chase*, New York, 1979, p. 80). Together with the brilliant treatment of the surface, this suggestive portrayal makes *Woman in White* one of Chase's memorable paintings.

EXHIBITIONS: *William M. Chase Retrospective Exhibition of Paintings,* American British Art Center, New York, 1948, no. 3. *William Merritt Chase,* University of California Art Gallery, Santa Barbara, 1964, no. 39.
LITERATURE: W. D. Peat, *Chase Centennial Exhibition* (catalogue), John Herron Art Museum, Indianapolis, 1949 (checklist of Female Figure Studies).

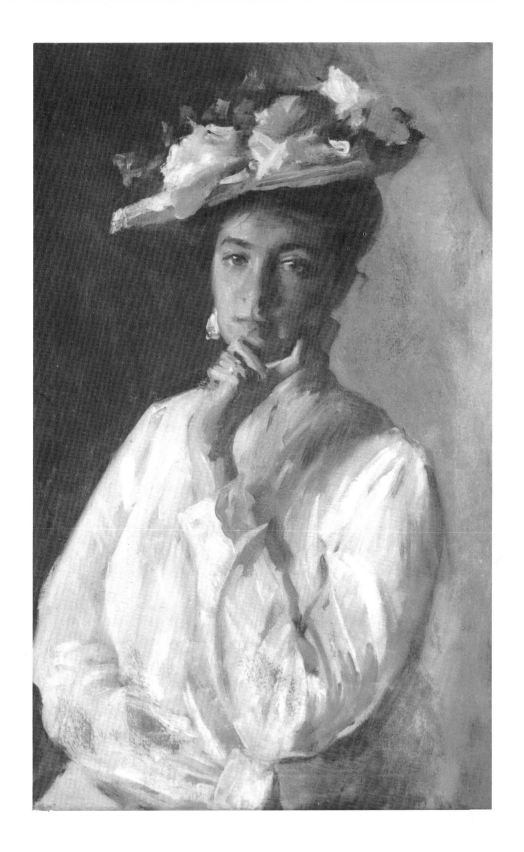

WILLIAM McGREGOR PAXTON
American, 1869-1941

Glow of Gold, Gleam of Pearl. 1906
oil on canvas, 75¾ x 35⅜ (192.4 x 89.9)
signed l.r.: PAXTON
Gift of Robert Douglas Hunter
79.345

William McGregor Paxton was born in 1869 in Baltimore. His family moved to Newton, Massachusetts, in 1870. He attended night classes at Cowles Art School in Boston, studying under Dennis M. Bunker. After graduating from high school in 1889, Paxton left for Paris, where he studied at the Ecole des Beaux-Arts, the Académie Julian, and with Jean Léon Gérôme. He returned to America in 1893 and resumed his studies at Cowles Art School under Joseph Decamp. In 1894 he became a member of the Art Students Association (Copley Society of Boston) and in 1898 joined the Boston Art Club. That year he returned briefly to Europe. He married Elizabeth Okie in 1899. In 1904 he won a bronze medal at the St. Louis World's Fair and endured a disastrous studio fire which destroyed over 100 of his paintings. In 1906 he was appointed drawing instructor at the School of the Boston Museum of Fine Arts. In 1907 he visited Italy and returned again to Europe in 1933. Paxton suffered a stroke in 1939 and died in 1941.

Paxton rightly regarded *Glow of Gold, Gleam of Pearl* as the masterpiece of his early career. A transitional work, it looks back to his training under Gérôme and DeCamp, while standing on the threshold of artistic maturity. Painted in 1906, the canvas immediately predates the first of his many pictures depicting young women at everyday tasks in sumptuous interiors, for which he is most famous. Such subjects, inspired by Alfred Stevens and especially Jan Vermeer, were a specialty of Boston artists, including DeCamp, Edmund Tarbell and Frank Benson. Paxton's treatment of this theme evolved from his earlier portrait paintings of women.

Glow of Gold, Gleam of Pearl is one of the artist's few paintings for which a finished drawing exists (now owned by the IMA). Dated March 26, 1906, the sheet captures the pose and proportions of the model, but differs in its essential character from the painting, on which it sheds considerable light. Emulating the drawings of his ideals Ingres, Gérôme and Degas, Paxton emphasizes the contour line at the expense of modelling, which is only lightly hatched in. By itself, the drawing is little more than a standard *Académie*, or life study, of the sort produced by every artist trained in

the French academic tradition. A skilled draughtsman, Paxton executed such studies throughout much of his career, but this drawing is one of the very few he translated into paint. Although his working methods are not always entirely clear, Paxton evidently copied the drawing onto the canvas, but then must have proceeded to paint the nude from the live model, turning to the sheet for only an occasional reference.

For that reason, the painting makes a totally different impression from the drawing. Fully modelled by the brush, the figure takes on an astonishingly life-like presence. In her solid construction, she shares the realism of the nudes by Gérôme that inspired Paxton, such as *Phryne before the Tribunal* (1861, Kunsthalle, Hamburg) and *Slave Market* (Hermitage State Museum, Leningrad). That our figure is just such a slave girl is further demonstrated by her resemblance to Paxton's *Phryne* of 1923 (Estate of the Artist), which evolved from a drawing of a *Standing Nude* (now owned by the IMA) based on Ingres' *The Source* (1856, Louvre, Paris). But unlike its exemplars, *Glow of Gold, Gleam of Pearl* lacks the idealization created by the porcelain finish that lends French nudes their icy perfection. The painterly brushwork instead approximates

248

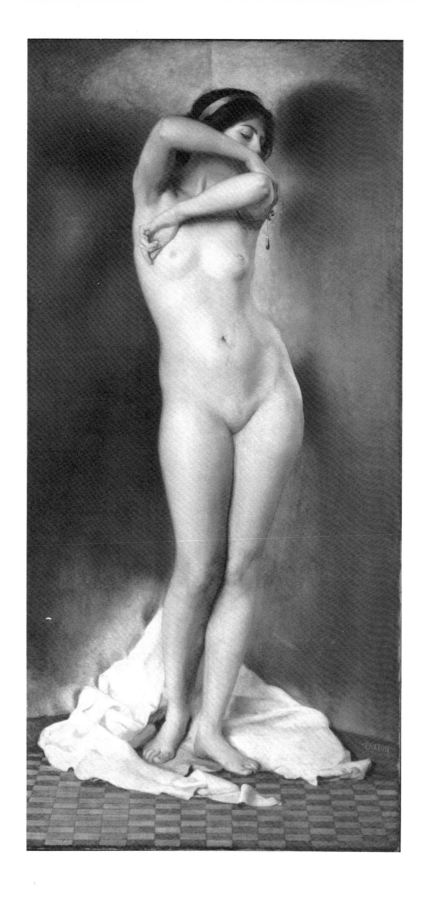

William M. Paxton. *Study for Glow of Gold, Gleam of Pearl.* 1906. pencil on paper, 12 x 8⅞ (30.5 x 22.5). Mr. and Mrs. Julian F. Pratt Fund. 79.448.

William M. Paxton. *Standing Nude.* 1920. crayon on paper, 24⅝ x 18¾ (62.5 x 47.6). Gift of Mrs. Charles Frederic Toppan. 79.169.

the texture and, hence, the appearance of human skin. Paxton depicts a woman of flesh and blood who lives and breathes, despite her statue-like immobility.

The difference between *Glow of Gold, Gleam of Pearl* and its French counterparts is accounted for by Joseph DeCamp's story about his first encounter with Paxton, as related by R. H. Ives Gammell:

> The newcomer, fresh from Paris and the Ecole des Beaux-Arts, had executed a very slick and polished rendering of the model, painted in a conventional tonality, before the admiring eyes of other students. As DeCamp approached to criticize the work of this so-phisticated young gentleman the students gathered behind him, awaiting their teacher's praise in awestruck silence. Quietly, without comment, DeCamp took palette and brushes out of Paxton's hand, mixed a tone

and smeared it onto the neat preparation on the canvas before him. "Don't you see, it's that color," he said, "and that color," putting down another tone and continuing until he had completely painted out the job at which Paxton had so proudly labored. "The boy took it right on the chin," DeCamp related, "and from that day on I've always been fond of Bill. What's more, the next week Bill had dropped the Paris tricks and really got the look of the model."

A product of the Munich school and a close associate of Frank Duveneck, DeCamp had a more painterly approach than Gérôme's. Under the influence of Impressionism, he and other Boston artists became absorbed by the study of color relations, which they tried to set down on canvas exactly as they appeared. Except for Benson, however, the Boston school can hardly be called Impressionists, for despite its sup-posedly optical approach, their aesthetic was funda-mentally different from Monet's and Renoir's.

250

Instead, like many young conservative French painters after 1870, they selectively absorbed only certain aspects of Impressionist color and brushwork. These they applied to traditional subjects and approaches, thereby updating them.

Glow of Gold, Gleam of Pearl uses the lessons of Impressionism to create a *tour de force* of color. The flesh tones acquire an extraordinary sensuousness through the yellow, orange and bronze colors surrounding them. It is this play in the pigments which gives rise to the title of the painting.

Interestingly enough, the string of pearls held by the model in the drawing was painted over in the canvas (where it is still faintly detectable). The blue stone of the oriental armband we now see adds a coloristic contrast to the flesh tones and serves as a visual focal point while picking up the color of the tile. Equally important, the band adds an exotic note evoking the sensuous world of the orient so often depicted in Gérôme's canvases.

The painting is, then, a remarkable combination of line and color, realism and idealization, purity and sensuousness. No wonder it continued to provoke such contradictory responses for several years after it was first exhibited in 1908, even though it won major prizes at the same time. The figure was lauded as "entirely modest in its suggestion" on the one hand, and castigated as "full-length aggressive nakedness" and as "a piece of super-refined affectation" on the other. The draughtsmanship likewise was both praised as accurate and beautiful, and criticized as mechanical and commonplace. The opposing opinions in part reflect the controversy surrounding the theme of the nude in the late Victorian era and the broader contradictions in the taste and mores of the period, for the patent eroticism in *Glow of Gold, Gleam of Pearl* was almost unheard of on this side of the Atlantic, which demanded mythlogical or allegorical trappings to justify such paintings morally. Yet the conflicting comments were also a direct response to qualities inherent in the painting, and testify to how amply Paxton succeeded in uniting his disparate elements into a nearly perfect harmony.

PROVENANCE: Estate of the Artist; R. H. I. Gammell, Boston; Robert Douglas Hunter, Boston.
EXHIBITIONS: *103rd Annual Exhibition*, Pennsylvania Academy of Fine Arts, Philadelphia, 1908, no. 103. *3rd Annual Exhibition*, Albright Art Gallery, Buffalo, 1908. *3rd Annual Exhibition*, Museum of Fine Arts, St. Louis, 1908. *Paintings by William M. Paxton*, St. Botolph Club, Boston, 1909, no. 5. *Exhibition of Paintings by William McGregor Paxton*, Rhode Island School of Design, Providence, 1909. *Exposicion Internacional de Arte del Centario*, Buenos Aires, 1910. *Expocision Internacional de Bellas Artes*, Santiago, 1910, no. 79 of U. S. section. *Panama-Pacific International Exposition*, San Francisco, 1915, cat. de luxe no. 3808. *Exposition d'Artistes de l'Ecole Americaine*, Musée Nationale du Luxembourg, Paris, 1919. *William McGregor Paxton, N.A.*, Indianapolis Museum of Art, 1978, no. 11.
LITERATURE: *International Studio*, XXXIV, Mar. 1908, supp. XXXII. *Academy Notes*, Albright Art Gallery, Buffalo, IV, 2, Jul. 1908, pp. 22-23, IV, 3, Aug. 1908, p. 37. E. W. Lee, I. Gammell, and M. Krause, *William McGregor Paxton, N.A.*, Pasadena, 1979, no.11, pp. 32, 122, 124. M. Krause, "Nineteenth-Century Taste in the Twentieth Century," *19th Century Magazine*, VI, 2, Summer 1980.

PABLO PICASSO
Spanish, 1881-1973

Ma Jolie. 1914

oil on canvas, 20 x 28 (50.8 x 71.1)
signed on back of canvas u.r.: Picasso
Estate of Mrs. James W. Fesler
61.36

Pablo Ruiz y Picasso was born in 1881 at Malaga in Andalusia. His father taught him to draw and paint at the School of Arts and Crafts of San Telmo. In 1891 the family moved to the seaport of Corunna. By 1895 they had moved again, to Barcelona where Picasso attended the School of Fine Arts. Two years later he passed the entrance examination for the Royal Academy of San Fernando in Madrid. In 1900 Picasso made his first trip to Paris with his friend Carlos Casagemus. The following year he settled in Madrid, and travelled to Paris again. During this trip to Paris he met Max Jacob and had his first exhibition at Vollard's gallery. In 1904 he moved to Paris and lived in Montmartre at the Bateau-Lavoir, where he stayed for the next five years. During this period he met Guillaume Apollinaire, Gertrude and Leo Stein, Matisse, and Daniel-Henry Kahnweiler, who became his art dealer in 1907. That year Apollinaire introduced him to Georges Braque. In 1917 Picasso collaborated with Diaghilev and the Russian Ballet Company, designing sets and costumes, as he would continue to do into the 1920s. He participated in the first Surrealist exhibition at the Pierre Gallery in 1925. In 1934 he made an extended visit to Spain and was in Spain in 1936 when the Spainish Civil War broke out. He was active on the side of the Loyalists during the Civil War and was made Director of the Prado Museum in Madrid. When World War II broke out, Picasso was in Antibes, but he returned to Paris where he remained for most of the war. In 1944 he joined the Communist party. Picasso moved to the Villa of Nôtre-Dame-de-Vie at Mougins near Cannes in 1961. Picasso died in April of 1973 at Mougins.

An old label on the stretcher of *Ma Jolie* bears the date 1914; the picture is closely related to canvases of the same title and year in a Paris private collection and the collection of Harry W. Anderson, Atherton, California. More generally, *Ma Jolie,* taken from the title of a popular French song, constitutes a *leitmotif* in Picasso's work of 1911-1914.

Our *Ma Jolie* is a fully mature example of collage (or synthetic) Cubism, which Picasso developed with Georges Braque by pasting paper and other materials to the picture surface. Although no actual objects have been incorporated into the canvas, the painting has been constructed according to the same principles. The still-life elements are juxtaposed in thin, overlapping layers distinguished by differences in color, texture and modelling. The picture consists of partial, simultaneous views which interrupt each other. They have been combined to produce a most satisfying composition, free of the restraints of normal visual perspective.

Collage Cubism partially reintegrates forms which had been dissected earlier in facet (or analytic) Cubism. Between 1907 and 1909, Picasso and Braque had begun to reduce their paintings to an abstract geometry by delineating and then extending the forms found in Cézanne's work. These they proceeded to break up into prismatic shapes which, in a sense, unfold the objects in a shallow layer across the picture plane. Collage Cubism reverses the process. Rather than reducing forms through abstraction, it uses the geometric shapes of facet Cubism to generate pictorial objects; hence the alternate term synthetic Cubism.

Cubism provided the vocabulary for much of twentieth-century painting because it was adaptable to an almost infinite range of artistic goals. Equally important, the new pictorial order implied a re-evaluation

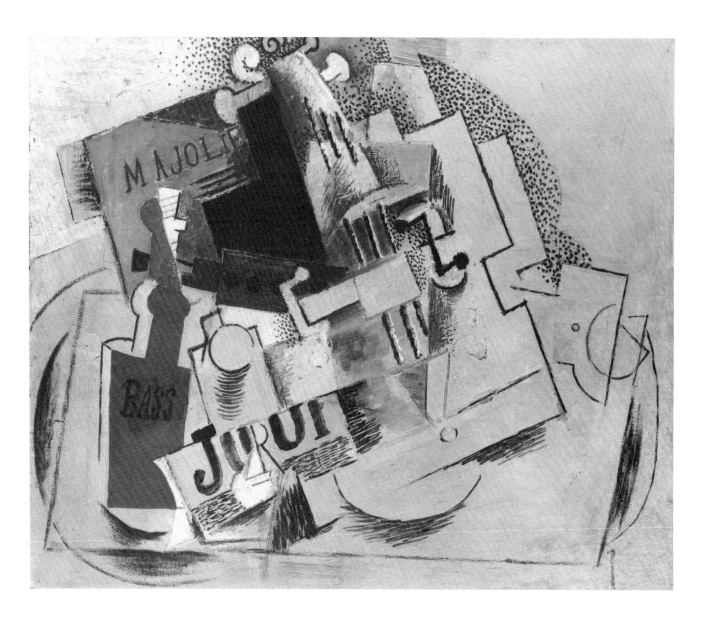

of space and time just as radical as Einstein's and just as distinctively modern. Moreover, Cubism opened up new symbolic possibilities. Partial forms in one material are often used, as here, to stand for entire objects of completely different shapes and sometimes different materials as well.

It should be emphasized, however, that Picasso and Braque were seeking a new aesthetic approach. Moreover, the items in their still lifes were generally selected from their daily life and therefore carry highly personal associations. Their favorite haunts were cafés, where they could while away the hours sipping aperitifs and listening to music or reading the news-paper. The choice and arrangement of objects in *Ma Jolie* successfully evokes that milieu in a way that is visually implausible, yet richly expressive.

PROVENANCE: Galerie Kahnweiler, Paris; Leonce Rosenberg, Paris; Theodore Schempp, New York.

EXHIBITIONS: *From Ingres to Picasso*, The Baltimore Museum of Art, 1925. *Société Anonyme*, International Exhibition, Brooklyn Museum, 1926. *La Peinture Française Collections Américaines*, Musée des Beaux-Arts, Bordeaux, 1966, pl. 68.

LITERATURE: *Lacerba*, May 1914. C. Zervos, *Pablo Picasso*, Paris, 1934, II, no. 505. W. Boeck and J. Sabartés, *Picasso*, New York, 1955, p. 463, no. 64. P. Daix and J. Rosselet, *Le Cubisme de Picasso, Catalogue raisonné de l'oeuvre peint 1907-1916*, Neuchatel, 1979, p. 309, no. 622.

AMEDÉO MODIGLIANI
Italian, 1884-1920

The Boy. 1919

oil on canvas, 36¼ x 23¾ (92.1 x 60.3)
signed u.r.: Modigliani/Cagnes
Gift of Mrs. Julian Bobbs in memory of
 William Ray Adams
46.22

Amedéo Modigliani was born at Leghorn, Italy, in 1884. He developed pleurisy in 1895. He studied with Guglielmo Micheli in 1898, and continued his studies in Florence in 1902 and Venice in 1903. By 1906 he had moved to Paris. In 1909, Modigliani, who had always thought of himself primarily as a sculptor, met Constantin Brancusi, who was to exercise a considerable influence on him. After failing to sell his sculpture, he decided in 1915 to concentrate on his painting. He died of tuberculosis in Paris in 1920.

Renowned for his sensuous nudes, Modigliani was a masterful portraitist as well. His sitters included many of the foremost artists and critics of the day in Paris, whose personalities he captured with great perception. But when nobody else was available, he would paint anyone who would pose for free, including a large number of anonymous urchins. Such was the case with this painting, which was probably done in the spring of 1919 at Cagnes near Nice, where the artist had gone for reasons of health with his friend Jeanne Hébuterne. Although the same boy posed for a second canvas (Solomon R. Guggenheim Museum, New York), Modigliani cannot have known him well. The picture is therefore not so much a study in character as in expression and pose, which recur as well in another painting by him.

The abstract forms, sober colors and spatial construction all owe something to Cézanne, but the linearism and elegance seem indebted to fifteenth-century Florentine painting. The boy's face, on the other hand, paraphrases African masks. Modigliani had been inspired by Brancusi's early sculpture to explore the forms in Archaic Greek and primitive statues, which he translated into two-dimensional images.

These sources, which share certain features despite their diversity, have been synthesized here into a consistent style. Equally important, each element has been adapted to a personal mode of expression. The languid pose, introspective face and blank eyes of *The Boy* suggest a state of ennui. Modigliani lived the life of the bohemian artist to the hilt during his brief career. As a result, he understood the deprivation and suffering of mankind with an acuity surpassed in this century only by Rouault.

PROVENANCE: Leopold Zborowski, Paris; Theodore Schempp, New York; Maurice J. Speiser, Philadelphia; Parke-Bernet Galleries, New York.
EXHIBITIONS: *Speiser Loan Collection*, Philadelphia Museum of Art, 1934. *Amedéo Modigliani*, Cincinnati Art Museum, 1954, no. 24, Bordeaux Museum, 1959, no. 108. *The Art of Amedéo Modigliani*, Atlanta Art Association Galleries, 1960, no. 24. *Arte Italiana del XX Secolo dei Collezioni Americane*, Ente Manifestazione i Milanese, Milan, 1960, no. 144. *Modigliani*, Boston Museum of Fine Arts, 1961, no. 32. *Modigliani*, Acquavella Galleries, New York, 1971, no. 41.
LITERATURE: M. Dak, *Modigliani*, New York, 1929, no. 12. E. McQuarie, "The Boy by Amedéo Modigliani," *Bulletin*, XXXIII, 1, Apr. 1946, pp. 5-7. Miller, pp. 215-216.

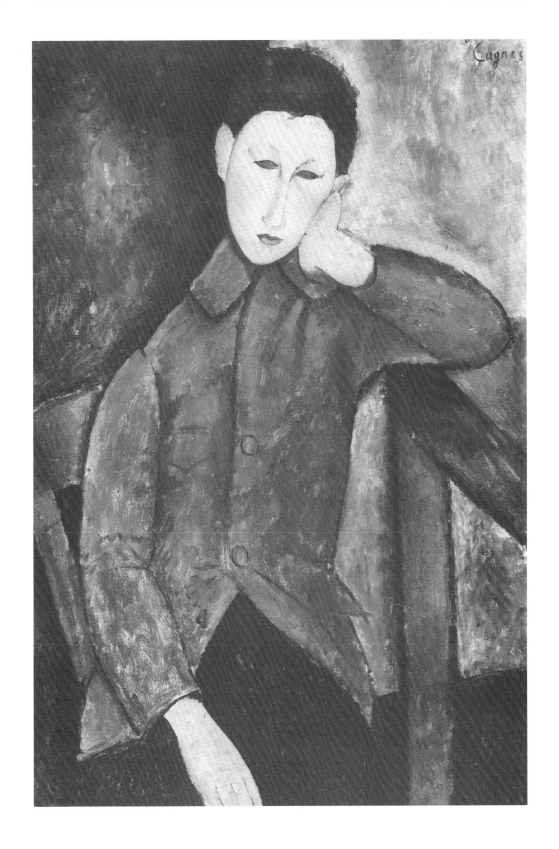

255

FERNAND LÉGER
French, 1881-1955

Man and Woman. 1921

oil on canvas, 36¼ x 25½ (92.1 x 64.8)

signed l.r.: F. Léger '21

inscribed on back: Homme et Femme definitif '21 F.
 Léger

Martha Delzell Memorial Fund

52.28

Fernand Léger was born in 1881 at Argentin, Normandy. From 1900 to 1902 he worked as a draughtsman in an architect's office, then served in the military. He entered the Ecole des Arts Decoratifs and the Académie Julian in 1903. His teachers were Jean Léon Gérôme and Ferrier. In 1903 and 1904 he worked as a photo retoucher for an architectural firm. Léger was a member of the Section d'Or group in 1911 and 1912. After several more years in the army during World War I, he married in 1919. He travelled to Ravenna in 1924, the United States in 1931, and Greece with Le Corbusier in 1935. Between 1940 and 1945 he taught at Yale University and Mills College in Oakland, California. Léger remarried in 1952 and settled at Gif-sur-Yvette, where he died in 1955.

Cubism provided a means for depicting the modern experience in purely modern terms. Because of the contradictions of modern life, however, early twentieth-century painters often used Cubism to express diametrically opposed outlooks. After 1910 Dadaism attacked the absurdity of modern existence by parodying man in mechanical terms, while the Futurists glorified technology as the basis of urban society by adapting Cubism to depict the dynamic quality, not the appearance, of the new world around them. Only the early Surrealism of Giorgio de Chirico placed the artist outside society by engaging him in the world of dreams and fantasies; yet after World War I he, too, utilized Cubism in his *Pittura Metafisica* to update the realm of Classical mythology in a contemporary style.

The mature work of Fernand Léger adopts aspects of these earlier movements. By 1918 the artist, who had been an early adherent of facet Cubism, began reducing the urban landscape and human forms to mechanical shapes based on collage Cubism. Painted in the same year as the famous *Three Women* (Museum of Modern Art, New York), *Man and Woman* of 1921

is, as the inscription on the back informs us, the definitive painting of a theme which appears in a drawing of as early as 1918 (Galerie Jeanne Bucher, Paris). It is closely related to *Woman with Mirror* (1920, Moderna Museet, Stockholm) and *Three Figures* (1920, Joseph Müller Collection, Soleure). In these canvases, Léger treats his figures as finely tooled machines indistinguishable in appearance and kind from the industrial objects around them. In accepting that modern man has become an extension of the new order he has created, Léger projects what H. H. Arnason has rightly called "a frightening symbol of the brave new world of the machine in a manner that stems from the French classic tradition of Poussin and David." (*History of Modern Art,* second edition, New York, 1977, p. 213). In *Man and Woman,* Léger's highly formal language has a discipline as rigorous in its style and social outlook as the Neo-Classicism of David. In fact, the artist later paid his respect to his great predecessor in *Homage to Louis David* (1948-1949, Musée National d'Art Moderne, Paris). At the same time, our painting has a strong element of fantasy which is reflected in its lively decorative appeal. These qualities

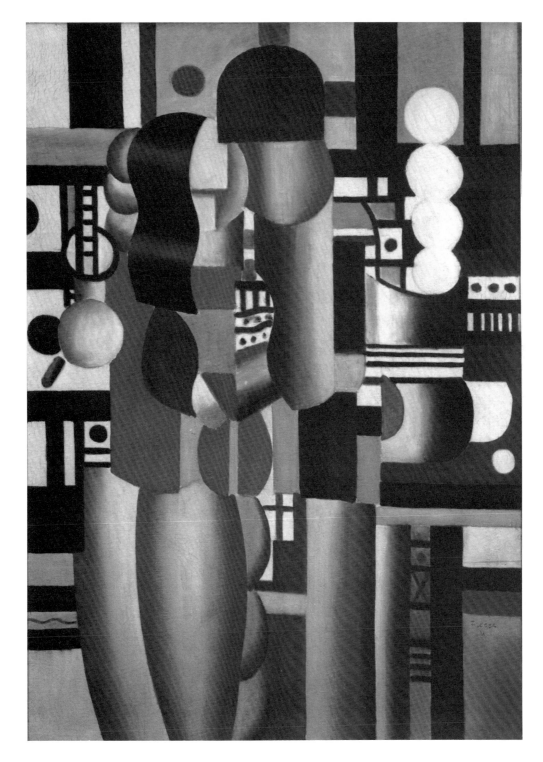

were later to make Léger the leading mural painter in France, and as such, he can also be regarded as the successor to Pierre Puvis de Chavannes.

PROVENANCE: Galerie Simon, Paris; Galerie Louis Lieris, Paris; Theodore Schempp, New York.

EXHIBITION: *Fernand Léger, Das figürliche Werk*, Kunsthalle, Cologne, 1978, no. 10.

LITERATURE: F. Elgar, *Léger: Peintures, 1911-1948*, Paris, 1948, pl. IV. J. Brown, "Fernand Léger: Man and Woman," *Bulletin* XL, 1, Apr. 1953, pp. 21-24. Miller, p. 209.

GEORGES ROUAULT
French, 1871-1958

Vollard as a Clown. 1939

gouache on paper, 13¼ x 9½ (33.7 x 24.1)
signed and dated l.r.: 1939: G. ROUAULT
James E. Roberts Fund
47.55

Georges Rouault was born in 1871 in Paris. He was first apprenticed to a stained-glass artisan, and attended evening classes at the Ecole des Arts Décoratifs. In 1890 he decided to become a painter and entered the Ecole des Beaux-Arts, where he studied in the studio of Gustave Moreau. There he met Henri Matisse in 1893. He is associated with the Fauves because he exhibited three works in the 1905 Salon d'Automne, although his paintings were not actually shown in the room of the Fauves. In 1908 he met the art dealer and publisher Ambroise Vollard, who by 1917 became his sole dealer. Rouault died in 1958.

Clowns, a popular motif in French art from Watteau through Picasso, appear frequently in Rouault's work. They are, in a sense, his Everyman, assuming a wide range of different guises. The IMA's *Head of a Clown,* for example, takes on the tragic features of Christ as the Man of Sorrows, so that unlike the classic clown who weeps behind his smile, the suffering is universal, not merely personal. In other cases, clowns act as counterparts to Rouault's prostitutes as symbols of moral and physical degradation. Finally, there is sometimes an element of grim satire aimed at the inhumanity of the bourgeoisie.

Painted in 1939, *Vollard as a Clown* shows the Parisian art dealer and publisher who was killed in an automobile accident in July of that year. Ambroise Vollard handled the works of most of the leading early modern French artists, including Rouault, long before they had gained fame. In fact, he not only had exclusive right to most of Rouault's major paintings, but he also virtually forced the artist to devote much of his time and energy to designing illustrations for numerous books and other projects. A perceptive dealer to some, he was the epitome of greed to others. Rouault himself often complained to his friends about Vollard's avarice, while appreciating the support he gave him.

Vollard as a Clown is a caricature of this strange man. The imperious gesture, stocky torso and puffy face are intended to convey his venality. His appearance in the role of a clown is related to two sets of illustrations Rouault did for Vollard: *Cirque de l'Etoile Filante*, which was published in 1938, and *Cirque* of the same period, which illustrated a text by Rouault's friend André Suares but which was never published. The gouache derives most directly, however, from a canvas of *Polichinelle* (ca. 1930, Mr. and Mrs. Walter C. Arensburg Collection, Philadelphia Museum of Art). Descended from Pulcinella of the Italian Commedia dell' Arte, Polichinelle was a grotesquely deformed character who masked beneath his buffoonish good humor a depravity and brutality born of megalomania but who possessed a quick wit that appealed strongly to the French. Vollard, however, also wears the colorful patchwork costume of Harlequin, the more benign alter-ego of Polichinelle, with whom he shared much in common, including their lover Colombine. The pointed hat, used by Rouault for almost all of his clowns, belonged to Pierrot, who was a tragic counterpart to Polichinelle taken from Pagliaccio. Whether by conscious design or subconscious intention, *Vollard as a Clown* unites several characters into one, revealing Rouault's ambivalence toward the man and his equally paradoxical personality, which the artist had come to know well over the course of their long and often tense relationship.

These feelings are further suggested by Rouault's

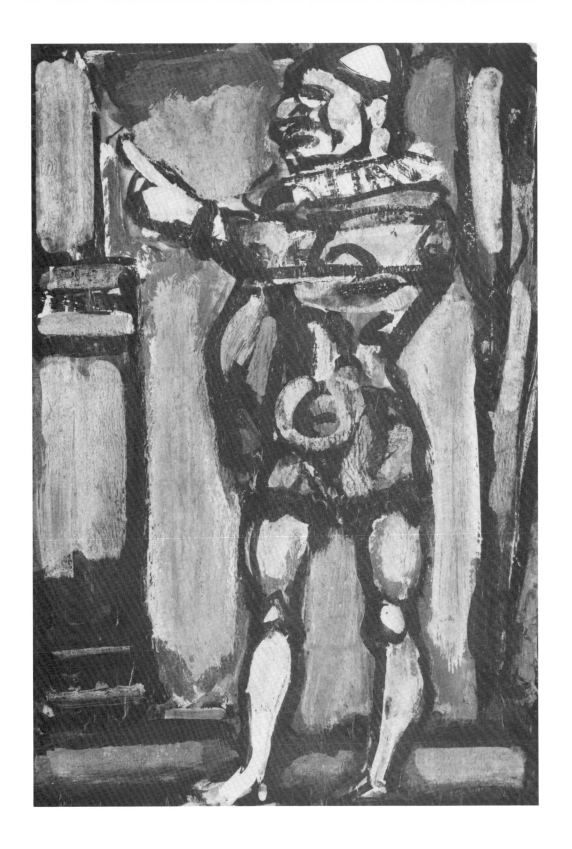

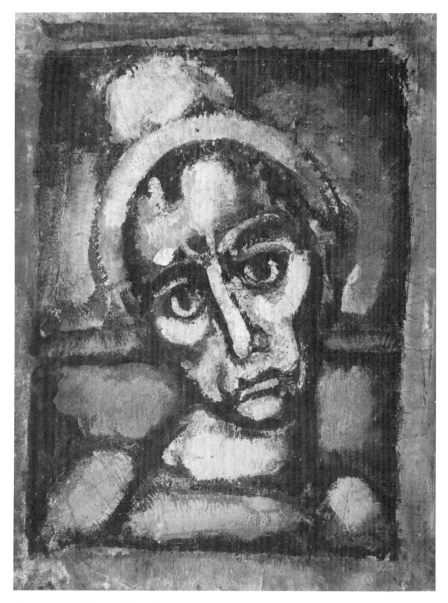

Georges Rouault. *Head of a Clown*. ca. 1920. oil and gouache on paper mounted on linen, 25½ x 19½ (64.8 x 49.6). Gift in Memory of William Ray Adams. 48.123.

technique. The color, texture and line reflect his training in stained glass, while the ritualized gesture is indebted to his teacher, Gustave Moreau (compare *The Apparition* [*Dance of Salome*], ca. 1876, Fogg Museum, Cambridge). The abstract forms indicate the influence of Cézanne's late figure paintings, perhaps through Henri Matisse who early on had appreciated their significance.

PROVENANCE: Paul Gardner, Kansas City.
EXHIBITION: *Rouault Retrospective*, Museum of Fine Arts, Boston, 1941, no. 29A.

ROBERT HENRI
American, 1865-1928

Scottish Girl in a Japanese Wrap. ca. 1915

oil on canvas, 20 x 24 (50.8 x 61)
Gift in memory of John P. Frenzel, Sr. by his heirs
77.105.2

Robert Henri was born Robert Henry Cozad in Cincinnati in 1865. He changed his name because his father had to flee a murder charge, and the family moved first to Denver, then to Atlantic City. Henri entered the Pennsylvania Academy of the Fine Arts in 1886. He went to Paris in 1888 to study at the Académie Julian, and visited Italy in 1890. He returned to Philadelphia in 1891 and began to teach there at the School of Design for Women. Henri also taught evening classes at the Charcoal Club, which was where the group known as The Eight first came together. A sojourn in Paris from 1895 to 1897 was crucial to the formation of Henri's style. His one-man show at the Pennsylvania Academy in 1897 established the Ash Can School style. In 1899 Henri wed Linda Craig and returned to Paris for two years. He settled in New York in 1900 and began teaching at the New York School of Art (Chase School) in 1902. His wife died in 1905. He was elected to the National Academy of Design in 1906, and spent the summer of 1907 in Holland. In 1908 the first exhibition of The Eight was held at the Macbeth Gallery in New York. Henri was elected to the National Institute of Arts and Letters that same year. In 1906 he married Marjorie Organ and travelled to Spain, returning to that country in 1908, 1910, and 1912. He opened his own school in 1909. In 1910 he organized the Exhibition of Independent Artists and was on the organizing committee for the New York Armory Show of 1913. By then he was increasingly influenced by the theories of Hardesty Maratta and, later, Jay Hambridge. He visited Ireland in 1913, and again between 1924 and 1928. Henri was in Santa Fe, New Mexico, in 1914, 1916, 1917, and 1922. He died of cancer in New York City in 1928.

The leader of the Ash Can School, Henri is remembered today primarily for his portraits, which are based largely on Manet, as well as the Frenchman's sources in Hals and Velazquez, but with influences from Bonnard and Vuillard. In this respect he can be regarded as the successor to William Merritt Chase (compare the IMA's *Woman in White*). *Scottish Girl in a Japanese Wrap* is typical of Henri's best studies. It shows a professional model, Edna Smith, who must have sat for this painting around the same time that she posed for a nude study in 1915 (Prof. Gian L. Campanile, Chicago). A similar study of Edna in the same wrap is in the Los Angeles County Museum of Art. While the rapid execution captures the spirit of the moment, this is hardly a casual picture, for it would seem to incorporate the theories of Hardesty Gillmore Maratta. Maratta had developed a system of color harmonies analogous to music, a concept which Henri and his circle further codified in a color chart during 1915. The choice of pigments in our painting generally follows his color chart and their juxtaposition approximates the color notes for a portrait of Helen Geary of 1919 (both are in the Beinecke Rare Book and Manuscript Library, Yale University).The impact of these experiments can be seen as well in the IMA's *Indian Girl (Julianita)* of 1917, which builds further on the approach being investigated in *Scottish Girl in a Japanese Wrap*.

Color theories have an important place in nineteenth- and twentieth-century art. Like Seurat, with whose ideas he was no doubt familiar, Henri sought a comprehensive approach to painting, and his artistic theories were similarly allied to social philosophy. Henri was a political Anarchist who believed that rational scientific systems would provide the basis for establishing a new and better order. Seen in this light, Henri was indeed America's first true modernist, despite the fact that his Post-Impressionist style was al-

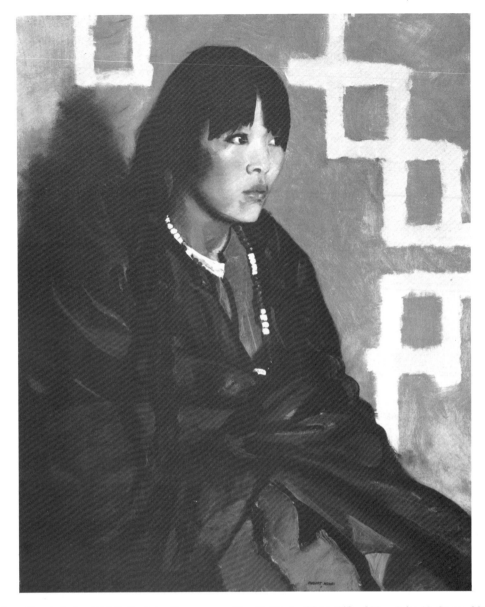

Robert Henri. *Indian Girl (Julianita)*. oil on canvas, 32 x 26 (81.4 x 66.1). Gift of Mrs. John N. Carey. 38.27

ready being supplanted by newer tendencies imported from Europe in the wake of the Armory Show of 1913. Henri's career was to suffer a serious decline after about 1920, when theory increasingly replaced painting as his main interest.

PROVENANCE: John P. Frenzel, Sr., Indianapolis

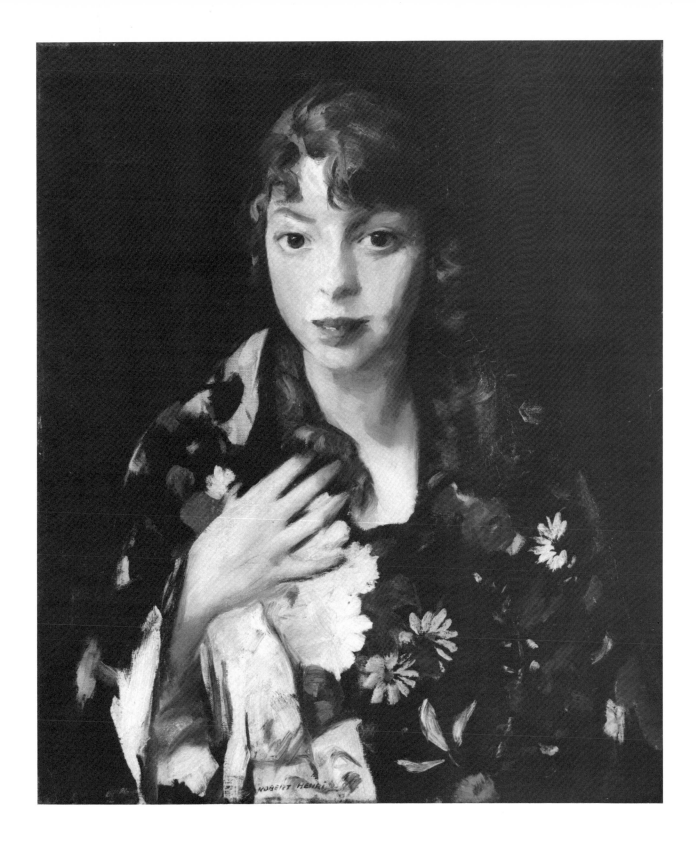

JOHN SLOAN
American, 1871-1951

Red Kimono on the Roof. 1912

oil on canvas, 24 x 20 (61 x 50.8)
signed l.l.: John Sloan
inscribed on back: Red Kimono on the Roof—
 John Sloan N.Y. 1912
James E. Roberts Fund
54.55

John Sloan was born in 1871 at Lock Haven, Pennsylvania. His family settled in Philadelphia in 1876. Sloan was largely self-taught, although he did attend drawing classes at the Spring Garden Institute in 1890 and studied at the Pennsylvania Academy of Fine Arts from 1892 until 1895. He worked for Philadelphia newspapers as an illustrator from 1892 to 1904. Throughout his career he illustrated numerous books and helped establish the Charcoal Club in 1893, serving as its vice-president. He began painting seriously in 1896. He wed Anna Wall in 1901; they moved to New York City in 1904. He ran as a Socialist candidate for the New York State Assembly in 1910 and again in 1915. In 1912 he became Acting Art Editor of *The Masses*, the publication of the Socialist party, but left the party in 1916. That year he began teaching at the Art Students League, and except for a hiatus between 1931 and 1935, he continued to teach there until 1938. In 1918 he became President of the Society of Independent Artists until his death. After 1918, he spent most summers in Santa Fe, New Mexico. His painting underwent a major change in style in 1928 and 1929. In 1929 he was elected to the National Institute of Arts and Letters. He became President of the Art Students League in 1931 and 1932. Sloan was very active as a teacher, working at Archipenko's Ecole d'Art in 1932, heading the George Luks School from 1933 until 1935, and returning to the Art Students League in 1935. He was elected to the American Academy of Arts and Letters in 1942. He wed Helen Farr in 1944. Sloan died in 1951 after an operation.

Red Kimono on the Roof was painted in 1912 when Sloan was at the height of his career. With the similarly conceived *Women Drying Their Hair* of the same year (Addison Gallery of American Art, Andover), it is one of his classic pictures. The circle of former Philadelphia newspaper illustrators grouped around Robert Henri that became known as the Ash Can School haunted the lower East Side of New York. There they found an endless source of subjects in the bustling daily life, to which they brought the reporter's eye for color and drama. Despite the socialist philosophy that Sloan and others of the group shared, theirs was not an art of social commentary. Rather, it was an art that felt the pulse of city life, discovering an underlying vitality and richness while ignoring the poverty and squalor that often affected the urban poor. To capture these qualities, Sloan used rapid brushwork, brilliant light and cheerful color, which lend our canvas its immediacy of spontaneous observation. The unself-conscious pose and expression of the woman show that she remains sublimely unaware of anyone else's presence. It is as if the artist has observed the scene by accident. Indeed, he may have painted it from his studio window. This fact would help to explain the elevated vantage point which turns us into witnesses, not participants, in the simple event before our eyes.

It is easy to see why the Ash Can School shocked some contemporary critics. With the exception of a minor strain of academic realism derived from European sources, later nineteenth-century American genre painting had largely ignored urban life. Moreover, the lack of finish in paintings by the School was too daring even for a country that had accepted Impressionism in landscape painting with relative

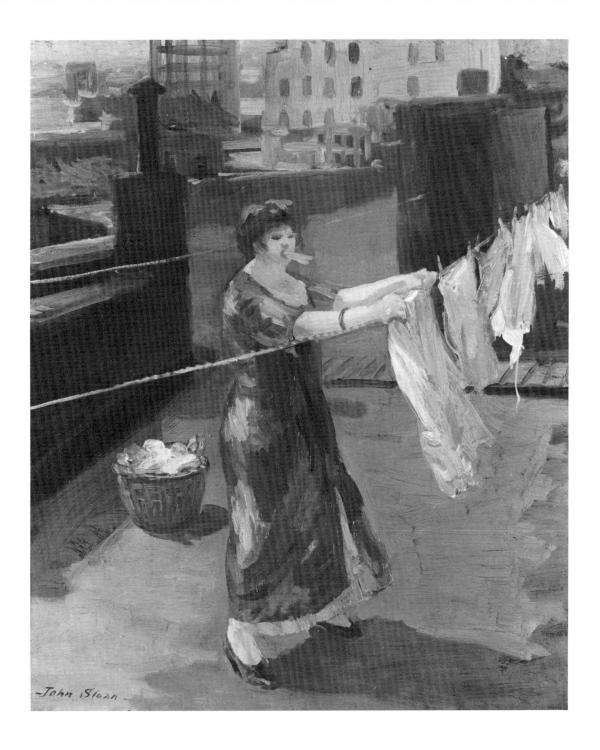

-John Sloan-

ease. During his second visit to France and immedi-
ately after his return to the United States, Henri had
formulated the group's point of view and style largely
on the basis of the Post-Impressionist art of Bonnard
and Vuillard. Although various members of the Ash
Can School turned in addition to Manet, Renoir and
Degas, Sloan was for a long time personally the closest
and artistically the truest to Henri. He was also the
most sensitive painter of the School, and maintained
the high quality of his work well into the 1920s, far
longer than the others, so that his achievement stands
as perhaps the most satisfying contribution of the
movement.

PROVENANCE: Kraushaar Galleries, New York
EXHIBITION: *The Eight*, Syracuse Museum of Fine Arts, 1958,
no. 26.

EDWARD HOPPER
American, 1882-1967

New York, New Haven and Hartford. 1931
oil on canvas, 32 x 50 (81.3 x 127)
signed l.r.: Edward Hopper
Emma Harter Sweetser Fund
32.177

Edward Hopper was born in 1882 in Nyack, New York. In 1899 and 1900 he studied illustration at a commerical art school. From 1900 to 1906 he attended the New York School of Art. Later he studied with Robert Henri and Kenneth Hayes Miller. Hopper visited Europe in 1906, 1909 and 1910, spending much of his time in Paris. After 1908 he worked in New York, participating in the Armory Show of 1913. He wed Josephine Nivison in 1924, and began to have his first real success as an artist in the middle and late 1920s, enabling him to give up illustration. Hopper was elected a member of the National Institute of Arts and Letters in 1945, and became a member of the American Academy of Arts and Letters in 1955. He died in 1967.

New York, New Haven and Hartford (the title is taken from the east coast railroad of the same name) was painted during the summer of 1931 in Cape Cod, where Hopper found many of his landscape motifs. His goal to make "the most exact transcription possible of my most intimate *impressions* (author's italics) of nature" permitted him considerable latitude in departing from natural appearances without actually violating them, so that the realism apparent in his work is often deceptive. The severe, almost classical structure of *New York, New Haven and Hartford* is relieved by the subtle placement of the landscape elements in space, which is articulated by the geometry of the composition in much the same way as in Cézanne's *House in Provence*. The sparse scene is made even starker by the subdued tonality accented by the raking afternoon light. The painting is more an evocation than a literal transcription of Cape Cod scenery, which is captured with such understatement as to seem initially matter of fact. The antecedents of our canvas can be traced back to Hopper's etching *American Landscape* and his painting *Railroad Sunset* (Whitney Museum of American Art, New York), both of 1929, which employ the same principles but in sparer form.

A student of Robert Henri, Hopper started out as an illustrator and was a successful commerical artist before his paintings achieved critical recognition. Although he was a nationalist and anti-modernist, his pictures reflect the impact of France, which he visited several times between 1906 and 1910. Despite the fact that he was a link between the two, Hopper's formalism placed him outside the Ash Can School and the American Scene painting of the 1930s. His tendency toward abstraction made his work equally appealing to modernists, who shared similar artistic concerns. Like Charles Burchfield, Hopper painted the strange combination of ugliness and beauty in the American landscape. However, he omitted Burchfield's expressive distortions and mocking satire, so that instead of claustrophobic drabness, his pictures are characterized by a haunting sense of loneliness. As Gail Levin has observed:

> Hopper used the tracks both to set off buildings and to lead the viewer's eye on beyond the confines of the picture. Railroad tracks seem to suggest for Hopper the continuity, mobility, and rootlessness of modern life as they merely pass by small towns and rural areas all but forgotten by the forces of progress. (G. Levin, *Edward Hopper: The Art and the Artist,* New York, 1980, p. 47.)

This love-hate relationship with the land contrasted sharply with the attitude of the Regionalists

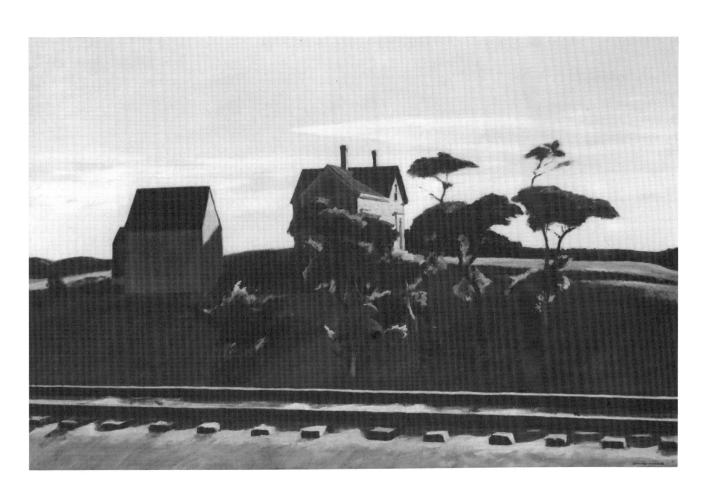

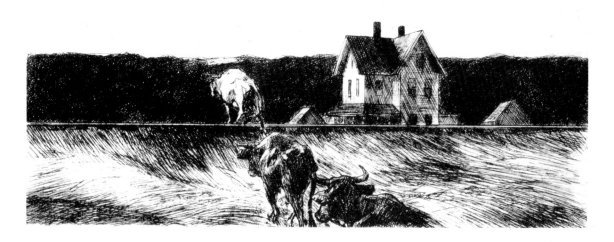

Edward Hopper. *American Landscape*. 1929. etching, 7⅜ x 12⅜ (18.8 x 31.5). Joseph Metzger Fund. 30.45

(compare the IMA's *Henry Look Unhitching* by Thomas Hart Benton), who sought to revive American idealism during the Depression by updating the American myth, which they redefined, however, in largely Midwestern terms. Because they transcend such limitations in vision, Hopper's scenes continue to exert a nearly universal appeal.

PROVENANCE: Frank Rehn Gallery, New York.

EXHIBITIONS: *Edward Hopper Retrospective Exhibition*, Museum of Modern Art, New York 1933, no. 23. *American Painting from 1860 to Today*, Cleveland Museum of Art, 1937, no. 96. *Retrospective Exhibition of Edward Hopper*, Whitney Museum of American Art, New York, 1964. *Two Centuries of American Art*, Grand Rapids Art Museum, 1977.

LITERATURE: M. S. Young, *American Realists, Homer to Hopper*, New York, 1977, p. 159. L. Goodrich, *Edward Hopper*, New York, 1978, pp. 119, 123. G. Levin, *Edward Hopper: The Complete Prints*, New York, 1979, p. 29, fig. 40, idem, *Edward Hopper: The Art and the Artist*, New York, 1980, p. 47, pl. 268.

Thomas H. Benton. *Henry Look Unhitching.* ca. 1942. tempera on masonite, 23⅛ x 27⅝ (58.8 x 70.2).
Gift of Mr. and Mrs. Joseph Cantor. 60.273.

EDWARD HOPPER
American, 1882-1967

Hotel Lobby. 1943
oil on canvas, 32¼ x 40¾ (81.9 x 103.5)
William Ray Adams Memorial Collection
47.4

Hotel Lobby of 1943 is seen as if by chance, but the encounter is anything but casual, for everything is frozen. The scene is defined by a strict geometry, which serves at the same time to create a subtle sense of spatial dislocation. With its generalized forms, the painting is fundamentally as abstract as the compositions constructed of geometric shapes by the artist's friend Patrick Henry Bruce. Individual pigments are carefully balanced in hue and saturation, but the sharp tonal contrasts created by the harsh lighting convey a somber mood. The net result is a sense of desolation which is almost surrealist in its intensity. The facelessness of the scene heightens the disquieting effect. Yet the observation is made without further comment.

Unlike the artists of the Ash Can School, Hopper had little interest in the colorful play of daily life. Thus his city scenes are rarely anecdotal. At the same time, they lack the ideological overtones of paintings by the Social Realists, who during the Depression condemned the squalor and inhumanity of a decaying urban America. But like those artists, Hopper had an eye for selecting scenes which typify the United States precisely because they are so banal. He homed in on an essential aspect of the American experience—its sense of alienation, which he immortalized by suspending his subjects in time and place through purely formal means.

Gail Levin has demonstrated convincingly that Hopper's paintings were often inspired by the theater sets of the Broadway plays he habitually attended. *Hotel Lobby* has all the starkness and artificiality of just such a set viewed from the balcony, where the artist usually sat. While it may be based on an actual lobby, the inspiration of stage designs would account for the theatrical conception of our picture, as well as many aspects of its appearance, especially the elevated vantage point and harsh lighting. Hopper created a metaphor of life in which he set the scene, chose the cast, and placed the characters within the stage-like space. The care with which he acted as director is indicated by the significant differences, particularly in the arrangement of the figures, between the canvas and the four preliminary drawings in the Whitney Museum, changes that are fully discussed by Dr. Levin in her new book on Hopper's paintings. Basically, the initial sheet shows a man staring blankly across the lobby at the old couple, who are talking to each other, and at a young woman seated in the chair next to them. The artist's wife, Jo, posed for separate studies of the women we see in the present arrangement, which emphasizes the total lack of communication between the three figures in the lonely setting.

EXHIBITIONS: *Painting in the United States*, Carnegie Institute, Pittsburgh, 1943, no. 33. *Contemporary American Paintings*, John Herron Art Museum, Indianapolis, 1944, no. 25. *LVI Annual American Exhibition of Paintings*, Art Institute of Chicago, 1945, no. 69 (winner of Logan Prize). *Six Americans*, Cincinnati Art Museum, 1948, no. 21. *Edward Hopper Retrospective Exhibition*, Whitney Museum of American Art, New York, 1950, no. 62. *Edward Hopper*, University of Arizona Art Gallery, Tucson, 1963, no. 1. *Edward Hopper*, Pennsylvania Academy of the Fine Arts, 1971. *Zwei Jahrzehnte Amerikanische Malerei*, Städtliche Museum, Düsseldorf, 1979, pp. 76, 80.
LITERATURE: *Art News*, November 1, 1945, p. 11. *Time Magazine*, November 5, 1945, p. 57. D. L. Smith, "Is there an American Style?", *American Artist*, Nov. 1960. L. Goodrich, *Edward Hopper*, New York, 1978, p. 257. G. Levin, *Edward Hopper as Illustrator*, New York, 1979, p. 28, fig. 22. *idem. Edward Hopper: The Art and the Artist*, New York, 1980, p. 49, pl. 283.

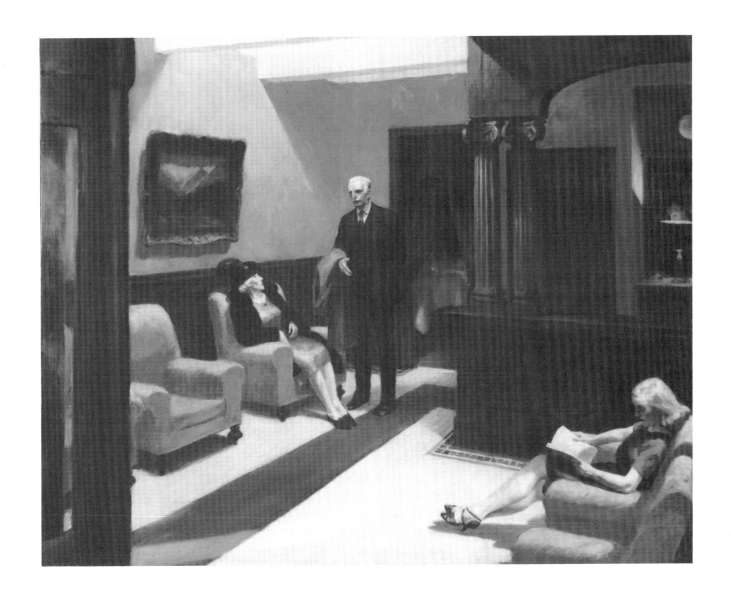

REGINALD MARSH
American, 1898-1954

Hauptmann Must Die. 1935

egg tempera on masonite panel, 27¾ x 35¾
 (70.5 x 90.8)
signed and dated l.r.: Reginald Marsh '35
Bequest of Felicia Meyer Marsh
79.167

Reginald Marsh was born in 1898 in Paris, where both his mother and father were artists. His family moved to Nutley, New Jersey, in 1900, and to New Rochelle, New York, in 1914. From 1916 to 1920 he attended Yale University where he took art classes during his last year. Upon graduation he went to New York City to work as a free-lance artist. He was on the staff of the *New York Daily News* from 1922 to 1925 and worked for *The New Yorker* magazine from 1925 to 1931. During this period he was involved with theatre and designed numerous stage sets. In 1922 he studied at the Art Students League under Kenneth Hayes Miller, George Bridgman, and George Luks. He joined the Whitney Studio Club in 1923, and wed Betty Burroughs that same year; they were divorced in 1933. After one of his frequent trips to Europe in 1925-1926, he studied again under Miller at the Art Students League in 1927 and 1928. He studied anatomical dissection in 1931 at New York College of Physicians and Surgeons and in 1934 at Cornell University Medical College in New York. From 1935 on, he taught at the Art Students League, sometimes as a full-time instructor and other times on a part-time basis. He studied with Jacques Moroger from 1940 to 1946. He married Felicia Meyer in 1943, and became a full member of the National Academy of Design that year. He was elected to the National Institute of Arts and Letters in 1946. Marsh died in Dorset, Vermont, in 1954.

Hauptmann Must Die, painted in 1935 at the zenith of Marsh's career, is at once a classic and an unusual work by this paradoxical artist. As with most of his canvases, the germ of this painting can be found in two drawings done from life. A consummate draughtsman, Marsh was an inveterate sketcher and photographer who collected a wealth of material in his voluminous notebooks. Like the members of the Ash Can School, Marsh was a former illustrator-turned-artist, and shared John Sloan's voyeuristic eye for the picturesque aspects of urban life, especially the lower East Side of New York below 14th Street, to which his friend and mentor Kenneth Hayes Miller had introduced him. However, his subject matter had more in common with the Social Realists around him, such as the Soyers. Marsh depicted the seamiest sides of New York, including the Bowery and the Times Square strip tease joints, but went anywhere that people congregated in large masses, be it Coney Island or, as here, Pennsylvania Station.

Hauptmann Must Die, in fact, has much in common with the waiting room scenes which epitomize Social Realism during the Depression. (Compare the IMA's painting of Marsh in a railway station by Alexander Brook.) But whereas Raphael Soyer's *Railroad Station Waiting Room* (ca. 1938-1940, Corcoran Gallery of Art, Washington) conveys the social dislocation and personal dispair of the era, *Hauptmann Must Die* is a topical painting. The title, taken from the newspaper headline, refers to the sentence given to the kidnapper of Charles Lindbergh's baby after a sensational trial. Like Sloan, Marsh was an acute observer of the contemporary scene, which he depicted without political or social comment, despite his moderate Socialist views.

For that reason, Marsh was bitterly attacked by the Social Realists and was championed instead by Thomas Craven, the spokesman for the Regionalists, and Thomas Hart Benton, their leader, with whom Marsh was on friendly terms. These two men could

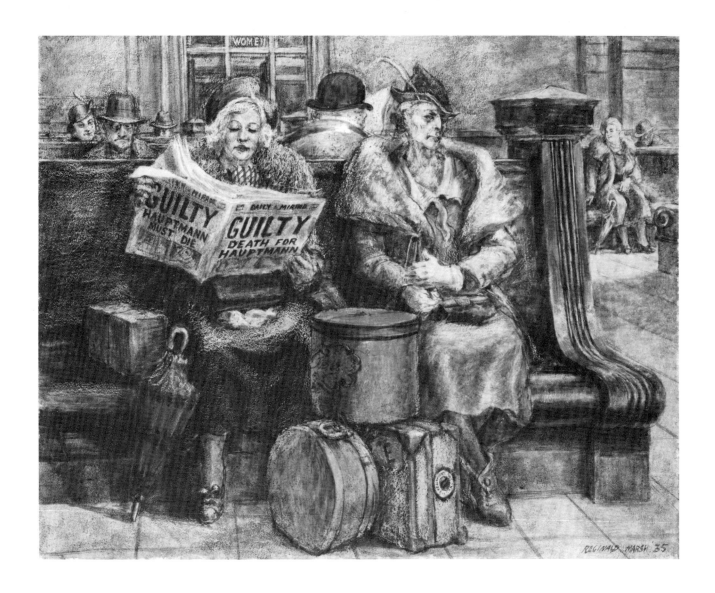

appreciate the vitality of Marsh's paintings, which capture the pulse and local feel of each scene without the bleak pessimism of Isaac Soyer's *Employment Agency* (1937, Whitney Museum of American Art, New York). In *Hauptmann Must Die*, each figure is sharply characterized rather than being portrayed as a pathetic type used to make a broader statement. In this respect the painting differs sharply from the deindividualization in the IMA's *Hotel Lobby* by Edward Hopper. Hopper likewise eluded convenient classification because he was allied to neither the Regionalist nor the Social Realist camp but, in contrast, he was esteemed by both. Instead of revealing the loneliness of the city by reducing a scene to its essential features, Marsh adds a wealth of detail to show the variety of the American experience.

Although he was very much a man of his times, Marsh was, like Benton, an avowed anti-modernist with a keen interest in the Old Masters, particularly in their techniques. It was probably Benton, in fact, who introduced Marsh to egg tempera in 1929. It soon became his favorite medium and was used in *Hauptmann Must Die*. He preferred egg tempera because it dried quickly, was easy to work with, and preserved

the graphic vitality of his art. In this way he tried to emulate the ability of Rubens, whom he admired, to draw with the brush. (Compare Rubens' sketch for *The Triumphant Entry of Constantine into Rome* in the Clowes Collection). Marsh later worked for several years with a paste invented by the Frenchman Jacques Maroger, who claimed it was the "lost secret" of artists from Jan van Eyck through Rubens.

Despite his studies, Marsh never developed a system and was without a trace of academicism. He was affected, however, by the paintings he saw during his frequent visits to museums on both sides of the Atlantic. While they did not provide the direct sources for any of his pictures, the influence of Renaissance, Baroque and, later, Mannerist art can be detected in the proportions and poses of Marsh's figures, as well as in some of his compositions. The main inspiration of Marsh's paintings nevertheless remained the life he witnessed around him. *Hauptmann Must Die* is ample testimony to his unsurpassed powers of observation.

LITERATURE: E. Laning, *The Sketchbooks of Reginald Marsh*, Greenwich, 1973, p. 129.

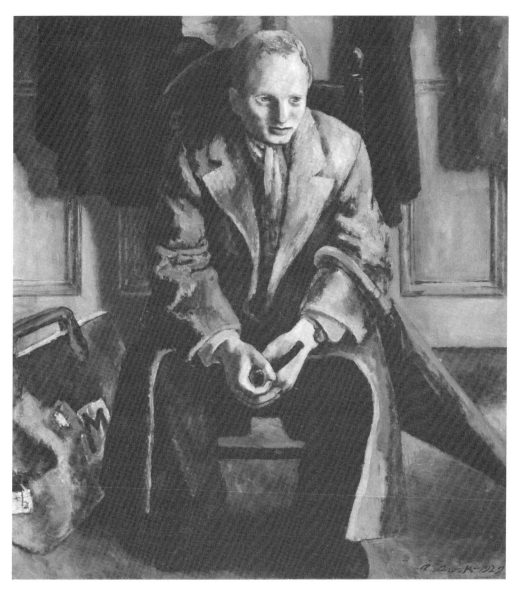

Alexander Brook. *Portrait of Reginald Marsh.* 1929. oil on canvas, 39⅞ x 36 (101.3 x 91.5).
Purchased with Funds from the National Endowment for the Arts and the Penrod Society. 71.10.

ALEXANDER CALDER
American, 1898-1976

Untitled. 1944

gouache on paper, 30½ x 22 (77.5 x 55.9)
signed and dated l.r.: Calder '44
inscribed l.r.: à Stephane Pizella/amicalement
 Calder mai 1945
The Mary B. Milliken Fund
71.181

Alexander Calder was born in 1898 in Lawton, Pennsylvania. Both his father and grandfather were sculptors. He moved often as a child. From 1915 to 1919 he studied engineering and held various jobs before entering the Art Students League in New York in 1923 where he studied until 1925. The following year he went to Paris and he continued to make a number of trips abroad throughout the rest of the 1920s. In the early 1930s Calder began working with kinetic sculpture. During World War II, he was in the United States but after the war ended he resumed his frequent travelling. After 1952 he spent most of his time at Sache, France. Calder died in 1976.

Famous for his mobiles and stabiles, the great sculptor Alexander Calder was also an important graphic artist. His mature graphics are delightfully imaginative works done in an extremely free style often incorporating the biomorphic forms of the Surrealist Joan Miro. This superb gouache of 1944 represents a much less well-known phase in his early development. During the mid-1940s Calder pursued a rigorous form of geometric abstraction which was largely non-representational. Here he has transformed a pure design into a dream image through the addition of two keyhole figures who are at once playful visual puns and ghostly psychic emanations set against an hallucinatory landscape which has been indicated through the most economical means. The geometry, in turn, translates the vision into an aesthetically satisfying composition. Both visually and expressively, this sheet must be counted among the artist's masterpieces of the period.

While they lasted only a few years, such experiments were of considerable importance in Calder's development. Their impact is seen not only in a series of strongly geometric gouaches from the summer of 1952 but also in the disarming freedom of his most spontaneous graphics, for the underlying visual principles remain essentially the same as in the IMA painting, despite the differences in appearance. The ability to evoke subconscious impulses with such artistic sureness was achieved only by first fully mastering fundamental problems of design in sheets such as ours.

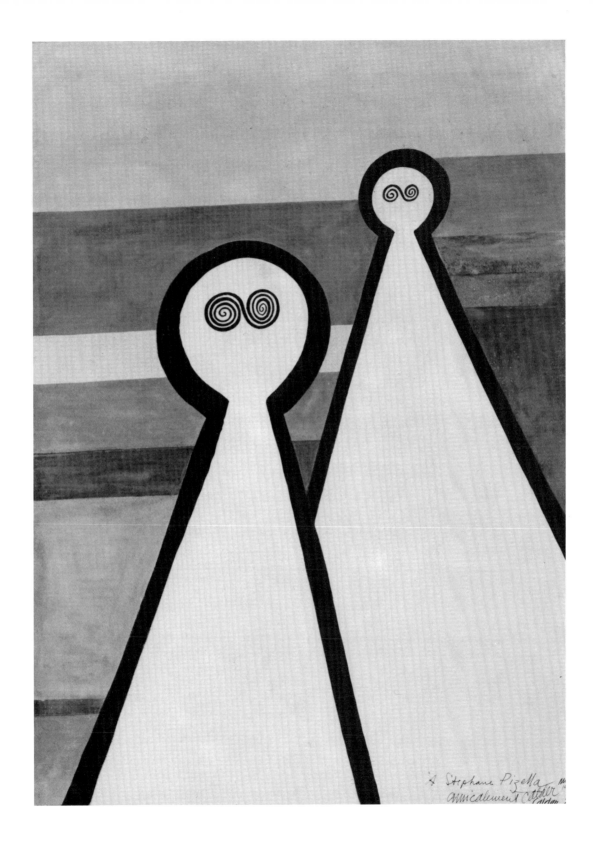

À Stephane Pizella
amicalement Calder

HANS HOFMANN
German-American, 1880-1976

Poem d'Amour. 1962

oil on canvas, 36¼ x 48 (92.1 x 121.9)
signed and dated l.r.: Hans Hofmann '62
inscribed on back: cat. no. 1446/poem d'amour/oil
 on canvas 1962/36 x 48 (signed) Hans Hofmann
Gift of the Contemporary Art Society
64.15

Hans Hofmann was born in 1880 in Weissenburg, Bavaria. His family moved to Munich in 1886. He was in Paris from 1903 to 1914. There he attended evening sketching classes at the Ecole de la Grand Chaumière in 1904, and had his first exhibitions in 1909 and 1910. A year after his return to Munich in 1914, he opened the Hans Hofmann School of Fine Arts. He wed Miz Wolfegg in 1923. He moved to the United States in 1932, and taught at the Art Students League and other schools until opening the Hans Hofmann School of Fine Arts in New York in 1934. The next year he opened a summer school in Provincetown and resumed painting after a long hiatus. He became a United States citizen in 1941. His work was represented in numerous one-man and group shows from 1944 on, and was the subject of a major retrospective organized by the Whitney Museum of American Art in 1957. Hofmann died in 1976 in New York.

Poem d'Amour of 1962 is important as one of the very few paintings to combine the two main sides of Hofmann's work in a single canvas: Abstract Expressionism and colored geometric shapes. The dichotomy represents the contradiction in Hofmann's art as a whole. As such, then, it is a remarkably complex painting.

In the early 1940s Hofmann became one of the first artists to experiment with a drip technique, which was to form the basis of Jackson Pollock's Action Painting. It was basically a modification of Surrealism's automatic handwriting, which was inspired by the theories of Sigmund Freud and was imported to these shores by André Masson and other emigrés. This approach theoretically allowed the subconscious to express itself directly through the spontaneous, though hardly random, flow of paint, which gave rise to new forms seemingly alive with a vital, almost organic, energy. To the Abstract Expressionist, however, the act of painting became a counterpart to life itself. In art as in life the painter faces comparable risks and resolves the dilemmas confronting him through a series of conscious and unconscious decisions.

In *Poem d'Amour* the background expresses the purely emotional side of the artist and his Existentialist philosophy. Against it float geometric shapes which appear regularly in Hofmann's work from the late 1950s on. Representing his European heritage, they reflect his conscious, intellectual side and his long experience as a teacher. The intense colors generate the forms and their arrangement. Although the actual process is as intuitive as Mondrian's, it is as if the artist had rationally analyzed the geometry of space by flattening a box and then dissecting it into separate rectangles lying in different planes. The result is a push-pull across the surface and a spatial tension behind it, because the different colors are perceived at varying depths according to their intensity.

While it pits seemingly incompatible tendencies against each other, the contradictions apparent in *Poem d'Amour* are resolved in a kind of uneasy truce by Hofmann's unifying cosmic vision. Mystical spiritualism was as widespread among the Abstract Expressionists in New York during the early 1950s as it had been among the Expressionists in Germany beginning with Wassily Kandinsky and then Paul Klee. Each

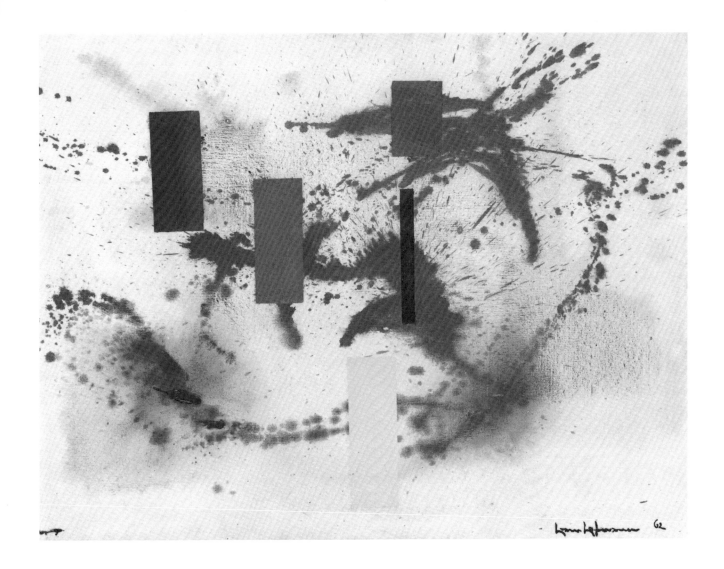

color, each shape and its placement against the galactic background of *Poem d'Amour* is intended to convey the artist's spiritual contact with nature in response to what he felt is the law of constant metamorphosis throughout the universe. This intuition he tried to raise to conscious realization by projecting it as a visual form in which the mystical and the rational complement each other. The title further suggests a lyrical state of mind in harmony with the universe. Since the Abstract Expressionist is guided solely by an inner impulse which he can recognize as his "subject" only after successfully completing his painting, the title is derived from the finished canvas through subconscious but by no means irrational associations.

PROVENANCE: Kootz Gallery, New York.
EXHIBITION: *Painting and Sculpture Today,* John Herron Art Museum, Indianapolis, 1964, no. 24.

PAUL JENKINS
American, b. 1923

Phenomena Danger—Pass Left. 1964
acrylic(?) on canvas, 51 x 76¾ (129.5 x 194.9)
signed l.l.: Paul Jenkins
inscribed on stretcher: Paul Jenkins 'Phenomena
 Danger—Pass Left' New York 1964
Gift of the Contemporary Art Society
65.1

Paul Jenkins was born in 1923 in Kansas City, Missouri, where he studied at the Kansas City Art Institute while apprenticed in a ceramic factory. He spent two years in the Navy Air Corps in 1944 to 1946. He moved to New York to study at the Art Students League from 1948 to 1951. Jenkins went to Paris in 1953, and has since divided his time between that city and New York. His first one-man show in the United States was at the Martha Jackson Gallery in New York in 1956. He has exhibited in numerous shows and won a prize at the Venice Biennale in 1964.

Like Jenkins' other paintings from the mid-1960s, which has so far proved his most consistently satisfying period, *Phenomena Danger—Pass Left* has a simplicity which is both bold and elegant. The title aptly characterizes the dynamic movement of form and contrast between the brown and blue merging into purple. To create his colored veils, Jenkins flexed and tilted his canvas as the pigments flowed across the white-primed surface. The technique permits an almost infinite range of changes in shapes and colors. While he does make corrections, Jenkins' approach relinquishes much of the control exercised by his contemporaries Helen Frankenthaler and Morris Louis in their stained canvases, which utilize a method of wiping introduced by Mark Rothko. In his greater spontaneity, Jenkins remains more closely allied to the classic Abstract Expressionism of the early 1950s, when all three of these artists began their careers. By staining rather than brushing his canvases, however, he eliminates the energetic gestures and personal handwriting of "Action Painting."

Jenkins was influenced by the same mystical currents that affected Hofmann. His staining technique is perfectly suited to his idea of the artist as a spiritual medium under supernatural guidance. In the act of painting, he must transcend himself by allowing his subconscious to respond as a kind of astral being to invisible phenomena. Because spiritual phenomena cannot be depicted literally in recognizable subjects, they can only be symbolized through a personal vocabulary that is necessarily abstract. For that reason, Jenkins prefers to call himself an "Abstract Phenomenist" and begins the title of each work with the term "Phenomena." Thus, through his non-representational canvases, he paints what God is to him in what he feels are primordial images of universal significance.

Jenkins' outlook reflects a wide range of sources. Besides the writings of such European artists as Paul Klee and Wols, his ideas incorporate Russian and oriental mysticism. Perhaps the greatest influence came from *Psychology and Alchemy* by the Swiss psychiatrist Carl Jung, who had a profound impact on the founding fathers of Abstract Expressionism. The alchemist considered water, one of the four basic elements, as the giver of life, and saw its fluidity as further signifying the flux of life and the movement of the universe. Jenkins' paintings always rely on the motion of liquid paint, primarily acrylics mixed with water, although he has used oil, acrylic and Chrysochrome. By implying varying rates of speed, he conveys a fundamental quality of modern life, thus providing a hu-

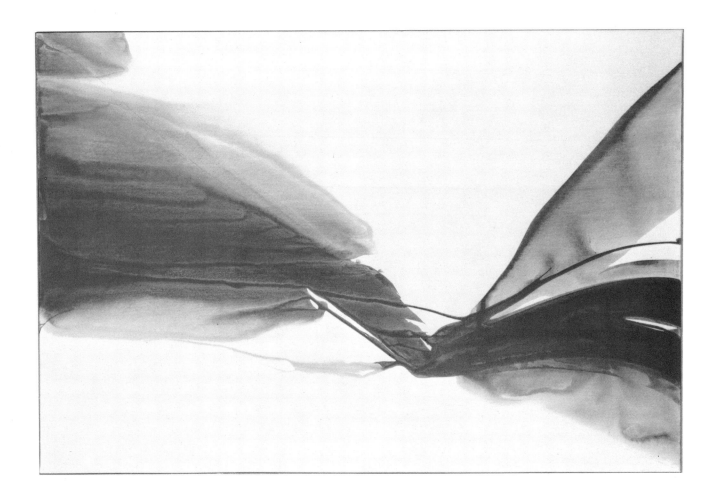

man reference in his work without actually depicting man. At the same time, he evokes the divine through the ebb and flow of his evanescent veils which, like Rothko's forms, rely on luminosity for much of their expressiveness. Light radiated from within and reflected from without reveals the invisible spiritual forces hidden beneath external appearances. The elements of earth, air and fire are suggested by the colors in his paintings. The harmony achieved between these components evokes the unity of the cosmos. As in Hofmann's *Poem d'Amour,* the specific combination of colors, form and movement in *Phenomena Danger-Pass Left* expresses a particular state of mind which is al-

ways different from what is found in his other paintings but which is consistent with his cosmic vision. And like Hofmann, Jenkins discovers the specific significance of each work through inner association gained after the canvas is done; he never starts with a preconceived idea. The title, while not absolutely essential to the painting, helps convey the visual message by amplifying its meaning.

PROVENANCE: Martha Jackson Gallery, New York.
EXHIBITION: *Painting and Sculpture Today,* John Herron Art Museum, Indianapolis, 1965, no. 19.
LITERATURE: A. Elsen, "Paul Jenkins' Phenomena Danger/Pass Left," *Bulletin, LII, 2, June 1965, pp. 32-37.*

JOSEF ALBERS
German-American, 1888-1976

Study for Homage to the Square: 'In Accord.' 1963

oil on masonite, 23⅞ x 23¾ (60.6 x 60.3)
inscribed on back: Study for/Homage to the Square:
 'In Accord'; Albers '63
 Ground: six coats of liquitex (Permanent Pigment)
 Painting: paints used—from center
 Cadmium yellow medium
 Naples Yellow reddish (Rhenish)
 Naples Yellow (Permanent Pigment)
 all in one primary coat
 all directly from the tube
 Varnish: Varnished in Butyl Methacrylate Polymer
 in Xylene Daniel Goodreyer Ltd., April 1963
 James E. Roberts Fund
 64.13

Josef Albers was born in Bottrop, Westphalia, in 1888. He studied at the Royal Art School in Berlin from 1913 to 1915, the School of Applied Arts in Essen from 1916 to 1919, and with Franz Stuck and Max Doerner at the Munich Academy. Albers taught at the Bauhaus from 1920 to 1933. In 1925 he married Anni Fleischmann and travelled to Italy. After the Bauhaus was closed by the Nazis in 1933, Albers moved to the United States and became an American citizen six years later. He was a member of the faculty of the Graduate School of Design at Harvard University from 1936 to 1940. Albers was Director of the Yale University School of Design from 1950 to 1958 and was a visiting professor there from 1958 to 1960. He held many guest professorships throughout the country. Albers died in New Haven, Connecticut, in 1976.

At face value, *Study for Homage to the Square* consists of nothing more than three colored squares on top of each other. Beneath this disarming simplicity, however, lies a complex theory which is outlined in Albers' famous book, *Interaction of Color.* The artist's sophisticated approach permitted him to investigate a wide range of perceptual and aesthetic responses to color within a tightly controlled geometric framework.

Basically, Albers relied on color scales in which the primary hue is desaturated in perceptually even gradations by giving it higher value, i.e. by diluting it with white or grey. A color step from one scale can be substituted for the same step in another one. They can be combined by following the laws of complementary colors, color mixing, harmony, contrast and so forth.

The transposition requires the utmost sensitivity to color, since the number and sequence of variations is potentially infinite. Although they are taken directly from commercially available tubes, the colors in our painting bear a complex relation to one another. The center square is an intense orange-yellow (Grumbacher cadmium yellow medium) which the viewer perceives as the color nearest to him; the outer square is a medium beige with some yellow (Rhenish Naples Yellow) and appears in an intermediate zone; while the middle square represents a mixture of the two but emphasizes yellow at the expense of orange (Naples Yellow, Permanent Pigment), so that it seems lightest and, hence, farthest away. The same colors recur singly or in different combinations and sequences in

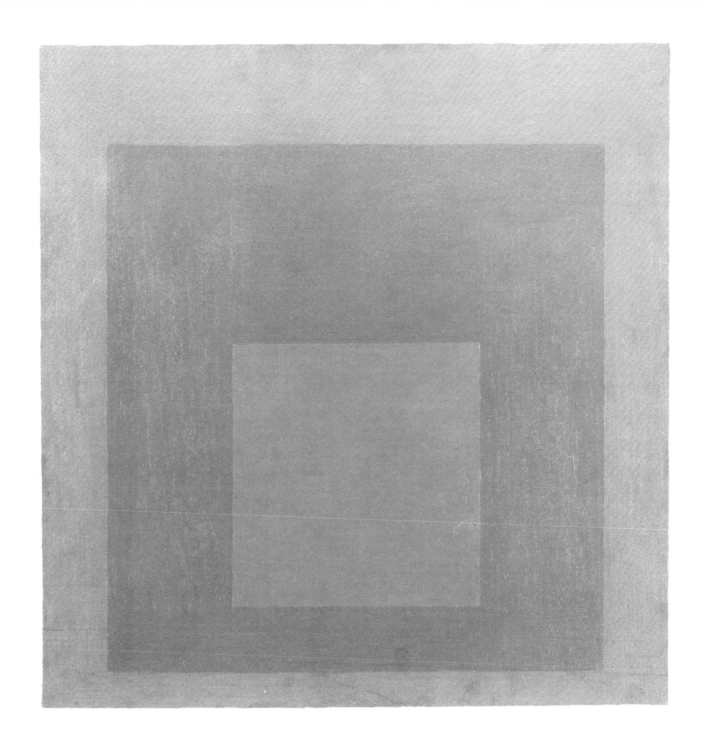

other works by Albers. Each painting achieves a different effect, but all are marked by the kind of optical push-pull found in our example.

The specific geometry of the IMA painting partly determines the result as well. The *Homage to the Square* series used four basic compositions, each with a strictly controlled set of proportions. These paintings represent a drastic simplification of Albers' earlier work. In the *Structural Constellation* series, he unfolded and analyzed the spatial geometry of the rectangles which appear as flat shapes in *Variations on a Theme*. By reducing his complex geometric schemes to a handful of types which remained constant, Albers was left free to concentrate solely on color, which was his primary concern throughout the latter part of his career. Albers' approach inverted the procedures of Piet Mondrian, the main source for his work. Mondrian used only the primary colors plus black and white, and limitlessly varied the geometry of his compositions. Both artists, however, relied on the subtle harmonies in their paintings to communicate their sophisticated intentions. Albers' work thus requires patient contemplation of its visual qualities in order for the viewer to gain a full appreciation of its aesthetic value.

RICHARD ANUSZKIEWICZ
American, b. 1930

Red Edged Emerald Green. 1980

acrylic on canvas, 48 x 48 (121.9 x 121.9)
Director's Discretionary Fund
80.195

Now living in Englewood, New Jersey, Richard Anuszkiewicz was born in 1930 in Erie, Pennsylvania. He studied at the Cleveland Institute of Art before receiving his Master of Fine Arts degree in 1955 from Yale University, where he was a pupil of Josef Albers. His work has been widely acclaimed since it first attracted critical attention in 1963.

While his majestic "door" paintings, such as *Entrance to Green* (1970, Sidney Janis Gallery, New York), remain his classic statements, Richard Anuszkiewicz has created a remarkable range of paintings and graphics which have established him as the foremost Op artist in America. Finding his own work the most fertile soil for further growth, the artist has often returned to earlier motifs and developed them in new directions. The Centered Square series, to which *Red Edged Emerald Green* belongs, represents a simplification of a composition found in his work of the mid-1960's without sacrificing richness of effect. Anuszkiewicz's debt to Josef Albers is apparent in the basic geometry and color theory underlying our painting. But unlike his teacher's *Homage to the Square: In Accord,* Anuszkiewicz's *Red Edged Emerald Green* uses concentric squares and relies on intense hues. The format of the Centered Square always remains the same, with radiating lines alternately swelling to twice their thickness from the inner square, which is one-half the dimensions of the outer one. Within this framework, Anuszkiewicz applies an almost infinite variety of color combinations. While the effects can range from the exquisitely sensitive to the vividly dynamic, the results always attain a complete harmony of geometry and color testifying to Anuszkiewicz's artistic intelligence.

What is perhaps most unexpected in *Red Edged Emerald Green,* an avowedly abstract work based on rigid geometry and complex color theory, is its expressive intensity. To achieve this impact, Anuszkiewicz carefully chose the exact shades he needed. In essence, green and red are complementary colors which strengthen each other. The emerald is an inherently poetic hue; intensified by the red, it acquires even greater expressiveness. Dominant toward the center, the red lines create the illusion of forming a corona around the inner square, which appears suspended in a visual web along the diagonal arms of the unified design. The longer one looks at it, the more *Red Edged Emerald Green* becomes an hallucinatory vision that possesses a mystical power capable of providing a deeply moving spiritual experience to the receptive viewer. Beautiful in itself, the painting is, in truth, a modern icon.

Op Art is concerned with the realm of optical illusions and other related phenomena of visual perception. In one sense, all art is illusionistic to at least some degree, but unlike such traditional genres as *trompe l'oeil,* Op Art investigates abstract illusions for their own sake. Pioneered by Victor Vasarely, Op uses all media, including light itself, but has relied primarily on geometric forms and intense colors applied to two-dimensional surfaces, be they paintings or graphics, to create unusual, often disturbing, spatial effects. A fine example is the IMA's *Obsession* painted in 1965 by Julian Stanczak, with whom Anuszkiewicz once shared a studio. Anuszkiewicz himself has experimented occasionally with comparable illusions, especially during the early 1960s. Many critics have continued to view Op as a controversial movement, because it places heavy visual demands on the viewer. At its best, however, Op Art forces us to see and feel in a new way. Anuszkiewicz has retained his position as America's leading Op artist precisely because aesthetic

Julian Stanczak. *Obsession.* 1965. acrylic on canvas, 52¾ x 44½ (134 x 113.1).
James E. Roberts Fund. 65.115.

concerns have remained at the heart of his work. In this respect he is the true heir of the legacy left by his teacher, Josef Albers, for whom theory was always secondary to aesthetics. Not only does Anuszkiewicz retain a unique freshness of vision, but in *Red Edged* *Emerald Green* he also has capacity to move us as few artists can today.

PROVENANCE: Purchased from the Artist.

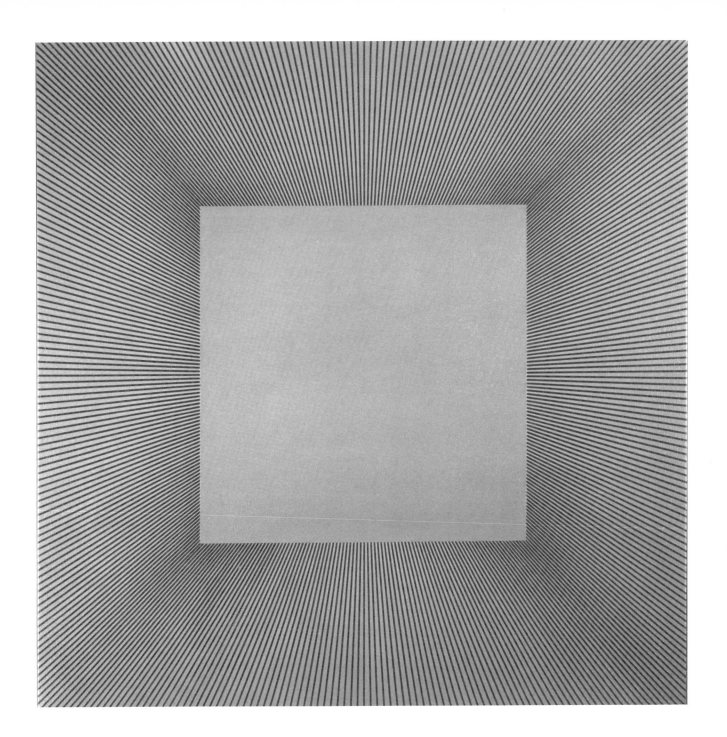

ROBERT INDIANA
American, b. 1928

Love. 1966

acrylic on canvas, 71⅞ x 71⅞ (180.7 x 180.7)
inscribed on back in stencil: RBG LOVE 36/73 x 72/
 Robert Indiana/ * 2 * / Spring/ New * 1966 * York
James E. Roberts Fund
67.08

Robert Indiana was born Robert Clark in New Castle, Indiana, in 1928. He studied at the John Herron Art School in 1945 and 1946; the Munson-Williams-Proctor Institute, Utica, in 1947 and 1948; and the Art Institute of Chicago from 1949 to 1953. In 1953 he spent the summer studying at the Skowhegan School, Maine. He went to Scotland in 1953 and 1954 to study at the Edinburgh College of Art. Indiana has had numerous one-man exhibitions since 1962.

Robert Indiana is a self-proclaimed "American painter of signs"—not of billboards, although old ones on the sides of buildings have provided part of the inspiration for his work, but of symbols, both visual and verbal, which we encounter in our society. Like such precursors of Pop Art as Robert Rauschenberg and Jasper Johns, Indiana uses words to help bridge the gap opened by Abstract Expressionism between art and daily life. And as in the works of Rauschenberg and Johns, his reconsideration of a sign's appearance is tied to a re-evaluation of its meaning. The play between form and content permits numerous variations on what is essentially the same image. Be it repetitive or sequential in format, such serialization derives from the same sense of the commonplace in American culture which also gave rise to Andy Warhol's images of Campbell soup cans.

Only rarely has an image come to stand for an entire age the way Indiana's LOVE has. Words by their very nature are symbols having a public as well as a private meaning. Much the same thing is true of art as a whole, since there is always some disparity between the creator's intention and his audience's understanding. All of Indiana's paintings come from his personal experiences and the objects associated with them. LOVE had its origin in a work commissioned by the Larry Aldrich Museum in Ridgefield, Connecticut. Titled *Love is God,* with the words stencilled

inside a circle contained by a diamond, it reversed the familiar phrase "God is Love" which he had seen during his youth in the Christian Science church he attended with his mother. This spiritual message had a profound effect on Indiana. He brought it into sharper focus by rephrasing and redesigning the words. Removed from its original context, the message could take on a new, more general meaning.

LOVE carries the process one step further by extracting the key word and isolating it within a new design. Now the viewer is free to provide his own private meaning through personal associations with his individual experience. Thus, love can be interpreted as spiritual, amorous or sexual. It can even become a command, much like the highway sign Yield which Indiana has also used in his paintings. In this way, the image could function almost as a talisman for the flower child generation (which it actually predates) precisely because LOVE accepts such a broad range of individual significance, thereby providing a common meeting ground for a widely shared sentiment.

The IMA canvas is the original LOVE painting. Ironically, the widespread commercial promotion of LOVE, both by Indiana and by others (the image is, perhaps fittingly, not copyrighted), has reduced this supremely original design to the realm of the commonplace from which it ultimately sprang. Yet it somehow manages to retain its freshness. Part of the reason

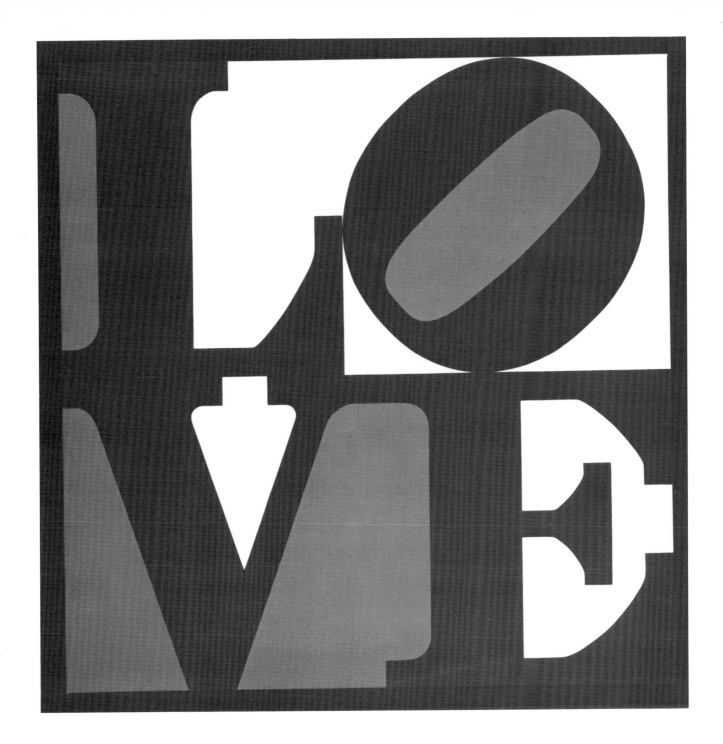

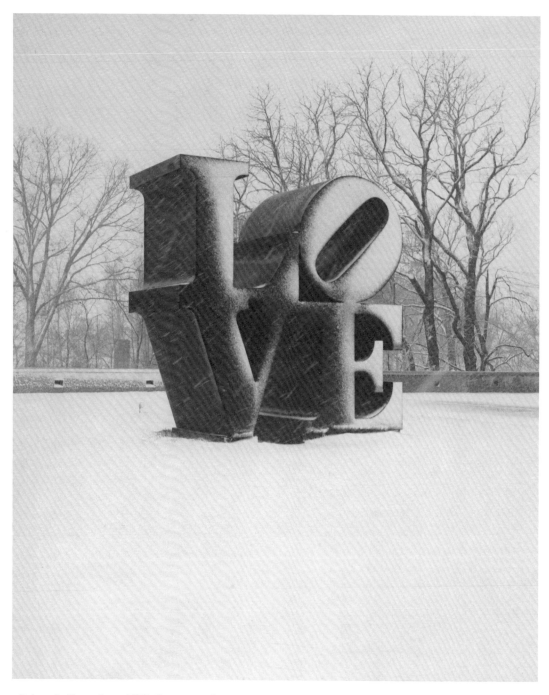

Robert Indiana. *Love.* 1970. Cor-ten steel, 144 x 144 x 72 (365.8 x 365.8 x 182.9). Gift of the Friends of the Indianapolis Museum of Art in Memory of Henry F. DeBoest. 75.174

lies in the inherent appeal of the word and the purely contemporary response to its variety of meanings. More important, the tilted O remains intriguing. It serves to attract our attention and leads us to question the significance of the word, to rethink its public as well as its private meanings, even though the piquant device as such provides no answer.

The design is, moreover, attractive in its own right. In Indiana's work, the words always generate the design, providing a suitable visual format for expressing new meaning. Yet, because of the colors, the word seems to emerge from the painting it gave rise to. The design is as formal and abstract as anything being done by hard-edge color field painters, so that it is thoroughly modern in appearance, despite the fact that the letters imitate old stencil forms. Indiana's interest in abstraction comes in part from his contact with Ellsworth Kelly, once the artist's neighbor, whose style has influenced many painters. By restricting himself to a few words, formats, and types of lettering, Indiana is able to investigate formal problems of color and design without "interference" from the meaning of words, which are de-emphasized through standardization without losing their ultimate potency.

LOVE has also been translated into a monumental sculpture twelve feet tall which stands near the entrance to the IMA. The third and final LOVE statue, it grew almost literally out of six multiples which were done in 1968 and measure only twelve inches high. The change in scale and context gives LOVE a new nuance of meaning. Like Indiana's later sculpture of the word ART, which seems a physical counterpart to a famous *New Yorker* cartoon by Saul Steinberg, LOVE has now become a concrete object of public appreciation, as well as one of aesthetic contemplation, outside the IMA. Over the years, it has also become a symbol of the museum itself. The sculpture's changing significance is reflected in its altered appearance. The Corten steel has acquired a brown patina through a natural rusting process as it weathers. As a tangible object, LOVE can be seen visually, touched physically, felt emotionally and interpreted symbolically on many different levels.

EXHIBITIONS: *American Painting since World War II*, Delaware Art Museum, 1971. *The Modern Image*, High Museum of Art, Atlanta, 1972.

MEL RAMOS
American, b. 1935

Miss Lemon Drop. 1964

oil on canvas, 40 x 36 (101.6 x 81.4)
Director's Discretionary Fund
80.196

Mel Ramos was born in 1935 in Sacramento, where he studied art from 1954 to 1958, taking lessons from Wayne Thiebaud among others. Since then he has had a highly successful career. He now resides in Oakland.

Ramos' earliest canvases were done in a typically West Coast form of Abstract Expressionism. He became one of the progenitors of Pop Art when he began to paint comic book heroes in 1961 at around the same time that Roy Lichtenstein was investigating the same subject matter in New York. Pop artists drew their imagery from magazines and commercial art as well. Unlike Surrealists, such as Max Ernst and Kurt Schwitters who had occasionally resorted to similar sources, they did so without ironic intention, although the results are often deliberately humorous. In 1963 Ramos turned his attention to the kind of female nude found in calendars and Playboy Magazine, which also provided inspiration for Tom Wesselman. Since then he has depicted a wide variety of nudes, from the Peek-a-boo series framed by a painted keyhole, through uproarious parodies of classical myths, incorporating wildly improbable combinations of nudes and animals, to witty restatements of Old Master and modern paintings using movie stars.

Painted in 1964, *Miss Lemon Drop* is one of Ramos' classic pictures. In subject and treatment it belongs to a large group of canvases, including *Miss Grapefruit Festival* done in the same year (San Francisco Museum of Art), which presents the girlie figure as a commercialized all-American ideal. As in most of his other works, Ramos painted the nude using a projector; for that reason, he has sometimes been regarded as one of the first Photo Realists. However, the thick pigments and painterly brushwork draw attention to the surface and emphasize the canvas as an independent picture, rather than as a recreation of a photographic image. This plastic treatment also has the effect of stressing the artificiality of the nude, with her forced pose and eternally cheerful smile. The painting as a work of art is further underscored by the framing device of the lemons, which provide an obvious visual pun on her anatomy as well.

To dismiss this kind of painting as mere *kitsch* (cultural trash elevated to the realm of art), as some critics have done, misses the point of Pop Art. Translated onto the large canvas, the nude in *Miss Lemon Drop* holds up a mirror to our cultural ideals and personal fantasies as embodied in this ubiquitous form of cheesecake. With good humor Ramos forces us to confront a side of ourselves in this sunny painting, which exerts an irresistible appeal. Although they are castigated as obscene and sexist, the erotic fantasies purveyed by cheesecake images are no less worthy a field of artistic investigation that Lichtenstein's paintings of war and love comic book frames or Andy Warhol's Campbell Soup cans and brillo boxes. The value of Pop Art lies precisely in the fact that it has drawn our attention to the images around us which shape our character and form our understanding of art, while exposing our values for all to see. Like most Pop artists, Ramos is clearly sympathetic to his subject. Interestingly enough, his work is enjoyed by most normal men and women because it is part and parcel of our cultural baggage. Rather than being offensive, Ramos' paintings evoke a brief interlude of national well-being in the early 1960s before the Vietnam era which in retrospect seems like an age of innocence. It is no accident that in our more troubled times Pop art has become preoccupied with formal aesthetic problems, so that it has been reassimilated into the mainstream of American abstract painting from which it sprang in the first place.

PROVENANCE: Gerald Rosen Collection, Santa Monica; Louis Meisel Gallery, New York.
EXHIBITION: *Mel Ramos, A Twenty Year Survey*, Rose Art Museum. Brandeis University, Waltham, 1980, no. 25.
LITERATURE: E. Claridge, *Mel Ramos*, London, 1975, ill. p. 78.

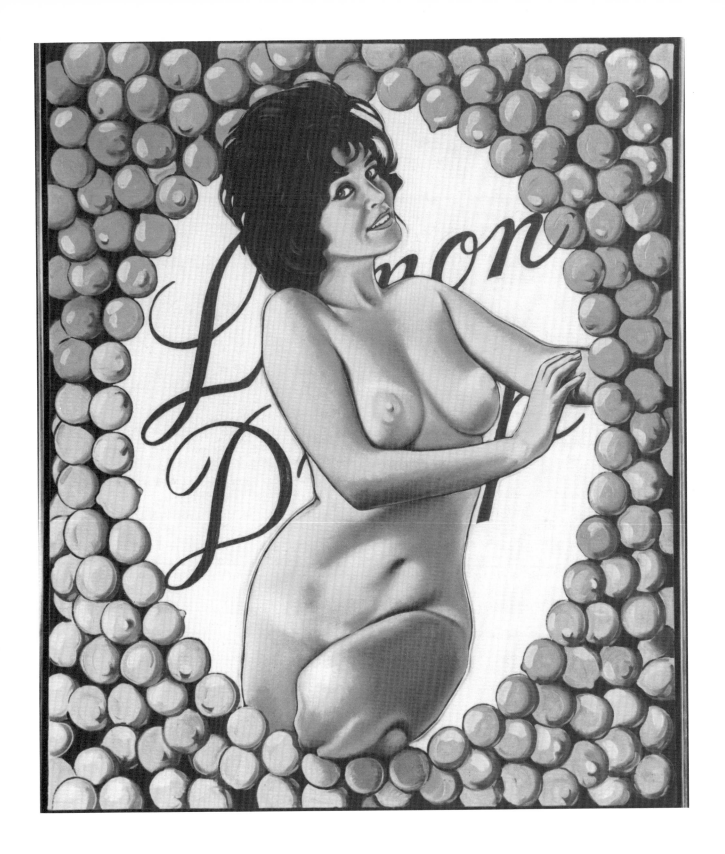

RICHARD ESTES
American, b. 1936

Car Reflections. ca. 1968

acrylic on masonite, 48 x 30 (121.0 x 76.2)
Purchased with Funds from the Penrod Society and
 the National Endowment for the Arts
71.207

Richard Estes was born in Evanston, Illinois, in 1936. He studied at the Art Institute of Chicago from 1952 to 1956 and has exhibited regularly since 1968.

Unlike earlier artists who used photographs as convenient substitutes for reality, Richard Estes accepted a photographic image—in this case a slide—as the reality on which to base his painting *Car Reflections*, done in the late 1960s. In the process of translating and enlarging the image into a picture, however, he altered the photograph's appearance so that the painting would look "right." To balance the painting and strengthen its design, the artist eliminated superfluous glare and reflections while showing everything in uniformly sharp focus, picking up details lost by the camera. This selectivity transforms the picture from a simple mirror of the world into an independent, self-contained image. The familiar scene becomes a rich visual experience through the fascinating play of reflections. At the same time, the painting poses the question, what is the reality: the distorted reflection or the crisp one below; the scene which is reflected but lies outside our view; the photograph or the painting? The more we look at this intriguing visual puzzle, the more we are drawn to the realization that the painting itself is the sole reality before us.

Richard Estes had established himself as one of the leading representatives of Photo Realism because his fresh vision in paintings such as *Car Reflections* forces us to see and think in a new way. Photo Realism was partly an outgrowth of Pop Art. In fact, the montage of images in *Car Reflections* is distinctly reminiscent of James Rosenquist's billboard paintings, such as *One, Two, Three and Out* (1963, Richard Bellamy Collection, New York). With an unerring sense for selecting visual clichés that define the modern American experience, Pop artists in the early 1960s turned for the source of their material to commercial art, which has often been separated from high art in the United States by only the thinnest of boundaries. But whereas Pop artists became increasingly absorbed by the formal problems inherent in their images and techniques, the Photo Realists still adhere to the appearance of the everyday world. However, the approach, while immediately ingratiating and easily learned, is very limited in the hands of most practitioners. So far only a few artists have managed to transcend the simple appeal of *trompe l'oeil* illusionism and elevate Photo Realism to a fully satisfying aesthetic. Richard Estes clearly belongs to that select group.

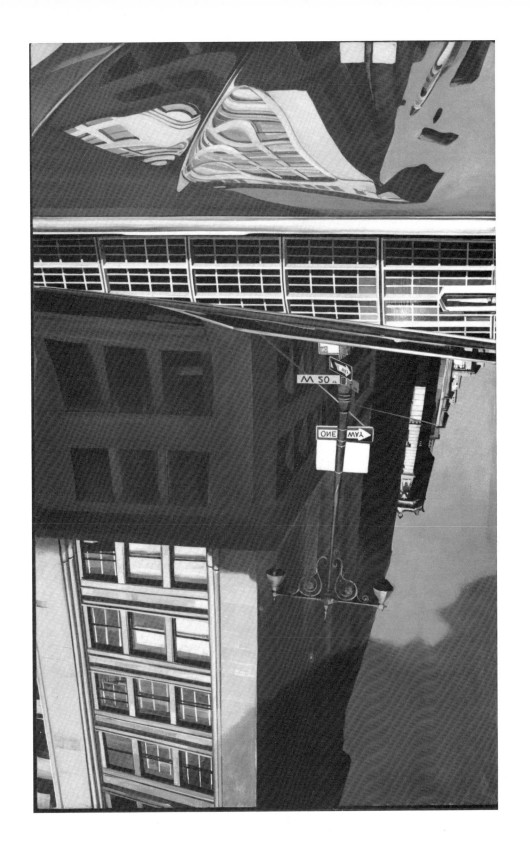